SURREALIST
ART

BY DAWN ADES

WITH CONTRIBUTIONS BY
MARGHERITA ANDREOTTI AND
ADAM JOLLES

MARGHERITA ANDREOTTI,
GENERAL EDITOR

SURREALIST ART

THE LINDY AND EDWIN BERGMAN

COLLECTION

AT THE ART INSTITUTE

OF CHICAGO

THE ART INSTITUTE OF CHICAGO

THAMES AND HUDSON

This publication was made possible in part by a grant from the Andrew W. Mellon Foundation.

Executive Director of Publications: Susan F. Rossen
Editor: Margherita Andreotti, assisted by Adam Jolles and Katherine Irvin
Research Assistants:
Matthew Gale and Michael White
Production Manager: Daniel Frank, assisted by Sarah E. Guernsey

Design: studio blue, Chicago
Typeset by Paul Baker Typography, Inc., Chicago
Color separations by LS Graphic, Inc., New York/Fotolito Gammacolor, Milan
Printed by LS Graphic, Inc., New York/Grafica Comense, Como
Bound by LE. GO Service S. R. L.

For photography credits, see p. 246.

First published in softcover in the United States of America in 1997 by Thames and Hudson Inc., 500 Fifth Avenue, New York, New York 10110

First published in Great Britain in 1997 by Thames and Hudson Ltd, London

First Edition
Library of Congress Catalogue Card Number 96-61200

ISBN 0-500-23711-5 (USA)
ISBN 0-500-27995-0 (UK)

British Library Cataloguing-in-Publication Data
A Catalogue record for this book is available from the British Library

FRONT COVER: Joseph Cornell, *Untitled (Forgotten Game)* (detail), no. 27 (see p. 58)

FRONTISPIECE: Salvador Dalí, *Imaginary Portrait of Lautréamont. . .* (detail), no. 53 (see p. 104)

BACK COVER: Joseph Cornell, *Soap Bubble Set* (detail), no. 22 (see p. 50)

TABLE OF CONTENTS

PREFACE

JAMES N. WOOD, DIRECTOR AND PRESIDENT

OVER THE COURSE OF THREE DECADES, CHICA-goans Lindy and Edwin Bergman assembled a truly remarkable art collection. Wide-ranging in their tastes, they surrounded themselves with pre-Columbian and Oceanic objects as well as the work of a broad spectrum of contemporary artists, including a number from Chicago. Their collection is perhaps best known for its unrivaled holdings of the enigmatic works of Joseph Cornell, the reclusive American artist whom they came to know in the late 1950s. In 1982 they decided to share their passion for Cornell by giving thirty-seven of his box constructions and collages to The Art Institute of Chicago. But the Bergmans did not limit themselves to one artist or to works of a certain type. They had become devotees of Surrealist art, with its emphasis on the power of the irrational to reveal the extraordinary and on the unconscious as a source of creativity. The Bergmans acquired hundreds of examples by the movement's European originators and by second-generation adherents in Europe as well as in South and North America (such as Cornell). This interest extended to the work of Chicagoans, such as the Hairy Who and other Imagist artists, whose art is infused with a Surrealist spirit.

While Lindy and Ed never confined their collecting to a particular medium, they showed an unusual affection for works of art on paper. More intimate in scale than paintings, drawings have historically been the vehicle through which an artist expresses his or her most personal thoughts. As Dawn Ades so aptly notes in the Introduction that follows, the act of drawing was central to the Surrealist process, tracing the thoughts and dreams of an artist's mind and sharing, in a sense, his or her secrets with the viewer. In the relative immediacy of their execution, drawings also lend special insight into the process by which the creative genius transforms common materials into works of art. Confident of their taste, without ever feeling the need to impose it on others, the Bergmans made acquisitions that are intimate and appropriately scaled to the home and family, and yet of such quality that they hang confidently in a museum setting.

In 1991 the Bergmans placed seventy-five works by thirty-three artists on long-term loan to the Art Institute. As museum trustees, Lindy and Ed Bergman believed that intensely private artistic statements should be integrated with larger or more public works of art within a museum's galleries and should not be segregated by medium, as is common practice. The loan of these works, along with the examples by Cornell and four other objects that the Bergmans had donated earlier, constituted the centerpiece of the 1993 reinstallation of the Art Institute's collection of European and American art from the first half of the twentieth century. The objects from the Bergmans solidified and rendered truly outstanding the museum's already extensive selection of Surrealist art. Thanks in part to the Bergmans, the Art Institute's galleries devoted to this area now include not only famous paintings and sculptures but also a wide range of works in other media and an extensive sampling of the ephemera that were so critical to the Surrealist enterprise. The Art Institute's particular strength in Surrealism can be traced to the exhibition and acquisition activities of a number of its curators, such as Katharine Kuh, A. James Speyer, and Charles F. Stuckey; as well as to the dedication and generosity of a number of private collectors, such as the Joseph Winterbotham family, Mary Reynolds, Mr. and Mrs. Earle Ludgin, and Joseph and Jory Shapiro. To this list of extraordinary individuals can be added Lindy and Ed Bergman.

The intelligence, enthusiasm, and support they extended to friends, collectors, and cultural institutions

made the Bergmans tremendously important for all art in Chicago. Such community leaders are all too rare. It is thanks to the Bergmans, and others like them, that the privately supported American art museum, dedicated to a public purpose, is admired and envied around the world.

Surrealist Art: The Lindy and Edwin Bergman Collection at The Art Institute of Chicago is the result of the dedication of a number of people, many of whom are thanked in the Acknowledgments on pages viii and ix. First and foremost, I wish to thank Lindy Bergman for her patience and understanding throughout the lengthy process that the research for and preparation of the manuscript entailed. The careful and loving cataloguing of the collection by her son, Robert, was essential to this effort, and we are all grateful to him. The collection has been sensitively displayed and taken care of by two departments under the leadership of Charles F. Stuckey,

formerly Frances and Thomas Dittmer Curator of Twentieth-Century Painting and Sculpture; and Douglas W. Druick, Prince Trust Curator of Prints and Drawings. Finally, I wish to thank Dawn Ades—whose great knowledge of Surrealism and Latin American art of our time makes her one of the few scholars who could do justice to the breadth of the Bergman Collection—for her engaging and perceptive text; as well as Margherita Andreotti for the dedication, scrupulous scholarship, and informed editing she brought to the project. * * *

ACKNOWLEDGMENTS

EDWIN AND LINDY BERGMAN FIRST GENER-
ously introduced me to their collection in 1979,
when I was involved with the exhibition of works
by Joseph Cornell that opened at The Museum of
Modern Art, New York, in 1980 and that then traveled to
a number of venues, including The Art Institute of
Chicago. When, following the donation of the Bergman
Collection, I was approached by the Art Institute to
write about it, I was excited at the prospect of deepen-
ing my knowledge of Cornell and of exploring this rich
and varied group of works by other Surrealists. First and
foremost, I would like to express my gratitude to Lindy
Bergman; her son, Robert; and her daughters, Carol
Cohen and Betsy Rosenfield. Both Mrs. Bergman and
Bob have been most supportive, sharing their archive
and providing crucial information and insights born of
long cohabitation with the works.

On my visits to Chicago to research the collection, in
1993 and 1994, I was given the fullest possible support
by the Art Institute's staff. I am of course most grateful
to Director and President James N. Wood, for inviting
me to participate in this exciting project. I would also
like to thank Deputy Director Teri J. Edelstein for her
encouragement and interest. The variety of media in the
Bergman Collection – paintings, works on paper, sculp-
ture, and mixed media – demanded the cooperation of
a number of departments. In Twentieth-Century Paint-
ing and Sculpture, I would like to acknowledge the as-
sistance of former curator Charles F. Stuckey, as well as
curators Courtney J. Donnell and Daniel Schulman and
support-staff members Nicholas Barron and Kathryn
Heston. In Prints and Drawings, I would like to mention
Prince Trust Curator Douglas W. Druick, Assistant
Curator Mark Pascale, and Paper Conservator David
Chandler. In the Department of Conservation, I am
grateful to Executive Director Frank Zuccari, as well as
to Emily Dunn, Barbara Hall, and Suzanne Schnepp.

The meticulous analyses of Cornell's boxes and other
works by Cynthia Kuniej Berry underpin my discussion
at every point. My thanks also go to a number of the
Imaging Department staff: Executive Director Alan B.
Newman, photographers Annabelle Clarke, Christopher
Gallagher, and Robert Hashimoto, as well as Anne Morse,
Pamela Stuedemann, and Julie Zeftel. They were very
helpful, solving many of the problems posed by the re-
production of complex works.

The Publications Department, led by Executive
Director Susan F. Rossen, showed great tolerance and
encouragement as the project grew in scale and ambi-
tion. In many respects, the book became a collaborative
project between myself, editor Margherita Andreotti,
and her assistant Adam Jolles. I am grateful to
Margherita for her perceptive advice, careful scholar-
ship, high intellectual standards, and sensitive editing.
An indefatigable researcher, Adam's fine work informs
the book throughout. Further research was carried out
by department members Sue Breckenridge and Kate
Irvin, and the latter also served admirably as photo-
rights editor and copy reader. Also to be thanked in
the Publications Department are Sarah Kennedy, Cris
Ligenza, and Bryan Miller.

Initial research for the book was undertaken with
the assistance of Matthew Gale and Michael White, whose
diligence and persistence I deeply appreciate. Lilian
Tone provided useful additional research on exhibition
histories. I am grateful to those who provided scholarly
advice on specific works in the collection: William A.
Camfield, Whitney Chadwick, Judith Cousins, Elizabeth
Cowling, Linda Roscoe Hartigan, Sandy Rower, David
Sylvester, and Sarah Whitfield. The contributions of
many others are acknowledged in the text, but I would
especially like to thank Timothy Baum, Olive Bragazzi,
Richard Feigen, Allan Frumkin, Françoise Guiter,
Jeanne Havemeyer, Eskil Lam, Lou Laurin-Lam,

Albert Loeb, Mme Marguerite Masson, George Melly, Gordon Onslow Ford, the late Joseph Randall Shapiro, and Allan Stone. Also performing tasks critical to our research were several members of the Art Institute's Ryerson and Burnham Libraries: Executive Director Jack Perry Brown, Maureen Lasko, Natalia Lonchyna, Susan Perry, and Alexis Petroff.

The manuscript was read by Carolyn Lanchner, Dickran Tashjian, and Charles Stuckey, all of whom made helpful suggestions and saved me from errors. I am grateful for their encouragement and insights. Terry Ann R. Neff provided wise counsel, based on her knowledge of the history of the collection, in shaping the Introduction.

The book's fine production is due to the talents and hard work of the Publication Department's Associate Director for Production, Daniel Frank, and his assistant, Sarah E. Guernsey. The imaginative design was contributed by studio blue, Chicago, under the direction of Cheryl Towler Weese and Katherine Fredrickson. I am also grateful to Nikos Stangos, of Thames and Hudson, Ltd., London, and Susan Dwyer, of Thames and Hudson, Inc., New York, for their enthusiasm for the project.

Finally, for their practical assistance at various stages in the preparation of the manuscript, I would like to thank Robert Ades, Ruth Breakwell, and Clare Moore.

* * *

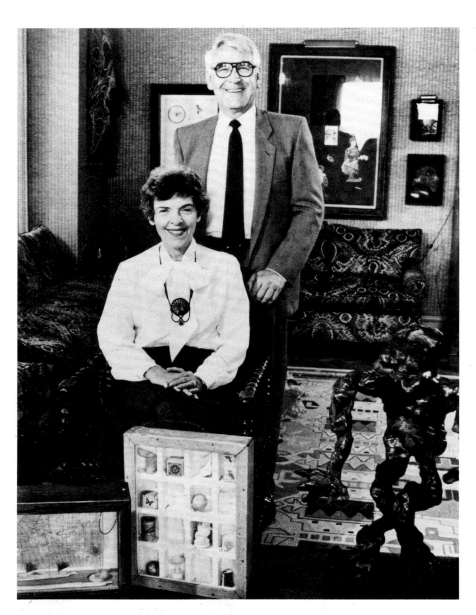

Figure 1. Lindy and Edwin Bergman
at home with their art, Chicago,
1982. Among the works that surround
them, at upper right, is a large
collage by Joan Miró (no. 100) now in
The Art Institute of Chicago [photo:
Arthur Shay, from *U. of C. Magazine*
1982, p. 23].

DAWN ADES

INTRODUCTION

THE ACTIVITIES OF LINDY AND EDWIN BERGMAN as collectors (fig. 1) belong to a distinguished history of art patronage in Chicago whose origins can be traced to Bertha Honoré Palmer's passion for contemporary French art. The group of great nineteenth-century works that she and her husband, Potter Palmer, gave to The Art Institute of Chicago launched its reputation in the area of French Impressionism and Post-Impressionism and established its commitment to the acquisition and exhibition of outstanding examples of European modernism. The gift of the Lindy and Edwin Bergman Collection to the Art Institute continues this tradition by transforming what was already a fine representation of Surrealist art into one of the most important concentrations anywhere of this influential movement. In 1982 the Bergmans presented the museum with thirty-seven boxes and collages by Joseph Cornell (see fig. 2), by far the finest group of works by this artist on public display anywhere in the world. With the addition in 1991 of a long-term loan of over seventy

pieces by other artists, the Bergman Collection now boasts fine examples by first-generation European Surrealists, such as Ernst, Masson, and Miró; by later adherents to the movement, such as Gorky, Lam, and Matta; and by artists who were both connected with Surrealism and of great consequence for postwar New York painting, such as Dubuffet and John Graham.

Edwin Bergman (1917–1986) and his college sweetheart, Betty (Lindy) Lindenberger (born 1918), were married in 1940. The businessman and his wife began to collect art in 1955 and rapidly developed their own, distinctive tastes. German Expressionism, one of their early enthusiasms, was quickly overtaken by Surrealism and works that had, as one writer put it, "a shiver of Surrealism about them."[1] By and large, they followed their own inclinations, while contributing to the strong tradition of collecting Surrealist art that developed in Chicago from the 1950s onward. This preference among collectors can be traced to two major sources: the city's leading art dealers, especially Richard Feigen and Allan

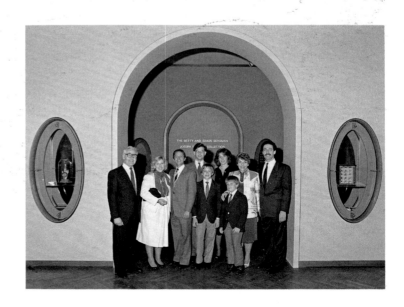

Figure 2. The Bergman family at The Art Institute of Chicago for the opening reception, on June 8, 1983, of "The Betty and Edwin Bergman Joseph Cornell Collection." They are standing at the entrance to the installation especially designed to showcase the thirty-seven works by Cornell the Bergmans had given to the museum the previous year. These were supplemented with the loan of thirty additional Cornells still in their private collection. Left to right: Edwin Bergman, Carol Cohen, Doug Cohen, Andy Rosenfield, Scott Cohen, Betsy Rosenfield, Michael Cohen, Lindy Bergman, and Robert Bergman.

Frumkin, who showed Surrealist art; and the persuasive collector Joseph Randall Shapiro (1904–1996), who was an inspiration and guiding force for Chicago's entire contemporary-art community of patrons, artists, and museums.

In accordance with the example set by the Surrealists, the Bergmans' interests extended to a wide range of objects from many periods and places, including pre-Columbian pottery and sculpture (see figs. 3 and 4). Their collection grew first at their home in Chicago's South Shore Highlands neighborhood, and then in their apartment in Hyde Park (see figs. 1, 3–5), the section of Chicago in which they had lived when they were first married.[2] The more than thirteen hundred works of art that entered their collection over the years underwent a constant process of sifting and refinement. With its natural and comfortable integration of art and life and of extraordinary and ordinary objects, the Bergmans' apartment reflected their attitude as collectors. Their very first collection, in fact, was not of art objects at all but rather of seashells,[3] and a fascinating if faint echo persists of this love of the intricate forms of the natural

world in some of their Cornell boxes (see, for example, fig. 8, the first Cornell box they acquired, which indeed contains a shell and sand).

In spite of the extraordinary number and quality of the art objects (on every wall, table, shelf, and even floor), the apartment was still very much a home, not a museum. One had a strong sense that the works were an active and dynamic part of family life, that they were known intimately and reexperienced daily. For example, a large glass cabinet, created where there was once a doorway,[4] gave easy access to a number of boxes and assemblages by Cornell and others, especially to some of Cornell's earliest pieces and memorabilia that require handling or opening to be properly viewed.

The Bergman Collection at the Art Institute offers a unique insight into Surrealism and the nature of its impact in the United States. At its center, and exemplifying this influence, is the large body of work by Cornell. This very private artist created intimate boxes and collages in which he distilled a rich web of associations and memories. His work invites the viewer to approach and peer into a kind of enchanted theater or to embark on

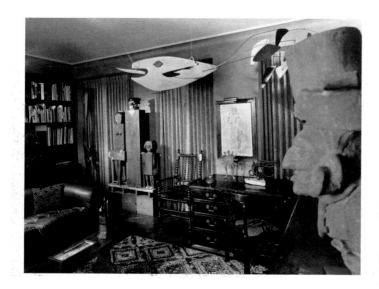

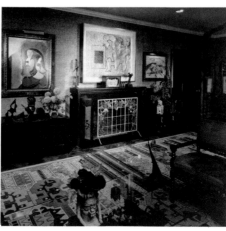

Figures 3 and 4. By 1972 the Bergmans' home in Hyde Park, Chicago, was filled with an array of art that encompassed more than the Surrealism for which they are best known. In the library (left) are a drawing by Richard Lindner (no. 85), a mobile by Alexander Calder, Marisol's Kennedy Family group, and, in profile, a pre-Columbian Mixtec figure. In their living room (below), pre-Columbian sculpture and a large portrait by Pablo Picasso share the space with one of Max Ernst's Loplop collages and his Garden Airplane-Trap (no. 67) [photos: Hedrich-Blessing, Chicago].

imaginary journeys. In these and other respects, such as the intimacy of scale and delicacy of materials, Cornell's art embodies traits of the Bergman Collection as a whole.

This invitation to close scrutiny extends to many other examples, from the haunting mystery of Yves Tanguy's *Certitude of the Never Seen* (no. 112) to the linear intricacy of André Masson's automatic drawings (nos. 88–90). Although the collection includes a number of major paintings and sculptures – by Balthus, Calder, Delvaux, Dubuffet, Ernst, Gorky, Magritte, and Richier, among others – a distinctive taste is evident for pieces of relative modesty, but of great intensity and physical impact. There are many works on paper: drawings and gouaches, superb *cadavres exquis* from the late 1920s (nos. 8–10), and object-assemblages that introduce the viewer to the richness and variety of materials employed by the Surrealists. This use of found and natural objects, rendered magical by new associations and juxtapositions, was at the heart of Cornell's artistic practice.

Two central aspects of Surrealist art are thus represented in the collection: the special value of drawing – most strongly evidenced in the spontaneity and freedom of automatic drawings – as the activity that most directly reflects an artist's thought; and secondly, the emphasis on the power of the imagination to transform the everyday, regardless of stylistic considerations. Indeed, there is no such thing as a Surrealist style, and works defined as Surrealist often present at first sight a highly eclectic appearance. Artists were free to find their own route to express the points of intersection between dream and waking life, conscious and unconscious, memory and action.

The Bergmans' taste for Surrealism was, moreover, part of a very contemporary sensibility. As demonstrated by many of the works they chose – by Jean Dubuffet and John Graham, for example – they clearly thought of Surrealism not as a past, closed movement but as a living one. Dubuffet, who had made a trip to Chicago in 1951,[5] was an important link between Breton's Surrealism and the postwar American painting that likewise appealed to the Bergmans, especially the work of a group of Chicago artists known as the Hairy Who.[6] Graham was another key, if enigmatic, figure in

Figure 5. René Magritte's superb painting *The Banquet* (no. 86), one of the Bergmans' signature pieces, is shown here gracing their dining room [photo: Alexas Urba, Chicago].

postwar American art, an influence on both Willem de Kooning and Jackson Pollock. Graham's work has been one of the enduring interests of the Bergmans, and he remains Lindy Bergman's preferred artist.[7]

Two of the artists who are major presences in the collection, Cornell and Wifredo Lam, became personal friends. During a 1956 visit to Lam's studio in Havana, the Bergmans saw a study (no. 79) for the large gouache *The Jungle* (The Museum of Modern Art, New York) and persuaded him to part with it. This powerful work is one of the highlights of the Bergman Collection and is critical to the understanding of Lam's relationship to Surrealist primitivism. Thereafter, the Bergmans remained among his most active supporters, regularly buying new works, as well as keeping their eyes open for fine, earlier ones. They began to correspond with Lam in 1956 (see figs. 6 and 7), and the artist stayed with them in Chicago a number of times. Communication flowed more easily when Lam married Lou Laurin, who was Swedish but spoke English fluently. Lam always adorned his wife's letters and cards to the Bergmans with a characteristic sketch or doodle to express his warm feelings for the col-

lectors (see fig. 7). As was typical of the Bergmans' relationships, the friendship extended to the artist's entire family. In 1961 the Lams wrote from Italy to announce the birth of their first child: "The new member of the family is a boy, called Eskil, Sören, Obini, Lam. His first two names are Scandinavian, the third African, and the last Chinese, what a tremendous mixture!"[8] In naming their son, the Lams reflected Lou's Scandinavian origins and Wifredo's mixed parentage—his father was Chinese and his mother was of African and Spanish origin. On one trip to Europe, the Bergmans stayed with the Lams in Italy, and they remained in touch with Lou after Wifredo's death in 1982.

Unquestionably, though, Joseph Cornell is the central figure in the collection. The Bergmans bought their first works by Cornell in 1958: *Sand Fountain* of 1951 (fig. 8) and a box known as *Trade Winds/Storm Warning* of 1958, both from the Allan Frumkin Gallery in Chicago;[9] and *Sand Box (Red Sand)* of c. 1957 (fig. 9), from the Stable Gallery in New York. Cornell was by then a legendary recluse, living on Utopia Parkway in Flushing, New York, with his mother and brother.

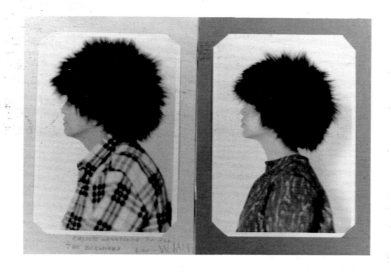

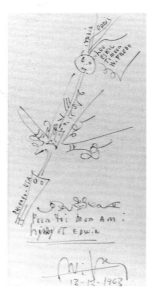

Figure 6. This photographic double-portrait of Wifredo and Lou Laurin-Lam was sent as an Easter card to the Bergmans in 1961 and is an example of the Lams' spirited sense of humor.

Figure 7. Numerous cards and letters to the Bergmans over the years from Wifredo Lam and his wife, Lou, contain family news reported by Lou, with Wifredo himself always contributing a personal note in the form of a whimsical drawing, as in this Christmas card from 1963.

In 1959 the Bergmans met the Italian painter Piero Dorazio, who offered to introduce them to Cornell. Knowing that he normally refused to see people, but could not resist a surprise gift, Dorazio gave them a present for Cornell, which indeed opened his door to them; on this first visit, the artist gave the Bergmans' daughter Carol a collage. Cornell wrote to Edwin Bergman afterward: "There is something about that day you were here that is not yet resolved, something so wonderful concerning 'gifts' that I'll try to tell you about it some day although we may have to wait until heaven for it." Edwin Bergman wrote back to say that he appreciated the thought, but that there was no rush.[10]

Regular visits followed, and the collection continued to grow. Cornell appreciated the Bergmans' faith in him and revealed to them aspects of his very personal feelings about the power of memory and association: "With best wishes to all," he wrote in November 1959, "and especially for the coming season, so rich in memories and creeping up much, much too fast to do them all justice before the snow flies and the Season gets thick."[11] Once again the relationship involved a familial connec-

tion beyond that of artist and patron. The Bergmans met Cornell's mother, Helen, and his brother, Robert; and on the latter's death in 1965, Cornell wrote to Edwin Bergman: "Our blessed Robert has gone to his Eternal rest, under, thank God, as beatific conditions as one could imagine or hope for. Mother is in retirement at Westhampton and a line to her there would mean so much to her."[12]

A certain contradiction in Cornell's mind between the inspiration behind a piece, which often lay in the idea of a gift or homage, and the commercial transactions involved in disposing of it, led to his ambivalence about parting with his creations. Sometime in the mid-1960s, Cornell told a dealer that the Bergmans had too many of his works and not to sell to them any more.[13] This did not, however, stop the collectors from buying his art at a steady pace through the 1960s and 1970s. After Cornell's

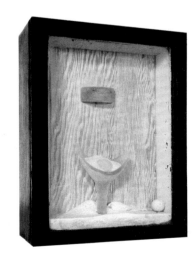

Figure 8. Joseph Cornell, *Sand Fountain*, 1951, construction, 28 x 20.7 x 11.4 cm, Chicago, Bergman family.

Figure 9. Joseph Cornell, *Sand Box (Red Sand)*, c. 1957, construction, 17 x 36.6 x 3.2 cm, Chicago, Bergman family. The cracks in the glass top of this box were not intended by the artist; they occurred accidentally after the box was purchased by the Bergmans.

death in 1972, they developed a close friendship with Cornell's sister Betty Benton, who was generous in giving them access not only to works, but also to the more ephemeral or documentary material that had been an important part of Cornell's working method.

A telling detail in the many press clippings highlighting Lindy and Edwin Bergman as collectors is that they are always pictured and interviewed together, unlike many collectors who, although married, function largely independently in their collecting decisions. The Bergmans' collection is the fruit of a genuinely joint project, a shared commitment, as was the wide range of their civic involvements. True philanthropists, they served Chicago in numerous ways—on hospital and various charitable boards, most notably on the Board of Trustees of the University of Chicago, their alma mater, on which Edwin Bergman served as chairman. The Renaissance Society at the University of Chicago, which, despite its name, has been a showplace for avant-garde

art, helped develop their interest in modern art. The Bergmans expressed their gratitude by establishing the Bergman Gallery, which was designed as a studio for undergraduates and as an exhibition center. Edwin Bergman was a founder and second president of the Board of Trustees of Chicago's Museum of Contemporary Art. He was also a member of the Board of the Art Institute, where he was an active and sensitive participant on important advisory committees for acquisitions, chairing the committee on Prints and Drawings.

Always immensely generous in opening their collection to visitors and in loaning to exhibitions, the Bergmans transmitted their commitment to collecting and their devotion to Chicago and its institutions to their three children. Their son, Robert, and daughters, Betsy Rosenfield and Carol Cohen, are all collectors in their own right; and Betsy Rosenfield for years owned and ran an important Chicago gallery. Robert Bergman has carefully documented his parents' collection in an impressive catalogue of purchase, exhibition, and reference data. This record, together with the Bergman Collection at The Art Institute of Chicago, reveals the double legacy of this remarkable family project: one that provides an exemplary model of cultural leadership and that extends the challenges and pleasures of living with a remarkable group of artworks into the public domain.

* * *

NOTES TO
THE READER

Entries are organized alpha-
betically by artist or by artistic
category (as in the case of
cadavres exquis). When there
are several works by a given
artist, entries are arranged
chronologically by the date of
the work.

Unless a work is inscribed by
the artist with a title or is
clearly documented to bear a
title assigned by the artist, it is
generally described as *Untitled*.
This designation is often fol-
lowed in parentheses by a
commonly used title or type, as
in *Untitled* (*Harlequin*), which
is intended to facilitate identi-
fication of the work, as in the
case of the many untitled works
by Joseph Cornell. Variant
titles are cited under Exhibi-
tions and References when they
differ from the given title of
the work.

A work's dimensions are listed
in centimeters, height pre-
ceding width, followed by
dimensions in inches in paren-
theses. Relevant inscriptions
are included after dimensions.
Provenance information is
based on the sources listed
under Exhibitions and
References, or on Bergman
family records, unless other-
wise specified.

The bibliographic abbrevia-
tions that appear in the entries
refer either to a source cited
earlier in the entry or to a fre-
quently cited source provided
in full in the list of abbrevia-
tions on page xviii.

BIBLIOGRAPHIC ABBREVIATIONS

ARCH. DIGEST 1973
"Entente Cordiale," *Architectural Digest* 29, 4 (Jan.–Feb. 1973), pp. 18–23.

ASHTON 1974
Dore Ashton, *A Joseph Cornell Album*, New York, 1974.

CHICAGO 1966
Chicago, Arts Club, *Drawings 1916/1966*, 1966, exh. cat.

CHICAGO 1967–68
Chicago, Museum of Contemporary Art, *Fantastic Drawings*, 1967–68, no cat.

CHICAGO 1973
Chicago, Museum of Contemporary Art, *Twentieth-Century Drawings from Chicago Collections*, 1973, no cat. nos, n. pag.

CHICAGO 1973–74
Chicago, Museum of Contemporary Art, *Cornell in Chicago*, 1973–74, pamphlet.

CHICAGO 1982
See New York 1980–82.

CHICAGO 1984–85
Chicago, Museum of Contemporary Art, *Dada and Surrealism in Chicago Collections*, 1984–85, exh. cat. published as *In the Mind's Eye: Dada and Surrealism*.

CHICAGO 1986
The Art Institute of Chicago, *A Tribute to Edwin A. Bergman (1917–1986): Selections from the Lindy and Edwin Bergman Collection*, 1986, pamphlet.

CORNELL 1993
Mary Ann Caws, ed., *Joseph Cornell's Theater of the Mind: Selected Diaries, Letters and Files*, New York, 1993.

CORNELL PAPERS, AAA
Joseph Cornell Papers, Archives of American Art, Smithsonian Institution, gift of Elizabeth Cornell Benton, available on microfilm.

ERNST COLLAGES 1991 (1974)
See Tübingen 1988–89.

ERNST KATALOG
Werner Spies, ed., *Max Ernst Oeuvre-Katalog*, 6 vols., compiled by Werner Spies, and Sigrid and Günter Metken, Houston and Cologne, 1975–; vol. 1, *Das graphische Werk*, 1975; vol. 2, *Werke, 1906–1925*, 1975; vol. 3, *Werke, 1925–1929*, 1976; vol. 4, *Werke, 1929–1938*, 1979; vol. 5, *Werke, 1939–1953*, 1987.

FLORENCE 1981
See New York 1980–82.

MAGRITTE CATALOGUE
David Sylvester, ed., *René Magritte Catalogue Raisonné*, 5 vols., Houston and London, 1992–; vol. 1, David Sylvester and Sarah Whitfield, *Oil Paintings, 1916–1930*, 1992; vol. 2, David Sylvester and Sarah Whitfield,
Oil Paintings and Objects, 1931–1948, 1993; vol. 3, Sarah Whitfield and Michael Raeburn, *Oil Paintings, Objects and Bronzes, 1949–1967*, 1993; vol. 4, Sarah Whitfield and Michael Raeburn, *Gouaches, Temperas, and Watercolours, 1918–1967*, 1994.

NEW YORK 1967
New York, The Solomon R. Guggenheim Museum, *Joseph Cornell*, 1967, exh. cat.

NEW YORK 1968
New York, The Museum of Modern Art, *Dada, Surrealism, and Their Heritage*, 1968, traveled to Los Angeles and Chicago, exh. cat.

NEW YORK 1980
New York, The Museum of Modern Art, *Pablo Picasso: A Retrospective*, 1980, exh. cat., no cat. nos.

NEW YORK 1980–82
New York, The Museum of Modern Art, *Joseph Cornell*, 1980–82, traveled to London, Düsseldorf, Florence, Paris, and Chicago, exh. cat. (separate exh. cat. for Florence venue, here designated as "Florence 1981"; separate checklist for works displayed only in Chicago, here designated as "Chicago 1982"; list of venues based on The Museum of Modern Art's own records, since venues are not all listed in the New York exhibition catalogue).

NEW YORK 1993–94
New York, The Museum of Modern Art, *Joan Miró*, 1993–94, exh. cat. by Carolyn Lanchner.

RUBIN 1968
William S. Rubin, *Dada and Surrealist Art*, New York, 1968.

SATURDAY REVIEW 1980
Vicki Goldberg, "Great Private Collections: The Bergmans' Treasures," *Saturday Review* (Nov. 1980), pp. 57–59.

TÜBINGEN 1988–89
Kunsthalle Tübingen, *Max Ernst: Die Welt der Collage*, 1988–89, traveled to Bern and Düsseldorf, exh. cat. by Werner Spies published as *Max Ernst Collagen: Inventar und Widerspruch* (text reprinted from Spies's 1974 book of the same title; tr. by John William Gabriel as *Max Ernst Collages: The Invention of the Surrealist Universe*, New York, 1991, here designated as "Ernst Collages 1991 [1974]").

U. OF C. MAGAZINE 1982
"A Record for Service, an Eye for Art: The Bergmans," *University of Chicago Magazine* 74, 2 (Winter 1982), pp. 22–27.

WALDMAN 1977
Diane Waldman, *Joseph Cornell*, New York, 1977.

CATALOGUE

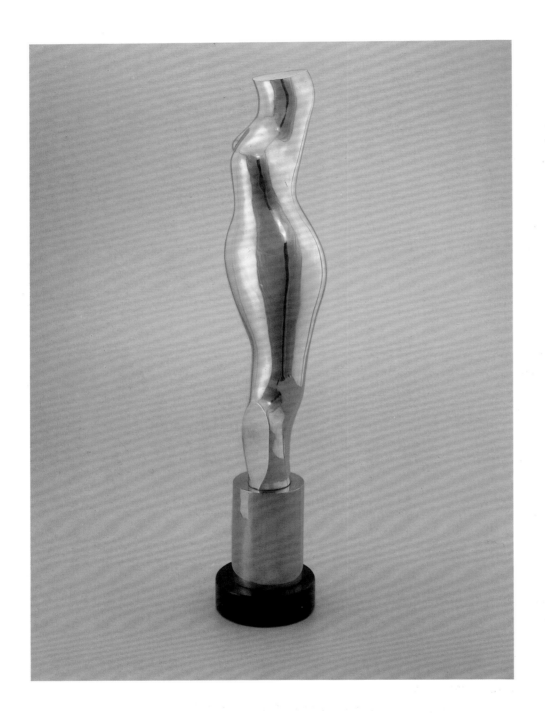

1. TORSO-KORE (TORSE-CHORÉE)

1958
Bronze (no. 2 of an edition of 5); 87 x 16.5 x 15
cm (34¼ x 6½ x 5¹⁵/₁₆ in.)
Inscribed on interior of bronze base: ᴴᴬ
(artist's monogram) *II/V*[1]
The Lindy and Edwin Bergman Collection,
97.1991

PROVENANCE: Edouard Loeb, Paris;[2] Albert
Loeb Gallery, New York; sold to Lindy and Edwin
Bergman, Chicago, 1963.

EXHIBITIONS: Chicago 1986, no. 1, as *Kore*.

REFERENCES: Herbert Read, *Arp*, London,
1968, fig. 119, as *Torse Chorée*, marble version.
Eduard Trier, *Jean Arp: Sculpture, His Last Ten
Years*, New York, 1968, p. XI, pl. 7, p. 107, no.
163, as *Kore, Torse de chorée*. Ionel Jianou,
Jean Arp, Paris, 1973, p. 75, no. 163, as *Torse
de chorée*. *Arch. Digest* 1973, pp. 20 and 21
(photo of Bergman home).

THE TITLE OF THIS WORK REFERS TO ANCIENT Greek sculpture. *Kore* or *kouros*, depending on the gender, is the term for a rather formal, rigid type of pre-Hellenic figure sculpture, commonly linked to ancient Egyptian art. Both the appearance of the sculpture and Arp's well-attested interest in the art and philosophy of ancient Greece confirm this interpretation. Other sculptures of the period bear titles drawn from antiquity such as *Ptolemy*, *Demeter*, and *Thales of Miletus*, the latter referring to a pre-Socratic philosopher and forerunner (c. 625–547 B.C.) of Heraclitus (c. 540–480 B.C.). Arp felt that Heraclitus's theory of constant change was close to his own sense of the organic unity of nature and quoted him in his essay on the painter Wassily Kandinsky (1866–1944): "It is always the same substance that is in all things: life and death, waking and sleeping, youth and old age. For, in changing, this becomes that, and that, by changing, becomes this again" (Jean Arp, *Jours effeuillés: Poèmes, essais, souvenirs, 1920–1965*, ed. by Marcel Jean, Paris, 1966, p. 296; tr. as *Arp on Arp: Poems, Essays, Memories*, New York, 1972, p. 228; see Dawn Ades, "Arp and Surrealism," M.A. report, London, Courtauld Institute, 1968).

In *Torso-Kore*, Arp used his characteristic organic morphology, through which analogies are set up with both the human body and plant forms without actually representing either. The sculpture's graceful curves may be compared to those of Arp's *Torso with Buds*, a sculpture of 1961 (Trier 1968, pl. 54, p. 117, no. 256), and the torso of 1960 he simply called *Classical Sculpture* (Trier 1968, pl. 56, p. 115, no. 240). But the relative symmetry and erect frontality of the figure strongly recall a *kore*, while echoing the Cycladic sculpture Arp also admired. The abruptly truncated planes at the top and bottom of Arp's sculpture reinforce its associations with ancient sculpture, which has often survived only in a fragmentary, truncated state.

Interesting comparisons can also be made with the sculpture of Auguste Rodin (1840–1917) and of Constantin Brancusi (1876–1957). Rodin was the first modern sculptor to revitalize the classical torso-fragment, a subject that was to preoccupy Arp throughout his career, in this and many other works (for the importance of this theme in Arp's work, see Margherita Andreotti, *The Early Sculpture of Jean Arp*, Ann Arbor and London, 1989, pp. 176–93). Arp admired Rodin's sculpture for its eroticism, so different from what he described as the "érotomachie mécanique de notre siècle" (the mechanical erotomachia of our century), and its primeval strength (see Arp's preface-poem to the *Rodin* exhibition, Curt Valentin Gallery, New York, 1954, reprinted in Arp 1966, p. 407). For Arp, however, Rodin's work was still too closely bound to a man-centered universe. Arp's black granite carving of 1938, *Homage to Rodin* (Stefanie Poley, *Hans Arp: Die Formensprache im plastischen Werk*, Stuttgart, 1978, fig. 166), probably received its title in response to the animated modeling of its surface, so unlike the smooth finish of most of Arp's bronze and stone sculptures.

Arp's relationship with Brancusi was even more complex, compounded both of admiration and of a desire to keep his distance from the older sculptor. An apparent formal similarity in their work masks a very different approach, in that Brancusi sought to condense the essence of a creature, a person, or a sensation, while Arp was more expansive and analogical in his ideas (for more on Arp's relation to Rodin and Brancusi, see Andreotti 1989, pp. 11–18, 20–24). Arp also rejected the highly polished, reflective surface of many of Brancusi's bronzes in favor of a darker, matte patina for his own bronze sculptures. Regrettably, this and many other bronze sculptures by Arp now exhibit the very finish he disliked.[3] As Andreotti has noted, "a shiny, gold patina . . . distorts Arp's artistic intentions not only by obscuring the clarity of line that was important to him but also by conferring on the work a precious, remote, ethereal quality entirely at odds with the informality and earthy concreteness" Arp favored for his sculptures (Andreotti 1989, p. 154).

Arp made an enlarged version of this sculpture in 1961 (129.5 x 21 x 28 cm), which was realized in marble and in an edition of three casts in bronze (Trier 1968, p. 116, no. 255, marble ill.; Jianou 1973, p. 79, no. 255).

* * *

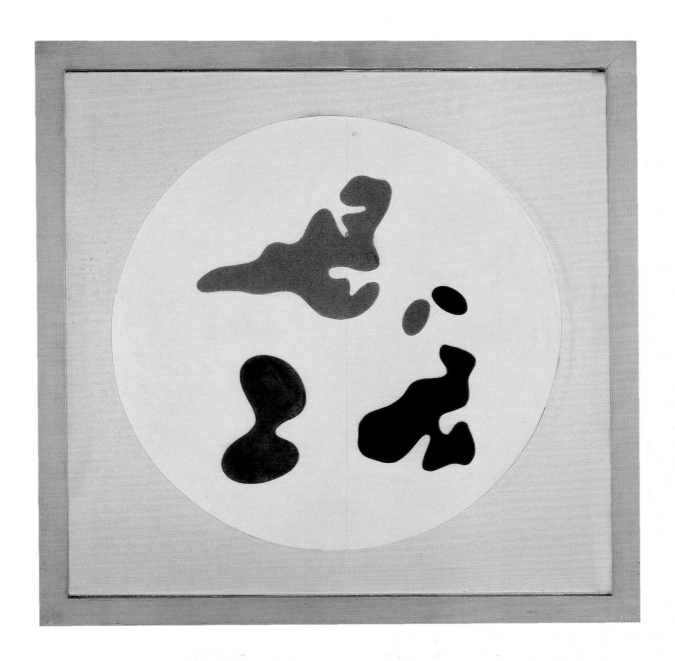

2. COMPOSITION IN A CIRCLE
(COMPOSITION DANS UN CERCLE)

1962
Collage of colored construction papers on paper;
36.5 x 36.5 cm (14 3/8 x 14 3/8 in.)
Signed, titled, and dated, on label on back: *JEAN ARP* (printed) / *composition dans un cercle* (typed) / *collage* (typed) / *1962* (typed) / *Arp* (in the artist's hand)
The Lindy and Edwin Bergman Collection,
98.1991

PROVENANCE: Edouard Loeb, Paris; sold to Lindy and Edwin Bergman, Chicago, 1965.

REFERENCES: Giuseppe Marchiori, *Arp*, Milan, 1964, frontispiece photograph of studio (fig. 1), showing this collage.

THE PHOTOGRAPH OF ARP WORKING IN HIS studio reproduced by Marchiori (fig. 1) shows this work on the shelf behind him, but oriented differently from the way it is currently hung.[4] As it is now, the black shape on the lower left evokes a human torso; on its side, as in the studio photograph, where this shape appears at top left, it reads rather as a bow tie. Pieces with one or more alternative orientations, which can prompt different readings of a configuration, are not uncommon in Arp's work. Examples occur as early as his Dada wood reliefs, as in *Oiseau hippique (Horse-Bird)* of c. 1916,[5] which can be hung in different ways to emphasize its morphological analogies with either "bird" or "horse" (Berndt Rau, *Jean Arp: The Reliefs, Catalogue of Complete Works,* New York, 1981, p. 11, no. 11, ill.). Arp continued to explore the possibilities of works without a fixed orientation, as in the multipart sculptures with movable components of the early 1930s, in which his long-standing interest in the operations of chance seems to be involved (see Margherita Andreotti, *The Early Sculpture of Jean Arp*, Ann Arbor and London, 1989, pp. 221–24 nn. 31–32). Such an approach furthermore enhanced the naturally multivalent and flexible quality of Arp's forms.

This *Composition* is related to Arp's series of Constellations of the 1930s (see especially Arp's wood reliefs of this period). In this collage, imaginary forms are grouped as if by chance in a golden circle. Some of these forms, the "bow-tie–torso" and the two "oval-navels," first appeared as part of Arp's "object-language," a vocabulary of forms he developed during the 1920s, which often combined allusions to the human figure and to the world of objects. Initially an aspect of Surrealist

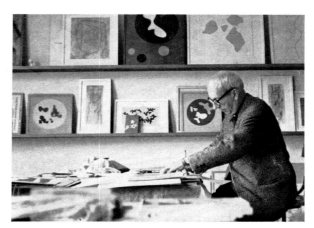

Figure 1. Jean Arp in his studio, 1962/ 64; no. 2 is visible at left [photo: Giuseppe Marchiori, *Arp*, Milan, 1964, frontispiece].

humor, with internal comic-poetic analogies – navels interchangeable with leaves, eggs, and commas – these shapes later assumed cosmic connotations. As Arp's friend the art historian and critic Carola Giedion-Welcker noted: "Navels, mouths, ties float over vast surfaces, like leaves blown by the wind into the immensity of the universe" (Carola Giedion-Welcker, "Die Welt der Formen und Phantome bei Hans Arp," *Quadrum* [Brussels] 11 [1961], p. 22). In 1962 Arp visited Delphi to see the famous "omphalos" or navel-shaped stone, which, according to the Greeks, marked the center of the earth and was thus the world's navel (Andreotti 1989, p. 143).

In this collage, there is a tension between the irregular, asymmetrical "constellation" forms and the perfectly geometric circle that frames them. Arp may have connected the circular form, as opposed to the oval, specifically with the artist Sophie Taeuber (1889–1943), his first wife, who during the 1930s made a series of Compositions in a Circle (see, for example, The Minneapolis Institute of Arts, *Arp, 1886–1966*, 1986–88, traveled to Stuttgart, Strasbourg, Paris, Boston, and San Francisco, exh. cat., Eng. ed., pl. 278). Arp's poem "Kreismärchen" (Circle Fairy-Tales) indeed celebrates "The innumerable fairy-tale circles of Sophie's dreams" (Hans Arp, *Zweiklang*, Zurich, 1960, p. 49, quoted in Minneapolis 1986–88, p. 260). * * *

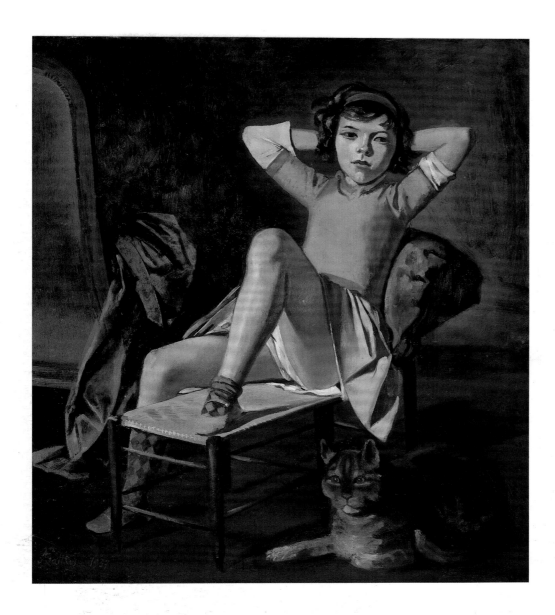

3. GIRL WITH CAT (JEUNE FILLE AU CHAT)

1937
Oil on board; 87.6 x 77.5 cm (34$\frac{1}{2}$ x 30$\frac{1}{2}$ in.)
Signed and dated, lower left: *Balthus 1937*
The Lindy and Edwin Bergman Collection,
1991.595

PROVENANCE: Pierre Colle, Paris; sold to
the Pierre Matisse Gallery, New York, June 14,
1937;[1] sold to Lindy and Edwin Bergman,
Chicago, 1963; given to the Art Institute, 1991.

EXHIBITIONS: New York, Pierre Matisse
Gallery, *Balthus*, 1962, no. 4 (ill.; detail
on cover). The Art Institute of Chicago, *Chicago
Collectors*, 1963, no cat. nos., n. pag., as
Young Girl with a Cat. The Arts Club of Chicago,

Balthus, 1964, no. 5, pl. 5. Cambridge, Mass.,
Massachusetts Institute of Technology, Hayden
Library, The New Gallery, *Balthus*, 1964, no. 7,
pl. 7. New York, Public Education Association,
*Seven Decades, 1895–1965: Crosscurrents in
Modern Art* (1935–1944 decade shown at Pierre
Matisse Gallery), 1966, no. 204 (ill.). London,
Tate Gallery, *Balthus*, 1968, no. 7 (ill.), as *Girl
and Cat*. Chicago, Museum of Contemporary Art,
Balthus in Chicago, 1980, no. 2 (ill.). Paris,
Musée national d'art moderne, Centre Georges
Pompidou, *Balthus*, 1983–84, exh. cat. by
Dominique Bozo et al., p. 135, no. 13 (ill.), p.
346, no. 42 (ill.). New York, The Metropolitan
Museum of Art, *Balthus*, 1984, exh. cat. by
Sabine Rewald, no. 17 (ill.), and pp. 41–42,
fig. 66.

REFERENCES: Milton Gendel, "H.M. The King
of Cats, a Footnote," *Art News* 61 (Apr. 1962),
p. 37 (ill.). New York, Sidney Janis Gallery, *Erotic
Art*, 1966, not in exhibition (ill. on cover). *Illinois
Arts* (Oct. 1980), exh. announcement, n. pag.
(ill.). Jean Leymarie, *Balthus*, New York, 1982,
p. 130 (ill.). Stanislas Klossowski de Rola,
Balthus, London, 1983, pl. 17 (ill.). Gary Indiana,
"Balthus in Wonderland," *Art in America* 72
(Oct. 1984), p. 184 (ill.). Ronald Paulson, *Figure
and Abstraction in Contemporary Painting*,
New Brunswick and London, 1990, p. 168 (ill.).
Linda Nochlin, "Women, Art, and Power,"
in Norman Bryson, Michael Ann Holly, and
Keith Moxey, eds., *Visual Theory: Painting and
Interpretation*, Oxford, 1991, p. 42 (ill.).

BALTHUS'S LEGENDARY SECRETIVENESS HAS inhibited critical commentary on his paintings. His son Stanislas appears at times to have been his spokesman, arguing that the girls in his father's paintings are "emblematic archetypes. . . . their very youth the symbol of an ageless body of glory, as adolescence (from the Latin *adolescere*: to grow toward) aptly symbolizes that heavenward state of growth which Plato refers to in the *Timaeus*" (Klossowski de Rola 1983, p. 10). He also suggested, a little more plausibly, that the paintings emphasize the act of seeing, though unfortunately he used this as an excuse to propose that an ideal state can be achieved from their contemplation "wherein the act of seeing, the seen and the seer become one" (Klossowski de Rola 1983, p. 8). All the evidence of the senses appealed to in such paintings—nostalgia, lubricity, frustration—work against such a reading.

Most literature on this painting considers alternative identifications of the cat, with either Balthus's model, Thérèse Blanchard, the daughter of a neighbor, or with the artist himself. The latter interpretation is supported by Balthus's long-standing fascination with cats. In 1920, at the age of thirteen, he published a series of prints narrating the story of a cat called Mitsou; even more directly relevant to the artist's personal identification with this animal is his 1935 self-portrait entitled *H. M. the King of Cats* (New York 1984, no. 9, ill.). In addition, in the work of writers in Balthus's circle, there is considerable support for the association of the cat with sexuality. Georges Bataille's erotic novel *Histoire de l'oeil* (Paris, 1928), for instance, has a chapter entitled "L'Oeil de chat" (The Cat's Eye) in which a sixteen-year-old boy and girl engage in sexual play with a cat's saucer of milk (see Paulson 1990, p. 168). However, an exclusive emphasis on these readings overstresses the biographical in Balthus's work and overlooks the degree to which he refers to and plays upon traditions of representing sexuality in Western painting.

The genre of salacious images of women with which Balthus's *Girl with Cat* is aligned traditionally include a small animal: cat or lap dog. The most famous examples perhaps are Jean Antoine Watteau's *Lady at Her Toilette* of 1716/17 (London, Wallace Collection) and Edouard Manet's *Olympia* of 1865 (Paris, Musée d'Orsay), but any number of thinly veiled Venuses or clothed beauties in eighteenth- and nineteenth-century painting carry, fondle, or are watched by a pet. Typical commentaries of the time would remark on how fortunate the pet was to enjoy such privileged proximity to the desired object. Unspoken, but often visually very obvious parallels were also made between the creature and the female body. Traditionally the animal thus has a double identity, related to both the artist/voyeur and the female sex.

The setting of *Girl with Cat* has many of the traditional trappings of the painter's studio. Thérèse lies on a daybed that figures in several other paintings by Balthus; on the left, the back of an upholstered chair is barely recognizable because of the rococo swath of blue fabric bunched around one of its arms (similar chairs appear in Balthus's paintings *The White Skirt* of 1937 and *Thérèse* of 1938; see New York 1984, nos. 80, 90, ills.).

Figure 1. Man Ray, photocollage
[photo: *Minotaure* 7 (1935), p. 16].

The model seems to be about twelve — the precise, pre-pubescent moment that Vladimir Nabokov described through Humbert Humbert's furtive eyes with such horrifying detail in his novel *Lolita* (1955). Not only did Balthus choose a girl younger than the traditionally acceptable, he also grotesquely increased the size of the cat, reversing the usual tendency to show the suggestive pet smaller than in nature. The cat's face is almost equal in size to Thérèse's, an exaggeration hardly justified by perspective. It is also positioned vertically below her face, on a strong compositional line that passes close to the genital area.

This painting thus exemplifies what Cyril Connolly called "the almost deliberate opposition between the choice of subject and the treatment, a kind of counter-point between them" (quoted in New York 1984, from Connolly's essay in London, Lefevre Gallery, *Balthus and a Selection of French Paintings,* 1952, exh. cat., n. pag.). The suggestiveness of the theme can be taken as either being "severely disciplined by a pictorial order of architectural rigor" (Sabine Rewald, in New York 1984, p. 41), or as subverting that order, or as even outrageously ex-aggerating it. The identification of face with genitalia is a commonplace (see, for instance, René Magritte's brilliant handling of this cliché in his painting *The Rape* of 1934; a drawing of this image was used on the cover of André Breton's *Qu'est-ce que le Surréalisme?* in 1934; London, The Hayward Gallery, *Magritte*, 1992–93, exh. cat. by Sarah Whitfield, n. pag., no. 63, ill., and fig. 6). The size of the cat enhances both readings; it can be understood, in Freudian terms, as the affective exagger-ation of that which is much feared or desired, and it can also supply the missing male presence.

Among Balthus's earliest essays in the male viewer's willful perception of adolescent female sexuality is the series of drawings for Emily Brontë's novel *Wuthering Heights*, depicting the relationship between Heathcliff and Cathy. These drawings were published in an issue of the Surrealist journal *Minotaure* (7 [1935], pp. 60–61), which included several comparable references to the idea of the *femme-enfant* among the illustrations for Paul Eluard's article "Appliquée" (pp. 15–16): a photograph of naked girls and a photocollage, both untitled and by Man Ray, and a work entitled *Composition* by Hans Bellmer. Thérèse's posture in *Girl with Cat* is closely modeled, as Rewald suggested, upon one of two young girls in the Man Ray photocollage (fig. 1), itself taken from a Pears Soap advertisement of 1901 (see New York 1984, p. 41, figs. 68–69).

In conclusion, this painting is one of the most com-plex and disturbing of Balthus's explorations of the in-terface between innocence and adolescent sexuality, its theme counterpointed by the multiple and sophisticated references both to the tradition of the nude in Western art and to the Surrealists' celebration of desire. ✳ ✳ ✳

F ROM 1961 TO 1972, BALTHUS WAS DIRECTOR of the French Academy in Rome, housed in the Villa Medici, destination for the winners of the coveted Prix de Rome for over two hundred years. It was a role he took very seriously, and to which, given its official character, his traditional figurative manner was well suited. The sitter for this portrait, which forms a pleasant counterpoint to *Girl with Cat* (no. 3), was Michelina Terreri,[3] the daughter of a female employee at the Villa Medici. She and her sister Katia posed for Balthus, as Thérèse Blanchard had done in the 1930s. The inscription on the drawing indicates that Balthus made this portrait of Michelina at Montecalvello, the sixteenth-century castle he owned near Viterbo. * * *

4. UNTITLED

c. 1972
Graphite and charcoal on tan elephant paper,
99.9 x 69.7 cm (39 3/8 x 27 1/2 in.)
Inscribed, lower left: *Bs* (artist's monogram) /
Michelina / Montecalvello
The Lindy and Edwin Bergman Collection,
100.1991

PROVENANCE: Fréderique Tison; sold to the
Galerie Claude Bernard, Paris, 1977;[2] sold
to Lindy and Edwin Bergman, Chicago, 1978.

EXHIBITIONS: Chicago, Museum of
Contemporary Art, *Balthus in Chicago*, 1980,
no. 40. Chicago 1986, no. 3.

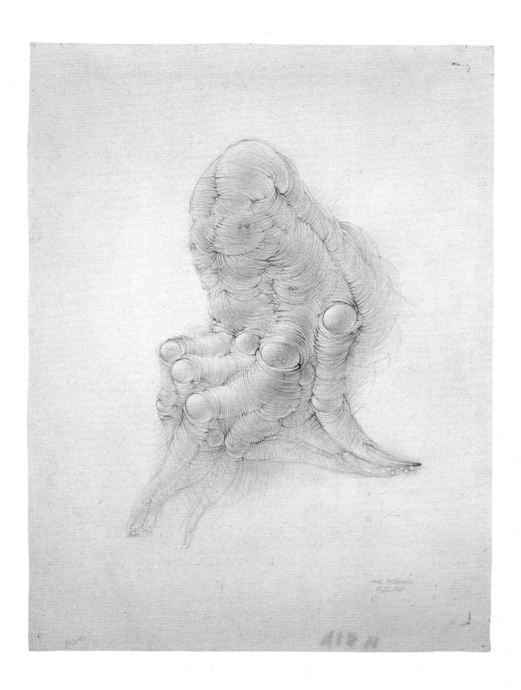

5. UNTITLED

18 March 1951
Graphite with smudging on cream wove paper;
38.1 x 28.1 cm (15 x 11 1/16 in.)
Signed and dated, lower right: *Hans Bellmer /
18.III.1951*
Inscribed along the bottom: *Ma[zé]* (lower left),
A18 11 (lower right)
The Lindy and Edwin Bergman Collection,
101.1991

PROVENANCE: Alexander Iolas Gallery,
New York; given to Lindy and Edwin Bergman,
Chicago, 1958.

EXHIBITIONS: Houston, Contemporary Arts
Museum, *The Disquieting Muse: Surrealism*,
1958, no cat. nos., n. pag. (ill.). Santa Barbara,
California, University of California, Art Gallery,
Surrealism: A State of Mind, 1924–1965, 1966,
no. 33 (ill.). Chicago 1967–68, no cat. Chicago,
Museum of Contemporary Art, *Hans Bellmer:*

Drawings and Sculpture, 1975, no cat. nos.,
n. pag., as *Hands*. Chicago 1984–85, no cat.
nos., p. 118, as *Untitled (Hands)*.

REFERENCES: Sue Taylor, "Hans Bellmer in
The Art Institute of Chicago: The Wandering
Libido and the Hysterical Body," *The Art Institute
of Chicago Museum Studies* 22, 2 (1996), p. 161,
fig. 12.

MUCH OF BELLMER'S WORK, WHETHER DRAW-
ings, paintings, or objects, has its origins in the
second Doll, or *poupée*, on which he began
work in 1935. The first Doll, photographs of which ap-
peared in the Surrealist journal *Minotaure* (6 [Winter
1934–35], pp. 30–31), was partially hollow, articulated,
and capable of assembly in diverse ways. Bellmer
sought, however, some method of making it more flexi-
ble and he found a solution in a pair of articulated wood
dolls in the Kaiser Friedrich Museum in Berlin, which
came from the circle of Albrecht Dürer. Every limb of
these dolls could be moved through beautifully con-
structed ball joints, and the whole body was "articulated
around a sphere which formed the stomach" (Peter
Webb with Robert Short, *Hans Bellmer*, London, 1985,
p. 57; see also Alain Jouffroy, *Hans Bellmer*, William and
Noma Copley Foundation, London, [1961], n. pag.). In
1935 he began the construction of the second Doll, and
chose fourteen of over a hundred photographs of it in
various permutations for *Les Jeux de la poupée*, a book
which included poetic texts by Paul Eluard and a pref-
ace by Bellmer entitled "Notes au sujet de la jointure à
boule," and which was finally published in Paris in 1949.

This Doll enabled an imaginative reconstruction of
the body, every fragment of which becomes erogenous.
Like the fetishist, Bellmer focused on an obsessive repe-
tition of the desired body fragment, but achieved at the
same time a new whole. In this drawing, the ball-and-
socket joints become interchangeably stomach, breasts,
knees, and buttocks. The joint enables the hand to move
far more freely than a real hand and contributes to its
mannequin-like aspect. Bellmer multiplied and bent
the fingers' "joints" so that they form a seated figure –
reformed as it were from the anatomical details of the
hand, which have cohered into a new whole. Hints of one
or more eyes and breasts, and a navel are visible in
the figure. Peter Webb has pointed out the affinities
between Bellmer's treatment of hands in this and other

works and the expressive distortions of the hands of the
lamenting Mary Magdalen in Grünewald's *Isenheim
Altarpiece*, which Bellmer knew well (Webb 1985, p. 212).

Bellmer's paintings and drawings of articulated
hands mostly date to the 1950s, although there are
earlier examples, such as a drawing of 1946 entitled *The
Hat of Hands*, in which entwined hands are posed above
a shadowy female face (Sarane Alexandrian, *Hans
Bellmer*, Paris, 1972, Eng. tr., New York, 1975, p. 23, ill.;
a similar drawing was first published in Paris, Galerie
Maeght, *Exposition internationale du surréalisme: Le
Surréalisme en 1947*, 1947, exh. cat., p. 130). As early as
1934, while working on the first Doll, Bellmer made a se-
ries of large pencil drawings on brown paper heightened
with white gouache, such as *Hands of a Budding Minx*
(Webb 1985, fig. 83), in which he positioned hands and
arms in suggestive, probing proximity to other objects
and fragments of flesh. In both medium and subject,
these recall the demonic images of Hans Baldung Grien
(see, for instance, *Witches' Orgy*, Webb 1985, fig. 80),
whose work Bellmer admired. The effect, in the present
drawing, of tightly wrapped drapery, making of the
hand/body a bound object, also goes back to the 1930s,
when he began to explore analogies between frills of
material and repeated curving lines, marking the con-
tinuous contour of a limb (see, for instance, *Dolls with
Striped Stockings* of 1935, Webb 1985, fig. 92).

The Bergman drawing is a preliminary study for a
colored lithograph entitled *Main articulée (Articulated
Hand)*, which exists in a number of artist's proofs, but
was never produced in a final numbered edition (see
Hans Bellmer: Oeuvre gravé, intro. by André Pieyre de
Mandiargues, Paris, 1969, no. 24, ill.; and New York,
Lerner-Misrachi Gallery, *Hans Bellmer, Twenty-Five
Years of Graphic Work: Drawings and Prints, 1942–1967*,
1972, exh. cat., no. 11, ill.). * * *

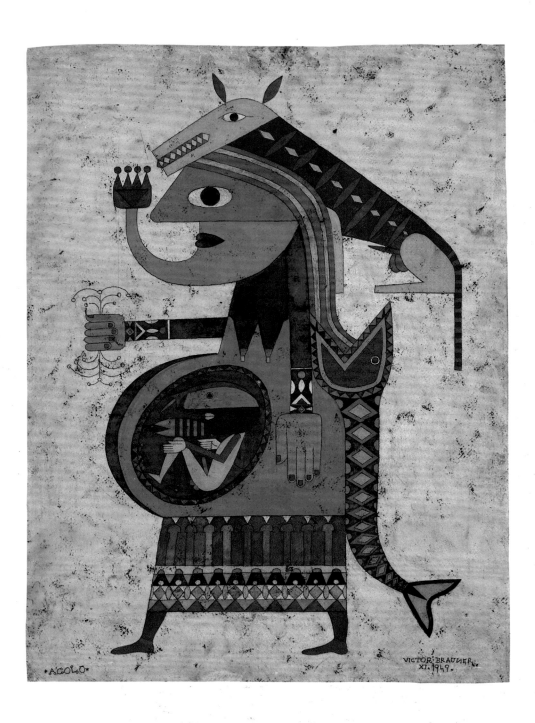

6. ACOLO

November 1949
Encaustic and collage on paper mounted on plywood board; 76.8 x 56.5 x 2.3 cm (30¼ x 22¼ x ⅞ in.)
Signed and dated, lower right: *VICTOR BRAUNER / XIx1949x*
Inscribed, lower left: *ACOLO*
The Lindy and Edwin Bergman Collection, 102.1991

PROVENANCE: Possibly Galerie Rive Gauche, Paris.[1] Hanover Gallery, London; sold to Lindy and Edwin Bergman, Chicago, 1960.

EXHIBITIONS: London, Hanover Gallery, *Victor Brauner*, 1951, no. 16. Chicago, Spertus Museum of Judaica, *The French Connection: Jewish Artists in the School of Paris, 1900–1940 (Works in Chicago Collections)*, 1982, no. 4 (ill.), as *Agolo*. Chicago 1984–85, no cat. nos., p. 125 (ill.), as *Agolo*.

REFERENCES: Sarane Alexandrian, "Le Symbolisme de Brauner," *Cahiers d'art* 24 (1949), pp. 321–27 (ill.), as *Là-bas (IIe version)*. Luce Hoctin, "Propos sur Victor Brauner," *Quadrum* (Brussels) 15 (1963), pp. 61 (ill.), 68. Paris, Musée national d'art moderne, *Victor Brauner*, 1972, exh. cat., p. 102, under no. 91. *Saturday Review* 1980, p. 57 (photo of Bergman home). *U. of C. Magazine* 1982, p. 25 (photo of Bergman home). Didier Semin, *Victor Brauner*, Paris, 1990, p. 180 (ill.), as *Agolo*. Sarane Alexandrian, "Une Amitié surréaliste," in Milan, Galleria Credito Valtellinese, *Victor Brauner, 1903–1966*, 1995, exh. cat., p. 74, as *Là-bas II*.

*A*COLO IS THE SECOND IN A SERIES OF THREE versions of the same image painted by Brauner in November and December of 1949. The title *Acolo* is Romanian for "there." Inscribed in the lower left corner of the picture, this word has been habitually misread as "Agolo" because of the peculiar serifs Brauner attached to his letters.[2] All three paintings in this series bear essentially the same title, although in the case of the first (fig. 1) and third (fig. 2) versions, Brauner inscribed the title on the paintings in French as *Là-bas* (*Over There*).

Following the German invasion of France, Brauner, who was Jewish, took refuge in an Alpine village in Switzerland. It was there that he developed in 1942–43 the encaustic technique used in these paintings. The process involved the application of layers of inks and wax, which were repeatedly pared back (see Semin 1990, p. 107), in a process of accumulation and reduction comparable to Max Ernst's *grattage* technique. The resulting clear, glowing colors, on a relatively dry surface, are reminiscent of ancient Mexican and Tibetan illustrated manuscripts. In *Acolo*, Brauner also made a subtle use of collage; the fetus is painted on a separate piece of paper and then attached to the figure's womb.

The stately and somewhat archaic profile figure that appears in all three paintings, with its frontal eye and its costume divided into flat, decorative segments of color,

recalls pre-Conquest Mexican painted books as well as ancient Eyptian art. The figure is heavy with a sense of ritual and symbolic order, reflecting in part the move within Surrealism in the late 1930s and 1940s toward a more pronounced interest in magic and esoteric thought. Brauner had contributed, for instance, to the preparation of the ritual "altars" in *Le Surréalisme en 1947*, the first exhibition of Surrealist art held in Paris after the return of the refugee Surrealists to France (see Paris, Galerie Maeght, *Exposition internationale du surréalisme: Le Surréalisme en 1947*, 1947, exh. cat.). He would also be included in Breton's book *L'Art magique* (Paris, 1957), although he had been expelled from the movement in 1948 for trying to defend Matta against his excommunication by André Breton.

Acolo and the two closely related paintings entitled *Là-bas* belong to a group of works Brauner produced, starting in 1948, "centered on the symbolic figure of the mother" (Walter Schönenberger et al., *Victor Brauner: Miti, presagi, simboli*, Lugano, 1985, exh. cat., p. 14). As Schönenberger noted, these works were "already announced in the painting of 1945, *Matriarcat* [*Matriarchy*], in which the lady of the tarots called *La Papesse* [*The Female Pope*] becomes the emblem of a civilization dominated by the maternal image" (ibid.). In developing this image, Brauner drew on his extensive readings

Figure 1. Victor Brauner, *Là-bas*, November 1949, oil, ink, and wax on paper, 77.8 x 57.2 cm, Houston, The Menil Collection.

Figure 2. Victor Brauner, *Là-bas*, December 1949, encaustic, 98 x 79.5 cm, private collection [photo: Didier Semin, *Victor Brauner*, Paris, 1990, p. 180].

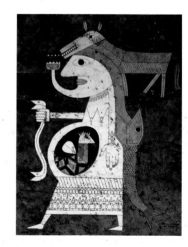

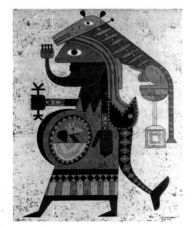

in psychology, psychoanalysis, alchemy, and the cabala. The image of the mother is one of the most potent of all symbols, psychologically, historically, and across civilizations. The encrusting of the figure here with symbolic attributes suggests that Brauner was more interested in the mythical, that is, Jungian aspects of the mother than in a Freudian, Oedipal understanding. His interest in psychoanalysis seems indeed to have been heavily Jungian. While in Switzerland in the summer of 1948, he was influenced by the psychoanalyst Marguerite Séchehaye's study of a schizophrenic patient, Renée, cured by "using a language of symbols" (Sarane Alexandrian, in Schönenberger et al. 1985, p. 38). At the same time, it appears that Brauner explored, through his psychoanalytic readings, prenatal experiences, the trauma of birth, and Oedipal urges.

In "Entre chien et loup...," the preface to Brauner's 1946 Paris exhibition at the Galerie Pierre (see André Breton, *Surrealism and Painting*, tr. by Simon Watson Taylor, New York, 1972, p. 127), Breton had already remarked on Brauner's use of the fish symbol:

Seeing the sun plunge into the sea each evening, the Indians reasoned that at night it visited the world of the fish; presuming that Brauner is entirely ignorant of this belief it is striking to see that some of the creatures of his imagination sport as a crown or a breastplate the fish thus charged with nocturnal sun.

Here the fish is fastened to the woman's back, as though swallowing or emitting her hair.

In the first version (fig. 1), the woman holds a double-headed snake; often a symbol of eternity, here it hangs, uncoiled, before the woman and functions as a phallic symbol (Alexandrian 1949, p. 327). In this first version, as Alexandrian noted, the dog is uneasily balanced, its legs waving in space. In *Acolo*, the second version, the snake has been replaced with a small, symmetrical device, and the dog is anchored firmly to the woman's back, its genitals now clearly visible. Alexandrian interpreted the seven bands on the dog's body as "cyclical revolu-

tions" (ibid.) and argued that the final version of the picture (fig. 2) is an image of triumph: the double-headed serpent is now present again in the woman's hand in graphic, geometric form; and the dog is anchored at the base of the neck with a pin and seated on a bowl, sign that the self-generation of the creature in the womb, who now appears again as a bird, as in the first image, is complete. Alexandrian argued that the womb is not just a place of refuge, but also "the equivalent of the Promethean desire to be the center of all things" (ibid., p. 324). The bird represents a privileged existence: "the shelter of the nest, the warmth of the duvet, the triumphant possibility of flight" (ibid., p. 325). The womb in *Acolo* shelters a human figure, which sprouts a fish; if the third image (fig. 2) represents victory, this second image is the most active and in some ways the most vivid of the three, suggesting generation and metamorphosis.

Acolo and the two *Là-bas* paintings reflect more than one set of beliefs or symbolic systems: the great stacked images of the totem poles of the Northwest coast of America (see, for instance, the masklike position of the head of the dog above the woman); the female warrior figure of the Mexican Coatlicue, who was also one of the parthenogenetic mothers of myth, like the Virgin Mary; the flat, decorative, balanced patterning of a mandala; the arcane numerology of the cabala; and perhaps even the spirit world of Haitian voodoo. Possibly Brauner knew of Jung's theories about the primordial, matriarchal world and the ways in which he thought it operated within the unconscious. Some connection, whether deliberate or not, may exist between Brauner's image and Jung's idea that the mother-son relationship represents the accommodation between the masculine, spiritual world and the female, earthly world (see Carl G. Jung, *Psychology and Alchemy*, London, 1980, p. 24, first published as *Psychologie und Alchemie*, Zurich, 1944). Jung stressed the universal and archetypal character of the mother-son image, and the fact that it represented not just the opposition between masculine and feminine worlds but also their harmonization. Evidently the result of a very personal, imaginative conjunction of the physical and the spiritual worlds, Brauner's *Acolo* subsumes the opposite sensations of menace and maternal embrace. * * *

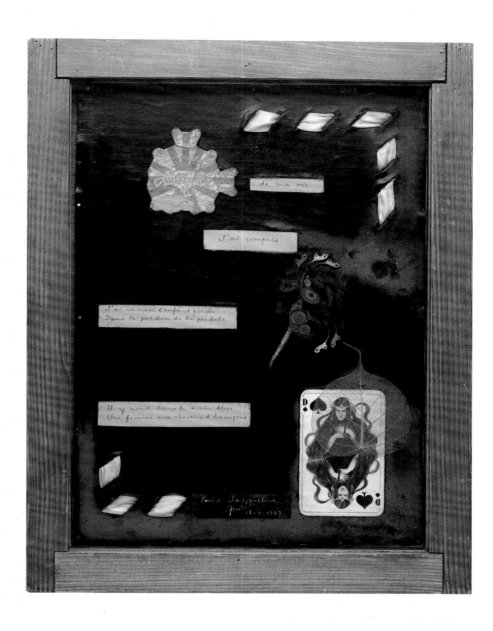

7. UNTITLED

18 January 1937
Collage composed of oilcloth laid down on cardboard, with woven ribbon, leaf, tarot card, metal mechanism, die-cut cardboard element, pen and black and white inks, nailed on wood panel in shallow wood box; 39.4 x 30.4 x 3.7 cm (15½ x 12 x 1⅞/₁₆ in.)

Signed and dated, lower center: *Pour Jacqueline / André / 18-1-1937*
Inscribed: *CARTE / RESPLENDISSANTE* (printed on card) *de ma vie / J'ai compris / J'ai caressé l'enfant perdu / Dans le jardin de la pendule / Il y avait dans le train bleu / Une femme aux cheveux d'hameçons* (Resplendent card of my life / I've understood / I've caressed the lost child / In the garden of the clock / There in the blue train was / A woman with hair of fishhooks)

The Lindy and Edwin Bergman Collection, 103.1991

PROVENANCE: Robert Elkon Gallery, New York; sold to Lindy and Edwin Bergman, Chicago, 1964; on loan to the Art Institute, 1988–89.

EXHIBITIONS: New York 1968, p. 230, no. 34, fig. 135, and p. 94, as *For Jacqueline*. The Arts Club of Chicago, *A Second Talent: An Exhibition of Drawings and Paintings by Writers*, 1971, no. 25 (ill. upside down), as *Pour Jacqueline*. New York, Robert Elkon Gallery, *Twentieth-Century Masters on Paper*, 1976, no. 40 (ill.). Chicago, Museum of Contemporary Art, *Words at Liberty*, 1977, no cat. nos., pp. 5, 16, as *For Jacqueline*. London, Hayward Gallery, *Dada and Surrealism Reviewed*, 1978, no. 12.23 (ill.), as *Objet-poème*. Chicago 1984–85, no cat. nos., pl. 13, pp. 23, 126, as *For Jacqueline*. Chicago 1986, no. 4, as *For Jacqueline*.

REFERENCES: *Minotaure* 10 (Winter 1937), p. 59 (ill.). Nicholas Calas, "Surrealist Heritage?," *Arts Magazine* 42 (Mar. 1968), p. 28 (ill.), as *For Jacqueline*. Hilton Kramer, "The Secret History of Dada and Surrealism," *Art in America* 56 (Mar.–Apr. 1968), p. 109 (ill.), as *For Jacqueline*. Rubin 1968, p. 266, fig. 264, as *Poem-Object*. Nahma Sandrow, *Surrealism: Theater, Arts, Ideas*, New York, 1972, opp. p. 61 (ill.), as *Pour Jacqueline*. Rutgers University Art Gallery, *Surrealism and American Art, 1931–1947*, 1977, exh. cat., p. 16, no. X (ill.), as *Poem Object*. The Cleveland Museum of Art, *Surrealism in Perspective*, 1979, exh. cat., p. 30, photograph of work exhibited, as *For Jacqueline*. Robert Short, *Dada and Surrealism*, London, 1980, pl. 136, as *Poem-Object*. José Pierre, *L'Univers surréaliste*, Paris, 1983, pp. 180, 185 (ill.), as *Pour Jacqueline*. *André Breton: Je vois, j'imagine, poèmes-objets*, intro. by Octavio Paz, Paris, 1991, pl. 17 and p. 172. Paris, Musée national d'art moderne, Centre Georges Pompidou, *André Breton: La Beauté convulsive*, 1991, exh. cat., p. 72 (hanging in Breton's home, c. 1939; see fig. 2) and p. 300 (ill.), as *Objet-poème (Carte resplendissante de ma vie)*. Phil Powrie, "The Surrealist *Poème-Objet*," in Silvano Levy, ed., *Surrealism: Surrealist Visuality*, Keele, Staffordshire, 1996, p. 75 n. 4.

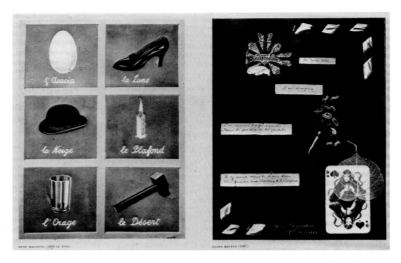

Figure 1. Page 59 of *Minotaure* 10 (Winter 1937), showing a work by René Magritte on the left and no. 7 on the right.

A NDRÉ BRETON'S UNTITLED OBJECT-POEM perfectly exemplifies two important themes within Surrealism: the freedom of writers to work in another medium, and the desire to marry words with images and objects. Breton, poet, leader, and chief theoretician of the Surrealist movement, encouraged the writers of the group to express themselves in visual as well as verbal forms. He himself was one of the originators of the Surrealist object, which during the 1930s became a focus of Surrealist activity among poets, writers, and artists. In "Introduction to the Discourse on the Paucity of Reality" (1924; see André Breton, *Oeuvres complètes*, Paris, 1992, p. 265), Breton described an object he had dreamed of, whose "loss" he regretted upon waking, and which he imagined inserting into the waking world, where such purely poetic objects would help undermine the dominance of the utilitarian "things of reason."

Breton was to make over one hundred and forty objects, collages, and drawings during his life (see *André Breton: Je vois, j'imagine* 1991). The *poème-objet* (object-poem) was a special category of Surrealist object, typically a small, nonsculptural construction, often composed of found and ready-made materials. In "Surrealist Situation of the Object" (1935; see André Breton, *Manifestoes of Surrealism*, tr. by Richard Seaver and Helen R. Lane, Ann Arbor, 1969, p. 263), Breton argued for the

great interest of the experiment that consists of incorporating objects, ordinary or not, within a poem, or more exactly of composing a poem in which visual elements take their place between the words without ever duplicating them. It seems to me that the reader-spectator may receive quite a novel sensation, one that is exceptionally disturbing and complex, as a result of the play of words with these elements, namable or not. To aid the systematic derangement of all the senses . . . we must not hesitate to bewilder sensation.

The following year, at the *Exposition surréaliste d'objets* at the Charles Ratton gallery in Paris, Breton exhibited an unspecified number of *poèmes-objets*; and at the *Exposition internationale du surréalisme* of 1938, also held in Paris at the Beaux-Arts gallery, he included, under the general heading "Objets" (Objects), a *cadavre exquis* and a group of *poèmes-objets* dated 1934–36. At the earliest exhibition of Surrealist objects, held at the Pierre Colle gallery, Paris, in June 1933, Breton had shown an undated "object," which can be identified with a work known as *Communication relative au hasard objectif* (*André Breton: Je vois, j'imagine* 1991, pl. 3; and André Breton, *Surrealism and Painting*, tr. by Simon Watson Taylor, New York, 1972, p. 274, 1933 installation photo, incorrectly dated 1936). He continued to make and exhibit object-poems after the war (for example, *Minuit juste* of 1959 [destroyed] at the *Exposition internationale du surréalisme*, Galerie Daniel Cordier, Paris, 1959; *André Breton: Je vois, j'imagine* 1991, p. 172, no. 20, pl. 20). By the time of the 1936 Ratton exhibition, the "objects" had been carefully classified into the following categories: natural objects, interpreted natural objects, incorporated natural objects, perturbed objects, found objects, found objects interpreted, American objects, Oceanic objects, mathematical objects, readymade and assisted readymade, and finally Surrealist objects, which included Breton's own object-poems and two objects made in conjunction with his wife Jacqueline Lamba (1910–1993).

This collage was dedicated to Lamba, whom Breton met and married in 1934, and who was the Ondine of his book *L'Amour fou* (Paris, 1937). She too was an artist, and collaborated with Breton on objects like *Le Petit*

Mimétique (c. 1936; included in the 1936 *Exposition surréaliste d'objets* at the Ratton gallery, Paris; private collection, Paris; *André Breton: Je vois, j'imagine* 1991, pl. 10). In his text of 1942, "Le Poème-objet" ("The Object-Poem," in Breton 1972, pp. 284–85), Breton gave a detailed interpretation of every element of his 1941 object-poem *Portrait de l'acteur A. B.* (*Portrait of the Actor A. B.*; see *André Breton: Je vois, j'imagine* 1991, p. 9, pl. 1), in a manner similar to his analysis of dreams in *Les Vases communicants* (Paris, 1932, reprinted 1955, p. 34ff.). He believed, in other words, that both the verbal and the visual materials of the object-poem are open, like a dream, to interpretation. Indeed, the coming into being of such objects originated in the subconscious processes of the dream, or in what Breton called "objective chance."

The combining of words with images or objects goes back to the heterogeneous practices of the Dadaists, and indeed beyond. When Breton reproduced the Bergman piece (without a title) in the Winter 1937 issue of *Minotaure*, it was on a double-page spread with paintings by Magritte, Miró, and Ernst, which similarly juxtaposed script and image, but in different ways (see fig. 1). In *Le Corps de ma brune* (*The Body of My Brunette*, 1925), for example, Miró counterpointed flowing and ambivalent forms with a poem scrawled in large letters over the work's surface. Magritte, instead, neatly labeled six objects with the wrong names, a disorienting lesson in the arbitrariness of language.

In this untitled object-poem, Breton built with great subtlety on the idea that his encounter with Jacqueline was "fated" through a kind of occult illumination. Just as the photographs by Brassaï, which illustrated *L'Amour fou*, show the corners of nighttime Paris, which Breton visited with Jacqueline, magically lit, the black surface of this work is interspersed with flashes of white. A white ribbon is woven through the black oilcloth at the top right and lower left corners, and the texts of the poem inscribed on white cardboard are revealed through cutout rectangles in the cloth. The frame of this collage also seems to have been originally painted white, based on a photograph of the work hanging in Breton's home (fig. 2). A red-and-gold printed card, perhaps from a fairground fortune teller, at the top left, bears the words "Carte resplendissante," forming with Breton's own words "de ma vie" the first line of the poem. The card's burgeoning shape is echoed in a little metallic bouquet of delicate cogs and prongs (perhaps from a music box or clock), which gives form to the line from the poem beside it, "Dans le jardin de la pendule."[1] Vegetal allusions occur again in the transparent skeleton of a leaf at lower right, which repeats in its shape the Ace of Spades. The leaf covers like a veil the upper half of the Queen of Spades (from a pack of cards manufactured in Germany, c. 1898; *Spielkarten: Jugendstil und Art déco*, Vienna, 1994, pp. 54–55, ill.), representing the Dark Lady, her long, trailing hair evoked in the last line of the poem, "Une femme aux cheveux d'hameçons." In the poem's preceding line, "Il y avait dans le train bleu," Breton situated this mysterious lady "in the blue train"; this was the luxurious, overnight train that linked Paris to the Côte d'Azur, a reference that hints at nocturnal assignation and romantic journey. The visual elements thus interact with the words of the poem, as Breton explained above, without repeating or illustrating them. * * *

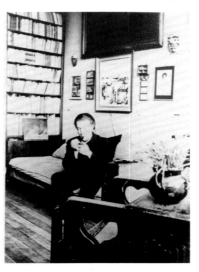

Figure 2. Photograph of André Breton taken around 1939 (private collection); no. 7 is visible on the wall at far left [photo: Paris, Musée national d'art moderne, *André Breton: La Beauté convulsive*, 1991, exh. cat., p. 72].

8. CADAVRE EXQUIS (EXQUISITE CORPSE)

BY MAX MORISE, MAX ERNST, AND ANDRÉ MASSON

18 March 1927
Graphite and colored crayons on ivory wove paper; 20 x 15.5 cm (7 7/8 x 6 1/8 in.)

Inscribed and dated on the back: *Appt. André Breton* (upper right in red graphite); *Max Morise / Max Ernst / André Masson / (18 mars 1927)* (upper right in graphite in Breton's hand); *"CADAVRE EXQUIS" (18 mars 1927) / De haut en bas: Max Morise, Max Ernst, André Masson.* (upper center in black ink in Breton's hand); *André Breton* (center right in black ink, Breton's signature); *600* (lower left in graphite)

The Lindy and Edwin Bergman Collection, 104.1991

PROVENANCE: André Breton, Paris.[1] Galerie Furstenberg (Simone Collinet), Paris;[2] sold to Lindy and Edwin Bergman, Chicago, 1961.

EXHIBITIONS: Chicago 1984–85, no cat. nos., p. 228 (ill.).

REFERENCES: *Ernst Katalog*, vol. 3, 1976, p. 212, no. 1201 (ill.).

See no. 10 for discussion.

9. CADAVRE EXQUIS (EXQUISITE CORPSE)

BY MAN RAY, YVES TANGUY, JOAN MIRÓ,
AND MAX MORISE

1928

Pen and black ink, and graphite with smudging,
with colored pencils and colored crayons on tan
wove paper; 36.2 x 23.1 cm (14¼ x 9⅛ in.)

Inscribed and dated on the back: *Man Ray /
Tanguy / Miro / Morise* (upper left in graphite);
"CADAVRE EXQUIS" (1928) / *De haut en bas*:
Man Ray, Yves Tanguy, Joan Miró, Max Morise
(upper center in black ink in Breton's hand);
André Breton (center right in black ink, Breton's
signature); *60* (center left in graphite); *68.200*
(lower right in graphite)

The Lindy and Edwin Bergman Collection,
105.1991

PROVENANCE: André Breton, Paris.[3] Galerie
Furstenberg (Simone Collinet), Paris;[4] sold
to Lindy and Edwin Bergman, Chicago, 1960.

EXHIBITIONS: Chicago 1967–68, no cat. New
York 1968, p. 234, no. 117, fig. 107. Philadelphia,
University of Pennsylvania, Institute of Contem-
porary Art, *Against Order: Chance and Art*,
1970, no cat. nos., n. pag. Kalamazoo, Michigan,
Kalamazoo Institute of Arts, *The Surrealists:
A Fifth Anniversary Fund Exhibition*, 1971, no cat.
nos. Washington, D.C., Hirshhorn Museum and
Sculpture Garden, *Artistic Collaboration in the*
Twentieth Century, 1984–85, no. 23 (ill.) and pp.
30–31, traveled to Milwaukee and Louisville.

REFERENCES: Rubin 1968, p. 278 and fig. 288.
H. A. Bouraoui, *Créaculture 1*, Philadelphia,
1971, p. 194 (ill.). Nahma Sandrow, *Surrealism:
Theatre, Arts, Ideas*, New York, 1972, opp. p. 46
(ill.). Jeffrey Wechsler, *Surrealism and American
Art, 1931–1947*, New Brunswick, N.J., Rutgers
University Art Gallery, 1977, exh. cat., p. 14,
pl. VI.

See no. 10 for discussion.

THE DISCOVERY OF THE CADAVRE EXQUIS, the perfect Surrealist game, dates to the winter of 1925–26, when debates about what visual Surrealism might be were at their height. The Surrealist group, centered around André Breton, had just met the inhabitants of 54, rue du Château: the poet Jacques Prévert, the painter Yves Tanguy, and Marcel Duhamel, owner of the house and aficionado of jazz and the cinema; and it was in the course of one of their evening meetings there that a game of consequences developed into a kind of communal automatism. The Surrealists' addiction to games, their fascination with the capacity of play to free the mind of critical control and foster metaphorical and analogical combinations of words and images, took numerous forms, from the *cadavre exquis* to *l'un dans l'autre* (a game of analogies; see the postwar Surrealist review *Médium*, n. s., 3 [May 1954]). Breton described the typical course of an evening at the house on the rue du Château:

When the conversation started to lose its interest in the facts and topics of the day . . . we used to pass to some game — written games in the beginning — combined in such a way that the elements of speech came face to face in the most paradoxical manner, and human communication, derailed from the beginning, set the mind running with the maximum of adventure. (André Breton, "The Exquisite Corpse, Its Exaltation," in Milan, Galleria Schwarz, *André Breton: Le Cadavre exquis, son exaltation*, 1975, exh. cat., p. 5, translation slightly amended)

10. CADAVRE EXQUIS (EXQUISITE CORPSE)

BY YVES TANGUY, MAN RAY, MAX MORISE, AND ANDRÉ BRETON

1928
Pen and brown ink, and graphite with smudging, with colored crayons on cream wove paper; 31.1 x 20 cm (12 1/4 x 7 7/8 in.)

Inscribed and dated on the back: "*CADAVRE EXQUIS*" (1928) / *De haut en bas*: Yves Tanguy, Man Ray, / Max Morise, André Breton (upper left in black ink in Breton's hand); *André Breton* (upper left in black ink, Breton's signature); *Yves Tanguy / Man Ray / Max Morise / André Breton* (upper right in graphite in Breton's hand); *450* (center left in graphite)

The Lindy and Edwin Bergman Collection, 106.1991

PROVENANCE: André Breton, Paris.[5] Galerie Furstenberg (Simone Collinet), Paris;[6] sold to Lindy and Edwin Bergman, Chicago, 1961.

EXHIBITIONS: Chicago 1967–68, no cat. Chicago 1984–85, no cat. nos., p. 228 (ill.). Chicago 1986, no. 55.

As Simone Collinet, Breton's wife at the time, recalled: "Violent surprises prompted admiration, laughter, and stirred an unquenchable craving for new images–images inconceivable to one brain alone – born from the involuntary, unconscious, and unpredictable mixing of three or four heterogeneous minds" (Simone Collinet, "The Exquisite Corpses," in Milan 1975, p. 30).

The name was born, it seems, that first evening, when Prévert's first written words "le cadavre exquis" were complemented by subsequent contributions, "boira" and "le vin nouveau," thus creating the phrase "le cadavre exquis boira le vin nouveau" (the exquisite corpse will drink the new wine). These verbal games were extended to visual experiments, consisting basically of the children's game of "head, body, and legs," in which each participant adds to the drawing, from the top down, with preceding contributions concealed. This produced results just as dazzling as the written sentences in their unexpected and violent juxtapositions of images.

Particularly seductive was the sometimes inexplicable symmetry of the contributors' imagination, as in the drawing (no. 9) by Man Ray, Tanguy, Miró, and Morise, in which Tanguy's firing gun is followed by Morise's prostrate figure. In the cadavre exquis by Tanguy, Man Ray, Morise, and Breton (no. 10), there is a similarly curious parallel between the mythological creatures: a flying sea-horse and a serpent-mermaid. In the drawing by Morise, Ernst, and Masson (no. 8), Ernst converted the voids under the figure's arms into birds, a fine example of a double image. Ernst's rather jagged drawing moreover echoes here the characteristic style of Masson, whose twin running figures double as the body's legs.

Many scores of these drawings were produced in the Surrealists' group sessions, and the practice spread to Surrealist groups elsewhere, for instance in Czechoslovakia and England. Of those cadavres exquis that have been preserved, the three in the Bergman collection are especially fine examples. The 1927 cadavre exquis (no. 8) is closely related to four other extant cadavres exquis by the same three artists, on sheets of the same size, probably dating to the same time. One of these was probably done the same day (Spies 1976, no. 1199, ill.), the others during the same month (Spies 1976, nos. 1202–03, ills.).

There were antecedents to the cadavre exquis in automatic and trance drawings, in Max Ernst's Dada collages and photomontages, and in found objects. In turn, the influence of the cadavre exquis is evident in Miró's work and in Tanguy's early paintings and drawings.

The journal La Révolution surréaliste (9–10 [Oct. 1927]) published several examples of both visual (pp. 8, 28, 30, 35, 44) and verbal (pp. 11, 24) cadavres exquis, interspersed throughout the texts and tellingly juxtaposed with dream narratives and with other visual material, including an automatic sand painting by Masson (p. 10), a painting by Tanguy entitled Second Message (p. 31), and most strikingly a kachina doll (p. 34). Two examples of pictorial cadavres exquis (pp. 28, 30) were reproduced in this issue within Freud's article "La Question de l'analyse par les non-médecins" (The Question of Analysis by the Layperson). None were actually placed within the fourth installment of Breton's "Le Surréalisme et la peinture," but a final example (p. 4) appeared in the middle of the article "Vie d'Héraclite" by the French churchman and philosopher François Fénelon (1651–1715), admired by the Surrealists for his defense of the famous mystic Madame Guyon and for his writings on the interior lives of saints. The placing of cadavres exquis throughout this issue of the journal is neither exactly random, nor intended to illustrate the texts. They are rather part of a continuous fabric of juxtaposition, which yields unexpected contrasts and analogies. Neither the drawings nor the written examples are attributed. All the visual cadavres exquis reproduced in the 1927 issue of La Révolution surréaliste are done by three hands, while those of 1928, such as the two examples in the Bergman collection, involve four contributors, although there was no prescription as to the number of participants. Particularly striking examples were on occasion traced or redrawn. * * *

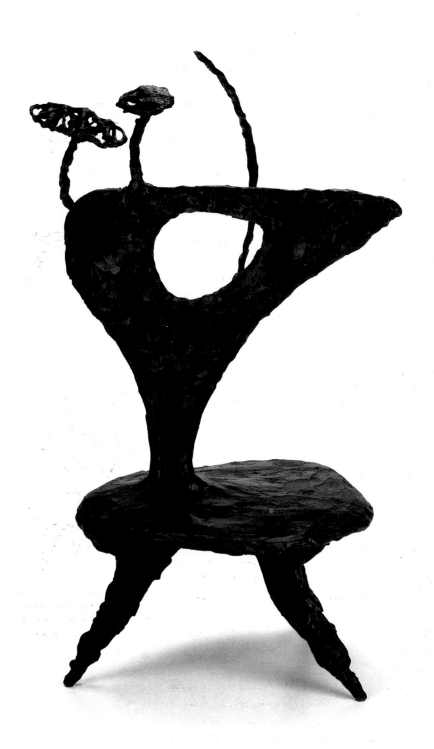

11. STILL LIFE, RENAMED THE CHICKEN

1944
Bronze (unique 1944 cast); 61.6 x 32 x 31.5 cm
(24¼ x 12⅝ x 12⅜ in.)
Signed and dated, under the tabletop-like
element at center: *A. CALDER / 1944*
The Lindy and Edwin Bergman Collection,
107.1991

PROVENANCE: Grace Hokin, Palm Beach,
Florida, by 1970.[1] B. C. Holland, Inc., Chicago;
sold to Lindy and Edwin Bergman, Chicago,
1973.

EXHIBITIONS: New York, Buchholz Gallery,
Recent Work by Alexander Calder, 1944, no. 23,
as *Still Life*. New York, Perls Galleries, *Alexander
Calder: Bronze Sculptures of 1944*, 1969, no. 14
(ill., this cast),[2] as *The Chicken*. Chicago,
Museum of Contemporary Art, *Alexander Calder:*

A Retrospective Exhibition, 1974, no cat. nos.,
n. pag., as *The Chicken*.

REFERENCES: "Art Collecting Is a Matter
of the Heart," Feb. 5, 1970 [place of publication
unknown], ill.[3]

FOLLOWING HIS LARGE RETROSPECTIVE AT The Museum of Modern Art, New York, in the autumn of 1943, Calder seemed, according to James J. Sweeney, to "feel that he should try to find a fresh idiom, or perhaps more truly a refreshment of idiom. He spoke of his worry over becoming ingrown, habit-bound and uninventive" (James J. Sweeney, *Alexander Calder,* New York, 1951, p. 59). A suggestion by Calder's friend, the architect Wallace Harrison, in the spring of 1944, that he might "make some large outdoor objects which could be done in cement" thus found an immediate response (Alexander Calder, *Calder: An Autobiography with Pictures*, New York, 1966, p. 195). It is unclear whether Harrison had some specific architectural or environmental project in mind; as Calder recalled, "He [Harrison] apparently forgot about his suggestion immediately, but I did not and I started to work in plaster. I finally made things which were mobile objects and had them cast in bronze—acrobats, animals, snakes, dancers, a starfish, and tightrope performers. These I showed that fall at Curt's [Buchholz Gallery]" (ibid.). The Bergman bronze, under the title *Still Life*,[4] was one of the twenty-four sculptures in bronze and plaster Calder included in this show.

The sculptures were cast by Roman Bronze Works, Inc., of Corona, New York, with the help of Sculpture Services, New York, and the involvement of Calder himself (New York 1969, n. pag.). It was not a wholly satisfactory experience: as Calder explained, he found it "disagreeable to have to check the manipulations of some other person working on the objects at the foundry," and the sculptures, when shown at his new dealer Curt Valentin's Buchholz Gallery in the autumn of 1944 did not sell well (Calder 1966, p. 196). Even so, he continued to "play with the idea, from time to time, of going back to this medium" (ibid.). In 1968 he decided to authorize an edition in bronze, limited to six numbered casts each, of the 1944 sculptures, most of which had been stored at his mother's home in Roxbury, Connecticut. The Bergman bronze is the unique original of 1944.[5]

Although Calder appears not to have relished either the process of casting or the inventive possibilities of using objects within this process (as Miró did, for example), there seem nonetheless to have been some imaginative formal transformations in the making of this sculpture. It is possible that the piece at some point in its making was the other way up, with the two knobbly-ended antennae reading as chicken's legs, supporting a pendulous body pierced by an egg-shaped hole. The hole retains the metaphorical dimension of egg/eye. A drawing by Calder of this sculpture (fig. 1) was reproduced in the catalogue of the Buchholz exhibition, but there is no evidence that this was anything other than an illustration, taking the place of a photograph. Calder was not in the habit of working out his sculpture through preparatory drawings; those that accompany some of the later mobiles are of a technical nature related to the complicated arrangements of these structures. The catalogue drawing of this sculpture does, however, seem to play on the contrast between the stool as support or "table" with its firmly splayed three legs, which consorts with the idea of "still life," and the perky animation of the "head" with its eye and antennae-like comb. The third, long, thin protrusion from the head is not visible in the drawing.

The change of technique, from Calder's usual type of construction in sheet metal, wood, and wire to modeling, accounts, in part, for the sculpture's unusual qualities. Other sculptures in this series, however, more evidently display the mobile character Calder described above in these pieces, which connected them with his more familiar work (see, for example, the two other sculptures in this series in The Art Institute of Chicago, both of which are mobile: *A Detached Person*, renamed *Antlers*, 1979.354, and *Starfish*, 1964.1139 [New York 1969, fig. 15; and Munich, Haus der Kunst, *Calder*, exh. cat., 1975, no. 116, ill.]). *On One Knee*, which is in several different parts and is very delicately balanced, was one of the sculptures in the series that demanded great technical ingenuity in the casting (see New York 1969, fig. 1).

Some of the flatness of Calder's sheet-metal mobiles persists in the contrasts between the upright and horizontal components of the Bergman sculpture. A thin, flat triangular shape meets at right angles the roughly modeled seat of the three-legged stool that forms the table of *Still Life* or the body of *The Chicken*, depending on which title one favors for this sculpture. Even if not actually mobile, nor obviously dependent upon precise balance, the humor and expressive stance of this sculpture still depends upon the tenuous point of conjunction of two large planes, the angle at which they meet, and the fine balance of positive and negative form. * * *

Alternate view.

Figure 1. Alexander Calder, drawing reproduced in New York, Buchholz Gallery, *Recent Work by Alexander Calder*, 1944, exh. cat., n. pag.

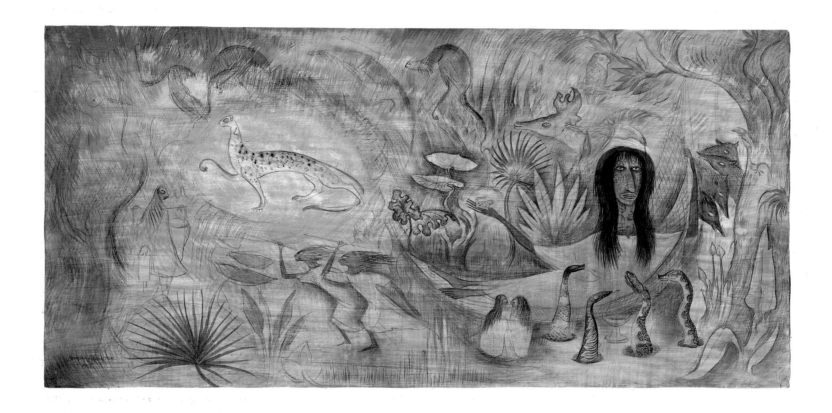

12. JUAN SORIANO DE LACANDÓN

1964

Graphite and casein on wood panel; 40.3 x 80.3 cm (15 13/16 x 31 9/16 in.)

Signed and dated, lower left: *LEONORA CARRINGTON / 1964*

Inscribed on the back: *JUAN SORIANO de LACANDON.* (along upper edge of panel, in what appears to be the artist's hand)

The Lindy and Edwin Bergman Collection, 108.1991

PROVENANCE: Galería Juan Martin, Mexico City; sold to Lindy and Edwin Bergman, Chicago, 1967.

REFERENCES: Clare Kunny, "Leonora Carrington's Mexican Vision," *The Art Institute of Chicago Museum Studies* 22, 2 (1996), pp. 166 (detail ill.) –79, fig. 1.

At the time of painting this delightful imaginary portrait of her friend the Mexican artist Juan Soriano,[1] Leonora Carrington had just completed a major commission she had received in 1963 to paint a large mural for the Museo de Antropología e Historia in Mexico City. The mural, now in the Museo Regional in Tuxtla Gutiérrez (San Francisco, The Mexican Museum, *Leonora Carrington: The Mexican Years, 1943–1985*, 1991, exh. cat., pp. 24–25, ill.), was entitled *El mundo mágico de los Mayas* (*The Magical World of the Mayas*), and in preparation for it Carrington made numerous sketches of the Lacandón Indians of Chiapas, in the south of Mexico. The Lacandón have remained strikingly faithful to the indigenous culture of the Maya. Carrington sought to draw upon their contemporary myths and beliefs, as well as upon the surviving fragments of the art and literature of the great Maya civilization that occupied the east and south of present-day Mexico, and stretched down through Guatemala and Belize into Honduras.

The 1963 commission demonstrates the degree to which the artist had become immersed in the culture of her adopted country, where she settled in 1943; it also reflects the preparation she had, in a sense, received from the Surrealist circles in which she moved before the war in Paris, and then in New York, where she contributed drawings and stories to both the New York-based Surrealist periodicals *VVV* and *View*. The Surrealists had helped to bring native American literatures to popular notice. The May 1945 issue of *View*, "Tropical Americana," published extracts from the Quiché Maya book *The Popol Vuh*, and one of the prophecies from the book of the Jaguar Priest, the Chilam Balam of Chumayel, which the Surrealist poet Benjamin Péret (Carrington's close friend and companion of her fellow artist Remedios Varo) translated into French and published in 1955 (*Livre de Chilam Balam de Chumayel*, Paris, 1955). The epic poem *Popol Vuh* is both a creation myth and a history of the Quiché Maya.

Juan Soriano was born in Guadalajara in 1920; an autodidact, his paintings draw upon a rich mixture of European and native imagery and myths, which gives them a natural affinity with Surrealism (Paris, Musée du Luxembourg, *Juan Soriano*, 1987, exh. cat., texts by André Pieyre de Mandiargues and Carlos Fuentes). In this portrait, Carrington has depicted Soriano as a Lacandón Indian, reclining in a hammock and communing with the surrounding fauna, the magical creatures of Mayan mythology: serpents, deer, birds (a hummingbird hovering over his head, an owl perched behind him), and above all the jaguar. The tiny jaguar he holds in his right hand is transfigured into the powerful creature of shamanic transformation, whose identity the priest, according to native beliefs, was privileged to assume. The water lilies flourishing in the center of the drawing are the typical flora of the Maya underworld, as preserved, for instance, in the pre-Conquest murals of the Maya city of Tulum, on the coast of Quintana Roo.

From the 1920s when, following the Mexican Revolution, muralists began to focus attention on the neglected Indian population, indigenous themes were popular among Mexican artists (see, for instance, Roberto Montenegro [1887–1968] or Ricardo Martinez [b. 1918]). There were wide variations in the treatment of these subjects: careful archaeological reconstructions of the pre-Columbian past (e.g., Diego Rivera), Socialist Realist scenes of contemporary Mexico (e.g., David Alfaro Siqueiros), and more fanciful scenes drawn from myth and legend. Carrington did not dramatically alter the manner she used to paint her own personal, imaginative world, which had its roots in European fairy tales, folk legends from England and Ireland, and alchemical literature, to fit her Mexican subject matter. Her graphic style, like that of her paintings, is deceptively simple, with echoes both of children's art and the art of the Middle Ages and Early Renaissance. In this work, though, the little figures in white, scattered through the landscape at Soriano's feet, recall the prints and drawings of Indian peasants by Miguel Covarrubias (1904–1957) and Alfredo Zalce (b. 1908). The magnificent, curvilinear jaguar loosely evokes those painted on Maya ceramic vessels of the Classic Period (A.D. 200–900).

* * *

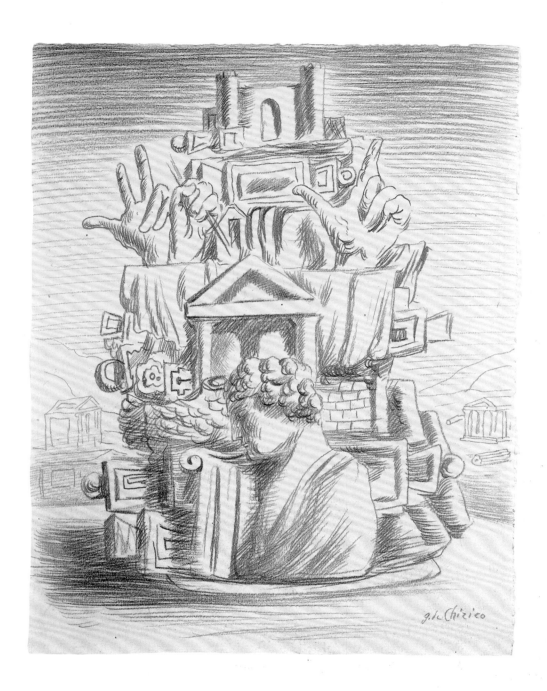

13. UNTITLED

c. 1926
Graphite and lithographic crayon on cream wove
paper; 31.9 x 24.6 cm (12⁹/₁₆ x 9¹¹/₁₅ in.)
Signed, lower right: *G. de Chirico*
The Lindy and Edwin Bergman Collection,
112.1991

PROVENANCE: Julien Levy Gallery, New York;
sold to the Richard Feigen Gallery, Inc., New
York, 1965;[1] sold to Lindy and Edwin Bergman,
Chicago, 1965.

EXHIBITIONS: Chicago 1967–68, no cat.
Chicago 1984–85, no cat. nos., p. 136 (ill.), as
Untitled (Figure among the Ruins).

REFERENCES: Jean Cocteau, *Le Mystère laïc,
essai d'étude indirecte (Giorgio de Chirico), avec
cinq dessins de Giorgio de Chirico*, Paris, 1928,
opp. p. 28 (ill.). Maurizio Fagiolo dell'Arco and
Paolo Baldacci, *Giorgio de Chirico: Parigi,
1924–1929*, Milan, 1982, p. 285 (ill.), reproduc-
tion of the illustration in *Le Mystère laïc*. Verona,
Galleria d'arte moderna e contemporanea
Palazzo Forti, *De Chirico: Gli anni venti*,

1986–87, exh. cat., p. 102 (ill.), reproduction
of the illustration in *Le Mystère laïc*. Lugano,
Dream Gallery, *Giorgio de Chirico all'epoca del
Surrealismo*, Milan, 1991, exh. cat. by Maurizio
Fagiolo dell'Arco, p. 12 (ill.), as *Trophy*, repro-
duction of the illustration in *Le Mystère laïc*.

THIS DRAWING WAS REPRODUCED AS ONE of the five illustrations by de Chirico in Jean Cocteau's 1928 essay on the artist, *Le Mystère laïc*.[2] These illustrations focused on some of de Chirico's major themes of the 1920s: Mannequins, Trophies, Paired Horses, Furniture in the Valley, and Temple in the Room. By the time Cocteau's essay was published, de Chirico had largely abandoned his earlier manner of painting, characterized by enigmatic and unsettling scenes with irrational perspectives and strange juxtapositions of objects, in favor of a more traditional style with strong classical overtones. This change in style cost him the admiration of André Breton and the Surrealists. (The fact that de Chirico's work was the subject of a study by Cocteau, of whom the Surrealists deeply disapproved, was a measure of the distance that by then existed between them.)

In this drawing, however, de Chirico still displayed a strong vein of fantasy and enigma in the precarious massing of heterogeneous, sculptured objects, and in his use of spatial disjunctions. The hands that rise from the draped balcony could be making a gesture of benediction. Maurizio Calvesi noted the appearance of the extended hand with two fingers turned down in other works by de Chirico (notably, in *The Span of Black Ladders* of 1914, United States, private collection; Maurizio Fagiolo dell'Arco, *L'opera completa di de Chirico, 1908–1924*, Milan, 1984, pl. XVIII) and asserted that the gesture has an "apotropaic," divinatory significance (Venice, Museo Correr, *De Chirico nel centenario della nascita*, Milan and Rome, 1988, exh. cat. ed. by Maurizio Calvesi, p. 16). The bust of the man in the foreground, which recalls an antique carving, could be a philosopher figure.

The Trophies constitute a relatively small group of Parisian works from the 1920s (see discussion in Fagiolo dell'Arco and Baldacci 1982, pp. 77–78, 117–18). They are related to the scaffoldings of objects in works such as *The Jewish Angel* of 1916 (private collection; Fagiolo dell'Arco 1984, pl. XXVI), and to the piled-up forms in *The Great Metaphysician* of 1917 (New York, The Museum of Modern Art; Fagiolo dell'Arco 1984, pl. XXXII) and the more contemporary painting *The Painter's Family* of 1926 (London, Tate Gallery;

Surrealism in the Tate Gallery Collection, Liverpool, 1988, p. 18, ill.). Waldemar George suggested (see his *Giorgio de Chirico*, Paris, 1928, p. XXIV; Eng. tr. in Elizabeth Cowling and Jennifer Mundy, *On Classic Ground: Picasso, Léger, de Chirico and the New Classicism, 1910–1930*, London, Tate Gallery, 1990, exh. cat., p. 82) that such compositions with their mannequin figures portray a

Western Europe conscious of its decrepitude . . . His [de Chirico's] *Olympians, who are god-like mannequins, or plaster statues, animated by an extraordinary extraterrestrial life-force, have their arms filled with various emblems of a civilization, the debris of which suggests old items from a bric-à-brac store or the back of a shop.*

The subject of the trophy has obvious classical, specifically Roman, antecedents. Its origins lie in trophies of battle, such as armor and heraldic standards, paraded in triumphal processions, but de Chirico seemed especially interested in the sculptural representations of trophies for permanent display. Most prominent among extant Roman examples are those erected by Michelangelo next to the *Dioscuri* as part of his restructuring of the Piazza del Campidoglio in Rome. De Chirico's first wife, Isabella Far, studied archaeology at the Sorbonne during the 1920s, and her work also had an influence on his classical themes.

De Chirico's Trophies have close connections with passages in his novel *Hebdomeros* (Paris, 1929), named after its main protagonist. In one instance, for example (*Hebdomeros*, tr. by Margaret Crosland, New York, 1988, p. 40), Hebdomeros comes across classical athletes, whom he had previously observed training,

absorbed in their favorite occupation: the construction of trophies.

As a result curious scaffoldings, simultaneously severe and amusing, rose in the middle of the bedrooms and drawing-rooms.

Though set here in a landscape of classical ruins, the trophy mounds resemble, as Hebdomeros noted, both mountains and pyres. * * *

JOSEPH CORNELL

AMERICAN, 1903–1972

INTRODUCTION

JOSEPH CORNELL WAS BORN IN NYACK, NEW York, just north of New York City. He never left the area, but was fascinated by the idea of travel. His work is full of references to a Europe he never saw, but whose culture and history gripped his imagination. This was especially the Europe of the Grand Tour and the Romantic ballet: Italian palaces, French hotels, the theaters with their legendary dancers and singers.

Cornell's art is distinctive and intensely personal, but he was not an isolated outsider as he is sometimes portrayed. Although he had no formal training as an artist, he was familiar from a young age with contemporary French painting and music. He exhibited regularly in New York, starting in the early 1930s, and developed a wide network of contacts in the artistic community. It was only slowly, however, that Cornell's works were recognized as being more than intriguing toys for grown-ups. The emigrant and then the war-exiled Surrealists provided important support and encouragement, and although he kept a certain distance from Surrealism, being a little alarmed at the "black" side of its magic, this movement provides the context in which his work is best understood. He certainly shared with the Surrealists a love of Romantic literature and nineteenth-century French poetry (Rimbaud, Mallarmé, Baudelaire), and, above all, a belief in the primary demands of the imagination. Like them, he had a broad conception of the operations of the poetic in the everyday, and his working practices similarly use chance and found objects.

In the box-constructions, the works for which he is best known, Cornell combined a very modern sensibility for space, form, and surface with a delicate sense of the associative power of objects, whole or fragmented. The boxes range widely in mood, from luminous, white structures to dark and gothic habitats. Whether urban or rural, they are poetic distillations of memory and experiences. Toward the end of his life he turned increasingly to collages; unlike his early collages of black-and-white engravings, those of the late 1950s and 1960s are built up from brightly-colored, contemporary magazines and commercial reproductions.

Cornell's activities were an unusual meld of collecting and fabricating. He amassed quantities of objects of all kinds, which he stored for future use, and also built up dossiers on various subjects, which pertained to the themes of certain boxes. Cornell was also passionately interested in cinema, and here his dual interest in collecting and making had a particularly fruitful outcome, although he felt that his films "never really got off the ground" (P. Adams Sitney, "The Cinematic Gaze of Joseph Cornell," in New York 1980–82, p. 69). He wrote his first film scenario, *Monsieur Phot*, in 1933; around 1936 he made his first film, the extraordinary and wholly original *Rose Hobart*. A banal B-movie, *East of Borneo*, involving an exotic romance, was transformed into a Surrealist drama through Cornell's montage and reorganization, which characteristically included eliminating the sound track to restore "the suggestive power of the silent film to evoke an ideal world of beauty" (ibid., p. 74). Although his relationship to cinema remains, as P. Adams Sitney has said, mysterious (ibid., p. 77), in some ways film and the idea of montage seem central to Cornell's aesthetic.

CORNELL'S WORKING PRACTICES AND SURREALISM

ORNELL'S WORK AND HIS WORKING PRAC-
tices evolved in the context of Surrealism;[1] he
showed his first experiments, collages of old en-
gravings in the manner of Max Ernst's collage-novel *La
Femme 100 têtes* (1929), to Julien Levy in 1931 (Julien
Levy, *Memoir of an Art Gallery*, New York, 1977, p. 77).
Levy, who published an important early anthology of
Surrealist art and literature (*Surrealism*, New York,
1936), gave Cornell his first one-man exhibitions, in-
cluded him in group shows, opened up a network of con-
tacts for him within New York's artistic circles, and even
prompted ideas for new types of construction. As Levy
recalled (Levy 1977, p. 79):

*Parting now from Max Ernst, Joseph crystallized his own
ideas. First he added to the engravings such glitter as mir-
ror and tinsel. He closely examined some of the collection of
old French puzzle boxes and watch springs in old contain-
ers with transparent covers (backed by views of the Arc de
Triomphe) I brought out to show him. I had found these
years before, sleuthing with Mina for finds in the Marché
aux Puces in Paris. Within a week he returned with several
objects in three dimensions, a few with moving parts.... in
several small boxes the mobile principle consisted of rolling
steel balls. These were delivered well thought out and so
promptly one wondered how they could have been made so
quickly following our talk. One could imagine his feverish
activity, as though they were ready in his mind just waiting
for my spoken word or approval. And the spirit of execu-
tion was entirely that of Cornell, quite unlike Max's or
Man Ray's or any other Surrealist then working in Paris.*

One may well wonder how far Cornell had already
anticipated Levy's hints to work in three dimensions,
using or gaining inspiration from found objects, and also
from film and photography (see *Untitled* [*Black Hunter*],
no. 15). Although his art grew out of his own need for ex-

pression, his early experiments may be connected with
devising entertainments for his wheelchair-bound
brother, Robert. Cornell projected films from his collec-
tion, and helped Robert build a large and elaborate lay-
out for his train set (Lynda Roscoe Hartigan, "Joseph
Cornell: A Biography," in New York 1980–82, p. 102).
Although the Surrealist object is in many respects the
"genre" to which Cornell's boxes belong, the boxes also
have distinctive features that distinguish them from it.

The Surrealist object was an expansive concept;
each new instance of it seemed to open up a host of possi-
bilities, starting with its first mention in André Breton's
"Introduction to the Discourse on the Paucity of Real-
ity" (1924; see André Breton, *Oeuvres complètes*, Paris,
1992). Its diverse manifestations all included, however,
ready-made and found materials. Three broad cate-
gories of Surrealist objects may be identified: first, the
object encountered "ready-made" in a dream, like the
book-object Breton described in 1924, which aroused a
sensation of delight and whose very uselessness cast a
shadow on the "hateful" utilitarian objects and "things
of reason" in the real world (ibid., p. 265). Secondly,
there was the object encountered by chance in the ex-
cursions the Surrealists undertook through the flea mar-
kets of Paris (to which Levy alluded above), an object
that would be suddenly and unpredictably recognized
as having some particular significance for the finder.
Such an encounter could not be foreseen, and the experi-
ence amounted to an "objective dream," an invitation to
the unconscious to focus, for instance, on the miracu-
lously jumbled stalls of the flea markets and then fasten
on one object in particular, in a way analogous to the
dreaming mind at work, which selects its material in an
apparently random fashion. This encounter might then
serve to solve a problem or prompt a discovery, and in the
process would itself be transformed. Breton described

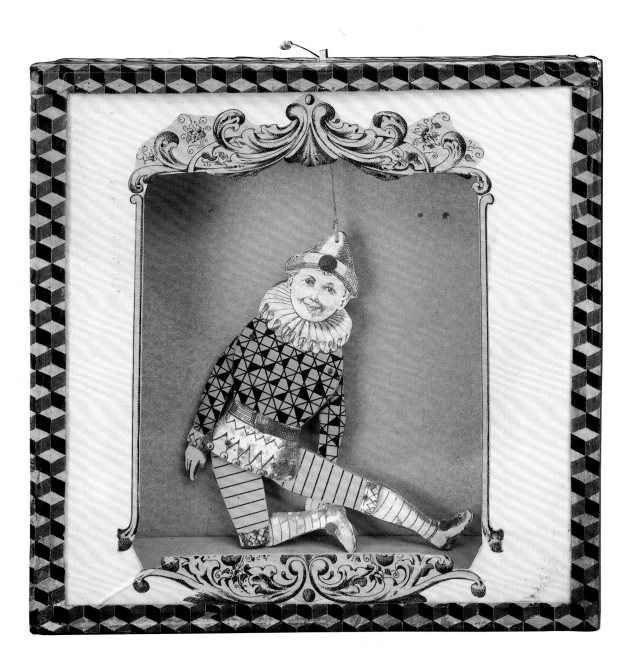

14. UNTITLED (HARLEQUIN)

1935/38

Fiberboard and wood box covered, inside and out, with patterned paper. Paper extends over edges of clear glass front. Box contains articulated marionette suspended from string. Marionette constructed of cut fiberboard pieces covered with photostated paper and ink collage. Nails secure marionette's limbs at joints. String, controlling marionette's movements, extends out of small hole in top of box and may be secured with small wood shim. Multilayered mat board with opening is placed behind glass front to create stage effect. Edges of opening are decorated with paper cutouts, glued to mat board. 33.3 x 32 x 6.9 cm (13 1/8 x 12 5/8 x 2 3/4 in.)

The Lindy and Edwin Bergman Joseph Cornell Collection, 1982.1843

PROVENANCE: Fourcade, Droll, Inc., New York; sold to Lindy and Edwin Bergman, Chicago, 1975; given to the Art Institute, 1982.

EXHIBITIONS: Washington, D.C., National Museum of American Art, Smithsonian Institution, *Joseph Cornell: An Exploration of Sources*, 1982–83, no cat. nos., p. 29, as *Untitled (Jumping Jack)*.

REFERENCES: Waldman 1977, pl. 47, as *Arlequin*.

Alternate view.

ORNELL'S EARLY TRANSITION FROM COLLAGE into three-dimensional assemblage and his experiments with the possibilities of movement were often, as here, accompanied by a theatrical element. "Shadow Boxes," as Cornell called some of his constructions of this period, were among the categories of objects named on the cover of the announcement for Cornell's *Exhibition of Objects* at Julien Levy's in December of 1940. Among the scattered illustrations on this cover is an image of Jean Antoine Watteau's *Gilles* (c. 1718, Paris, Musée du Louvre; Humphrey Wine, *Watteau*, London, 1992, pp. 56–57, ill.), cut up and arranged to look like an articulated marionette, in a manner similar to the marionette in this box.

Toy shadow-box theaters were popular in the United States in the latter part of the nineteenth century and were a simpler version of the miniature toy theaters that were especially popular in Europe. As Lynda Hartigan explained,

sold in sets or as separate sheets of hand-colored prints of characters, scenery, and the stage itself, miniature theaters were marketed as educational toys and pastimes to be cut out and assembled at home. The shadow-box toy was less complicated than the miniature theater in structure and frequently included [as in this box by Cornell] *single figures of performers and animals that could be manipulated to create a sense of action.* (Lynda Roscoe Hartigan, in Washington, D.C. 1982–83, p. 29)

Halfway between a box and a collage, this work similarly combines elements of a game and of a stage. The pattern of the colored wrapping paper covering the outside of the box and visible along the edges of the glass front is reminiscent of Roman and Italian Renaissance mosaic floors. It creates an optical illusion of cubes that read either as convex or concave and also resembles the diamond-patterned costume of Harlequin from the commedia dell'arte.

The inside walls of the box are covered with colored paper of a more muted, leafy pattern. A mat board, at the center of which has been cut a large opening, is placed directly behind the glass to create the effect of a stage, its edges decorated with paper cutouts of rococo swirls and acanthus leaf patterns appropriate to the romantic theater. The articulated marionette inside the box is suspended from a string extending out of a tiny hole in the top of the box. Pulling the string changes the marionette's position, which may be secured using a tiny wood shim lodged in the hole. The marionette is articulated at shoulders, hips, and knees, while its head and trunk remain rigid. The figure is constructed of pieces of fiberboard; Cornell covered some of these with photostated paper, others with paper bearing geometric designs in ink of his own making.

There is some disagreement about the identity of the marionette; often described as Harlequin, because of its diamond costume, it also has the flounced collar and cone-shaped hat of Pierrot, a clown, or a punchinello figure. Harlequin is typically depicted wearing a black tricorne. The conflation of these two characters may derive from a jack-in-the-box toy. Cornell may also have intended some reference to the revival of commedia dell'arte imagery in the work of European artists like Pablo Picasso and Gino Severini during the 1920s, which was seen as part of a reaction against modernism and a return to a classical tradition. Although aware of this, Cornell is more likely, in a manner typical of his multilayered references to art history and his personal memories, to have had in mind the stock figures of the Italian theater as they became part of popular tradition during the eighteenth and nineteenth centuries, from Watteau's *Gilles* to the shadow-box theater. * * *

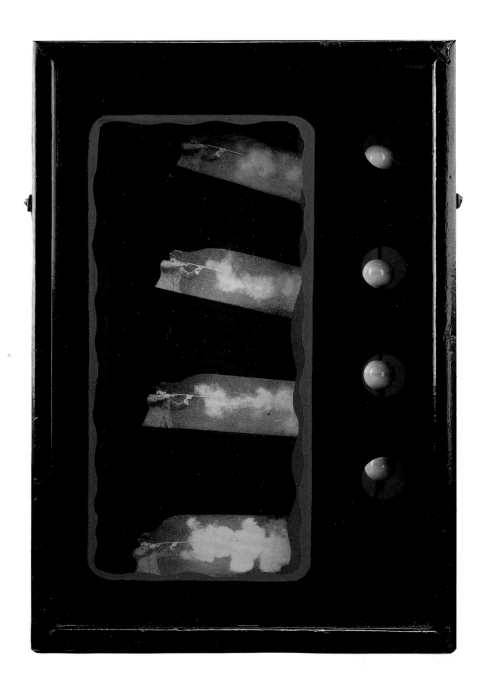

15. UNTITLED (BLACK HUNTER)

c. 1939
Wood box painted glossy black. Glass front framed with wood painted black. Front can be removed by releasing metal hook clasps at right and left. Interior sides lined with red paper and rear wall with black paper. Interior divided at uneven angles into four horizontal sections by wood slats covered with black paper. Each section contains a photostated reproduction of a hunter shooting a rifle and a circular glass disk (1½ inches in diameter), which rolls across the wood slat when box is tilted left or right. Each disk is decorated with a different photostated image adhered to it – a sea shell, a bird being born, a

bird in flight, and a cooked bird. Disks are confined in their respective compartments by interior glass painted at right with wavy red line. Black string suspends four white wood balls (diameter ⅝ in.) from upper right interior and secures them at lower right. Each ball hangs directly in the line of fire for each image of the hunter. Glass front panel painted black, with exception of large vertical window with red, painted trim at left, revealing images of hunter, and four circular windows at right, revealing white balls. 30.5 x 20.3 x 7 cm (12 x 8¹/₁₆ x 2³/₄ in.)

The Lindy and Edwin Bergman Joseph Cornell Collection, 1982.1844

PROVENANCE: Parker Tyler;[2] sold to the Tibor de Nagy Gallery, New York; sold to Lindy and Edwin Bergman, Chicago, 1964; given to the Art Institute, 1982.

EXHIBITIONS: Probably New York, Julien Levy Gallery, *Exhibition of Objects (Bilboquet) by Joseph Cornell*, 1939, no cat. nos., n. pag.[3] New York 1967, no cat. nos., p. 22, as *Black Hunter*. Kassel, Galerie an der Schönen Aussicht, Museum Fredericianum, and Orangerie im Auepark, *4.documenta*, 1968, vol. 2, no. 3, as *Black Hunter*. Chicago 1973–74, no cat. nos., n. pag.,

THE SECRETIVE CHARACTER OF THIS BOX AND its kinetic elements render it particularly resistant to reproduction. Cornell chose four photographic images of a man shooting a gun, presumably taken in quick sequence, as in early photographic experiments investigating motion, which he photostated and arranged vertically. They are slightly tilted into an arc, with the size of the image reduced toward the top, giving an impression of recession.

The movement within this box (see media description) is clearly related to film. Cornell wrote two movie scenarios, one of which, *Monsieur Phot* (1933), was published in Julien Levy's *Surrealism* (New York, 1936, pp. 77–88). *Monsieur Phot* shows a sophisticated sense of film's potential for transforming its material and creating a kind of technical fantasy through such devices as montage and dissolve. Its atmosphere is an ambiguous mixture of slapstick and dream, characteristic of such Surrealist films as *Un Chien Andalou* by Salvador Dalí and Luis Buñuel (1929). The scenes shift swiftly; Diane Waldman summarized one sequence, in which the reflection of chandeliers in a mirror

becomes the chandeliers, in the interior of a 'large, sumptuous glass and china establishment' . . . through which a pheasant of gorgeous plumage flies as if through the 'branches of his native wood.' Suddenly, in a dream scene of considerable symbolic significance, revolver shots ring out, shattering the glass into a million crystal fragments. . . . The suggestions of action, especially the sequences involving the pheasant and revolver shots, coalesce in a construction of 1939, Black Hunter, *one of Cornell's earliest experiments with movement.* (Waldman 1977,

p. 18; quotations within quotation from *Monsieur Phot,* in Levy 1936, pp. 83–84)

Both the scenario and the box itself echo René Clair's Dada film *Entr'acte* of 1924, especially in the latter's "hunting sequence," where the target continually and magically changes. In its imagery of birds, balls, glass, and mirrors, *Monsieur Phot* also prefigured many of Cornell's later themes and materials. The enclosed blackness of the box evokes the dark interior of the cinema, Cornell's and the Surrealists' favorite *lieu d'enchantement* (place of enchantment). The touches of brilliant red provide a theatrical and fittingly violent note.

Julien Levy, who first met Cornell in November of 1931, when the artist brought a sheaf of his collages to Levy's Gallery, remembered suggesting on this occasion that Cornell might

'try working in the round? Maybe add some motion, some mobility? Look. Here's a photograph of a man with a gun.' I pointed to one of the sepia prints on the wall behind me. 'And here's a partridge. One could paste them at two ends of a shadow box. Build a little sloping alley and let a bullet, or a ball bearing roll between them.' I glanced at him, but you would never know from his expression whether he was considering or resenting another's idea. (Julien Levy, *Memoirs of an Art Gallery,* New York, 1977, p. 78)

Whether or not Cornell took the idea of the box with movable parts at this moment from Levy is impossible to say; certainly Levy's suggestion does seem to foreshadow the construction of this box. * * *

as *Black Hunter*. New York 1980–82, no. 68 (ill.) and pp. 26, 286. Florence 1981, no. 5 (ill.).

REFERENCES: Ashton 1974, p. 156 (ill.), as *Black Hunter*. Waldman 1977, pl. 3 and p. 18, as *Black Hunter*. Lynda Roscoe Hartigan, "Joseph Cornell's Penny Arcade Portrait of Lauren Bacall," paper presented at the annual meeting of the College Art Association, Washington, D.C., Feb. 1, 1979, pp. 4–5, fig. 18. Dickran Tashjian, *A Boatload of Madmen: Surrealism and the American Avant-Garde, 1920–1950*, New York, 1995, pp. 237, 285 (ill.).

CORNELL'S PASSION FOR THE BALLET, ILLUS-
trated here by this collage and several other works
(nos. 18, 20, 26, 28), centered on nineteenth-
century Romantic ballet and its contemporary manifes-
tations. Most of his many boxes, collages, and keepsakes
connected with ballet are firmly rooted in the traditional
imagery of the Romantic ballet, particularly that of its
most famous examples: *Swan Lake* (1877) and *Ondine*
(1869). Cornell's works would lead us to conclude that he
showed little interest in other forms of dance, including
the Surrealist ballets *Baccanale* (1939) and *Labyrinth*
(1941), grand productions of which were mounted at
New York's Metropolitan Opera House with sets and
costumes designed by Salvador Dalí (Dalí's own para-
noiac ballet *Mad Tristan*, with music by Richard
Wagner, premiered in 1944). Cornell's contributions to
the journal *Dance Index*, however, demonstrate that his
sensibility did respond to other types of dance, revealing
the extraordinary depth of his knowledge of and inter-
est in every aspect of the history of this most ephemeral
of art forms.

Ballet had become the rage in the United States dur-
ing the 1930s, and Lincoln Kirstein, one of the founders
of *Dance Index* in 1942, was one of the first to set up an
American-based dance company in 1934, called Amer-
ican Ballet (see Christine Hennessey, "Joseph Cornell: A
Balletomane," *Archives of American Art Journal* 23, 3
[1983], p. 7). Cornell not only designed many of the cov-
ers of *Dance Index*, including that of the first issue, a
montage of an unusually modernist character entitled
Homage to Isadora, he also contributed material from his
extensive archives and collections of memorabilia. The
great stars of nineteenth-century Romantic ballet –

16. HOMMAGE À TAMARA TOUMANOVA

December 1940
Collage composed of cut and pasted, commer-
cially printed papers, with sprayed and spattered
gouache, on blue wove paper; 39.2 x 22.8 cm
(15 3/8 x 9 in.)

Titled, signed, and dated, lower right: *Hommage
à Tamara Toumanova* (Homage to Tamara
Toumanova) / *Joseph Cornell / December 1940*

The Lindy and Edwin Bergman Joseph Cornell
Collection, 1982.1873

PROVENANCE: Given by the artist to Tamara
Toumanova, Beverly Hills, California; sold to
James Corcoran, Los Angeles, May 1978.[4] Sold
by the American Dovecote and Shooting Gallery,
New York, to Lindy and Edwin Bergman, Chicago,
1979; given to the Art Institute, 1982.

EXHIBITIONS: New York 1980–82, no. 99
(ill.), and pp. 21, 105, 288. Florence 1981, no. 88
(ill.). New York, Castelli, Feigen, Corcoran,
Joseph Cornell and the Ballet, 1983, no. 33 (ill.)
and p. 60.

Fanny Cerrito, Fanny Elssler, Carlotta Grisi, and Marie Taglioni—all figure prominently in his work (see, for instance, the cover to "Le Quatuor danse à Londres," *Dance Index* 3, 7–8 [July–Aug. 1944]). Cornell's interest in these famous ballerinas was profound and in a sense scholarly, but his contributions to the magazine are often even more remarkable for their wide-ranging imaginative connections and revealing biographical anecdote. One interesting issue, compiled and arranged entirely by Cornell, was "Americana Romantic Ballet" (*Dance Index* 6, 9 [Sept. 1947]). In the space of a brief two-paragraph introduction, he managed references to Herman Melville, Emily Dickinson, and "the hermit of Walden" (Henry Thoreau), before making his special brand of cultural patriotism very clear:

This issue of Dance Index *presents a handful of neglected selections from well and not so well known American authors which serve to highlight a more widespread intellectual attitude toward ballet than might be thought to have then existed. The present contents point up as well the fascinating and still existing possibilities of fresh finds in forgotten tomes and bins, the least trifle ever absorbing and welcome to the devotee of the Romantic Ballet.*

The final sentence expresses Cornell's own delight in finding "trifles," the very word so apt to describe the frothy and ephemeral fascination of the Romantic ballet. Knowledge of the ballet was also in some ways Cornell's defense against the image of a culturally barbaric nineteenth-century America, such as that caricatured by Charles Dickens in *Martin Chuzzlewit* (1844). Although Cornell's enthusiasm for ballet was arguably part of a widespread fashion, it was as much the history of this art form that exerted its magic over him as it was the living dancers.

Another remarkable issue of *Dance Index* devised by Cornell was entitled "Clowns, Elephants and Ballerinas" (*Dance Index* 5, 6 [June 1946]). The issue examined the curious overlap between classical dance and the circus. The poet Marianne Moore, a friend and correspondent of Cornell's, who shared his interest in natural history, contributed a defense of the elephant in the form of a review of Balanchine's *Ballet des éléphants* at the Barnum and Bailey Circus in 1942. In his introductory remarks to

this issue, Kirstein aptly described Cornell as "brother to the scientist who recreated a whole pre-historic age from the glimpse of a dinosaur's tooth." The fragment—whether sequin, feather, face, line of poetry, or briefest anecdote—engendered a world in Cornell's imagination, or in the dreams that were such an intimate part of his working process.

Tamara Toumanova (1919–1996), to whom this collage is dedicated, was, as Lynda Hartigan has noted,

the subject of more than two dozen boxes, collages, and objects created by Cornell between 1940 and the 1960s. Introduced to Toumanova in 1940, he found in her the living counterpart to the Romantic ballerina Taglioni, as well as a woman with whom he remained deeply enamored until his death. (Washington, D.C., National Museum of American Art, Smithsonian Institution, *Joseph Cornell: An Exploration of Sources,* 1982–83, exh. cat. by Lynda Roscoe Hartigan, p. 34)

He met Toumanova through Pavel Tchelitchew, a friend and fellow artist on the fringe of Surrealist circles in New York, who designed ballet sets and exchanged gifts with her (see Dickran Tashjian, *Joseph Cornell: Gifts of Desire,* Miami Beach, Fla., 1992, p. 111). This collage incorporates a photograph of Toumanova with printed images of butterflies, and sea plants and creatures, evoking both an aerial and underwater world. Cornell thereby suggested that Toumanova is a star who may take her place among the constellations, alongside such mythical figures as Andromeda. The merging of ethereal blue with hints of an underwater environment may also allude to the watery settings of the ballets *Swan Lake, Ondine,* and *Les Sylphides* (for a discussion of the connections between this collage and Cornell's unpublished scenario for *Les Sylphides,* see New York 1983, exh. cat. by Sandra Leonard Starr, pp. 60–61). The butterflies connect this work with other boxes of this period that do not have ostensible links with the ballet (see no. 17, *Untitled [Butterfly Habitat]*). * * *

17. UNTITLED (BUTTERFLY HABITAT)

c. 1940

Wood box, exterior stained dark brown with black paper adhered to back. Top of box is removable by releasing screw at either end. Interior of box under glass front is divided into six glazed compartments with wood walls, painted white. A single, colored-paper butterfly is suspended by two strings from ceiling of each compartment. Wood shavings or hollowed reeds and white plaster fragments are scattered on floor of each compartment and move freely. The six inner glass panels are spattered with white paint, with a circle at the center of each left clear. 30.5 x 23.4 x 8.1 cm (12 x 9³/₁₆ x 3³/₁₆ in.)

Signed and dated on back, lower center, on paper label: *Joseph Cornell* (typed) / *Joseph Cornell* (in the artist's hand) / *ca. 1940* (typed)

The Lindy and Edwin Bergman Joseph Cornell Collection, 1982.1845

PROVENANCE: Sold by the artist to William Copley, Beverly Hills, California, by 1948.[5] Mr. and Mrs. Jacob Berman, Sherman Oaks, California, by 1966; sold to Mr. and Mrs. Richard L. Feigen, New York, 1973;[6] sold to Lindy and Edwin Bergman, Chicago, 1976; given to the Art Institute, 1982.

EXHIBITIONS: Beverly Hills, California, Copley Galleries, *Objects by Joseph Cornell*, 1948, no. 11, as *Series of Butterflies*. Pasadena, California,

Pasadena Art Museum, *An Exhibition of Works by Joseph Cornell*, 1966–67, no. 12 (ill.), as *Untitled (Series of Butterfly Habitats)*. Washington, D.C., National Collection of Fine Arts, Smithsonian Institution, *Joseph Cornell (1903–1972)*, 1973–74, no cat.[7] New York, Castelli, Feigen, Corcoran, *Joseph Cornell Portfolio*, 1976, no. 7 (ill.). New York 1982–83, no. 160 (ill.; New York and Chicago only).

REFERENCES: Ashton 1974, pp. 82–84 (ill.), as *Butterfly Habitat*. Waldman 1977, pl. 5. A. M. Hammacher, *Phantoms of the Imagination: Fantasy in Art and Literature from Blake to Dalí*, New York, 1981, fig. 324 and p. 344, as *Butterfly Habitat*.

ORNELL'S BOXES OFTEN PROMPT A DIZZYING series of associations; here, these include windows, sailor's boxes, natural history displays, collector's cabinets for specimens, Christmas decorations, and microscopes. Some of these associations may even be contradictory, reinforcing the work's ambiguity. In *Untitled (Butterfly Habitat)*, ideas linked to flight, voyages, and the exotic are countered by the rigid and symmetrical organization of the display. The butterflies are not, however, pinned as they would be on a specimen board. As noted in the media description for this box, each pane of paint-spattered glass encloses a small compartment with white, wood walls, in which a cutout of a paper butterfly is suspended with string. Cynthia Kuniej Berry has rightly remarked that the "wood shavings, or hollowed reeds . . . scattered on the floor of each compartment [are] . . . curled" in a way that is "suggestive of empty cocoons. . . . The butterflies flutter on the strings, and the particles on the floors move about freely as the box is handled" (Cynthia Kuniej Berry, Examination Report, The Art Institute of Chicago, July 30, 1993, copy in curatorial files). The empty "cocoons" support the idea of a "habitat" found in the titles commonly attributed to this box, but the movement of the butterflies behind the glass when the box is handled suggests their imprisonment too. Their fluttering motion also evokes the ballet, and recalls Cornell's juxtaposition of butterflies and ballerina in *Hommage à Tamara Toumanova* (no. 16).

The fragility and ephemeral brilliance of the butterflies are beautifully counterpointed by the "snow" frosted on the compartment windows, which is reminiscent of Christmas decorations. In 1948 Cornell used a very similar arrangement for the cover of a Christmas edition of *House and Garden* (Nov. 1948), with nine little compartment windows displaying Christmas gifts, haloed with artificial snow (Dickran Tashjian, *Joseph Cornell: Gifts of Desire*, Miami Beach, Fla., 1992, pl. 4). The circular hole that Cornell left clear at the center of each window is similar to the view framed by a microscope, here focused on the body of the butterflies and on parts of their patterned wings, thus suggesting an analogy between scientific curiosity and the viewer as voyeur.

Shortly before making this box, Cornell assembled what he described as "a montage of one of Mr. Beaton's pictures of princess Paley. She is incorporated into a label of a perfume bottle producing a radiogrammed butterfly with the aid of a glass wand and some silk thread and bits of paper" (Cornell 1993, p. 88). Although the associations in the montage as Cornell described it are different—recalling Marcel Duchamp's perfume bottle with photo-collage label, *Belle Haleine, Eau de Voilette* (1921, private collection; Pontus Hulten, ed., *Marcel Duchamp: Work and Life*, Cambridge, Mass., 1993, p. 80, ill.)—the idea of the fluttering butterfly may have been prompted by this work.

There is a close parallel between this box and a 1931 painting by Pierre Roy, *Butterflies No. 1* (fig. 2). Roy was one of the artists included in the first Surrealist exhibitions in the United States, organized by Julien Levy. These were held during the winter of 1931–32 at the Wadsworth Atheneum, Hartford, under its dynamic new director Everett "Chick" Austin, and at Levy's own gallery in New York. Roy's magic-realist still lifes and landscapes often have an illusionistic painted frame to make them look like shallow boxes. In *Butterflies No. 1*, the butterflies, arranged in rows, are formed with a variety of materials—string, ribbon, wood cutouts, cloth—and are apparently pinned to the rear of the box on which they cast shadows.

A later box by Cornell, *Untitled (Parrot and Butterfly Habitat)* of c. 1948 (private collection, Tokyo; New York 1980–82, exh. cat., no. 132, ill.), includes a section combining butterflies and caterpillars among plants and flowers, which is partitioned off from one of his favorite motifs, birds, hinting at the fact that the former are food for the latter. * * *

Figure 2. Pierre Roy, *Butterflies No. 1*, 1931, oil on canvas, 41 x 33 cm, New York and Chicago, Richard L. Feigen and Co., Inc. [photo: Gregory W. Schmitz, New York].

Top of lid

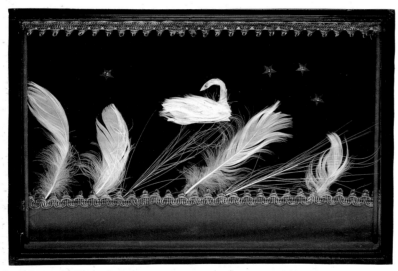

Box interior

LIKE THE COLLAGE DISCUSSED ABOVE (HOMMAGE *à Tamara Toumanova*, no. 16), this box (also known as *Feathered Swan*) was made for the ballerina Tamara Toumanova. Cornell saw Toumanova perform *Swan Lake* in 1941, and he subsequently often associated her with this role. The swan here evidently suggests her presence, floating as it does above feathers that more vividly evoke the dancer's costume than the bird itself. Cornell did on occasion incorporate actual fragments of the dancer's costume in his tributes to Toumanova. On the back of one of these, *Swan Lake for Tamara Toumanova* (1946, Houston, Menil Foundation), Cornell wrote, "An actual wisp or two of a white feather from a head piece worn by Toumanova in *Swan Lake* mingles with the larger ones bordering the box" (Christine Hennessey, "Joseph Cornell: A Balletomane," *Archives of American Art Journal* 23, 3 [1983], p. 11 and fig. 2). The white paper cutout swan covered with white feathers, like the swan in *Cygne crépusculaire* (no. 26), recalls Cornell's miniature paper cutouts of scenes from Hans Christian Andersen (see also no. 20, *Homage to the Romantic Ballet*). * * *

18. UNTITLED (FOR TAMARA TOUMANOVA)

c. 1940
Shallow, lidded wood box painted glossy black inside and out. Top of lid decoupaged with four colored images of birds on branches. Interior back wall covered with black velvet over upper section and green velvet over lower section, with ornate gold braid trim along top and bottom edges of black velvet. Four white feathers and two bare white quills extend diagonally upward to the right from lower band of gold braid. A white, feather-covered paper swan is centered just

above the diagonally placed feathers. Four silver-coated plastic stars are placed on the black velvet, three to the right of the swan and one to its left. Swan's eye and center of each star contain tiny, silver metallic beads. Rod is placed at right and left edges. Box's interior is covered with clear sheet of glass, which is supported by wood strips and dowels around the perimeter.
28.3 x 40.6 x 3.8 cm (11⅛ x 16 x 1½ in.)

Embossed on bottom of box: *A Few Interesting Facts About CALIFORNIA REDWOOD [. . .]*

The Lindy and Edwin Bergman Joseph Cornell Collection, 1982.1863

PROVENANCE: Given by the artist to Tamara Toumanova, Beverly Hills, California; sold to Castelli, Feigen, Corcoran, New York, 1978;[8] sold to Lindy and Edwin Bergman, Chicago, 1981; given to the Art Institute, 1982.

EXHIBITIONS: Chicago 1982, no. S-31.

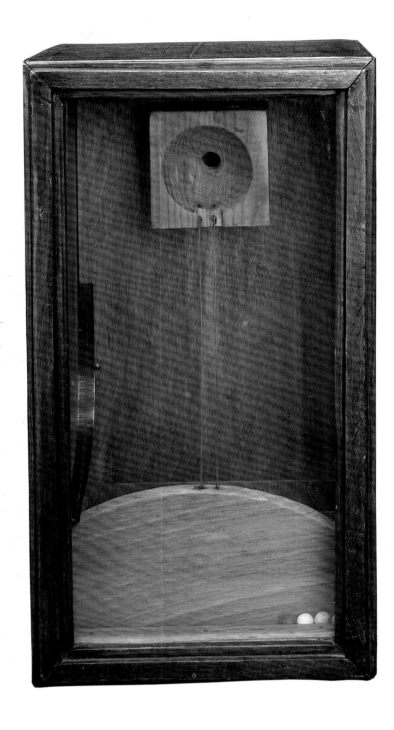

19. UNTITLED (GAME)

c. 1940

Wood box stained dark blue on exterior. Exterior bottom, top, and back covered with seven pages of French text under stain. Front of box enclosed by clear sheet of glass with wood frame. Interior walls are natural color of raw wood. Interior contains two flat barrier walls of different heights extending approximately one quarter of way up from bottom along back wall. A higher barrier wall with curved top is placed in front of these. Two metal wires, placed approximately one-half inch apart, extend upward from center of curve and connect with bottom center edge of square wood block attached to upper inside back

wall. The block has a cone-shaped depression carved into it, and a hole is drilled into the cone. A narrow metal ruler is tacked at right angles against left interior wall, its ends attached one to rear wall and one to curved barrier wall near front glass, thus forming a curved slide. Eight wood balls (one blue, two pink, and four white) are scattered in the bottom of the box. By rotating the box, balls can be caught in hole at center of wood block, or forced to slide down wires or along ruler slide. 33.3 x 18.4 x 15.3 cm (13⅛ x 7¼ x 6⅙ in.)

Signed on back, upper right, on scrap of book page: *Joseph Cornell*

The Lindy and Edwin Bergman Joseph Cornell Collection, 1982.1842

PROVENANCE: Elizabeth Cornell Benton, Westhampton, New York; sold to Xavier Fourcade, Inc., New York; sold to Lindy and Edwin Bergman, Chicago, 1977; given to the Art Institute, 1982.

EXHIBITIONS: New York, Xavier Fourcade, Inc., *Works on Paper, Small Format, Objects: Duchamp to Heizer*, 1977, no cat. nos., n. pag., as *Untitled*. New York 1980–82, no. 185 (ill. horizontally), as *Untitled* (New York and Chicago only).

I N A DIARY ENTRY FOR MARCH 1960, CORNELL pointed to the centrality of the idea of a game or toy for his boxes:

perhaps a definition of the box could be as a kind of "for-gotten game," a philosophical toy of the Victorian era, with poetic or magical "moving parts," . . . that golden age of the toy alone should justify the "box's" existence. (Cornell Papers, AAA, reel 1060, Mar. 1960)

Although Cornell here related the idea of the toy to the Victorian era, it was not incompatible with the notion of Surrealist object that had been an important source for him (see Cornell introduction). The second time Cornell's works were shown by Levy, in a joint exhibition with etchings by Picasso (Nov.–Dec. 1932), they were presented under a variety of headings in the exhibition announcement: "Minutiae, Glass Bells, Shadow Boxes [cutout figures and montages], Coups d'oeil, and Jouets surréalistes [Surrealist toys]." Levy thus recognized, in the very multiplicity of these categories, that Cornell's constructions were not easily classified under conventional labels, and acknowledged the toy as an important reference.

The notion of the "Surrealist toy" may be understood as one of Cornell's responses to the complex and elastic idea of the Surrealist object. A toy or game normally involves movement in the object and the active participation of the player(s). In addition to the early puzzle boxes and the optical and kinetic games with which Cornell tinkered, there are two Surrealist sources for the game boxes. One is the Surrealist object as conceived by Salvador Dalí in 1931 (see Cornell introduction; and Salvador Dalí, "Objets surréalistes," *Le Surréalisme au service de la révolution* 3 [Dec. 1931]); the other is found in Duchamp's work. The immediate inspiration for Dalí's type of object was Alberto Giacometti's *Suspended Ball* (1930–31; Yves Bonnefoy, *Alberto Giacometti: A Biography of His Work*, Paris, 1991, pl. 176), the difference between this and the Surrealist object with symbolic function being that the latter was to be constructed of ready-made, found materials, rather than traditional sculptural ones. Cornell was certainly

aware of Giacometti's *Suspended Ball* by the time he made his construction *Ball and Book* in 1934 (*Art of this Century*, New York, 1942, exh. cat., p. 149; and New York 1980–82, no. 63, ill.), but unlike Giacometti he significantly refrained in his construction from any erotic overtones. He seems to have felt more kinship with the readymades and "readymades aidés" (assisted readymades) of Marcel Duchamp. Duchamp was the first person literally to introduce movement into his work in his *Bicycle Wheel* of 1913 (original lost; Pontus Hulten, ed., *Marcel Duchamp: Work and Life*, Cambridge, Mass., 1993, p. 30, ill.), but more relevant to Cornell's work are Duchamp's *With Hidden Noise* (1916) –the first object to incorporate noise as an element–and *Why Not Sneeze Rrose Sélavy?* (1921, both in the Philadelphia Museum of Art; Hulten 1993, pp. 63, 79, ills.). The secretive character of the former would certainly have appealed to him. Duchamp's *With Hidden Noise*, enigmatic as it is, looks however like a machine part forgotten on a factory floor, its invisible, rattling innards the result of a random oversight; Cornell's game boxes resemble instead toys long relegated to the attic, the noise generated by rolling ball or rattling counter clearly part of their original function as games, whose rules or objectives have long since been forgotten.

Although this particular game box invites handling, its orientation is uncertain. It was reproduced horizontally in the catalogue for The Museum of Modern Art's Cornell retrospective (New York 1980–82, no. 185, ill.), but it is currently installed at the Art Institute in a vertical position. Positioned vertically, it resembles certain Sand-Fountain Boxes (see no. 39). * * *

Three-quarter view.

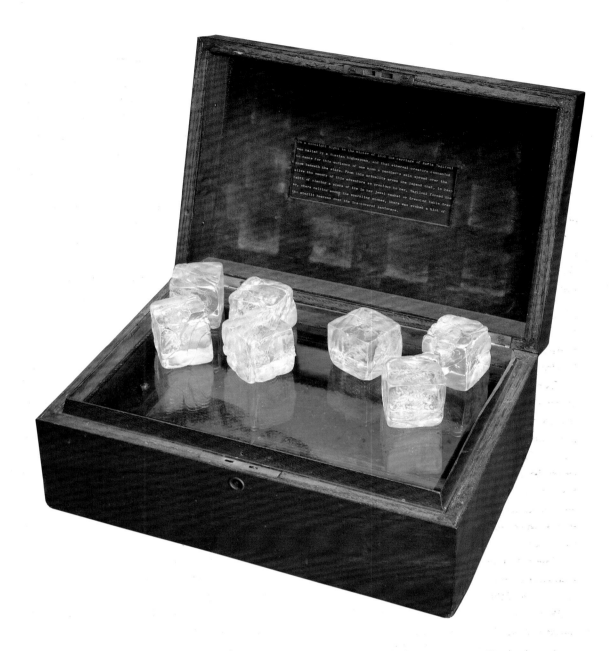

20. HOMAGE TO THE ROMANTIC BALLET

1942

Wood box with hinged lid. Underside covered with lizard-textured, vinyl-like, gray-green fabric. Inside of lid is lined with purple velvet; a black, inscribed piece of paper is recessed within opening cut in center of velvet. Bottom interior of box lined with mirror and interior walls covered with dark royal-blue velvet. Many tiny particles of broken glass and simulated gems are scattered across the mirror. Two larger simulated gems are hanging from a tack on the left interior wall. A sheet of blue glass under a sheet of colorless glass is placed over box interior, resting on a recessed lip along inside edge. Seven plastic 1¼-inch cubes, containing many air bubbles, rest on this glass surface. 10.2 x 25.3 x 17.1 cm (4 x 9¹⁵/₁₆ x 6¾ in.)

Titled, signed, and dated within box lip, on black paper in white type: *Homage to the Romantic Ballet* *************************** **** *Joseph Cornell* **** *1942* **** *******************************

Inscribed on inside of lid, on black paper in white type: *On a moonlight* [sic] *night in the winter of 1835 the carriage of Marie Taglioni / was halted by a Russian highwayman, and that ethereal creature commanded / to dance for this audience of one upon a panther's skin spread over the / snow beneath the stars. From this actuality arose the legend that, to keep / alive the memory of this adventure so precious to her, Taglioni formed the / habit of placing a piece of ice in her jewel casket or dressing table draw- / er, where melting among the sparkling stones, there was evoked a hint of / the starlit heavens over the ice-covered landscape.*

The Lindy and Edwin Bergman Joseph Cornell Collection, 1982.1854

PROVENANCE: Sold by the artist to William Copley, Beverly Hills, California, by 1948;[9] sold to Richard L. Feigen, New York, July 1969;[10] on loan to The Metropolitan Museum of Art, New York, 1972–73;[11] sold to Lindy and Edwin Bergman, Chicago, 1976; given to the Art Institute, 1982.

EXHIBITIONS: Beverly Hills, California, Copley Galleries, *Objects by Joseph Cornell*, 1948, no. 2, as *Taglioni Jewel Case*. Pasadena, California, Pasadena Art Museum, *An Exhibition of Works by Joseph Cornell*, 1966–67, no. 13 (ill.). New York, The Cosmopolitan Club, *Joseph Cornell*, 1970, no cat. Washington, D.C., The Corcoran Gallery of Art, *Depth and Presence*, 1971, no cat. nos., n. pag. Washington, D.C., National Collection of Fine Arts, Smithsonian Institution, *Joseph Cornell (1903–1972)*, 1973–74, no cat.[12] New York, Whitney Museum of American Art, *Two Hundred Years of American Sculpture*, 1976, no. 43, fig. 245 and p. 166. The Cleveland Museum of Art, *The Spirit of Surrealism*, 1979, no. 102 (ill.). New York, Castelli, Feigen, Corcoran, *Joseph Cornell and the Ballet*, 1983, no. 6 (ill.) and pp. 13, 16.

REFERENCES: Ashton 1974, pp. 26 (ill.), 75, 99. Rosalind Krauss, *Passages in Modern Sculpture*, New York, 1977, fig. 96 and p. 124. Dickran Tashjian, *Joseph Cornell: Gifts of Desire*, Miami Beach, Fla., 1992, pl. 34 and p. 113.

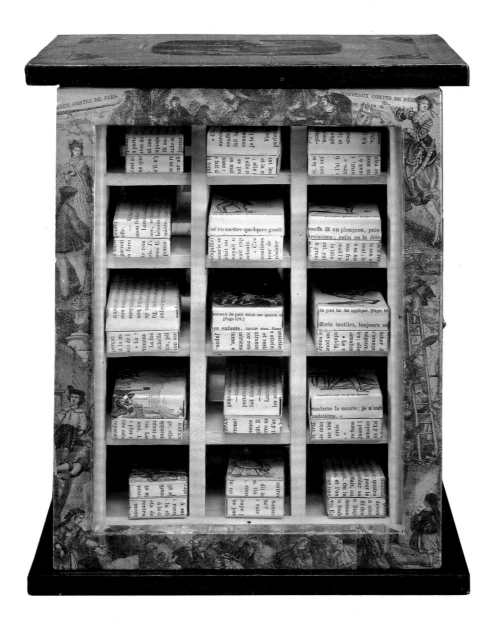

21. NOUVEAUX CONTES DE FÉES
(NEW FAIRY TALES)

1948
Wood box, exterior painted blue, with fourteen paper Victorian images glued to it. Wood frame of glass door also covered with paper. Inside of box contains fifteen small cardboard boxes, all of them empty, covered with pages of French text, resting in individual wood cubby holes painted pink. Rear interior wall covered with mirror. Wood strips, trimming front interior edges, are covered with pink velvet. 32.2 x 26 x 14.9 cm (12⅝ x 10⅜ x 5⅞ in.)

Inscribed, upper right and left: *NOUVEAUX CONTES DE FÉES* (printed)

The Lindy and Edwin Bergman Joseph Cornell Collection, 1982.1857

PROVENANCE: Eleanor Ward, New York, by 1964; Stable Gallery, New York; sold to Lindy and Edwin Bergman, Chicago, 1966; given to the Art Institute, 1982.

EXHIBITIONS: New York, Hugo Gallery, *La Lanterne Magique du Ballet Romantique of Joseph Cornell*, 1949, no cat. The Hague, Haags Gemeentemuseum, *Nieuwe Realisten*, 1964, no. 40 (ill.), as *Poison Boxes*. New York 1967, no cat. nos., pp. 19, 23, 35 (ill.), as *Nouveaux Contes de fées (Poison Box)*. Chicago 1973–74, no cat. nos., n. pag., as *Nouveaux Contes de fées (Poison Box)*. Houston, Rice University, Institute for the Arts, *Joseph Cornell*, 1977, no cat. New York 1980–82, no. 106 (ill.), as *Untitled (Nouveaux Contes de fées)* (New York and Chicago only).

REFERENCES: Harold Rosenberg, "The Art World: Object Poems," *New Yorker* 43 (June 3, 1967), p. 112. Harold Rosenberg, *Artworks and Packages*, New York, 1969, pp. 75–76 (ill.). Henri Coulonges, "Cornell et ses oeuvres fragiles connaissent subitement une faveur grandissante," *Connaissance des arts* 262 (Dec. 1973), p. 131 (ill.), as *Nouveaux Contes de fées (Boîte à poison)*. Katharine Kuh, "Joseph Cornell: In Pursuit of Poetry," *Saturday Review* 2, 25 (Sept. 6, 1975), pp. 37 (ill.), 39, as *Poison Box*. Waldman 1977, pl. 76 and p. 26, as *Nouveaux Contes de fées (Poison Box)*. *Saturday Review* 1980, p. 58 (photo of Bergman home). A. M. Hammacher, *Phantoms of the Imagination: Fantasy in Art and Literature from Blake to Dalí*, New York, 1981, p. 344 and fig. 323, as *Nouveaux Contes de fées (Poison Box)*. *U. of C. Magazine* 1982, p. 25 (photo of Bergman home). Rosalind Krauss, "Grids," *October* 9 (Summer 1979), p. 62 (ill.). Dickran Tashjian, *Joseph Cornell: Gifts of Desire*, Miami Beach, Fla., 1992, p. 27 and pl. 6, as *Nouveaux Contes de fées (Poison Box)*.

THIS BOX, LIKE SO MANY OF CORNELL'S CONstructions, elicits multiple associations. The glazed front of the box is in fact a hinged door, opening like a medicine cabinet or an old-fashioned bookcase. The neat, gridlike compartments contain tiny boxes, which are like miniature keepsake containers or perhaps jewel boxes, an impression enhanced by the pink velvet interior. Each is pasted over with pages cut from a French book or journal, whose engraved illustrations and typeface both suggest nineteenth-century text. We are invited to link these now yellowing fragments of the text to the title *Nouveaux Contes de fées*, which is pasted in the top left and right corners of the door frame, invoking the title page in a book of fairy tales.

The box was designed as a kind of toy to be played with, for the little boxes inside can be rearranged at will. Cornell's choice of a French publication with which to cover them, together with the images, evokes French novels, which at the time to which the illustrations belong could signify the illicit and the erotic, and were considered unsuitable reading for young ladies. Although this is belied by the title, an aura of the secretive remains. This work is most closely related to Cornell's

Untitled (*Paul and Virginia*) of c. 1946–48 (Chicago, Bergman family; see New York 1980–82, pl. IX), which similarly combines engravings and pages of text with mysterious stacks of tiny, closed boxes. In the latter, Cornell used pages from an English edition of Bernardin de Saint-Pierre's *Paul et Virginie* (1789) together with engravings that originally accompanied the Curmer edition of 1838. This hugely successful tragic love story of the Romantic era may well have had an additional appeal for Cornell because it was set in the New World. The austere, grid structure of *Nouveaux Contes de fées*, which is emphasized by the simple, geometric shapes of the boxes and is related to Cornell's Dovecote series, is in striking contrast to the romantic and rather sugary images. * * *

Side view. Side view.

Rear view.

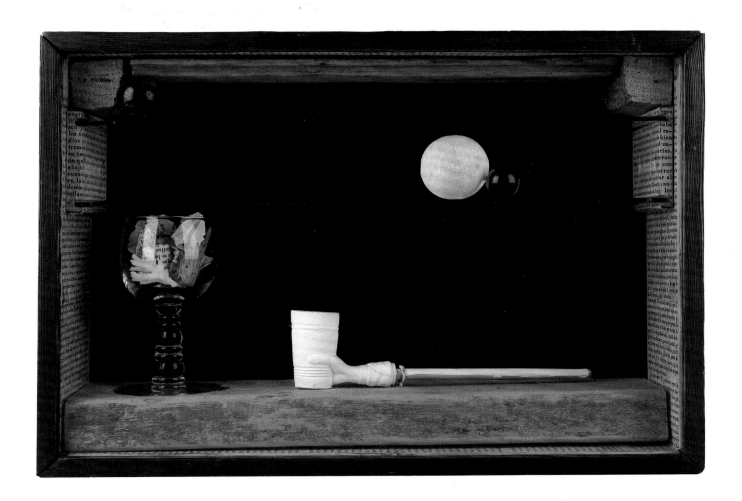

22. SOAP BUBBLE SET

1948

Wood box stained dark brown on exterior, with clear glass front. Top of box is removable by releasing screw at either end. Interior side walls, ceiling, and floor are covered with Spanish newspaper text. Rear interior wall is covered with dark blue velvet. A thin piece of wood is attached to ceiling, and a thicker piece of wood is fixed to floor. Base of small, colorless cordial glass is set into hole carved into left end of thick piece of wood. The hole is painted blue around inside edge. The glass contains a piece of crumpled paper, a piece of driftwood, and a piece of coral. A clay-and-wood pipe is wired to the wood, its stem placed parallel to the front of the box. Two glass shelves are fitted into slots in wood blocks attached to side walls above cordial glass.

A wood ball, painted white, and a small blue marble roll freely on lower shelf, and a larger blue marble rolls on upper shelf. 22.5 x 33 x 9.5 cm (9 x 13 x 3¾ in.)

Titled, signed, dated, and inscribed on back, center, on book page (see fig. 4): *SOAP BUBBLE SET* (typed) / *Joseph Cornell.* (in the artist's hand) / *Joseph Cornell / 1948 / Upper level should contain / large blue glass marble,- / lower level, a wooden white / ball and a small (3/4") blue / glass marble. If contents in / glass become deranged they / may be set in order by remov- / ing top of box.* (typed)
Inscribed on back, lower center, on paper label (see fig. 4): *Delicate sprig of coral in glass should / be adjusted to show prominently in case / of derangement.* (typed)

The Lindy and Edwin Bergman Joseph Cornell Collection, 1982.1861

PROVENANCE: Sold by the artist to William Copley, Beverly Hills, California, by 1948.[14] Mrs. de Menocal Simpson, New York. Stable Gallery, New York, 1967; sold to Lindy and Edwin Bergman, Chicago, 1967; given to the Art Institute, 1982.

EXHIBITIONS: Beverly Hills, California, Copley Galleries, *Objects by Joseph Cornell*, 1948, no. 19, as *Soap Bubble Set (Spirit Level)*. Bennington, Vermont, Bennington College, The New Gallery, *Bonitas Solstitialis and an Exploration of the Colombier: Selected Works by Joseph Cornell*, 1959, no. 4, as *Spirit Level*. New York 1967, no cat. nos., pp. 23, 36 (ill.). Chicago 1982, no. S-10.

REFERENCES: Ashton 1974, p. 56 (ill.).

A SOAP BUBBLE SET BOX (1936, HARTFORD, Wadsworth Atheneum; New York 1980–82, pl. I) was part of Cornell's first "theme" installation, in Alfred Barr's exhibition *Fantastic Art, Dada, Surrealism* at The Museum of Modern Art, New York, in 1936–37. Cornell called the installation *The Elements of Natural Philosophy*; it consisted of a glass showcase containing eighty-seven pieces in all, including the box itself (for a photograph of this installation, see New York 1980–82, p. 14, fig. 1). Cornell described this 1936 box as "a real 'first-born' of the type of case that was to become my accepted milieu" (Joseph Cornell, memorandum to Hans Huth, 1953, Archives, The Art Institute of Chicago). In it the spiraling connections between the pipe and "bubbles," which Cornell metamorphosed into planetary bodies, in this case the moon, are already present.

In the present *Soap Bubble Set*, the white ball resembles either the moon or a bubble. The fragment of coral in the glass introduces the idea of a beach and driftwood; Cornell frequently scoured the beach for flotsam and jetsam thrown up by the tides, even finding there, it seems, clay pipes and glasses (verbal communication to the author from Elizabeth Cornell Benton, Cornell's sister, in 1980). Cornell acquired many of the Dutch clay pipes he used in his boxes from the New York World's Fairs of 1939 and 1940 (Lynda Roscoe Hartigan, in New York 1980–82, p. 100). The deep-blue velvet that covers the box's rear wall both creates a night-sky setting for the balls/planets and hints at the proscenium setting of an old-fashioned, velvet-hung theater.

This box was first shown in an exhibition William Copley organized at his Beverly Hills gallery in 1948, the entire contents of which he had bought from Cornell. The show was, in Copley's words, an "enormous failure." Copley attributed this to the fact that his installation transformed the gallery into one large box. Plastering the walls and ceiling with the blue-and-white catalogues and scattering clay pipes among the boxes displayed on glass shelves, he created a whole artwork, which he felt inhibited the public from entering (see Bill Copley, "Joseph Cornell," in New York, Castelli, Feigen,

Figure 4. Detail of back of no. 22.

Corcoran, *Joseph Cornell Portfolio*, 1976, exh. cat., n. pag.). Judging from the catalogue of the 1948 show, at least four Soap Bubble Sets were displayed. In the brief catalogue notes, Cornell wrote:

Soap Bubble Sets
Shadow boxes become poetic theatres or settings wherein are metamorphosed the elements of a childhood pastime. The fragile, shimmering globules become the shimmering but more enduring planets – a connotation of moon and tides – the association of water less subtle, as when driftwood [sic] pieces make up a proscenium to set off the dazzling white of sea-foam and billowy cloud crystalized in a pipe of fancy.

When this work was shown by Copley in 1948, it was given the subtitle *Spirit Level*. While the blue and the white balls on the lower shelf recall heavenly bodies, like moon and planet, the isolated blue marble on the upper shelf indeed recalls the bubble of a spirit level, a device to determine or maintain a level surface, consisting of a bubble suspended in a glass tube full of liquid. The bubble in a spirit level is highly sensitive to minute shifts of orientation, like the balls that roll freely on their glass shelves in the present box. Perhaps the idea of a spirit level was prompted in Cornell's mind by his anxiety about the displacement or, as he put it, the "derangement" of the objects in this construction, a concern he expressed in the two typewritten labels on the back of the box (see fig. 4). The subtitle *Spirit Level* may thus allude to the actions of tilting, adjusting, and straightening the box, with the constant possibility of displacing its delicately disposed contents, in what amounts to a mental as well as physical process.　　　 * * *

the Surrealist context, its heavily grained effect also recalls the long history of experiments with *frottage* and *grattage* by artists such as Max Ernst.

There is, however, a strict geometry to this box, to which even the toylike accoutrements scattered on the floor conform. Square or rectangular forms dominate, though there are also circles (wood disk, ball, cork). The bird looks toward a wad of paper squares, probably already darkened with age and acidity when the box was constructed, nailed to the wall at left. The effect is of a tear-off wall calendar, or spiked receipts, or even old-fashioned toilet paper.

The key detail is the pair of arrows behind the bird's perch, cut from very thin pieces of wood. Formally, the arrows echo the two dowels, which can move freely on the floor of the box like the disk and ball. The proximity of the arrows to the bird's breast suggests a variation on the theme of the bird as victim or target (see, for instance, *Habitat Group for a Shooting Gallery*, 1943, Des Moines Art Center; New York 1980–82, pl. XXIII); the relatively plain form of the bird and its whitish color also recall the white dove of peace. Symbolically, the arrows are richly associative. They recall the arrows on signposts, as well as the black arrows in Giorgio de Chirico's "playthings" paintings, like *The Evil Genius of a King* (1914; New York, The Museum of Modern Art; Maurizio Fagiolo dell'Arco, *L'opera completa di De Chirico, 1908–1924*, Milan, 1984, no. 68, ill.) or *The Feast Day* (1914, Chicago, Neumann collection; ibid., no. 67, ill.). But the conjunction of the arrows with the bird has an even stronger association with the national emblem of the American bald eagle, perched on olive branches and arrows. The effect is somewhat ambiguous: the box could be a simple, folksy version of the American emblem or it could be a critical comment on the immediate postwar era in the United States, with its witch-hunts of those involved in so-called un-American activities. * * *

T HIS BOX IS DECEPTIVELY SIMPLE, WITH ITS apparently rudimentary materials and construction. The wood cutout of a bird, unusually, does not have a colored print pasted onto it. It is constructed of natural raw wood, partially stained with a chalklike substance, similar to the interior walls of the box. The liming of the wood makes it resemble driftwood; within

23. UNTITLED (BIRD)

1948
Wood box stained with natural finish. Clear glass front. Top of box is removable by releasing screw at either end. Interior walls partially stained white to a driftwood appearance. Rear interior wall stamped with forty-one tiny holes arranged almost in a square around wall's perimeter. Two pieces of wood are secured side by side to rear interior wall, forming a 6-inch square. A shelf protrudes from the lower center of this square. The wood form of a bird is perched on this shelf and is recessed slightly into a bird form cut

out of the wood square behind it. Two wood arrows are placed behind the shelf against the square and to the right of the bird. A nail holding a stack of square pieces of paper is nailed to upper corner of left interior wall. A piece of dark-colored cork is secured to front right corner of interior floor. Two dowels (one round and red, the other square and tan), a small wood ball, and a painted blue wood disk are loose on the interior floor of the box. 30.8 x 25.5 x 14.3 cm (12 1/8 x 10 1/16 x 5 5/8 in.)

Stamped on back, upper right: (RL)

The Lindy and Edwin Bergman Joseph Cornell Collection, 1982.1867

PROVENANCE: Jane Wade, Ltd., New York; sold to Mr. and Mrs. Richard L. Feigen, New York, 1967;[15] on loan to The Metropolitan Museum of Art, New York, 1972–73;[16] sold to Lindy and Edwin Bergman, Chicago, 1976; given to the Art Institute, 1982.

EXHIBITIONS: New York 1967, not in cat.[17] New York, The Cosmopolitan Club, *Joseph Cornell*, 1970, no cat.[18] Washington, D.C., National Collection of Fine Arts, Smithsonian Institution, *Joseph Cornell (1903–1972)*, 1973–74, no cat.[19] New York 1980–82, no. 154. Florence 1981, no. 35.

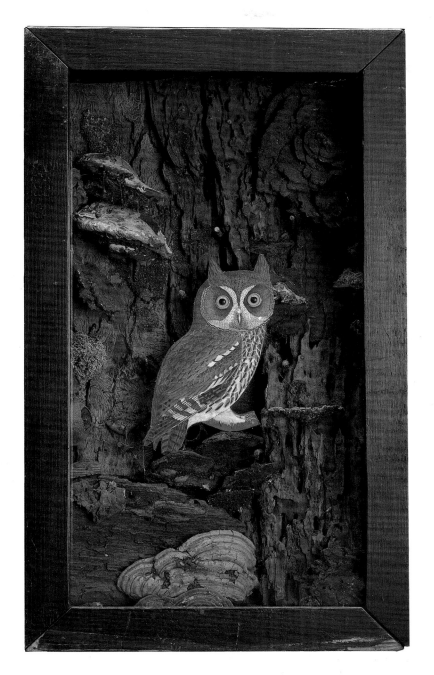

ORNELL'S OWLS, ILLUSTRATED HERE BY THIS box and a slightly later one (no. 29) known as *Lighted Owl*, form a distinct group among his bird boxes. The catalogue of William Copley's 1948 exhibition, *Objects by Joseph Cornell*, which included a box entitled *Owl (Habitat Setting)*, contained evocative descriptions of the various categories of objects, including "Owl – a habitat with secrets." In creating settings that are dark, mysterious, and woody, Cornell appears to have sought a more complete illusion of the owl's natural habitat than he did normally for his birds.

The making of the Owl Boxes dates largely from the mid-1940s, a time when Cornell took many rural excursions by bicycle from his home on Utopia Parkway in Flushing, New York. In his diary, he wrote eloquently about the nostalgia and elation aroused by the sight of the old houses and meadows in the outlying suburbs, and he recorded memorably how he gathered the materials for the Owl Boxes:

the many trips made by bicycle gathering dried grasses of different kinds, the fantastic aspect of arriving home almost hidden on the vehicle by the loads piled high

the transcendent experiences of threshing in the cellar, stripping the stalks onto newspapers, the sifting of the dried seeds, then the pulverizing by hand and storing in boxes.

These final siftings were used for habitat (imaginative) boxes of birds, principally owls. The boxes were given a coating of glue on the insides then the grass dust thrown in and shaken around until all the sides had an even coating

24. UNTITLED (LARGE OWL)

c. 1948

Box of light-colored wood, stained black. Clear glass front. Six 1½-inch, light-colored wood squares nailed to back of box (possibly not part of original construction). Large cross scratched into back of box. Two white chalk circles drawn on box above and below scratched cross, indicating positions of two empty nail holes. Top of box is removable by releasing screw at either end. Interior walls are completely covered with a sawdustlike material, suggesting the inside of a tree trunk. Box is entirely filled with elements from a forest, including large, coarse pieces of tree bark, fungi, and tree galls. An owl made of wood, covered with a colored-paper image, is perched on piece of wood in center. Two yellow plastic eyes with brown centers are glued to the image. Six wood rods, perhaps suggesting branches, extend toward front of box from various points around the owl. Several other pieces of bark, lichen, moss, and decayed wood are scattered inside box. 58.1 x 34.9 x 15.7 cm (22⅞ x 13¾ x 6³/₁₆ in.)

The Lindy and Edwin Bergman Joseph Cornell Collection, 1982.1839

PROVENANCE: Elizabeth Cornell Benton, Westhampton, New York; sold to Lindy and Edwin Bergman, Chicago, 1975; on loan to the Art Institute, 1976–82; given to the Art Institute, 1982.

EXHIBITIONS: Chicago 1982, no. S-26, as *Owl*.

REFERENCES: Alan G. Artner, "New at the Art Institute: Cornell Constructions, Contemporary Works," *Chicago Tribune*, June 26, 1983, sec. 12, p. 16 (ill.), as *Owl Box*.

to give them the aspect of a tree-trunk or nest interior.
(Cornell 1993, p. 117)

In a diary entry of April 15, 1946, he wrote about "the 'discovery' for the owl boxes in progress" of what he described as a "particularly fine example of rotted tree from which a piece of bark and clinging trailing shrubbery branches had fallen." Cornell continued his account by noting that he "took off by the handful the wood from outer part of trunk which was in powder state – lined box that evening and added powdered wood to *Natural History* boxes" (Cornell 1993, p. 128). On another occasion, in late August 1946, Cornell rode out in the late afternoon and, as he recorded in his diary, in a "cleared field by pile of stumps (dumping ground) found many fine pieces of fungi – 3 or 4 *coral* pieces, bark. Turned off toward Bayside – was *strongly* reminded in the autumnal evening of former vacations in country" (Cornell 1993, p. 132). The fungi mentioned here may have included the ones incorporated into this box. These finds of country flotsam were powerfully evocative of Cornell's childhood, of a lost American countryside, and an even more distant, imagined past. Pounding his grasses, he thought of himself "working like an herbalist or apothecary of old with these sweet scents in my own fashion" (Cornell 1993, p. 117).

Surrounded by these natural materials, Cornell felt his boxes were "like a bird's own nest," and this realization, he wrote, "was inexpressibly satisfying in such a warm and redolent atmosphere" (Cornell 1993, p. 117). This description suggests the artist's high degree of identification with the bird in its womblike home; there is indeed a strong sense, in these diary jottings, of Cornell living and reliving various real and imagined experiences in the preparation and making of the boxes.

But Cornell was also capable of playing on the humorous aspects of his vaguely anthropomorphic feelings about the "habitats," as suggested by a diary note of July 10, 1948, which included an advertisement for a comfortable holiday home for owls, with picturesque associations: "Large SEQUESTERED BOWER – HUMOROUS COMPARTMENTS – LOOK-OUTS; GUEST ROOMS; LOUNGE; IVY COVERED OBSERVATORY FOR EARLY DAWN VIEWS. . . . moss lined alcoves with dripping water and large variety snails" (Cornell Papers, AAA, reel 1058; cited in Dawn Ades, "The Transcendental Surrealism of Joseph Cornell," in New York 1980–82, p. 41).

The owls themselves in the two Bergman examples are ingeniously constructed of ready-made, paper illustrations, which are pasted onto half-inch thick, flat pieces of wood, cut out to form the silhouette of an owl. In the case of *Large Owl,* as mentioned in the media description, two yellow plastic eyes with brown centers are glued to the image. In the later *Lighted Owl* box (no. 29), a large plastic spider rests on the tip of the piece of bark on which the owl is perched. Such devices clearly point up the ambiguity of what Cornell called his "Natural History" habitats, where the clash between the natural elements, such as bark and moss, and the modern, manufactured materials posits their artificiality and makes very explicit the distance between Cornell's boxes and the dioramas of a natural history museum with their "real" stuffed birds, of which he undoubtedly knew (see Ades, in New York 1980–82, p. 38).

Since antiquity, owls have been associated not only with wisdom, but also with death. The owl is Minerva's bird, and also that of the alchemists, not too distant cousins of the apothecaries with whom Cornell identified as he prepared his grasses. The owl's association with death often takes the form of a warning about mortality: the "remember thine end" of the *memento mori.* One such image, with which Cornell was certainly familiar, a *Memento Mori* of 1769, exhibited in *Fantastic Art, Dada, Surrealism* at The Museum of Modern Art, New York, in 1936–37 (see exh. cat., no. 90, ill.), shows an owl perched on a head that is half skull, half living face, with the trappings of the *vanitas* theme around it. * * *

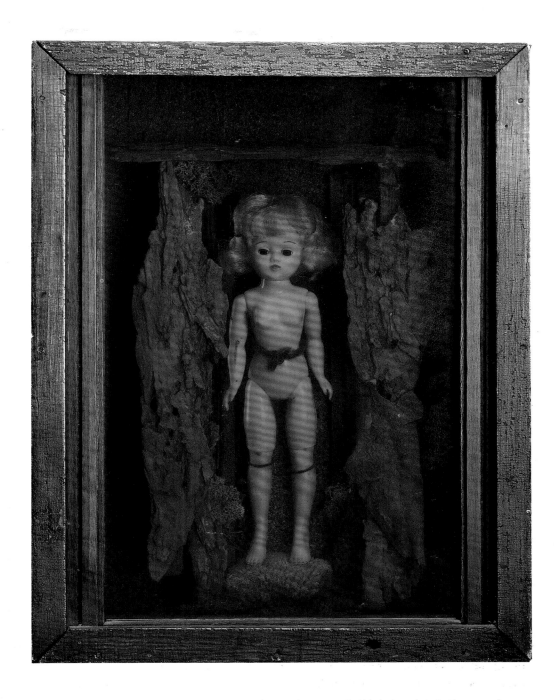

25. UNTITLED (SEQUESTERED BOWER)

c. 1948

Wood box, exterior stained blue. Sides and top covered with six, blue-stained pages in German, Italian, Spanish, and Latin. Back of box covered with four pages in French. A sheet of amber glass is inserted behind clear front glass. Top of box is removable by releasing screw at either end. Box contains a blonde, nude, female plastic doll, which is flexible at neck, shoulders, hips, and knee joints. She is secured to back wall with twine, knotted around her waist, and with wire around each of her knees, and she stands on a piece of dried moss. Three bark fragments form a doorway around her. Hidden behind bark on each side are mirrors, placed at an angle, which allow sides of doll to be viewed. Pieces of dried plants are placed at base and top of mirrors. Interior walls are covered with a saw-dustlike material. 39.4 x 30.5 x 12.4 cm (15½ x 12 x 4⅞ in.)

Signed on back, lower right: *Joseph Cornell*
Inscribed on back, upper left: *Joseph Cornell / undated*

The Lindy and Edwin Bergman Joseph Cornell Collection, 1982.1862

PROVENANCE: Bequeathed by the artist to his niece Helen Batcheller, New York, 1972;[20] sold via the ACA Galleries, New York, to Lindy and Edwin Bergman, Chicago, 1980; given to the Art Institute, 1982.

EXHIBITIONS: New York, ACA Galleries, *Joseph Cornell: Boxes and Collages*, 1977, no. 11, as *Sequestered Bower*. Chicago 1982, no. S-27, as *Sequestered Bower*.

THE TITLE SEQUESTERED BOWER COMMONLY attributed to this work seems to derive from Cornell's humorous description of one of his Owl Boxes, in a diary note of July 10, 1948, as "Large SEQUESTERED BOWER" (Cornell Papers, AAA, reel 1058; cited in Dawn Ades, "The Transcendental Surrealism of Joseph Cornell," in New York 1980–82, p. 41). The "habitat" of bark and dried moss further links this box to Cornell's Owl Boxes (see nos. 24 and 29) and suggests that it was made during the same period. The substitution of a blonde, naked, female plastic doll with painted red lips for the owl, whose habitat she occupies, is startling. The box is disturbing on several levels. The contrast between the owl in its natural habitat and the doll/woman, whose appearance is as emphatically artificial as her setting is unnatural, produces an unusually jarring effect. Is she to be understood as displacing the owl or as being herself trapped or displaced? The ambiguity of the figure – child's toy but also child-woman – is underlined by the mirrors hidden inside the bark and placed at an angle on either side of her, which allow her to be viewed from the side. This mode of presentation is redolent of a strip club rather than of the *vanitas* or *memento mori* theme, which often included a mirror and was linked, as discussed earlier (see no. 24), to the Owl Boxes. The idea of the *femme-enfant* hints at a premature sexuality which inevitably suggests a connection with Hans Bellmer and Balthus (see nos. 3 and 5). Cornell would certainly have been aware of Bellmer's articulated *Poupée*; photographs of the doll had earlier been reproduced in the French Surrealist journal *Minotaure* (see Hans Bellmer, "Poupée: Variations sur le montage d'une mineure articulée," *Minotaure* 6 [Winter 1934–35], pp. 30–31; Bellmer's *Jointure de boules* in *Minotaure* 8 [1936], p. 9; and an untitled photograph by Bellmer of the *Poupée*, defenceless, in a wooded environment, which was published adjacent to Cornell's *Glass Bell*, in *Minotaure* 10 [1937], p. 34).

However, rather than emulate Bellmer's violent dismantling of the female doll's body, Cornell left his doll intact. There is just a suspicion here that Cornell is making a faintly ironic protest at Bellmer's over-explicit and aggressive works; he was uneasy with the "darker" side of Surrealism, which he saw in the work of Max Ernst and surely in Bellmer. The manicured primness of this doll, with its overlarge head, in its grim setting, provides such a strong contrast to Bellmer's *Poupée* that it is hard not to find humor in it.

Cornell made two other boxes that offer close comparisons with this one, both of them now in The Museum of Modern Art, New York: *Untitled (Bebé Marie)*, a larger box of the early 1940s containing a dressed doll immured in an undergrowth of frosted twigs; and *Untitled (Mélisande)* of 1948/50, in which a naked doll appears through a small square opening in a box surrounded by moss or bark, as if buried alive (New York 1980–82, pl. VIII and no. 167, ill., respectively). Cornell supposedly took the doll in *Untitled (Bébé Marie)* surreptitiously from his sister Betty (Elizabeth Cornell Benton). These boxes share the disturbing aspect of *Untitled (Sequestered Bower)*, but not the further dimension of humor.

Although immured in a forest enclave, the doll in the Bergman box seems an unlikely Rapunzel or Sleeping Beauty. It should be noted, however, that she is the type of doll whose eyes close when she is tilted backward, and unlikely as it may seem, given the fragility of the other materials in the box, this raises the possibility that this box, too, is a kind of toy: a Sleeping Beauty toy. ✳ ✳ ✳

THIS BOX IS CLOSELY RELATED TO THE EARLIER, untitled box known as *For Tamara Toumanova* (no. 18) and is specifically a tribute to the prima ballerina's performance in an outdoor production of *Swan Lake*, which Cornell attended. Its spare elegance, the contrast of the simple "rustic" frame with the picturesque intricacy of the wooded landscape, and the various light effects created by the blue glass and the mirror seem to recreate the experience of open-air ballet. The swan itself fills the foreground and appears at home in its natural setting, but is simultaneously distanced from it by the blue moonlight, its identity with the ballerina indicated only by a brilliant, clear gemstone (a second one is now lost). Cornell has here restricted his incorporation of the delicate and decorative materials associated with the ballerina's presence, which elsewhere include feathers and sequins, to this artificial diamond, a conceit in keeping with the paradoxical nature of the event. ✳ ✳ ✳

26. CYGNE CRÉPUSCULAIRE (TWILIGHT SWAN)

1949

Deep wood frame or shallow box attached to center of larger wood backing board. Back board stained either black or dark blue. Exterior sides of box covered with dark blue velvet. Front of box enclosed by sheet of blue glass. A reproduced engraving of a wooded landscape is adhered to a flat surface and recessed about an inch inside the box. A section in the shape of a swan was cut out of the landscape and removed, leaving an opening. A drawing of a swan on paper is adhered to a wood silhouette in the shape of a

swan, and the wood shape is placed directly in front of the opening in the landscape. Feathers and details on drawing appear to be executed with graphite on white paper. A colorless gemstone, probably made of paste, is mounted into the wood form near the bird's tail feathers. A hole is visible near lower edge of swan, where similar gem may have originally been attached. Interior bottom edge of box is covered with a mirror, which reflects image of swan. The other interior walls are dark and not readily visible through the blue glass. They are either covered with dark blue or black velvet, or are painted dark blue or black. 37.2 x 38.4 x 8.1 cm (14⅝ x 15⅛ x 3⅜ in.)

Titled, dated, and signed on back, on paper label: *Cygne Crepusculaire 1949* (typed) / *Joseph Cornell* (in the artist's hand) / *Joseph Cornell* (typed)

The Lindy and Edwin Bergman Joseph Cornell Collection, 1982.1865

PROVENANCE: Elizabeth Cornell Benton, Westhampton, New York; sold to Lindy and Edwin Bergman, Chicago, 1975; given to the Art Institute, 1982.

EXHIBITIONS: Chicago 1982, no. S-13.

27. UNTITLED (FORGOTTEN GAME)

c. 1949

Wood box, exterior painted ivory. Interior painted light gray. Clear glass front. Two small, hinged trapdoors have been cut into right side of box, one at top and one at bottom. Upper door opens downward, lower door opens upward. The handles of the trapdoors are screws that have not been screwed in all the way. A blue rubber ball sits in bottom of box near lower door. Ball can be removed, placed in upper door, and allowed to roll down a series of wood ramps inside box until it reaches door at bottom again. Wood panel directly behind front glass has thirty circular holes, arranged in five rows of six holes each, resembling the front of a large birdhouse. Twenty of the holes are framed by thick paper disks, some fragmentary, painted white.

Holes are graded in size. Top row starts on left with a large hole, and the holes descend in size from left to right. Size gradation is reversed in next row down and alternates in successive rows. A colored paper cutout of a bird is placed just behind each hole. Some birds are attached to inside edge of circle, others are secured to little wood slats that cross behind holes like branches. An opening is cut into lower right corner of wood panel front. Opening is trimmed by wood slats nailed to front. A broken piece of clear glass is secured to opening, like a window. A yellow metal bell is hung over the ramp behind the largest hole in each row, for a total of five yellow bells. There is a silver bell behind the broken window at bottom right. The bells are suspended from little metal chains on hooks. As the ball is rolled down the ramp from the top, it hits each bell, ringing it as it passes, until the ball is stopped

by the little door at bottom. 51.1 x 40.5 x 9.9 cm (21 1/8 x 15 9/16 x 3 7/8 in.)

The Lindy and Edwin Bergman Joseph Cornell Collection, 1982.1852

PROVENANCE: Sold by the artist to the Allan Frumkin Gallery, Chicago;[21] sold to Lindy and Edwin Bergman, Chicago, 1965; given to the Art Institute, 1982.

EXHIBITIONS: New York, Egan Gallery, *Aviary by Joseph Cornell*, 1949–50, no. 23, as *Forgotten Game*. New York Public Library, Central Children's Room, *The Fairy Tale World*, 1950, no cat. The Arts Club of Chicago, *Art and the Found Object*, 1959, no cat. New York 1967, no cat. nos., pp. 20, 23. Chicago, Museum of Contemporary Art, *Modern Masters from Chicago*

THE FORGOTTEN GAMES ARE AMONG THE MOST evocative of Cornell's boxes, and the Bergman version is perhaps the most completely realized of them all. There are evidently links here with the Dovecote series (see no. 30), but the primary reference is to games and toys, which had an enduring fascination for Cornell. As is often the case with Cornell's work, the active involvement of the spectator is invited. This box is not a purely visual game; it also moves and makes sounds. As noted in the media description, through a small trapdoor in the upper right side of the box, a ball can be rolled down a series of ramps to hit five yellow bells hung above the ramps, which the ball rings as it passes, finally hitting the silver bell visible through the cracked pane of glass at the bottom right. This last bell rings with a faint, flawed note as though penetrating a fog at sea. Five rows of six circular holes each are cut into the wood front of the box, which is painted an ivory white and weathered to look like a neglected birdhouse. Cornell devised various ways of purposefully aging surfaces, and the flaking of the paint here, like the cracked glass, is intentional. The holes are smallest at the begin-

ning of each slope and increase in size, as it were, in pace with the growing noise of the ball gathering speed as it descends each ramp in turn.

Sounds are essential to this box: both the rumbling of the rolling ball and the periodic tinkling of the bells. Writing about this work, Diane Waldman recalled Max Ernst quoting Leonardo da Vinci, "like the tinkling of a bell, which makes one hear that which one imagines" (Max Ernst, "Au delà de la peinture," *Cahiers d'art* 2, 6–7 [1936], n. pag.; cited in Waldman 1977, p. 26). One is also reminded of the continuous ringing of a bell in Salvador Dalí and Luis Buñuel's film *L'Age d'or* (1929), throughout the scene in which the young woman gazes into a mirror and dreams of the man she loves. In this box, Cornell used sound as vividly as he did visual and kinetic elements to invoke memory. * * *

Collections, 1972, no cat. nos., n. pag. Chicago 1973–74, no cat. nos., n. pag. (ill. on cover). Houston, Rice University, Institute for the Arts, *Joseph Cornell*, 1977, no cat. New York 1980–82, no. 169 (ill.), and pp. 29, 107, fig. 21 (New York and Chicago only).

REFERENCES: Marcel Jean with Arpad Mezei, *The History of Surrealist Painting*, tr. by Simon Watson Taylor, London, 1960, p. 317 (ill.), as *Forgotten Game*. David Bourdon, "Imagined Universe Stored in Boxes," *Life* 63 (Dec. 15, 1967), p. 59 (ill.). Ashton 1974, p. 25 (ill.). Waldman 1977, p. 26 and pl. 22. Dickran Tashjian, *Joseph Cornell: Gifts of Desire*, Miami Beach, Fla., 1992, p. 87 and pl. 27. Sakura, Japan, Kawamura Memorial Museum of Art, *Joseph Cornell: Seven Boxes by Joseph Cornell*, 1993, exh. cat., p. 21 and fig. 30.

Cornell's work on the Romantic Ballet and of Petit's ballet productions under the title *"La Lanterne magique du ballet romantique" of Joseph Cornell/Decors for Ballets Choreographed by Roland Petit*.) Jeanmaire's flamboyant performances in *Carmen* "set a high-water mark in the projection of unabashed sexuality in ballet" (New York, Castelli, Feigen, Corcoran, *Joseph Cornell and the Ballet*, 1983, exh. cat. by Sandra Leonard Starr, p. 74). Cornell's diary entries record his passionate involvement in a friendship that was, in fact, one-sided, for Jeanmaire barely recalled him (ibid.). In November of 1949, he noted in his diary *"grat[itude]. for Zizi* different mood from orig. intensity. Less obsession" (ibid., p. 75), and in the same month had a fantasy about her one night while passing the Winter Garden Theater where she was dancing (ibid., p. 75 n. 9). It was, however, as the Princess Aurora in *La Belle au bois dormant* (*Sleeping Beauty*), the epitome of the Romantic Ballet, that he chose to depict her, rather than as the fiery Carmen.

Cornell's use of artificial light, with which he also experimented in some of his bird boxes (see, for example, no. 29), is particularly effective here; the dancer is caught in the spotlight, as if on stage, and the specks of glass and glitter flash in the dim blue light like a sequined costume. As so often in Cornell's works, the division between the natural and the artificial is erased here, conferring an uncanny character to the scene. The dancer is surrounded not by obvious stage scenery or curtains, but by a large chunk of real tree bark. The viewer has the momentary feeling of looking out from a hole in a tree trunk, like one of Cornell's owls, onto this moonlit star. * * *

THE SUBJECT OF THIS BOX IS THE DANCER Renée "Zizi" Jeanmaire (b. 1924), whom Cornell met in New York in 1949, when she performed in a ballet adaptation of Bizet's *Carmen*, partnered by her husband Roland Petit. (That same year, the Hugo Gallery in New York put on a joint exhibition of

28. UNTITLED (LIGHTED DANCER)

c. 1949
Wood box, exterior stained blue. Constructed of smaller box joined to back of large box. Opening at back-upper-left edge of small box contains small light bulb. Bottom of large box was initially removable, but now is secured by nails. Bolt at upper left of small box will release top of this box. Front enclosed by sheet of blue glass behind colorless glass. A large fragment of tree bark,

with its higher surfaces painted white, is directly behind blue glass. Opening cut into center of bark has edges covered with particles of glitter or glass chips. A piece of glass spattered with white paint, except in a center oval, is placed directly behind bark opening and provides view of ballerina, constructed of colored-paper image, adhered to a wood form. Two twigs, partially painted white, are secured to interior floor on either side of her. 34 x 29.9 x 18.1 cm (13¼ x 11½ x 7⅛ in.)

The Lindy and Edwin Bergman Joseph Cornell Collection, 1982.1841

PROVENANCE: Elizabeth Cornell Benton, Westhampton, New York; sold to Lindy and Edwin Bergman, Chicago, 1977; given to the Art Institute, 1982.

EXHIBITIONS: Chicago 1982, no. S-30, as *Untitled* (*Dancer*).

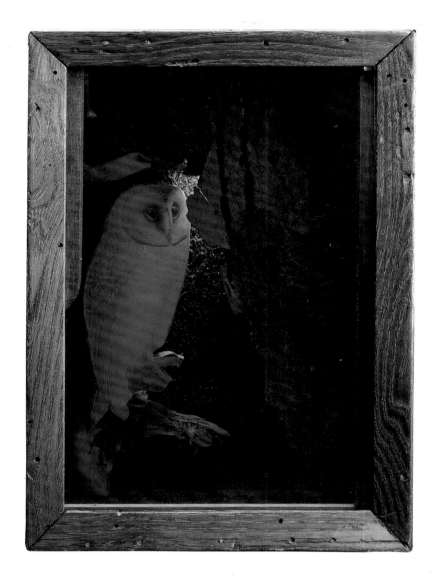

ORNELL'S BIRD BOXES OFTEN PLAY WITH forms of representation and with the contrast between the natural and the artificial. In his trips into the countryside, he would often gather materials for his boxes, and in this one, the large, angular piece of bark placed toward the right interior edge may be the lump Cornell reported finding in January 1948 and described as "magnificently dried bark for owl bark, single piece, for owl boxes" (Cornell 1993, p. 152). In any case it adds a sense of depth to the box by providing a kind of opened curtain, from behind which the owl is revealed. The sheet of blue glass (see media description) renders the interior as dark as a forest at night, and the small electric bulb above, when lit, suggests moonlight. The dramatic chiaroscuro effect prompts comparison with photography, as well as underlining the contrast between the two-dimensional pictorial representation of the owl and its "real" habitat. The numerous worm holes in the wood frame are the result of simulated rather than authentic insect damage and appear to be original to the box's construction. For more on Cornell's Owl Boxes, see no. 24. * * *

29. UNTITLED (LIGHTED OWL)

c. 1949

Wood box, stained blue around front edge. Sides painted black. Back covered with paper, stained blue. Back wood panel provides access for a lightbulb. Top is removable by releasing screw at either end. Clear glass front. Interior contains sheet of blue glass separated from glass front by narrow wood strips at either edge. A colored-paper owl, mounted on wood, perches with large plastic spider on piece of painted tree bark at lower left. Interior is covered with crushed dried leaves. Large angular piece of bark conceals right half of interior. 36.2 x 26 x 13.3 cm (14¼ x 10¼ x 5¼ in.)

Signed on back, lower center, on strip of paper: *Joseph Cornell*

The Lindy and Edwin Bergman Joseph Cornell Collection, 1982.1840

PROVENANCE: Elizabeth Cornell Benton, Westhampton, New York; sold to Lindy and Edwin Bergman, Chicago, 1977; given to the Art Institute, 1982.

EXHIBITIONS: Chicago 1982, no. S-33, as *Untitled (Owl Box)*.

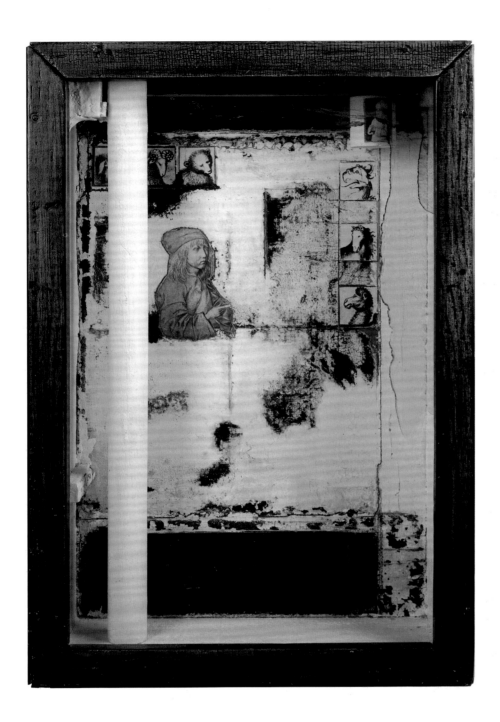

31. UNTITLED (HÔTEL DU NORD)

c. 1950

Wood box, exterior stained blue. Wood frame surrounding front of clear glass is painted white, then stained blue. Top of box is removable by releasing screw at either end. A deep-blue stain, leaving darker tide lines along edges, is visible on glass at upper right. Exterior back covered with blue-painted paper. Interior back, side, and bottom walls painted white. Paint on rear wall is cracked to simulate aging, while side walls remain pristine. Ceiling wall, and upper and lower edges of back wall, painted deep blue. Printed paper images adhered to rear wall: boar, ram, and bear horizontally at upper left; griffin, horse, and camel vertically at upper right; boy pointing finger, beneath horizontal row of animals. Wood dowel extends down left side from ceiling to floor. Thin metal rod extends horizontally from one block of wood in upper left corner to another in upper right corner. A wood cylinder, painted white, is suspended from rod on metal hook. A postage stamp of half-length image of little girl with folded hands against dark blue background is adhered to cylinder. 47 x 31.5 x 11.4 cm (18½ x 12⅜ x 4½ in.)

Signed on back, lower center, on paper label: *Joseph Cornell*

The Lindy and Edwin Bergman Joseph Cornell Collection, 1982.1855

THIS BOX SHARES MOTIFS AND CLIPPINGS WITH several other boxes bearing the title *Hôtel du Nord* (see, for example, *Hôtel du Nord*, c. 1953, New York, Whitney Museum of American Art; Ashton 1974, p. 92, ill.). This was the name of a hotel in Copenhagen, in which the Danish writer Hans Christian Andersen, one of Cornell's favorite authors, often stayed; it was also the title of a 1938 film by Marcel Carné starring Arletty (pseud. for Léonie Bathiat). "From the moment she stood on the bridge over the Canal St.-Martin in the 1938 . . . classic *Hôtel du Nord*, Arletty entered film history," reads her obituary; "her testy reply to her violent, wayward lover, 'Atmosphère, atmosphère . . . ,' indeed became one of the most memorable moments in French film" ("Obituaries," *New York Times*, July 25, 1992). This moment is one that could well have endeared the film to Cornell.

The fact that the upper and lower edges of the rear wall, as well as the ceiling, are painted a deep blue, and the nature of the printed reproductions, hint at celestial or astronomical associations, which are more explicit in the box known as *Hôtel de l'Etoile* (see no. 36). At the top left are three printed images of a boar, a ram, and a bear (the first concealed in this photograph by the white dowel in the foreground). Vertically, on the right, are a griffin, a horse, and a camel. All six of these animal images are reproductions of drawings in a late fourteenth-century sketchbook (Oxford, Magdalene College; see Colin Eisler, *Dürer's Animals*, Washington, D.C., 1991, p. 9, figs. 1.7–8). Cornell may have intended these animals to allude to constellations. They were no doubt just some of the many images of animals he collected from natural history albums, astronomical charts, and endpapers. Cornell wrote to Marianne Moore in a letter decorated with collaged etchings of animals, birds, and plants: "Could one call the spirit that animates the animals in the end-paper snips 'gargoylesque lyricism'?" (Cornell 1993, p. 123).

The image of the boy is Albrecht Dürer's *Self-Portrait* (1484, silverpoint, Vienna, Graphische Sammlung Albertina; see Walter L. Strauss, *The Complete Drawings of Albrecht Dürer*, vol. 1, New York, 1974, pp. 4–5, ill.). Dürer was an important figure to Cornell, both as artist and astronomer. According to Catherine Tennant, "It is to no less an artist than Dürer, who published two star maps in the sixteenth century, which were copied in one form or another in all the star atlases which came after, that we owe the Western vision of the constellations" (*Box of the Stars*, London, 1993, p. 4).

A French postage stamp of Jean Hey's painting *Suzanne de Bourbon in Prayer* (1492/93, Paris, Musée du Louvre; see Philippe Lorentz and Annie Regond, *Jean Hey: Le Maître de Moulins*, 1990, exh. cat., pp. 44–45, ill.) is pasted onto a cylindrical wood weight, suspended from a rod by a metal hook. The same image, enlarged, appears in the box *Ann – in Memory* (no. 35). * * *

PROVENANCE: Bequeathed by the artist to his niece Helen Batcheller, New York, 1972;[23] sold via the ACA Galleries, New York, to Lindy and Edwin Bergman, Chicago, 1975; given to the Art Institute, 1982.

EXHIBITIONS: Possibly Bennington, Vermont, Bennington College, New Gallery, *Bonitas Solstitialis and an Exploration of the Colombier: Selected Works by Joseph Cornell*, 1959, no. 13, as *Hôtel du Nord*. New York, ACA Galleries, *Joseph Cornell*, 1975, no. 12 (ill.), as *Hôtel du Nord*. Chicago 1982, no. S-18.

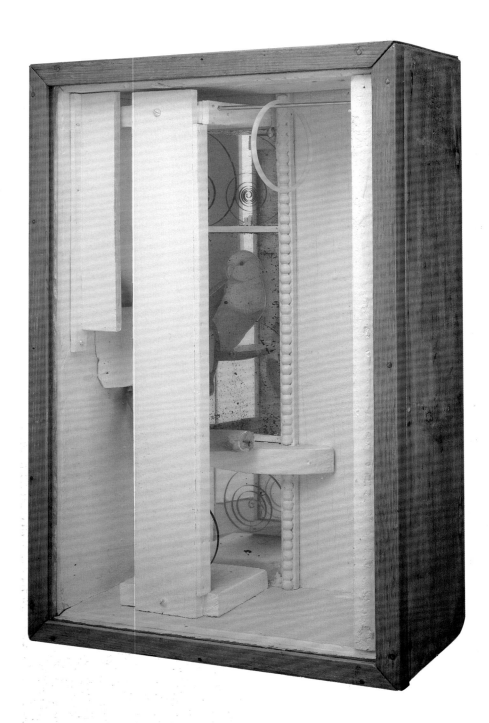

32. YELLOW CHAMBER

1950–51

Wood box, exterior stained with natural clear finish. Back of box (fig. 5) covered with seven book pages in French. Page headings read *DANS LES POISSONS*. Top of box is removable by releasing screw at either end. Clear glass front. Interior painted white. Three rectangular mirrors are placed one above another against left half of rear wall. Vertical strip of beaded wood trim, painted white, flanks right side of mirrors. Beneath middle mirror, curved piece of wood, painted white, forms shelf on which rests a tree branch without bark. Above branch, a silhouette of two

birds in wood, painted white, is nailed to left interior side wall, as if perched on branch. Side of wood silhouette that faces toward back wall of box is covered with colored-paper image of two parakeets, and this image is visible in mirror on back wall. A square wood platform rests on left side of floor, directly in front of lowest mirror section. A metal, spiral clock spring is secured to wood platform extending upward, and a similar metal spring is suspended from ceiling directly above it. Springs bounce when box is handled. Birds, springs, and shelf with branch are blocked from frontal view by flat strip of wood, extending from top to bottom and backed with a mirror, as

well as by smaller flat wood strip, running down from top left. A narrow mirror (not visible in this photograph) is placed at an angle over right back corner of box, flanked on left with white strip of beaded wood trim. Right interior wall is covered by a wood plank with seven circular holes. Wall revealed behind holes is painted yellow. A metal rod extends along top of box from wood strip with holes at right to wood shelf on left. A yellow plastic ring, reminiscent of the rings on which caged birds alight, encircles rod. 45.4 x 31.2 x 12.1 cm (17 7/8 x 12 5/16 x 4 3/4 in.)

ELLOW CHAMBER IS ONE OF THE MOST INTRI-
cate of the boxes Cornell constructed with mir-
rors. The white interior, with its beading and
planks of wood, appears at first sight to be deserted,
as does that of another box of these years, *Toward the
"Blue Peninsula"* (1951–52, Geneva, Daniel Varenne;
New York 1980–82, pl. XXVII). However, whereas the
blue sky, the open cage, and the single bird's feather in
that evocative box signal escape, in *Yellow Chamber* the
birds are hidden or trapped, visible only in a series of
mirror reflections.

The "chamber" of the title reinforces the ambiguity
of the interior space, which has strong associations with
both architecture and a bird's cage. It suggests both en-
forced enclosure – the locked chambers of fairy tales –
and hotel rooms (*chambres*). The unusual presence of two
parakeets hints at a "double room." The spatial games
Cornell played with mirrors here indeed evoke a double
room within the restricted area of the box. The title,
Yellow Chamber, seems to refer to the yellow wall visible
through the holes in the white wooden plank to the right
(not visible in this photograph), and also hints at a par-
ticular, but unknown, story or history. The formal effect
of the mirroring is to give the box an asymmetrical, rec-
tilinear geometry, lightened and balanced by the circu-
lar elements (ring, holes, beads, springs). * * *

Figure 5. Back of no. 32.

Titled, dated, signed, and inscribed on back on four paper labels (see fig. 5): *Directions for care of box inside top cover* (typed and photostated, "directions" not found) / *YELLOW CHAMBER / 1950–1951.* (typed) / *Joseph Cornell* (in the artist's hand) / *KEEP GLASS CLEAN* (typed and photostated)

The Lindy and Edwin Bergman Joseph Cornell Collection, 1982.1866

PROVENANCE: William N. Copley, Paris; traded for Hans Bellmer, *Hands and Arms*, c. 1950, oil on canvas, to Lindy and Edwin Bergman, Chicago, 1961; given to the Art Institute, 1982.

EXHIBITIONS: Paris, Galerie Daniel Cordier, *Exposition internationale du surréalisme*, 1959–60, no cat. nos., p. 114. Paris, Musée Rodin, *Etats-Unis: Sculptures du XXe siècle*, 1965–66, traveled to Berlin and Baden-Baden, Fr. cat., no. 7; Ger. cat., no. 5. New York 1967, no cat. nos., p. 23. Kassel, Galerie an der Schönen Aussicht, Museum Fridericianum, and Orangerie im Auepark, *4.documenta*, 1968, vol. 2, no. 6. Chicago 1973–74, no cat. nos., n. pag. Chicago 1982, no. S-20.

THE GRID OF THIS AUSTERE BOX IS COMPEL-lingly architectural, as is often the case with Cornell's boxes of the 1950s (see, for example, *Dovecote*, no. 30). As noted in the above media description, the interior is painted white and cracked as if with age, and the rear wall is entirely covered with a mirror. The effect of the reflections in the mirror behind is to suggest a scale and depth greater than in actuality. The torn remnants of painted paper around the edges of the twenty compartments resemble the white paint applied to new shop windows, or even the frosting of shop windows at Christmas. This casual or decorative effect contrasts with the geometric complexity of the box. The rather elegant frame, which has miter joints instead of the butt joints of many other boxes, also works against the miniature architectural effect, enclosing it like a picture.

In spite of the similarity in structure with *Nouveaux Contes de fées* (no. 21), there is no suggestion here of stacks or shelves to house and order things; whereas that box suggests a wealth of treasures within, hidden from sight, this is bleak and empty. The mirror, however, reflects the viewer, and recalls Cornell's fascination with the ambiguity of shop windows, which reflect the window gazer and confuse inside and outside.

The letters *WiNd*, followed by a period, are roughly lettered on the inner side of the glass. They recall the use of lettering in Georges Braque's and Pablo Picasso's Cubist paintings, which simultaneously emphasized the work's surface and gave an often ambiguous clue to its subject. As in Cubist lettering, where *journal* was often shortened to *jour*, this word could be a truncated allusion to "window," as well as a reference to the "wind" blowing outside.　　　* * *

34. UNTITLED (CRYSTAL CAGE)

c. 1953
Wood box, covered with clear coating. Back covered with four pages of French text entitled *SIECLE*. Top of box is removable by releasing screw at either end. Clear glass front. Interior side walls painted white and rear wall covered with mirror. A pane of window glass is secured into routed channel around side and bottom interior edges. It is held in place at top by wood slat painted white. The pane is divided into twenty sections (four across and five down) by wood strips, painted white, placed both in front of and behind the window pane. A heavy paper appears to have been applied to wood strips

behind glass and then to have been painted white at same time as strips. The paper has been largely torn away from the window openings. Each of the twenty windows is divided into four equal quadrants by two painted gray lines. A circular dot of gray paint is applied at the intersection of each set of two crossed lines. Dotted splashes of gray paint are scattered across these little windows. The word *WiNd.* has been painted in white on inside of glass front. 48.4 x 28 x 10.4 cm (19 x 11 x 4 1/16 in.)

Inscribed, upper center, on inside of glass front: *WiNd.*

Signed on back, lower center, on paper label: *Joseph Cornell*

The Lindy and Edwin Bergman Joseph Cornell Collection, 1982.1846

PROVENANCE: Elizabeth Cornell Benton, Westhampton, New York; sold to Behringer, Hurley, and Hurley, Riverhead, New York; sold to Lindy and Edwin Bergman, Chicago, 1976; given to the Art Institute, 1982.

EXHIBITIONS: New York 1980–82, no. 219 (ill.), as *Untitled (Window Facade)*.

REFERENCES: *The Art Institute of Chicago: Twentieth-Century Painting and Sculpture*, Chicago, 1996, p. 105 (ill.).

35. ANN – IN MEMORY

October 8, 1954

Wood box, exterior colored with yellowish stain. Back covered with five or more pages of French text. Top of box is removable by releasing screw at either end. Interior painted white, possibly over newspaper lining (some yellowed newsprint is visible under paint losses). Wood slat with five holes adhered to left interior wall. Blue paint visible on interior edges of circular holes, yellow paint on front edge of wood slat. Two metal clock springs are stapled to and suspended from ceiling. Another spring is stapled to upper edge of right interior wall, but rests against ceiling. Narrow piece of mirror rests vertically on wood shelf, painted blue, at right rear corner. Mirror held in place by two wood slats to its right and left. One face of each slat is painted white, the other yellow. Blue postage stamp from Mozambique with butterfly is adhered to right wall, beneath shelf. Paper with the printed word *Ostend* is adhered to wall, below stamp. Red stamp printed *SAAR*, with boy and melon, is attached to rear wall, beneath shelf on which mirror rests. Green stamp from Haiti, with bust of man in military garb, is attached to rear interior wall, below and left of center. Collage of paper labels with hotel names is

adhered to top and center of interior rear wall. These include: *Hotel Taglioni*, *GRAND HOTEL FONTAINE*, and *Hôtel BON PORT*. Purple stamp printed *SAAR*, showing young boy, is adhered to top right corner, next to black-and-white (photographic) image of young child in cap and colored stamp of insect. Back interior wall inscribed at top and left edges with straight lines. Traces of yellow paint visible at upper right and back right interior corners. 32.4 x 26.2 x 8.4 cm (12³/₄ x 10⁵/₁₆ x 3¹/₄ in.)

Signed, titled, dated, and inscribed on back (see fig. 7): *Joseph Cornell* (upper center, on paper label); "*Ann – in memory*" / *Thomas De Quincey* / *Schumann "Etudes Symph."* / *October 8. 1954. Fri* (lower left, on paper label)

The Lindy and Edwin Bergman Joseph Cornell Collection, 1982.1869

PROVENANCE: Probably sold by the artist to the Richard Feigen Gallery, Chicago;²⁵ sold to Lindy and Edwin Bergman, Chicago, 1961; given to the Art Institute, 1982.

EXHIBITIONS: New York, The Museum of Modern Art, *The Art of Assemblage*, 1961, traveled to Dallas and San Francisco, no. 53, as *Hôtel Bon Port: Ann in Memory*. Chicago, Richard Feigen Gallery, *Recent Acquisitions*,

1962, no. 7. Paris, Musée Rodin, *Etats-Unis: Sculptures du XXᵉ siècle*, 1965–66, traveled to Berlin and Baden-Baden, Fr. cat., no. 9, as *Hotel Bon Port – En Souvenir d'Anne*; Ger. cat., no. 7, as *Hotel Bon Port – Anne in Memory*. New York 1967, no cat. nos., pp. 24, 43 (ill.), as *Hotel Bon Port (Ann in Memory)*. Kassel, Galerie an der Schönen Aussicht, Museum Fridericianum, and Orangerie im Auepark, *4.documenta*, 1968, vol. 2, no. 7, as *Hotel Bon Port (Ann in Memory)*. Chicago 1973–74, no cat. nos., n. pag. (ill.), as *Hôtel Bon Port (Ann in Memory)*. Houston, Rice University, Institute for the Arts, *Joseph Cornell*, 1977, no cat. Chicago 1982, no. S-23, as *Hôtel Bon Port (Ann in Memory)*.

REFERENCES: Irving H. Sandler, "New York Letter," *Art International* 5 (Nov. 20, 1961), p. 55 (ill.), as *Hôtel Bon Port: Ann in Memory*. Ashton 1974, pp. 91, 197 (ill.), as *Hôtel Bon Port (for Ann in Memory)*. Alex Mogelon and Norman Laliberté, *Art in Boxes*, New York, 1974, p. 82 (ill.), as *Hotel Bon Port: Arms* [sic] *in Memory*. Waldman 1977, pp. 28, 29, and pl. 30, as *Hôtel Bon Port (Ann in Memory)*. Devonna Pieszak, "Shadowed Realms of Wonder," *Christian Science Monitor*, Oct. 23, 1989, pp. 16 (ill.), 17, as *Hotel Bon Port (Ann in Memory)*.

THE THEME OF THE HOTEL, TREATED HERE and in other boxes, had many ramifications for Cornell, intersecting with the bird boxes, the Navigation series, and the Juan Gris series, among others. Cornell's Hotel Boxes always contain references to travel in Europe, with echoes both of the seaside vacation and Grand Tour luxury of an earlier age. Postage stamps from far-flung places reinforce this impression in this box, as well as in the boxes known as *Hôtel de la Duchesse-Anne* (no. 42) and *Hôtel du Nord* (no. 31). *Ann —in Memory* and *Hôtel de la Duchesse-Anne* share stamps from the same sets: the butterfly stamps are from a set issued by Mozambique in 1953, and the insect stamps in both boxes are from a set issued by Portuguese Guinea in 1953. This suggests that Cornell bought stamps in sets from a stamp-collector's shop, rather than collecting them individually, at least during this period. The Saar stamps in *Ann – in Memory* are again part of one set, issued in 1952 by the National Relief Fund at a time when Saar, an embattled region on the border between France and Germany, was under French control; in 1957, it officially became part of West Germany. The stamp in the top right corner reproduces Johann Friedrich Dietrich's *Baron Emil von Maucler*, and the one at lower right shows a detail from Murillo's *Two Boys Eating Melon and Grapes* (Munich, Alte Pinakothek). It is difficult to say whether or not Cornell intended here a reference to the earlier, brief, failed political experiment in this region: the creation by the League of Nations of a small independent state after World War I, which was absorbed into Nazi Germany in 1935. Similarly it is difficult to judge whether the Haitian stamp at lower center, issued in 1954 to celebrate the 150th anniversary of Toussaint L'Ouverture's revolution, has any particular significance. The Surrealists had a special link with Haiti: Breton stopped there for a while on his way back to France in December 1945, and was not only enchanted

Alternate view.

with the country but contributed through his lectures there to a political uprising. This stamp, then, does recall the journeyings of Cornell's more adventurous Surrealist colleagues. The butterfly and insect stamps in *Hôtel de la Duchesse-Anne*, however, have a specific iconographic function: they are clearly there to represent the food of the parrot shown seated on a branch, eyeing them. The image at upper right of *Suzanne de Bourbon Praying* by the Master of Moulins (Paris, Musée du Louvre) is related in subject to the two Saar stamps of children.

An impression of neglect and decay, bordering on tawdriness, and a sensation of loneliness nag, however, at the glamorous associations of exotic postage stamps and foreign hotels – some even named after the stars of the great era of opera and ballet, such as the Hotel Taglioni in Florence (see no. 20). There are elliptical hints of an empty bird box here, as in *Hôtel du Nord* (no. 31), through the association of elements Cornell often placed in his bird boxes. These include the circular holes, like those of *Dovecote* (no. 30), visible along the left interior wall, and the coiled metal springs. The interiors of these Hotel Boxes are more than usually worn. The white

paint in the interior of *Hôtel de la Duchesse-Anne* (no. 42) has been especially heavily applied and is severely cracked. In *Ann – in Memory,* there are patches of blue and yellow paint layered over the white, which, in conjunction with the fragments of printed paper advertising hotels and the scrap of aged newsprint visible through the flaking paint surface in the back left corner, bring to mind peeling walls and forgotten posters in the old quarters of a town. The same hotel advertisements and titles are used in several boxes; that in the center of *Ann – in Memory* for the Grand Hôtel Fontaine in Ostend is a photostat of an advertisement, burnt round the edges, that Cornell used again in *The Caliph of Baghdad* of c. 1954 (Chicago, Bergman family; New York 1980–82, no. 135, ill.).

A clue to the tangled sentiments in these boxes lies in the inscription, *"Ann – in Memory" | Thomas De Quincey | Schumann "Etudes Symph.,"* written on a label on the back of this box (see fig. 7). The English author Thomas De Quincey (1785–1859) figures frequently in Cornell's writings; his story *Ann of Oxford Street* (partially reprinted in Ashton 1974, pp. 196–202) was especially resonant for the artist. It concerns the author's lost, youthful love for a London girl of the streets. The story ends with a tumultuous dream (or to use the wonderful word Cornell coined to describe De Quincey's English mail-coach, "tumultuousissamente"; Cornell 1993, p. 170). In this dream Ann reappears to the author, as she had been seventeen years before, "as for the last time I kissed her lips" (De Quincey, quoted in Ashton 1974, p. 198). Ann seems to have stood for Cornell as a symbol of tarnished purity; as he wrote in a diary entry of February 21, 1966: "I'd remembered the image of a diva of the bel canto era in a banal gilt plaster frame – recrimination for not having bought it for the more interesting visage – some deep poignancy in an adjacent

area 8 Ave + 42 despoiled youth, innocence in a sadly bedraggled (De Quincey's) Anne [*sic*] etc. etc." (Cornell 1993, pp. 338–39). But it is also important not to isolate her from a whole nexus of associations and memories, exemplified by the shift in De Quincey's dream from the vision of Ann to a dream of a "far different character – a tumultuous dream – commencing with a music." As De Quincey described it, "the undulations of fast-gathering tumults were like the opening of the Coronation Anthem; and, like *that,* gave the feeling of a multitudinous movement, of infinite cavalcades filing off, and the tread of innumerable armies. The morning was come of a mighty day – a day of crises and of ultimate hope for human nature" (De Quincey, quoted in Ashton 1974, p. 200). This apocalyptic scene would seem far from the nostalgia and mild decay of *Ann – in Memory,* but it points to Cornell's belief in the potential of the least fragment or scrap of music to unleash powerful memories and emotions. * * *

Figure 7. Back of no. 35.

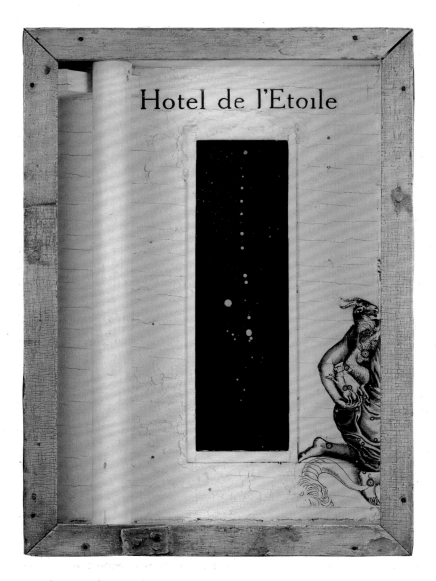

Hotel de l'Etoile

As to the former it got under way on Friday via Railway Express and I believe that it will arrive in the same condition as you saw it. I have kept a tracing of the inner spattered "pane" in case of breakage, and so will you kindly advise if such it might require? (Joseph Cornell, unpublished letter to Edwin Bergman of September 20, 1959)

This letter is revealing of the artist's attitude to replacement parts for his boxes and to his titles, which he used in a generic, descriptive way, rather than as precise labels.

As noted in the above media description, a large vertical opening is cut into the box's rear wall to reveal the interior of a smaller box. A pane of clear glass is placed behind the opening, through which a panel covering the rear wall of the smaller box is visible. This panel, which may well be of glass (thus explaining Cornell's reference in the above letter to an "inner spattered 'pane'"), is painted dark blue and spattered with white paint to resemble a constellation. As Cornell's letter to Bergman indicates, this apparently random splatter was carefully recorded in case the box was broken.

Cornell's interest in both the scientific and imaginative aspects of the study of the stars is well documented. Here, there is a perfect balance between the three main elements of the image: the title, which introduces the multiple associations with glamour and travel of the word "star"; the "abstract" pattern of a constellation formed by the spattered paint, which resembles scientific photographs of the night sky, taken with the assistance of telescopes; and the figurative representation of the myth of Auriga, after which the constellation is named. The image of Auriga Cornell used in this box derives from Johannes Hevelius's star atlas, *Uranographia totum coelum stellatum*, published in 1690 (see Giuseppe Maria Sesti, *The Glorious Constellations: History and Mythology*, New York, 1991, p. 256, ill.). In a diary entry

THIS WAS ONE OF THE FIRST BOXES EDWIN Bergman acquired directly from Cornell. Following Bergman's first visit to the artist's home in mid-September 1959, Cornell wrote about the travel arrangements for the box in a letter:

I wanted to see the "Night Sky" box under way before I wrote to thank you for your courtesy in bringing me the fairy tokens from the Dorazios.

36. UNTITLED (HÔTEL DE L'ETOILE)

1954

Wood box, exterior painted white, extremely soiled and cracked with age. This is intentional, as the wood appears to have been in this condition when the box was constructed. Smaller box attached to center back of larger box (see fig. 8). Back of larger box covered with several pages of Italian text, and back of smaller box with three pages of French text. Top of box is removable by releasing screw at either end. Clear glass front. Interior painted white and distressed in many areas to simulate the effects of age. Large vertical opening cut into rear wall of larger box to reveal interior of smaller

one through glass window lightly sprayed with white paint. Interior back wall of smaller box covered with a panel, probably of glass, painted deep blue and spattered with larger drops of white paint. Interior side walls of smaller box painted white. Printed words and images adhered to interior of larger box: a man with a goat and her two kids on his back, and holding a whip and reins (the constellation Auriga), on lower right corner of rear wall and over lower portion of right wall; the words *l'Etoil* [sic] on right wall; the words *Hotel de l'Etoile* on rear wall. A thick, white, wood dowel extends from ceiling to floor at left and is fixed to a white triangular shelf in upper left corner. Two white wood slats are secured horizontally against upper corner of right wall. 48.3 x 34.3 x 18.4 cm (19 x 13½ x 7¼ in.)

Signed and inscribed on back (see fig. 8): *Gwendolina Gwendolina* (in reverse) / *Joseph Cornell* (on paper label)

The Lindy and Edwin Bergman Joseph Cornell Collection, 1982.1856

PROVENANCE: Sold by the artist to Lindy and Edwin Bergman, Chicago, 1959; on loan to the Art Institute, 1970–71; given to the Art Institute, 1982.

EXHIBITIONS: New York, Stable Gallery, *Winter Night Skies by Joseph Cornell*, 1955–56, no cat. nos., n. pag., as either *Auriga I*, *Auriga II*, or *Auriga III*. The University of Chicago, Renaissance Society, *But – Is It*

Three-quarter view.

Figure 8. Back of no. 36.

of July 15, 1941, the artist described his first visit to the Hayden Planetarium in New York:

another moving experience, especially on the second floor with its blue dome, silhouetted city sky-line fringing it, and the gradual appearance of all the stars in the night sky to music. . . . The astronomical paraphernalia: charts, transparencies, broken meteors, and especially compass curios (also armillaries, telescopes, etc.) are intriguing. . . . On the main floor a particularly fine set of murals of the zodiac, picked out in white on blue. The nicest rendition of the Gemini I've seen. (Cornell 1993, p. 96)

Cornell was subsequently a frequent visitor to the Planetarium, subscribing to its periodical, *Sky Reporter*, and becoming an expert on stars.

At the Stable Gallery, in December of 1955, Cornell exhibited a group of works under the general title of *Winter Night Skies*, giving them the names of the constellations Auriga, Andromeda, and Camelopardalis. Three versions of *Auriga* were shown, of which this box was very likely one. A short preface by Garrett P. Serviss in the exhibition announcement merits being quoted in full for its insight into Cornell's interest in astronomy:

The mythology of Auriga is not clear, but the ancients seem to have been of one mind in regarding the constellations as representing the figure of a man carrying a goat and her two kids in his arms. Auriga was also looked upon as a beneficent constellation, and the goat kids were believed to be on the watch to rescue shipwrecked sailors. As Capella, which represents the fabled goat, shines nearly overhead in winter, and would ordinarily be the first bright star to beam down through the breaking clouds of a storm at that season, it is not difficult to imagine how it got its reputation as the seaman's friend.

Auriga as a constellation, was invented long before the time of the Greeks, and was intended prophetically to represent that Good Shepherd who was to come and rescue the sinful world.

This romantic and Christian interpretation of the myth of Auriga is strikingly different from the one given by Catherine Tennant. She emphasized a different stage of the myth: that Auriga was Erecthonious, future king of Athens, deformed son of Earth and Vulcan, who was placed in a box by Athena and given to the care of two maidens, who opened the box and "when they saw the child inside, entwined by a serpent . . . fled in terror and fell to their death from the Acropolis" (*Box of Stars*, London, 1993, p. 27). Characteristically, Cornell focused on the beneficent rather than the malevolent aspects of the myth.

The words *Hotel de l'Etoile*, which Cornell incorporated into this box, point directly to stargazing. Moreover, these words are thought to refer to the ballet *Le Rendez-vous*, whose set design by Brassaï included huge photographic enlargements of hotel logos (see Sandra Leonard Starr, in New York, Castelli, Feigen, Corcoran, *Joseph Cornell and the Ballet*, 1983, exh. cat., p. 75). Cornell frequently merged notions of theatrical or cinematic and astronomical stargazing.

The trail of spattered paint, intended to evoke a constellation of stars, is also interesting in relation to the new painting practices in New York at the time, which were in turn influenced by Surrealist automatism. Both Max Ernst and Jackson Pollock had experimented with paint-dripping in their work. It is thus possible, given the profusion of both veiled and explicit references to other artists in Cornell's work, that the white trail of paint refers to this new development as well, and reflects the artist's capacity to internalize and play with aspects of abstraction that otherwise seem alien to his art. * * *

Art?, 1960, no. 7, as *Hotel de l'Etoile*. New York, The Museum of Modern Art, *The Art of Assemblage*, 1961–62, traveled to Dallas and San Francisco, no. 54 (ill.), as *Night Skies: Auriga*. Boston, Institute of Contemporary Art, *American Art since 1950*, 1962, traveled to Waltham, Mass., no. 83, as *Night Skies: Auriga* (Boston only). Seattle, World's Fair, *Art since 1950: American and International*, 1962, no. 83, as *Night Skies: Auriga*. The Cleveland Museum of Art, *Fifty Years of Modern Art: 1916–1966*, 1966, no. 123 (ill.), as *Night Skies: Auriga*. The Art Institute of Chicago, *Twenty-seventh Annual Exhibition by the Society for*

Contemporary American Art, 1967, no cat. The University of Chicago, The Bergman Gallery, *Avant-Garde Chicago*, 1968, no cat. nos., as *Night Skies Auriga*. Chicago 1973–74, no cat. nos., n. pag., as *Night Skies Auriga (Hotel de l'Etoile)*. Kansas City, The Nelson-Atkins Museum of Art, *Joseph Cornell*, 1977, no cat. The Cleveland Museum of Art, *The Spirit of Surrealism*, 1979, no. 104 (ill.), as *Night Skies: Auriga*. New York 1980–82, no. 210 (ill.), as *Untitled (Hotel de l'Etoile; Night Skies: Auriga)*. Florence 1981, no. 59, as *Senza titolo (Hotel de l'Etoile; Night Skies: Auriga)*. Saint Louis, Washington University Gallery of Art, *Exploring Joseph Cornell's Visual Poetry*, 1982, no cat. nos., pp. 5, 24, and fig. 1, as *Untitled (Hotel de l'Etoile; Night Skies: Auriga)*.

REFERENCES: Dore Ashton, "Art USA 1962," *Studio* 163 (Mar. 1962), p. 93, fig. 15, as *Night Skies 'Auriga.'* Dore Ashton, "The Arts of Joseph Cornell," *One 2* (Jan. 1974), p. 15, as *Night Skies*. Ashton 1974, p. 9, as *Night Skies Auriga*. Alex Mogelon and Norman Laliberté, *Art in Boxes*, New York, 1974, p. 80, as *Night Skies: Auriga*. Waldman 1977, p. 28 and pl. 89, as *Night Skies: Auriga*. Anne d'Harnoncourt, "The Cubist Cockatoo: A Preliminary Exploration of Joseph Cornell's Homages to Juan Gris," *Philadelphia Museum of Art Bulletin* 74 (June 1978), p. 4 and fig. 4, as *Night Skies: Auriga*. Deborah Soloman, *Utopia Parkway: The Life and Work of Joseph Cornell*, New York, 1997, p. 216, as *Untitled (Hotel de l'Etoile: Night Skies, Auriga)*.

37. FOR JUAN GRIS #7

c. 1954

Exterior of wood box shows traces of dark stain. Back covered with four pages of Italian text. Top of box is removable by releasing screw at either end. Clear glass front. Interior walls covered with French newspaper. Pieces of orange, yellow, and black paper applied as collage over upper center of rear wall. The contour of a parrot is cut out of this added paper, and the newsprint underneath is colored in with gray and blue crayon. A wood branch is cut at an angle and extends away from rear wall beneath parrot. Paper on right and left walls is partially colored yellow, and paper on floor is partially painted white. White-metal rod extends between two blocks of wood secured to upper right and left corners. Yellow-metal ring encircles rod. A bunch of white thread rests in lower right corner. 45.7 x 26.7 x 10.4 cm (18 x 10½ x 4⅛ in.)

Signed, titled, and inscribed on back: *Joseph Cornell* (lower left, in reverse, on paper label); *For Juan Gris / #7* (lower left, on another paper label); *GR7* (lower right, upside down)

The Lindy and Edwin Bergman Joseph Cornell Collection, 1982.1850

PROVENANCE: Bequeathed by the artist to his niece Helen Batcheller, New York, 1972;[26] sold via the ACA Galleries, New York, to Lindy and Edwin Bergman, Chicago, 1980; given to the Art Institute, 1982.

EXHIBITIONS: Valparaiso, Indiana, Valparaiso University, The University Art Galleries and Collections, *Joseph Cornell Mini-Festival*, 1981, no cat. Chicago 1982, no. S-15.

CORNELL'S INTEREST IN THE CUBIST ARTIST Juan Gris prompted a series of boxes and several collages, as well as a dossier containing notes, cutout reproductions, and catalogues. At least fifteen boxes and several collages related to Gris have been identified by Lynda Roscoe Hartigan (see Anne d'Harnoncourt, "The Cubist Cockatoo: A Preliminary Exploration of Joseph Cornell's Homages to Juan Gris," *Philadelphia Museum of Art Bulletin* 74 [June 1978], p. 6). The imagery of this series of boxes is tied both to Cornell's bird boxes and to his Hotel Boxes. In boxes such as this one, Cornell showed an unusual and subtle response to Gris's unique type of Cubist collage. This is particularly apparent when, as in this case, the white cockatoo that is so often the central feature in the Gris series is absent and only the outline remains, echoed by a black paper shadow more geometric in character than the outline itself. The play between representation and reality so central to Cubism is alluded to not just in the outline and shadow, and in the central cluster of forms of varying degree of abstraction, but also in the real wooden branch extending from the rear wall of the box-cage.

Here Cornell used a French newspaper text to cover the inside walls of the box, integrating it into the box's surface by painting and pasting over it in a manner similar to Gris's. More generally, however, Gris's persistent love of the particular shapes of his objects and his unexpected tenderness for the picturesque and romantic (see, for example, his 1914 *Flowers*, collection Hester Diamond, or his 1913 *Guitar*, Paris, Musée national d'art moderne, with its fragment of a sentimental nineteenth-century print; ill. in London, Whitechapel Art Gallery, *Juan Gris*, 1992, exh. cat., nos. 44, 28, respectively) find an echo in Cornell. As Anne d'Harnoncourt noted, "The bits of newsprint, flowered and marbleized papers, or empty tobacco packets in Gris's collages of 1913–14 have a keepsake quality quite unlike similar fragments incorporated into works by Picasso and Braque" (d'Harnoncourt 1978, p. 9). Moreover, Gris incorporated a fragment of mirror into his *Washstand* of 1912 (private collection; Douglas Cooper, *Juan Gris*, vol. 1, Paris, 1977, no. 26, ill.).

This is not to argue an "influence" of a simple or direct kind. Cornell's work is built on a series of responses and experiences of a peculiarly private nature. There is no obvious reason, for example, for Cornell's choice of a cockatoo as the emblem of his Gris Boxes. Music, so important to Cornell, may have provided the thread of connections here. It seems that he associated Gris with the nineteenth-century contralto Malibran, who like Gris died at a tragically young age, and was described as "the bird of song" by Hans Christian Andersen, whom Cornell also admired (Ashton 1974, p. 24, citing Monica Stirling, *The Life and Times of Hans Christian Andersen*, New York, 1965).

Although Cornell could well have been familiar with Gris's work earlier (Curt Valentin's Buchholz Gallery, New York, held an exhibition in 1950), it was the sight of *Figure Seated in a Café* (1914, Mr. and Mrs. Leigh B. Block; Cooper 1977, no. 76, ill.) in 1953 at the Sidney Janis Gallery, New York (see exh. cat., no. 17), that first seized his imagination. He wrote in retrospect, in 1961: "The so-called '*Juan Gris*' boxes were not worked out slavishly – mechanically – from this collected material – the original inspiration was purely a human reaction to a particular painting at the Janis Gallery – a man reading a newspaper at a café table covered almost completely by his reading material" (Cornell 1993, p. 285). Cornell's interest in Gris, which lasted through the mid-1960s, experienced a renewal in the late 1950s with the large Gris retrospective at The Museum of Modern Art, New York, in 1958, and the publication of John Golding's *Cubism: A History and an Analysis* in 1959, to which he referred on several occasions in his diaries.

Cornell's practice of working on a piece over a period of several years, or of leaving it fallow for a while, seems to be true of *For Juan Gris #7*. He wrote in a diary entry of January 1960 (Cornell 1993, p. 273):

1/24/60 Sunday Gris #7
"creative" reviewing
Gris #7 taken from storage in semi-unresolved difficult time – and then – miracle of unfoldment
> *appreciation*
> *"treasure"*

Whether Cornell implied here, through the use of one of his favorite words, "unfoldment," that he resolved the work, or simply reviewed it and found it complete, remains uncertain. * * *

38. UNTITLED (BLUE SAND BOX)

early 1950s
Wood box, exterior stained blue. Bottom covered
with two blue-stained pages in French. Clear
glass top. Interior painted white. Floor of box
has sixteen raised lines radiating from center and
an approximately 4 inch-wide oval in one corner.
Box contains blue crystals or sand, with which a
small, shiny, metallic bead is mingled. A metal
ring, with a 1/2 inch gap, is lying loose on floor of
box. Left edge of covering glass is stained gray-
ish-blue on interior face. 23.8 x 38.2 x 4.8 cm
(9 3/8 x 15 1/16 x 1 7/8 in.)

Signed on back, lower left, on paper label:
Joseph Cornell

The Lindy and Edwin Bergman Joseph Cornell
Collection, 1982.1860

PROVENANCE: Sold by the artist to the Allan
Frumkin Gallery, Chicago, mid-1950s;[27]
sold to Lindy and Edwin Bergman, Chicago, 1965;
given to the Art Institute, 1982.

THIS IS ONE OF A SERIES OF FLAT SAND BOXES which, although few of them can be precisely dated, are probably from the late 1940s or early 1950s. A very similar, but slightly smaller, box in the Art Institute's collection (1951.201, Gift of Frank B. Hubachek) was the subject of correspondence between Cornell and Hans Huth, a reseach curator, between June and August 1953. Cornell could not remember "even the approximate date" of the Art Institute box and suggested the designation "sand-painting box" (see letters in curatorial files).

This box is, like others of its type, designed to be handled, the sand, the metal ring, and the ball scattering into different formations like iron filings or a kaleidoscope. The inside of the box is painted white on all sides; a fine network of cracks suggests that it was artificially aged. As noted in the above media description, sixteen faint lines are etched into the bottom (or rear wall) of the box, radiating from a common center, and resulting in raised lines of white paint on either side of the incisions. An oval form was etched, using the same technique, in the upper right corner. The blue sand forms patterns when shaken that are determined by the raised lines. The three different mobile elements – ring, ball, and sand – make very different sounds as the box is shaken.

Cornell mentioned "sand boxes" as early as 1945 in his diary jottings. Significantly, in an entry of October 8, 1945, he referred to two different kinds of objects that are possible sources for these boxes: the "sailor's box" and the "sand box as discovered in shop – birdhouse that might have [been] tended by her hands" (Cornell 1993, pp. 125–26). It is not entirely evident what he meant by the latter, but the link with the "birdhouse" suggests the sand tray that is customarily placed on the bottom of a bird's cage. The sailor's box was an object of deep resonance for Cornell, with its references to voyages, exotic birds and butterflies, navigation, and treasured keepsakes in general. In a diary note of April 4, 1943, Cornell described an "Exhibition of miscellaneous objects found in trunks of sailors . . . shells, toy snake, wales [sic] tooth, beads (exotic), a butterfly box" (Cornell Papers, AAA, reel 1058; originally cited in New York 1980–82, pp. 33–34). The Sand Boxes are perhaps like some such treasure salvaged from the bottom of the sea. * * *

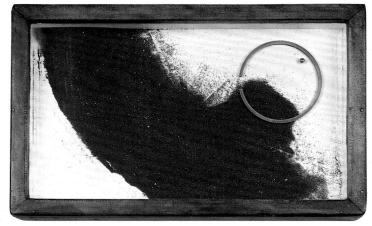

Alternate view.

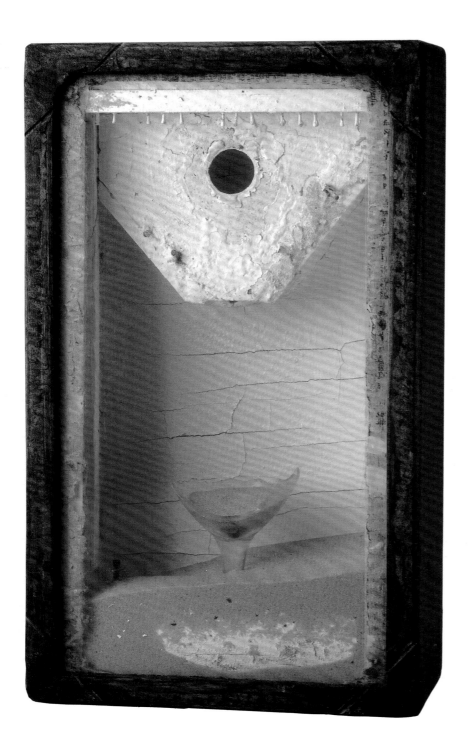

39. UNTITLED (YELLOW SAND FOUNTAIN)

early 1950s
Wood box, exterior stained brown. Three brown-stained pages in French glued to back. Interior face of clear glass front shows traces of dripped blue stain along top and upper right and left edges. Exposed surface of glass front shows traces of newsprint and adhesive residue along all edges. Interior, painted white, contains truncated triangular birdhouse, secured to rear wall of box, with round hole at center and smaller hole at bottom. A broken, glass goblet is centered beneath it on large, white, wood block, with protruding nails at either end. Yellow sand and white paint flakes can flow freely between birdhouse and goblet. Rows of nails protrude from wood strip fastened along box's top, and from box's left and right edges. 37.5 x 21.9 x 10.2 cm (14³/₄ x 8⁵/₈ x 4 in.)

Signed on back, upper left, on paper label:
Joseph Cornell

The Lindy and Edwin Bergman Joseph Cornell Collection, 1982.1859

PROVENANCE: Elizabeth Cornell Benton, Westhampton, New York; sold to Lindy and Edwin Bergman, Chicago, 1975; given to the Art Institute, 1982.

EXHIBITIONS: Chicago 1982, no. S-3, as *Untitled (Sand Fountain)*.

IN A DIARY ENTRY OF SEPTEMBER 1945, CORNELL wrote, "one of the finest boxes (objects) ever made was worked out this day (completed or almost). The box of a white chamber effect with a 'fountain' of green sand running. Shell, broken stem glass for receptacle" (Cornell 1993, p. 124). The Sand Fountain Boxes are perhaps the most difficult of Cornell's works to appreciate in reproduction, for the pleasure of looking is ideally complemented by the pleasure of handling the boxes and watching the changes of shape in the pouring sand. In *Untitled* (*Yellow Sand Fountain*), when the box is turned upside down, the yellow sand collects within the hollow, triangular birdhouse. As the box is righted, it then pours from the entrance hole onto the broken glass, cascading from the glass's irregular edges onto the floor of the box. This work thus combines the symbolic resonance of the hourglass, whose sands measure the passage of time, with the idle fascination of watching something (like waves) in unpredictable but repetitive motion. To paraphrase Marcel Duchamp, when asked about his *Bicycle Wheel* (1913, original lost; see Pontus Hulten, ed., *Marcel Duchamp: Work and Life*, Cambridge, Mass., 1993, p. 30, ill.), the movement provides a useful distraction, like watching a fire in a grate. The comparison with an hourglass is interesting from a formal point of view as well: in the latter the movement of the sand is regulated by passing through the instrument's narrow waist; here, the space between the upper and lower containers is open; the glass, rather than containing and enclosing the sand, allows it to spill out, its broken and irregular edge causing the sand to flow unequally.

The broken glass is one of several signs of age and decay in the box, which underline the notion of time passing. The interior of the box is painted white and is intentionally aged, possibly by baking, a practice Cornell is known to have used. There are wide horizontal and vertical cracks in the paint on the rear wall, and feathered cracks on the birdhouse. White paint flakes are mingled with the yellow sand, and it is difficult to determine whether the effects of aging have been more dramatic than intended at the outset. As noted in the above media description, the edges of the glass front show traces of newsprint and adhesive residue. This effect is "matched" by the weathering on the wood frame.

A blue stain on the interior side of the glass front, which looks like an accidental drip and has possibly faded over the years, contributes to the impression of the passage of time and its chance operations. The faint trace of a watery blue underlines the inversion of the idea of "fountain," which here literally "runs dry." The apparently accidental character of this stain should not mislead one into overlooking both the visual complement it provides to the yellow of the sand, and the powerful associations the color blue had for Cornell. The artist in fact identified this color with the azure of the heavens, which he linked with the poetry of Emily Dickinson and Stéphane Mallarmé. The latter's poem *L'Azur* (*The Blue*) indeed opens with the line, "The serene irony of the eternal azure" (my translation; for the complete text of this poem, see *Mallarmé: The Poems*, bilingual edition tr. with intro. by Keith Bosley, Middlesex, 1977, pp. 86–89). * * *

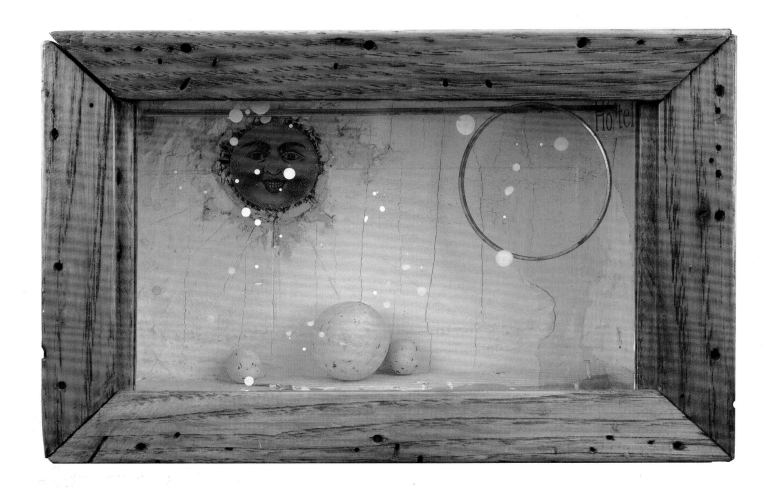

40. UNTITLED (SUN BOX)

c. 1955
Wood box, exterior stained brown. Two pages in French glued to back (fig. 9). A bisected postage stamp, issued by French Equatorial Africa in 1946, is glued to back, lower right corner, on either side of "Cornell" in the signature. Top of box is removable by releasing screw at either end. Clear glass front has second piece of glass behind it, which bears a blue stain along right edge and yellow or white dots of paint splashed on inside face. Interior, painted white, contains elements that can be rearranged by tilting box: a brass ring, encircling a horizontal metal rod, and three cork balls, thinly painted white. Bright yellow paper sun with smiling face is glued to upper left corner of rear wall, and surrounding area is painted yellow in a pattern of rays. Piece of paper with word *Hotel* is glued to right interior wall at upper corner. Several nail heads, painted yellow and white, protrude upward from floor of box. A wood shim, painted white, is secured to lower right floor. 16 x 24.8 x 10.8 cm (6¼ x 9¾ x 4¼ in.)

Inscribed and signed on back on paper labels (see fig. 8): ~~blue marble in glass~~. / *Joseph Cornell*

The Lindy and Edwin Bergman Joseph Cornell Collection, 1982.1864

PROVENANCE: Sold by the artist to Lindy and Edwin Bergman, Chicago, October 1959;[28] given to the Art Institute, 1982.

EXHIBITIONS: Sheboygan, Wisconsin, John Michael Kohler Arts Center, *Glass/Backwards*, 1979, no cat.

REFERENCES: Ashton 1974, p. 110 (ill. upside down), as *Sun Box*.

Figure 9. Back of no. 40.

ALTHOUGH SPARE IN APPEARANCE, THIS BOX brings together several familiar themes in Cornell's work: birds (associated with the ring), travel, cosmology, and popular imagery. The startling, grotesquely grinning paper sun suggests children's entertainment, perhaps even a cardboard theater. The contrast between this yellow sun and the white cork balls, which by association become moons, is echoed in the white and yellow dots of paint, meticulously formed into circles, for all their apparently random splattering. The formal and the metaphorical are beautifully balanced here, as so often in Cornell's work. ✳ ✳ ✳

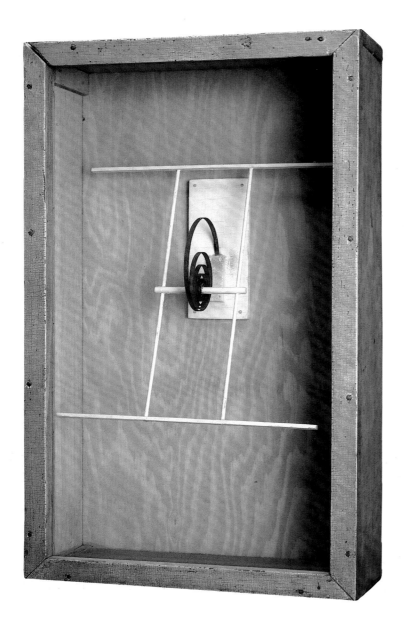

THIS BOX IS AN EXCELLENT EXAMPLE OF Cornell's ability to convey ideas and associations by minimal means. A construction of thin pieces of wood is delicately balanced from the center of the metal spring coil, on which it bounces freely. The arrangement hints at the wings and propeller of a biplane, thus relating to the title, which in earlier exhibitions was listed simply as *Blériot*. Louis Blériot (1872–1936) was a pioneering French aviator, the first to fly across the English channel in 1909. The strongly marked wood grain, stained pale blue, of the inner wall of the box evokes both the waves of the sea, over which early planes flew low, as well as perhaps clouds in the sky. Cornell papered the back of the box with a French newspaper, *L'Economiste français* (June 15, 1893). Given the subject of this box, the choice of paper backing–always an integral part of a box's construction for the artist– seems not entirely fortuitous. Another, closely related box, referred to as *Blériot #2*, has been dated around 1956 (estate of Joseph Cornell; New York 1980–82, no. 115, ill.). It differs from this one primarily in the relationship of the components within the box. * * *

41. UNTITLED (HOMAGE TO BLÉRIOT)

1956
Wood box, exterior stained a whitish gray. Back covered with French newspaper. Top of box is removable by releasing screw at either end. Clear glass front. Interior of box stained light blue. A corroded, metal clock spring extends vertically outward from base of two wood blocks, painted white, slightly above center of interior. From center of spring coil is suspended a framework of wood dowels, painted white, in the form of a slender "H," on top and bottom of which are fastened horizontally two white balsa slats. The arrangement bounces freely on the spring coil. 47 x 30.4 x 12.1 cm (18 1/2 x 11 5/16 x 4 13/16 in.)

Signed on back, lower right, on piece of newsprint: *Joseph Cornell*

The Lindy and Edwin Bergman Joseph Cornell Collection, 1982.1853

PROVENANCE: Eleanor Ward, New York, by 1961; Stable Gallery, New York; sold to Lindy and Edwin Bergman, Chicago, 1966; given to the Art Institute, 1982.

EXHIBITIONS: New York, The Museum of Modern Art, *The Art of Assemblage*, 1961–62, traveled to Dallas and San Francisco, no. 56 (ill.), as *Blériot*. London, Tate Gallery, *Painting and Sculpture of a Decade: 54–64*, 1964, no. 71 (ill.), as *Blériot*. The Cleveland Museum of Art, *Fifty Years of Modern Art, 1916–1966*, 1966, no. 128 (ill.), as *Blériot*. New York 1967, no cat. nos., pp. 24, 44 (ill.), as *Homage to Blériot*. Kassel, Galerie an der Schönen Aussicht, Museum Fridericianum, and Orangerie im Auepark, *4.documenta*, 1968, vol. 2, no. 9, as *Homage to Blériot*. New York, The Metropolitan Museum of Art, *New York Painting and Sculpture: 1940–1970*, 1969–70, no. 44, as *Blériot*. Chicago 1973, no cat. nos., n. pag. New York, Whitney Museum of American Art, *Two Hundred Years of American Sculpture*, 1976, no. 47, p. 166 and fig. 243, as *Homage to Blériot*. The Cleveland Museum of Art, *The Spirit of Surrealism*, 1979, no. 105 (ill.), as *Homage to Blériot*.

REFERENCES: Harriet Janis and Rudi Blesh, *Collage: Personalities, Concepts, Techniques*, New York, 1962, fig. 170, as *Blériot*. Fairfield Porter, "Joseph Cornell," *Art and Literature* 8 (Spring 1966), p. 124 (ill.), as *Blériot*. Fred Licht, *Sculpture: Nineteenth and Twentieth Centuries*, New York, 1967, fig. 265, as *Blériot*. *Arch. Digest* 1973, p. 20 (photos of Bergman home). Henri Coulanges, *Connaissance des arts* 262 (Dec. 1973), p. 127 (ill.). Ashton 1974, p. 53 (ill.), as *Homage to Blériot*. Hilton Kramer, "A Joseph Cornell Album by Dore Ashton," *New York Times Book Review*, Dec. 29, 1974, p. 2 (ill.), photo of Cornell looking at box in 1970 (see fig. 1). Rosalind Krauss, *Passages in Modern Sculpture*, New York, 1977, dust jacket cover (ill.). Waldman 1977, pl. 34 and p. 26, as *Homage to Blériot*. New York 1980–82, p. 10, fig. 2, photo of Cornell in his workshop with *Blériot* box on storage shelf, before 1961. Edmund Burke Feldman, *Varieties of Visual Experience*, 3d ed., New York, 1987, p. 348 (ill.), as *Blériot*.

THIS BOX HAS FORMAL SIMILARITIES TO *YELLOW Chamber* (no. 32) in its use of white panels and in its balance between asymmetry and regularity. It also includes similar components: the bird, the metal springs, the ring, and the metal rod. But the idea of travel is more strongly evoked here, not least through the contrast between the white interior of the box and the tiny, brilliantly colored stamps, which are colorful and exotic in both a metaphoric and literal sense. The contrast between their small scale and the expanse of whiteness also suggests geographic distance. The idea of the box as a surrogate for travel is indeed very present here. Some of the openings in the white lattice at the right contain bingo chips, which conjure ocean voyages where deck games and gambling played a large part in the entertainment provided on board. Other lattice openings contain wood blocks with constellations on a blue background, which similarly recall navigation. The parrot contributes to the exotic atmosphere and introduces an element of tension, as it suggests both the freedom of travel and a bird caged or trapped. A coiled spring curls over the bird's head to form a targetlike shape, while the bird itself seems to eye the butterfly and beetles on the stamps as if they might become its lunch.

The names of two hotels are included in this box: the Hôtel des Voyageurs in Brest, a port in Brittany, and the Hôtel de la Duchesse-Anne in Nantes. The latter may have appealed to Cornell because of its association with the Surrealists: André Breton had spent part of World War I in Nantes, where he met Jacques Vaché, whose anarchic humor had a strong influence on him. The name Anne also recalls one of Cornell's favorite heroines, Thomas De Quincey's Ann (see *Ann—in Memory*, no. 35). * * *

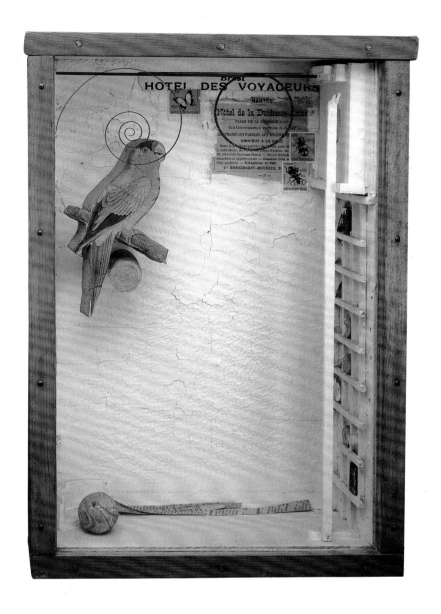

42. UNTITLED (HÔTEL DE LA DUCHESSE-ANNE)

1957
Exterior of wood box has clear coating, aged to a matte patina. Back is covered with six pages in Italian. Top is removable by releasing screw at either end. Clear glass front. Interior painted white. A parrot cut out of wood, covered with colored-paper illustration of bird and painted green on sides, is perched over a wood branch protruding from rear wall. Corroded, metal clock spring extends sideways from upper left interior wall, in front of parrot. Collaged on upper right of rear wall: *Brest / HOTEL DES VOYAGEURS,* French newspaper advertisement for *Hôtel de la Duchesse-Anne* in Nantes, blue postage stamp from Mozambique, and two stamps from Portuguese Guinea. Right interior wall covered with lattice, painted white. Some of lattice's interstices filled with four wood bingo chips (nos. 27, 90, 65, and 6) and two small wood blocks painted with constellations on a

blue background. Square block, with hole cut through it, is located above lattice on right wall. Thin wood strip, painted white, extends upward from lower right front corner to rest against square block. Tarnished metal rod extends from square block across to left interior wall. Black ring or bracelet, with imitation gem, encircles rod. A curved wood form, in the shape of a half circle with raised side walls, is secured to bottom left corner of floor. Four long strips of darkened newsprint are lying on floor. Marbleized rubber ball is loose on floor of box. 44.8 x 31.1 x 11.3 cm (17⁵⁄₈ x 12¹⁄₄ x 4⁷⁄₁₆ in.)

Signed on back, lower right, on paper label: *Joseph Cornell* (in the artist's hand) / *joseph cornell* (typed)

The Lindy and Edwin Bergman Joseph Cornell Collection, 1982.1868

PROVENANCE: Stable Gallery, New York; sold to Lindy and Edwin Bergman, Chicago, 1960; given to the Art Institute, 1982.

EXHIBITIONS: New York, Time, Inc., *Art and the Found Object,* 1959–60, traveled to Williamstown, Massachusetts; Bloomfield Hills, Michigan; Chicago; Notre Dame, Indiana; Montreal; Poughkeepsie, New York; and Waltham, Massachusetts; no cat. The University of Chicago, The Bergman Gallery, *Avant-Garde Chicago,* 1968, no cat. nos., n. pag., as *Hôtel de la Duchesse-Anne.* The Cleveland Museum of Art, *The Spirit of Surrealism,* 1979, no. 106 (ill.) and p. 169.

REFERENCES: Ashton 1974, p. 48 (ill.), as *Hôtel de la Duchesse Anne.* Brian O'Doherty, *American Masters: The Voice and the Myth in Modern Art,* New York, 1982, p. 321 (ill.), as *Hôtel de la Duchesse-Anne. U. of C. Magazine* 1982, p. 22 (ill.). *The Art Institute of Chicago: The Essential Guide,* Chicago, 1993, p. 276 (ill.).

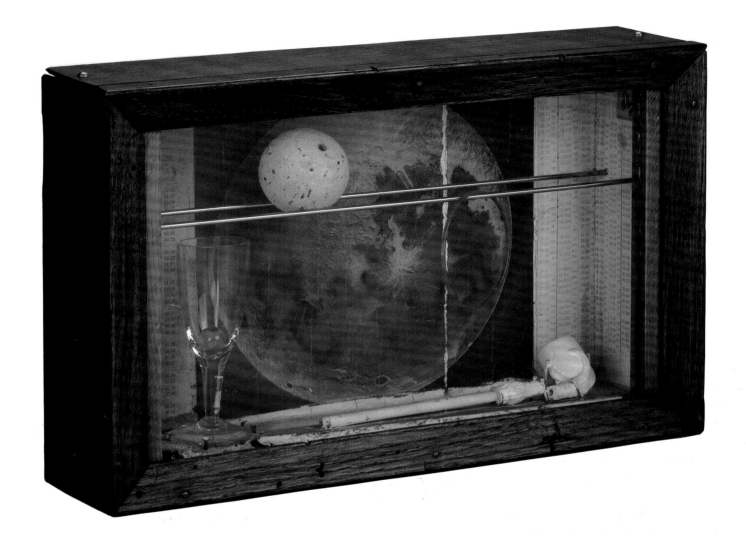

43. UNTITLED (SOAP BUBBLE SET)

c. 1957
Wood box, exterior stained blue. Back covered with two pages in Latin. Top of box is removable by releasing screw at either end. Clear glass front. Interior painted white. Rear interior wall covered with color picture of moon and with tables of astronomical data on either side of moon. These numerical tables extend over right interior wall and are partially stained blue. A rectangular scrap of wood is secured to floor at left with cordial glass nailed to it, and a strip of wood extends horizontally across front edge with broken clay pipe nailed to it. A transparent marble with yellow inclusions rests inside cordial glass. Two metal rods, secured to wood block located two thirds of way up on left wall, extend horizontally across box to right wall. A yellow cork ball, with a narrow hole through the center, is resting on the two rods. Metal ring encircles front rod. A postage stamp from Mozambique of a butterfly is adhered to upper edge of right wall. 23.1 x 36.8 x 9.5 cm (9 1/8 x 14 1/2 x 3 3/4 in.)

Signed on back, lower right, on paper label: *Joseph Cornell* (legible in reverse, see fig. 10)

The Lindy and Edwin Bergman Joseph Cornell Collection, 1982.1848

PROVENANCE: Sold by the artist to Lindy and Edwin Bergman, Chicago, October 1959;[29] given to the Art Institute, 1982.

EXHIBITIONS: Chicago, Rosenstone Art Gallery, Bernard Horwich Center, *Surrealism*, 1966, no. 17, as *Soap Bubble Set*. The Art Institute of Chicago, *Twenty-seventh Annual Exhibition by the Society for Contemporary American Art*, 1967, no cat. Chicago 1973, no cat. nos., n. pag., as *Dream World*.

REFERENCES: Mary Ann Caws, *Robert Motherwell: What Art Holds*, New York, 1996, p. 121 (ill.).

Soap bubble sets were among Cornell's earliest imaginary constructions, going back to his contribution to the 1936–37 exhibition *Fantastic Art, Dada, Surrealism* at The Museum of Modern Art in New York (see New York 1980–82, p. 14, fig. 1, and pl. I). This box forms an interesting contrast with the other Soap Bubble Set in the Bergman collection (see no. 22). Here the bold form of the moon fills the back panel, its pitted surface finding an echo in the cork ball suspended on the parallel rods. Like the earlier box, this one includes a drinking glass. A clay pipe lying on the floor of the box forges the link between the "bubbles" and the planets. Cornell seems to wish to counteract, however, the obviously poetic, dreamlike connotations of this box by emphasizing the scientific interest of the moon through its precisely "mapped" surface and the tables with astronomical data pasted in at the left and right.

* * *

Figure 10. Back of no. 43.

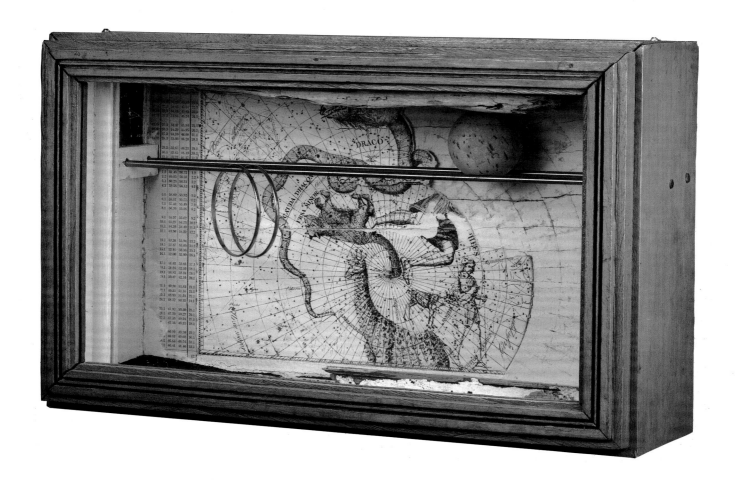

44. THE EAGLE, THE ARROW, AND THE DOLPHIN

c. 1960
Wood box, exterior stained a pale blue-green. Back (fig. 11) covered with four pages of a genea-logical table in Italian. Interior painted white. Top of box is removable by releasing screw at either end. A long piece of driftwood is nailed to interior roof of box just inside glass front. A second sheet of glass is inserted into wooden channel approximately one inch behind outside glass. Rear interior wall is covered with cropped illustration of constellations with charts of numerical data along left edge. The upper right corner and right edge of rear interior wall are inscribed with lines to continue pattern of celestial sphere. The etched design is tinted blue to accentuate its visibility. Deep-blue crystals of sand or glass are piled on floor, behind interior sheet of glass. Two metal dowels, approximately 1½ inches apart, are secured, parallel to each other, to right and left walls, near top of box. At left, the rods are inserted into wood block nailed to wall. Above block, a blue piece of paper with white constellations on it is adhered to wall. Blue cork ball rests on dowels. Two brass rings encircle front dowel and slide along it when box is tilted. Two long, thin pieces of wood, glued together and partially painted white, are positioned on right side of floor, parallel with and inside interior sheet of glass. 27.9 x 45.1 x 13.7 cm (11 x 17¾ x 5⅜ in.)

Titled and signed on back on paper labels (see fig. 11): *THE EAGLE, THE ARROW, and THE DOLPHIN* (printed) / *Joseph Cornell* (in the artist's hand)

The Lindy and Edwin Bergman Joseph Cornell Collection, 1982.1849

PROVENANCE: Sold by the artist to the Allan Frumkin Gallery, Chicago;[30] sold to Lindy and Edwin Bergman, Chicago, 1967; given to the Art Institute, 1982.

EXHIBITIONS: The University of Chicago, Renaissance Society, *The New Curiosity Shop*, 1971, no. 22. Carbondale, Southern Illinois University, University Galleries, *Small Environments*, 1972, traveled to Madison, no. 12 (slide ill.). Chicago 1973, no cat. nos., n. pag. Saint Louis, Washington University Gallery of Art, *Exploring Joseph Cornell's Visual Poetry*, 1982, no cat. nos., p. 24.

REFERENCES: René Passeron, *Histoire de la peinture surréaliste*, Paris, 1968, p. 281 (ill.).

Figure 11. Back of no. 44.

THE TITLE OF THIS BOX REFERS TO A SMALL section of a map of the heavens attached to the top of the box's interior left wall. It reproduces several constellations with their Latin names, including *AQUI[LA]* (Eagle), *SAGITTA* (Arrow), and *DELPHINUS* (Dolphin). Cornell used the larger illustration attached to the box's interior back wall, showing a group of constellations labeled *CEPHEUS, URSA MINOR, DRACO,* and *CAUDA DRACONIS*, in several other boxes, including *Pavilion* (no. 33). The original image appears to have been photographically reproduced, and then partially colored in by hand by Cornell himself. The artist used it again in *Cauda Draconis* of 1958 (New York, Xavier Fourcade, Inc.; Waldman 1977, pl. 33), a box that offers a close comparison to *The Eagle, the Arrow, and the Dolphin*. Both boxes are horizontal in their construction and include metal rods supporting a rolling ball. *The Eagle, the Arrow, and the Dolphin*, however, has two metal rings rather than one and lacks the row of wine glasses with blue marble balls arranged on a shelf in *Cauda Draconis*.

A comparison between *Pavilion* (no. 33) and *The Eagle, the Arrow, and the Dolphin* draws attention not only to their shared imagery but also to an interesting similarity in their formal construction. Although one box is vertical and the other horizontal, the spatial divisions created by the wood or metal rods, which function as either "columns" or "shelves," seem to follow the same proportional rules. Strong geometric and structural principles often underlie the heterogeneous collections of materials and objects within Cornell's boxes.

The study of the constellations had many layers of significance for the artist. Constellations were connected to ancient mythology and bore witness to the power of the human imagination to imprint images and patterns on chaos. The illustration pasted into these boxes exemplifies these aspects in its particularly pleasing combination of science and fantasy. Cornell associated favorite constellations, such as Andromeda, Orion, and the Dragon, with friends, film stars, or ballerinas. The very term "constellation" took on a particular significance for him in his effort to understand and describe his working process, as he sought patterns in his experiences, his feelings, and his works. A handwritten note in his diary reads: "What about '*constellations*' for experiments in going over past experiences on various subjects and picking out certain points for a presentation" (Cornell Papers, AAA, reel 1060; see Cornell 1993, p. 227). ✳ ✳ ✳

CORNELL'S WORKS SOMETIMES GIVE THE AP-pearance, as in this case, of being wholly ready-made. Only at second glance do they reveal his additions and alterations to the original found object. In *Untitled (L'Abeille)*, the frame resembles the frames of his boxes, thereby suggesting a genre somewhere in between collage and construction. The blue staining that runs down the inside of the glass on each side of the text enhances its antique look, and the gold bees are added so subtly that they seem part of the fancy advertising for the company, L'Abeille, offering daily trips for English visitors in Belgium to Waterloo. The latter had become a tourist attraction, as the site of Napoleon's defeat in 1812 at the hands of the English. Cornell may also have been attracted by the slight misprints on this notice ("THESE AND BACK," for instance), which reinforce the idea of the foreign. A contemporary English audience would find a further oddity in this announcement, since it would immediately identify Waterloo as the London railway station. As indicated by the inscription on the back of this work, Cornell dedicated this collage to Jacques Brel (1929–1978), the French songwriter and singer, who became internationally known after 1957 and toured the United States in the 1960s. * * *

45. UNTITLED (L'ABEILLE)

7 April 1966.
Collage composed of commercially printed papers, and gold paper appliqués on untempered masonite, with coin and blue ink on glass; including frame: 27 x 34.6 cm (10⅝ x 13⅝ in.)

Inscribed, dated, and signed on back:
pour Jacques Brel / le magnifique! / 4-7-66
Joseph Cornell

The Lindy and Edwin Bergman Joseph Cornell Collection, 1982.1875

PROVENANCE: Robert Schoelkopf, New York; sold to Lindy and Edwin Bergman, Chicago, 1966; given to the Art Institute, 1982.

EXHIBITIONS: Possibly New York, Robert Schoelkopf, *Joseph Cornell: Collages*, 1966, no cat. nos., n. pag. Chicago 1973–74, no cat. nos., n. pag., as *L'Abeille (Pour Jacques Brel le Magnifique)*. Chicago, Museum of Contemporary Art, *Words at Liberty*, 1977, no cat. nos, pp. 5, 12 (ill.), 16, as *L'Abeille (Mail Coach)*. Sheboygan, Wisconsin, John Michael Kohler Arts Center, *Glass/Backwards*, 1979, no cat.

REFERENCES: Ashton 1974, p. 102 (ill.), as *L'Abeille (pour Jacques Brel le Magnifique)*. Waldman 1977, pl. 96.

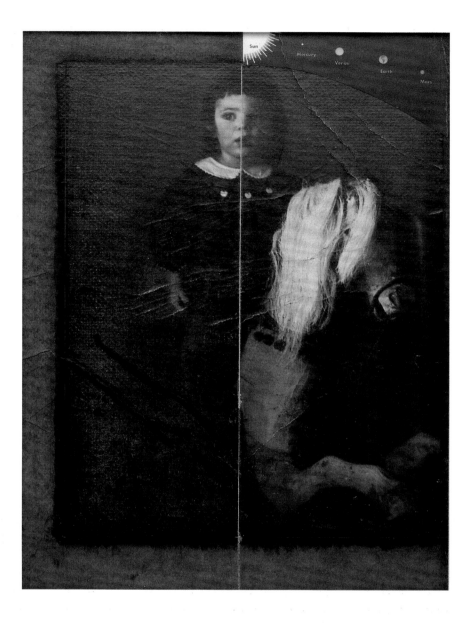

THE TITLE OF THIS COLLAGE ORIGINALLY derives from a two-line poem by Walt Whitman: "The untold want by life and land ne'er granted,/ Now voyager sail thou forth to seek and find" ("The Untold Want" [1871], in Walt Whitman, *Complete Poetry and Collected Prose*, New York, 1982, p. 608). *Now Voyager* was also the name of a 1941 novel by Olive Higgins Prouty and of a 1942 movie, based on the novel, starring Bette Davis. The title's attraction for Cornell, given the voyage theme in so many of his works, is obvious. Here, though, the combination of title and image suggests a journey of a more interior kind, which is indeed evoked by Whitman's poem, and is a theme developed in both the novel and movie: these focus on the growth of the main protagonist, Charlotte Vale, from repressive childhood into mature adulthood. In Cornell's collage a child of uncertain gender is shown riding a merry-go-round horse, but the child's distant gaze and the planets above hint at an imagined voyage of much grander dimensions. * * *

Figure 12. Detail of back of no. 46.

46. NOW, VOYAGER

1966
Collage composed of cut and pasted, commercially printed papers, with brush and black ink and touches of yellow gouache, on untempered masonite; 30.4 x 22.9 cm (12 x 9 in.)

Titled, inscribed, and signed on back (see fig. 12): "* *Now, voyager* " / *Based upon a photograph by Susan Rosenthal* (typed) / *Joseph Cornell* (in the artist's hand)

The Lindy and Edwin Bergman Joseph Cornell Collection, 1982.1870

PROVENANCE: Robert Schoelkopf, New York; sold to Lindy and Edwin Bergman, Chicago, 1966; given to the Art Institute, 1982.

EXHIBITIONS: Possibly New York, Robert Schoelkopf, *Joseph Cornell: Collages*, 1966, not in cat. Chicago 1973–74, no cat. nos., n. pag. New York, The Solomon R. Guggenheim Museum, *Twentieth-Century American Drawings: Three Avant-Garde Generations*, 1976, traveled to Baden-Baden, Germany, and Bremen, no. 154. Chicago 1982, no. S-39. The Art Institute of Chicago, *Joseph Cornell and Twentieth-Century Collage*, 1985, no cat.

47. THE TIARA

1966/67
Collage composed of cut and pasted, commercially printed papers, and painted mixed media, with pen and black and brown ink, on untempered masonite; 30.8 x 38.8 cm (12⅛ x 15¼ in.)

Inscribed, titled, and signed on back (see fig. 13): *Tiepolo* (upper left, in pencil) / *"The Tiara (tent.)"*

(upper center, in ink) / *Joseph Cornell* (lower center, in ink)

The Lindy and Edwin Bergman Joseph Cornell Collection, 1982.1872

PROVENANCE: Elizabeth Cornell Benton, Westhampton, New York; sold to Lindy and Edwin Bergman, Chicago, 1977; given to the Art Institute, 1982.

EXHIBITIONS: New York 1980–82, no. 29, pl. XXIX. Florence 1981, no. 123 (ill.). The Art Institute of Chicago, *Joseph Cornell and Twentieth-Century Collage*, 1985, no cat.

Figure 13. Detail of back of no. 47.

T HE PATCHY AND CRACKED SURFACE OF THE central, circular form in this collage mimics the pitted surface of the moon, and this hint of celestial spheres is echoed in the additional, outer circle incised in the paint, which suggests a planetary ring. This incised line is not continued to the right of the central form, where, squeezed somewhat to the side, is a fragment of a color reproduction of Giovanni Battista Tiepolo's fresco *Cleopatra and Mark Antony at the Harbor* from the ballroom of the Palazzo Labia, Venice (see Sacheverell Sitwell, ed., *Great Houses of Europe*, London, 1961, pp. 183 [ill.], 185). Cornell's chosen portion is from the right-hand side of the scene, showing only the secondary figures; the tiara, which gives the collage its title, is being carried on a blue cushion by a page and is possibly about to be offered to Cleopatra. This fragment introduces a group of figures into the composition in a manner similar to the celestial, mythological figures in *Pavilion* (no. 33). The dog could perhaps be a reference to the constellation Canis. A formal connection between Tiepolo's painting and the collage as a whole is established through the white stone globe, an architectural fragment at the center of the group of figures, which recalls the form of the moon. * * *

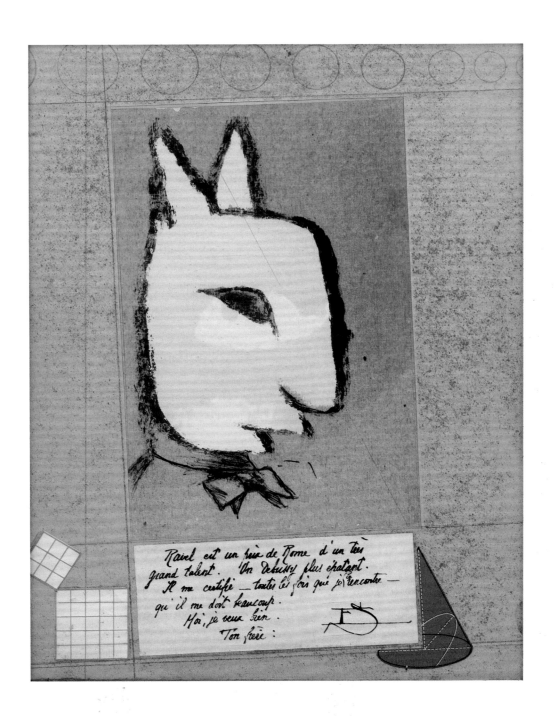

48. UNTITLED (SATIE AND RAVEL)

14 March 1968–early September 1969
Collage composed of cut and pasted, commercially printed papers, with graphite, on cardboard; 30 x 22.3 cm (11¹³/₁₆ x 8³/₄ in.)

Inscribed, lower center: *Ravel est un prix de Rome d'un très / grand talent. Un Debussy plus épatant. / Il me certifie – toutes les fois que je le rencontre – / qu'il me doit beaucoup. / Moi, je veux bien. / Ton frère: ES* (Ravel is a prix de Rome of very / great talent. A more splendid Debussy. / He assures me – every time I meet him – / that

he owes me a lot. / I am very pleased. / Your brother: E[rik] S[atie]）
Inscribed on back (see fig. 14): ('He assures me, every time that I meet him, that he owes me a lot. I am very / pleased', said Satie of Ravel.) (printed on paper label); *Costume for the Cat from / 'L'Enfant et les Sortilèges' (P. Colin)* (printed on paper label); *Robert Cornell* (photostat on paper label); *"Valse du / Mystérieux / [?] / dans / l'oeil" / Dumas – / Rousseau – / [?] / variant / 3-14-68 / early / Sept 69 / template / grail. / sig* (handwritten on left edge of frame)

The Lindy and Edwin Bergman Joseph Cornell Collection, 1982.1871

PROVENANCE: Elizabeth Cornell Benton, Westhampton, New York; given to Lindy and Edwin Bergman, Chicago, 1976; given to the Art Institute, 1982.

EXHIBITIONS: The Art Institute of Chicago, *Joseph Cornell and Twentieth-Century Collage*, 1985, no cat.

CORNELL USED PHOTOSTATS OF A 1927 DRAW-
ing by his beloved brother Robert in this and sev-
eral other collages (see, for example, New York
1980–82, nos. 282–83, ills.). Here he combined it with a
reproduction of a note by Satie about Ravel who, Satie
wrote, "assures me every time that I meet him, that he
owes me a lot." Robert, who suffered from a form of cere-
bral palsy, had died in 1965 at the age of fifty-four. A
memorial exhibition of drawings by Robert and collages
by Joseph had been held at Robert Schoelkopf's New
York gallery in 1966. There is no reason to doubt the
dates noted on the frame of the collage: Cornell refers
on many occasions during this period to his brother
Robert's drawing of a rabbit, and also to Satie and Ravel.
In February and March, when this collage was presum-
ably begun, Cornell described its powerful emotional
associations, linking it to music: "what seemed elusive,
lost earlier – the way that Robert's drawing . . . brought
about this lovely business – bringing to life, bringing
together Chabrier, S. Saens, Mme Manet (and by impli-
cation, Debussy) via the *original* drawing" (Cornell
1993, p. 390; entry for Feb. 23, 1968); in March he men-
tioned again "Carolyn's 'Ravel Rabbit' par excellence /
Robert's 'Rabbit'" (Cornell 1993, p. 391; entry for March
10, 1968).

Ravel was much in Cornell's mind at the time, per-
haps partly because of an anecdote he mentioned in his
diary: after the death of his mother, Ravel never re-
turned to the apartment they had shared at 4, avenue
Carnot. Cornell's mother had died a year after Robert, in
1966, and his diary reveals how painful this double loss
was. He addressed notes to his mother and on occasion
heard Robert's voice in the house. But he had by no
means lost his avid curiosity and continued to work.
Cornell had often worked listening to music – an impor-
tant element in the complex associations he sought to in-
still in his boxes and collages. He became more reflective
about his own working procedures toward the end of his
life, commenting on the working procedures of artists
and musicians he admired: "*A musing*: Erik Satie's 'hys-
terical' obsessions with putting things to music. Ravel
anecdote about Satie even wanting to put a menu to
music" (Cornell 1993, p. 416). * * *

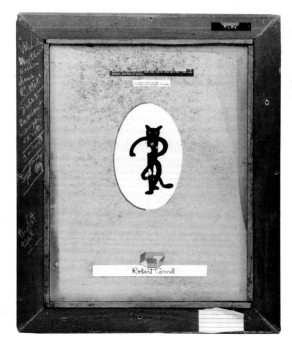

Figure 14. Back of no. 48.

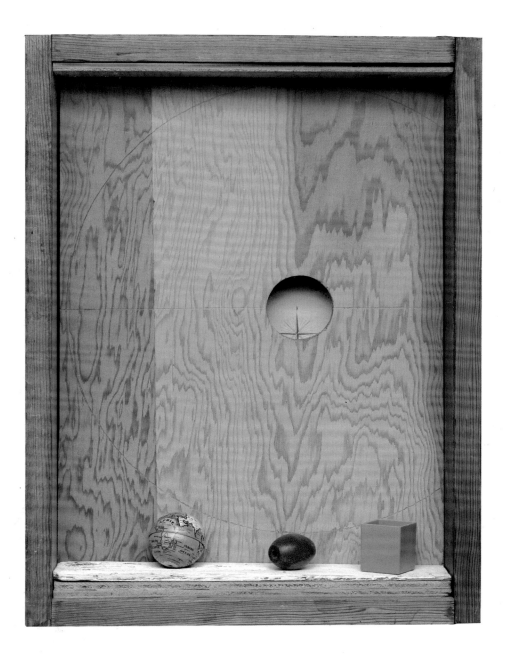

49. UNTITLED (FOR TRISTA)

c. 1969

Wood box, exterior faintly tinted blue. Right side of box is attached with two metal hinges to the back of the box, so that it operates like a door. Door is held shut by metal hook clasp attached to right side of top of box. A groove is routed into front edge of door to accommodate Plexiglas front. Back of box covered with plain, natural-colored paper, tinted blue. Interior is natural color of raw wood and is divided by thin sheet of plywood into a front and rear section. Plywood board has circular hole to right of center. Part of a large circle has been incised into board so that the hole is its approximate center. In front section, a piece of wood, painted white, with a gentle downward slope from left to right, is laid across bottom interior. Three objects rest on this slope:

a metal globe; a hollow, blue plastic cube; and a wooden oval bead, painted red and pierced with a hole. Each object can be caught in the hole in the plywood panel by moving the box. However, only the metal globe fits precisely into the hole. Back of rear section of box is covered with map entitled *A MAP OF THE PRINCIPAL RIVERS SHEWING* [SIC] *THEIR COURSES, COUNTRIES, AND COMPARATIVE LENGTHS: AFRICAN, AMERICAN, ASIATIC, AND EUROPEAN.* The orienting compass of the map is visible through the hole when plywood panel is in place. Map can be viewed in its entirety only when plywood panel is removed, which can be done by opening the hinged right side of the box, and sliding the panel out of its fitted slot. 45.4 x 34 x 11.4 cm (17⅞ x 13⅜ x 4½ in.)

Signed and inscribed on back (see fig. 15): *Joseph Cornell* / x (sideways, lower left); *for Trista* / x (upper left); *from Joseph* x (lower right)

The Lindy and Edwin Bergman Joseph Cornell Collection, 1982.1851

PROVENANCE: Sold by the artist to the Allan Stone Gallery, New York;[31] sold to Lindy and Edwin Bergman, Chicago, 1976; given to the Art Institute, 1982.

EXHIBITIONS: Washington, D.C., National Collection of Fine Arts, Smithsonian Institution, *Joseph Cornell (1903–1972),* 1973–74, no cat. New York 1980–82, nos. 199–200 (ills.) and p. 112.

REFERENCES: Joseph T. Butler, "The American Way with Art," *Connoisseur* 185 (Apr. 1974), p. 305, as *For Trista.*

THIS BOX MAY HAVE BEEN THE LAST ONE COR-nell ever made.[32] He dedicated it to Trista Stern (born 1960), eldest daughter of the ballerina Allegra Kent and the photographer Bert Stern. Cornell met Kent in 1956, and they were particularly close in 1969. As Kent recalled, "My greatest rapport with Joseph came on a visit August 13, 1969. I was very depressed. . . . I went out to see Joseph and we lost ourselves talking about music, nature and shells" (Allegra Kent, "Joseph Cornell: A Reminiscence," in New York, Castelli, Feigen, Corcoran, *Joseph Cornell Portfolio,* 1976, exh. cat., n. pag.).

Like so many of Cornell's boxes, this is a game, which can only be fully revealed when it is manipulated. The map is a comparative chart of the world's rivers, as its title informs us (see above media description). It is, in other words, an imaginary map, and the blank area at its heart, resembling a map of the Arctic or Antarctic, is a purely notional "source" point. At its center is an orienting compass, the only part of the map visible when the back panel is closed. Although topographical charts appear relatively infrequently in Cornell's work, compared with maps of the heavens ancient or modern, the ingenious character of this one must have appealed to him.

As noted in the above media description, three objects move freely on top of the plywood panel: a metal globe, a hollow blue plastic cube, and a red wooden bead. Each can be caught in the hole in the panel by tilting the box, which may well have been conceived to work horizontally, as well as vertically, based on the orientation of the inscriptions on the back (see fig. 15). Rather than the navigation boxes, to which it has a superficial resemblance, this box strongly recalls the educational, "philosophical" toy so popular with the Victorians: a lesson about the world and its dimensions. * * *

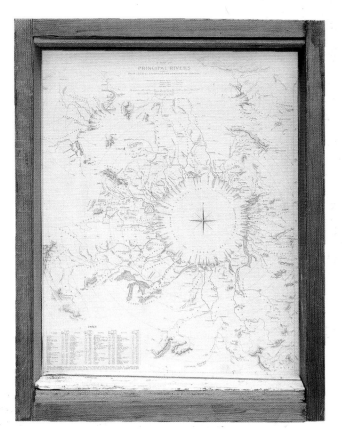

Without partition and objects.

Figure 15. Back of no. 49, *Untitled (For Trista),* 1982.1851.

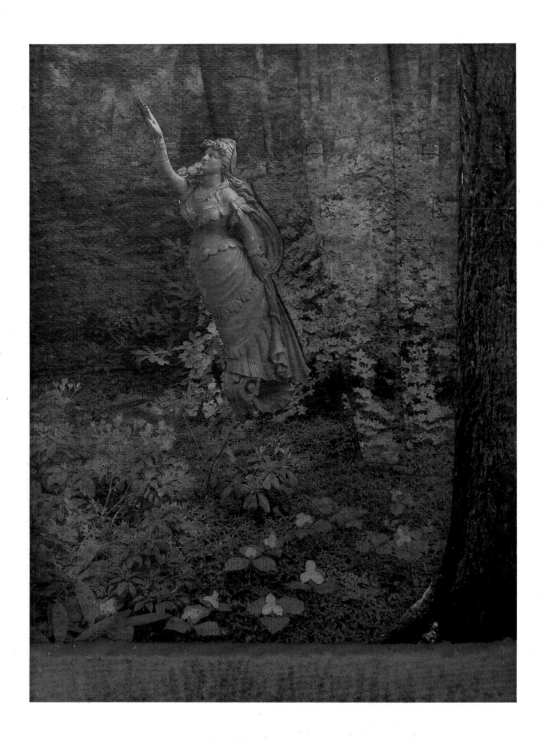

50. UNTITLED (COLLAGE #36)

n.d.
Collage composed of cut and pasted, commercially printed papers, and gray wove paper, on untempered masonite; 36 x 26 cm (14⅛ x 10¼ in.)

Signed and inscribed on back (see ill.): *J. C.* (lower left); *too misleading for a full-fledged signature / recto worthy of development? 8 yrs. later / would cancel out this / verso in favor of the / recto. / Something didn't come / through* (upper left and right)

The Lindy and Edwin Bergman Joseph Cornell Collection, 1982.1874

PROVENANCE: Elizabeth Cornell Benton, Westhampton, New York; sold to Lindy and Edwin Bergman, Chicago, 1976; given to the Art Institute, 1982.

EXHIBITIONS: The Art Institute of Chicago, *Joseph Cornell and Twentieth-Century Collage*, 1985, no cat.

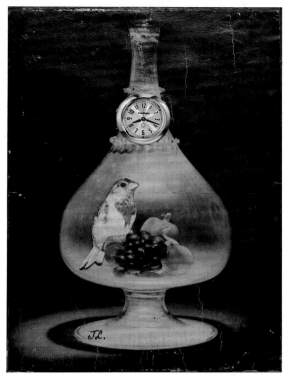

Back of no. 50.

ORNELL WORKED ON BOTH THE FRONT AND back of this masonite board. Based on the inscription, he preferred the side made of collaged color photographs, showing a female figurehead emerging from a tree-shaded garden, and regarded it as the front. Cornell's usual practice in his boxes was to work all surfaces, and he often extended this practice to his collages, which are, like this one, frequently double-sided.

His preference in this case for one side over the other throws light on what it was that Cornell regarded as "successful." He may have been aiming to achieve similar effects by different means on the two different sides of this collage. Broadly speaking, we could locate these effects within the Surrealist notion of *dépaysement*, that is, the disorientation of the viewer, through the displacement and odd combination of familiar objects and settings.

On the front, the sculpture of a woman is set in a woodland garden, composed of tree trunks, azaleas, Japanese maples, and shade-loving flowers in the foreground – nature, in other words, carefully tended in its luxuriance. The carved figure of the woman is probably a ship's figurehead, though the raised arm and flowing hair also recall French allegorical images of Liberty. She "sails" across the woodland floor like a galleon, thriving on the disorientation of place, on being "out of her element," and enhancing, by her association with the sea, the green underwater atmosphere of the wood. She also resembles the type of eighteenth-century, animated garden statue seen, for example, in the park settings of Jean Antoine Watteau's paintings.

The other side of the collage inverts this idea. Here, "nature" is trapped inside the glass jar – not just in the form of a still life (*nature morte*, or dead nature) of grapes and other fruits, but in the form of a "live" linnet as well. The watch face set into the bottle just below the stopper also reinforces a connection with Joseph Wright of Derby's *Experiment on a Bird in the Air Pump* (1768, London, National Gallery; Judy Egerton, *Wright of Derby*, London, Tate Gallery, 1990, exh. cat., no. 21, ill.), in which a dove is placed within a glass jar and sacrificed to a timed scientific experiment in a vacuum.

Cornell may have thus preferred the front because the sense of enclosure, of nature trapped, was too complete on the back. The sense of *dépaysement*, which he planned to achieve through contrasting effects on both sides, was too disturbing, conceived in terms of life and death. In the woodland scene on the front, Cornell was able to achieve a gentler kind of disruption by emphasizing what links rather than separates the images. ✳ ✳ ✳

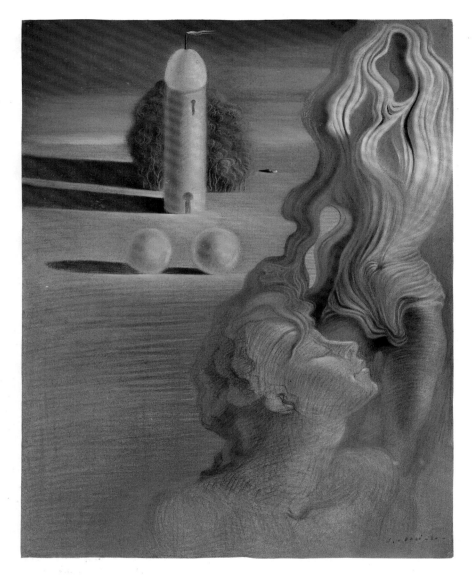

I N THE SPRING OF 1929, WHEN HE ALIGNED himself with the Surrealists, Dalí began to produce dreamlike images charged with sexual desires and anxieties. This pastel unites two motifs from Dalí's new repertoire: the "anthropomorphic" tower,[1] and a female head and torso intermingled with a fragment of Art Nouveau architecture. The latter relates closely to the 1929 painting *The Great Masturbator* (fig. 1). In the painting, however, the torso has prominent, if shrouded, male genitals, while in the pastel, the torso's gender is more ambiguous. At first it appears female, but its gender becomes mysterious due to the dark, disturbingly empty genital area and suggestively bunched drapery. The head, too, whose features in *The Great Masturbator* are clearly female, takes on in the pastel an ambiguous and androgynous quality. These shifting identities reflect Dalí's acute sexual anxieties at this time (see, for example, Salvador Dalí, *The Secret Life of Salvador Dalí*, tr. by Haakon M. Chevalier, New York, 1961, pp. 227–29). The landscape, by contrast, assumes a highly graphic, phallic character. In the upper part of the torso, the drapery solidifies into forms reminiscent of the work of architect and sculptor Antonio Gaudí. For Dalí, the irrational forms of Art Nouveau architecture such as Gaudí's, consisting of stone or iron convulsed into soft and organic shapes, were "ornamental automatism. . . . the realization of solidified desires. A majestic blooming with unconscious erotic-irrational tendencies" (Salvador Dalí, "De la beauté terrifiante et comestible, de l'architecture Modern'Style," *Minotaure* 3–4 [Dec. 12, 1933], p. 73).

51. ANTHROPOMORPHIC TOWER

1930
Pastel and stumping on tan wove paper; 65 x 50 cm (25⅝ x 19⅝ in.)
Signed and dated, lower right: *S.-Dali-30-*
The Lindy and Edwin Bergman Collection, 109.1991

PROVENANCE: Carstairs Gallery, New York; sold to Lindy and Edwin Bergman, Chicago, 1961.

EXHIBITIONS: Chicago, Rosenstone Art Gallery, Bernard Horwich Center, *Surrealism*, 1966, no. 1, as *Red Tower*. Chicago 1967–68, no cat. Chicago 1973, no cat. nos., n. pag., as *The Red Tower*. Chicago 1984–85, no cat. nos., pl. 15, pp. 23, 132, as *The Red Tower*. Chicago 1986, no. 5, as *The Red Tower* (*Anthropomorphic Tower*). Staatsgalerie Stuttgart, *Salvador Dalí, 1904–1989*, 1989, traveled to Zurich, exh. cat. by Karin v. Maur, no. 69 (ill.), as *La Tour rouge* or *La Tour anthropomorphique*. Humlebaek, Denmark, Louisiana Museum of Modern Art, *Salvador Dalí*, 1989–90, exh. cat. published in *Louisiana Revy 2*, 30 (Dec. 1989), no. 94 (ill.), as *La Tour rouge*

or *La Tour anthropomorphique*. The Montreal Museum of Fine Arts, *Salvador Dalí*, 1990, no. 13 (ill.), as *The Red Tower* or *The Anthropomorphic Tower*.

REFERENCES: Robert Descharnes and Gilles Néret, *Salvador Dalí, 1904–1989*, tr. by Michael Hulse, Cologne, 1994, vol. 1, *The Paintings, 1904–1946*, pl. 316; vol. 2, *The Paintings, 1946–1989*, p. 748, no. 316, as *The Red Tower* (*Anthropomorphic Tower*).

The motif of the tower-penis is related to the massive columns that began to appear in Dalí's paintings early in 1930, and also harks back to the towers in Giorgio de Chirico's pictures. In one of Dalí's first "paranoiac-critical" works, *Paranoiac Woman-Horse* (1930, Paris, Musée national d'art moderne, Centre Georges Pompidou; Descharnes and Néret 1994, vol. 1, pl. 354), the base of the tower at the top of the painting and the two blue spheres in the lower corners frame the image with metaphorical male genitalia. Dalí used the motif of the column transformed into a phallic tower, with minor variations, in several drawings. One of these is reproduced in the program for the film he made with Luis Buñuel, *L'Age d'or* (Paris, 1930, p. 18), in which the tower appears more sturdily architectural, with emphatic brickwork around the door and window. A similar motif appears in a dedicatory drawing on the title page of a copy of André Breton and Paul Eluard's book *L'Immaculée Conception* (fig. 2). In the latter drawing, the door becomes a more obvious keyhole. The other sexual symbols, the flag and the bush behind the tower, feature regularly in Dalí's work.

The connection with *L'Immaculée Conception* is significant because the book contains texts in which Breton and Eluard simulated disturbed mental states. Dalí named his technique of "seeing" and reproducing double images after the tendency of paranoiacs to misinterpret the objects around them according to an overriding delusional and obsessional idea. Hence Dalí's famous claim that the only difference between himself and a madman was that he was not mad (see Dawn Ades,

Salvador Dalí, London, 1995, pp. 119ff., for a detailed discussion of his "paranoiac-critical" method).

In the Bergman drawing, the head and torso appear shadowed and monochromatic, in contrast to the lurid brilliance of the tower. The sleeping, dreaming head can be understood as the subject who "sees," in dream or hallucination, this brightly colored transformation – or rather symbolic materialization – of the torso's missing genitals. The two balls have prominent yellow highlights, which suggest a further sequence of double images: eggs, which had a special significance for Dalí and a little later became frequent motifs in his work, and even eyeballs. Together with the tower, they cast long shadows across the deep plain, recalling the imagery of both de Chirico and Max Ernst. Many of de Chirico's paintings from the period that was especially admired by the Surrealists contain towers, and comparisons can be made particularly with de Chirico's *Silent Statue* (1913, Düsseldorf, Kunstsammlung Nordrhein-Westfalen) and *Red Tower* (1913, Venice, Peggy Guggenheim Collection, Solomon R. Guggenheim Foundation; Maurizio Fagiolo dell'Arco, *L'opera completa di de Chirico, 1908–1924*, Milan, 1984, pls. 8, 11). * * *

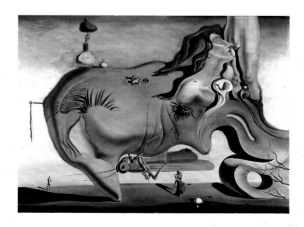

Figure 1. Salvador Dalí, *The Great Masturbator*, 1929, oil on canvas, 110 x 150 cm, Madrid, Museo nacional centro de arte Reina Sofía, gift of Dalí to the Spanish state [photo: courtesy of photographic archive of Museo nacional centro de arte Reina Sofía].

Figure 2. Salvador Dalí, dedicatory drawing to Edward Wasserman on the title page of André Breton and Paul Eluard, *L'Immaculée Conception*, Paris, 1930, Saint Petersburg, Florida, Salvador Dalí Museum Archives.

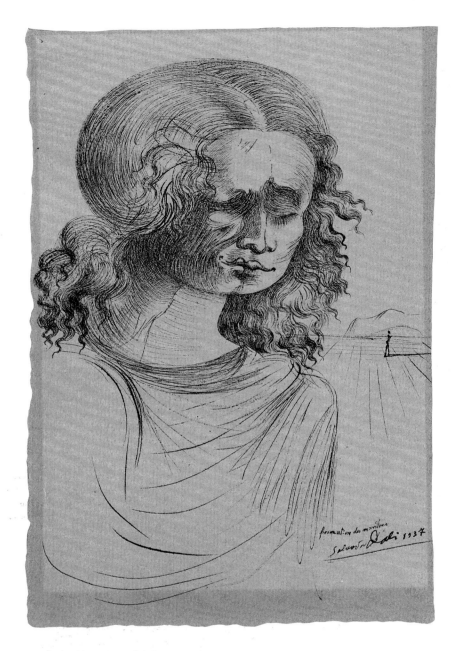

THIS DRAWING IS A PREPARATORY STUDY FOR the double figure at the far left in Dalí's painting *Inventions of the Monsters* (fig. 3). The artist explained that this figure was the Pre-Raphaelite version of the merged portraits of Gala and himself (Robert Descharnes, *Salvador Dalí*, tr. by Eleanor R. Morse, New York, 1976, p. 120), both of whom can be seen in the painting seated at a table directly behind the figure. Another version of this drawing was once in the Julien Levy Collection (location unknown; New York, The Museum of Modern Art, *Salvador Dalí: Paintings, Drawings, Prints*, 1941, exh. cat. by James T. Soby, no. 57, ill.). In the painting, the figure holds a butterfly and an hourglass, symbols of transitoriness.

Dalí linked *Inventions of the Monsters* to his "premonitions of war" paintings (see, for example, *Soft Construction with Boiled Beans: Premonition of Civil War*, 1936, Philadelphia Museum of Art; Descharnes and Néret 1994, vol. 1, pl. 632) and peopled it with different kinds of "monsters." On hearing in 1943 that the Art Institute had acquired *Inventions of the Monsters*, he sent a telegram:

Am pleased and honored by your acquisition. According to Nostradamus the apparition of monsters presages the outbreak of war. This canvas was painted in the Semmering mountains near Vienna a few months before the Anschluss and has a prophetic character. Horse women equal maternal river monsters. Flaming giraffe equals masculine apocalyptic monster. Cat angel equals divine heterosexual monster. Hourglass equals metaphysical monster. Gala and Dalí equal sentimental monster. The little blue dog alone is not a true monster.

Nostradamus (Michel de Nostredame, 1503–1566) published a collection of prophecies in 1566 that seemed to predict the war that was soon to engulf Europe. The Civil

52. FORMATION OF THE MONSTERS (FORMATION DES MONSTRES)

1937
Pen and black ink on pink laid paper; 25.6 x 16.7 cm (10¹/₁₆ x 6⁹/₁₆ in.)
Titled, signed, and dated, lower right: *formation des monstres / Salvador Dalí 1937*
The Lindy and Edwin Bergman Collection, 110.1991

PROVENANCE: Probably sold by the artist to Edward James, West Dean Estate, Chichester, England, between 1937 and 1938;[2] transferred to the Edward James Foundation, West Dean Estate, 1964;[3] on loan to the Brighton Art Gallery, 1966–76;[4] sold through The Mayor Gallery, London, to Lindy and Edwin Bergman, Chicago, 1983.

EXHIBITIONS: Sussex, Worthing Art Gallery, *Paintings from the Edward James Collection*, 1963, no. 67. Brighton Art Gallery, *Thirty Years of Surrealist Painting from the Edward James Collection*, 1967, no. 31. Durham, Dunelm House, *Durham Surrealist Festival*, 1968, exh. cat. by Ian Barker and Andrew Lanyon, no. 13, p. 15 (installation photo). Edinburgh,

Scottish National Gallery of Modern Art, *The Edward James Collection: Dalí, Magritte, and Other Surrealists*, 1976, no. 18. Paris, Musée national d'art moderne, Centre Georges Pompidou, *Salvador Dalí, rétrospective, 1920–1980*, 1979–80, no. 247 (ill.). London, The Tate Gallery, *Salvador Dalí*, 1980, no. 182. Tokyo, Isetan Museum of Art, *Rétrospective Salvador Dalí 1982*, 1982, traveled to Osaka, Kitakyushu, and Hiroshima, no. 42 (ill.). London, Robert Fraser Gallery and The Mayor Gallery, *Fifty Drawings by Salvador Dalí*

War in Spain, which broke out in 1936 between the Spanish Republican government and the Nationalist rebels, led by General Franco with support from Nazi Germany, was seen by many as the start of an international struggle against fascism. Hitler's long-threatened annexation of Austria (the Anschluss) took place in 1938, though it was not until 1939, after his invasion of Poland, that Britain and France declared war on Germany. In the spring of 1939, the Spanish Civil War ended with the victory of Franco.

Dalí was notoriously indifferent to European politics, however, an attitude that had contributed to his break with the Surrealists by the end of the 1930s. *Inventions of the Monsters* is thus not an "anti-war" painting in a politically engaged sense, unlike Picasso's *Guernica*, painted in the same year, which was a protest against the bombing of the Basque town of Guernica by the German Condor Legion. Dalí said of his painting *Autumn Cannibalism* (1936, London, The Tate Gallery; Descharnes and Néret 1994, vol. 1, pl. 636), for example, which depicts two melting figures devouring each other with knife and fork: "These Iberian beings, devouring each other in autumn, express the pathos of the civil war considered (by me) as a phenomenon of natural history, unlike Picasso who considers it as a political phenomenon" (Rotterdam, Museum Boymans-van Beuningen, *Dalí*, 1970–71, exh. cat., n. pag., under no. 53). The monsters presaging war in the Art Institute's painting should thus be understood as monsters "of natural history," close in their role and appearance to traditional allegorical or symbolic figures – the blue dog, as Dalí explained, being the only exception. The "monstrous" allegorical figures, such as the woman with the horse's head, if not traditional, conform at least on a structural level to mythical creatures such as centaurs or satyrs. Except for the flaming giraffe and the now

almost invisible blue dog, the figures in the final painting are all massed to the left-hand side of the canvas, leaving a desertlike space in the right half. This unbalanced structure reflects Dalí's "contempt for the classic formulas of composition" (James T. Soby, in New York 1941, p. 28).

The drawing focuses on the heads alone, combining a profile and frontal view of two heads of more ambiguous gender than those in the painting. In the drawing, the head on the left could be male and the other female. The profile on the left seems to represent an older, more marked, and sagging figure. The profile as a whole exhibits the androgynous character of much Renaissance portraiture and bears some resemblance to Raphael's *Portrait of Agnolo Doni* (c. 1506, Florence, Palazzo Pitti; Mina Gregori, *Paintings in the Uffizi and Pitti Galleries*, Boston, 1994, p. 168, no. 208, ill.). The drawing of the eyes is peculiar, however, in that lines representing eyebrows fill out the space of the eye sockets. In the painting, the eyes are so dark as to appear like hollows, thus suggesting that this figure may represent blind fate. The references to the classical tradition, both in antiquity and in the Renaissance – the figure's robes, for instance, or the amphora half-buried in the ground in the painting – are typical of Dalí's preoccupations at the time, but this tradition seems here to be under threat, pointing perhaps to his idea that a medieval period had been announced, "which was going to spread its shadow over Europe" (Salvador Dalí, *The Secret Life of Salvador Dalí*, tr. by Haakon M. Chevalier, New York, 1961, p. 371). * * *

Figure 3. Salvador Dalí, *Inventions of the Monsters*, 1937, oil on canvas, 125.1 x 99.1 cm, The Art Institute of Chicago, Joseph Winterbotham Collection, 1943.798.

from the Edward James Collection, 1983, no. 16 (cover ill.). Chicago 1984–85, no cat. nos., p. 133 (ill.). Staatsgalerie Stuttgart, *Salvador Dalí, 1904–1989*, 1989, traveled to Zurich, exh. cat. by Karin v. Maur, no. 194 (ill.), as *Etude pour "L'Invention des monstres."* Humlebaek, Denmark, Louisiana Museum of Modern Art, *Salvador Dalí*, 1989–90, exh. cat. published in *Louisiana Revy* 2, 30 (Dec. 1989), no. 112 (ill.), as *Etude pour "L'Invention des monstres."* The Montreal Museum of Fine Arts, *Salvador Dalí*, 1990, no. 38 (ill.), as *Study for "The Invention of Monsters."*

REFERENCES: Robert Descharnes, *Salvador Dalí: The Work, the Man*, New York, 1984, p. 212 (ill.). Margherita Andreotti, "The Joseph Winterbotham Collection," *The Art Institute of Chicago Museum Studies* 20, 2 (1994), p. 168 (ill.). Robert Descharnes and Gilles Néret, *Salvador Dalí, 1904–1989*, tr. by Michael Hulse, Cologne, 1994, vol. 1, *The Paintings, 1904–1946*, pl. 651; vol. 2, *The Paintings, 1946–1989*, p. 757, no. 651, as *Creation of the Monsters*.

53. IMAGINARY PORTRAIT OF LAUTRÉAMONT AT THE AGE OF NINETEEN OBTAINED ACCORDING TO THE PARANOIAC–CRITICAL METHOD

1937
Graphite on ivory wood-pulp laminate board; 53.5 x 36.2 cm (21¹/₁₆ x 14¹/₄ in.)
Signed and dated, lower center: *Gala Salvador Dalí / 1937*
Titled, lower right: *Portrait imaginaire de Lautreamont a 19 ans / obtenu d'apres la metode* [sic] *"PARANOYAque critique"*
The Lindy and Edwin Bergman Collection, 111.1991

PROVENANCE: Probably sold by the artist to Edward James, West Dean Estate, Chichester, England, between 1937 and 1938;[5] transferred to the Edward James Foundation, West Dean Estate, February 1978;[6] sold through The Mayor Gallery, London, to Lindy and Edwin Bergman, Chicago, 1983.

EXHIBITIONS: New York, Julien Levy Gallery, *Salvador Dalí*, 1939, no. 25, as *Imaginary Portrait of Lautréamont.* Paris, Musée national d'art moderne, Centre Georges Pompidou, *Salvador Dalí, rétrospective, 1920–1980*, 1979–80, no. 275 (ill.). London, The Tate Gallery, *Salvador Dalí*, 1980, no. 189. Tokyo, Isetan Museum of Art, *Rétrospective Salvador Dalí 1982*, 1982, traveled to Osaka, Kitakyushu, and Hiroshima, no. 40 (ill.), as *Imaginary Portrait of Lautréamont.* London, Robert Fraser Gallery and The Mayor Gallery, *Fifty Drawings by Salvador Dalí from the Edward James Collection*, 1983, no. 17. Chicago 1984–85, no cat. nos., p. 133 (ill.). Chicago 1986, no. 6. Staatsgalerie Stuttgart, *Salvador Dalí, 1904–1989*,

The focus on certain details and the emphasis on a single, gazing eye recall other portraits by Dalí of this period, most significantly his self-portrait in *Impressions of Africa* and related preparatory drawings for this painting of 1938 (Rotterdam, Museum Boymans-van Beuningen; Descharnes and Néret 1994, vol. 1, pls. 671–73). Dalí may also have taken a cue from a mysterious image, a very detailed pencil drawing of a single eye, reproduced in *La Révolution surréaliste* (2 [Jan. 15, 1925], p. 25) with the caption "Marcel Proust, par Georges Bessière." Imagery centering on eyes or an eye is ubiquitous in Surrealist art, where it usually stands paradoxically for the idea of internal rather than external vision. Lautréamont was regarded by the Surrealists as one of the great visionaries.

Dalí signed this drawing with his own name preceded by that of his companion, Gala, whom he had met in 1929, when she was still married to Paul Eluard. This dual signature reflects the intensity of his relationship with Gala (see Dalí 1961, pp. 399–400), which led to a degree of identification with her. * * *

THIS DRAWING WAS REPRODUCED AS THE FRONtispiece to Comte de Lautréamont, Isidore Ducasse, *Oeuvres complètes: Chants de Maldoror, poésies, lettres* (Paris, 1940). Lautréamont was central to the alternative literary genealogy the Surrealists constructed for themselves; his violent, gothic epic, *Les Chants de Maldoror,* was particularly valued for its extraordinary poetic images, such as the famous metaphor "as beautiful as the chance encounter on a dissecting table of a sewing machine and an umbrella" (*Oeuvres complètes*, Paris, 1963 ed., rev. and enl., p. 327), which virtually became the Surrealists' motto.

Very little was known about Lautréamont, however. Dalí claimed the portrait was obtained using his "paranoiac-critical" method, which he thought of as a "spontaneous method of irrational knowledge" (Salvador Dalí, *Conquest of the Irrational*, New York, 1935, p. 15). Usually, this method involved alternative readings of objective phenomena, as in the double images with which he was experimenting at this time (see *The Image Disappears*, no. 54), which Dalí described as a form of delirium. Here, however, it seems there was no original object or image to provoke the paranoiac associations; the image developed spontaneously by a process of intense concentration of the imagination. Dalí once compared himself to a medium, able to "see" images "that would spring up in my imagination" (Salvador Dalí, *The Secret Life of Salvador Dalí*, New York, 1961, tr. by Haakon M. Chevalier, p. 220), which he could then situate on the blank page or canvas.

1989, traveled to Zurich, exh. cat. by Karin v. Maur, no. 160 (ill.), as *Portrait imaginaire de Lautréamont.* Humlebaek, Denmark, Louisiana Museum of Modern Art, *Salvador Dalí,* 1989–90, exh. cat. published in *Louisiana Revy 2,* 30 (Dec. 1989), no. 107, as *Portrait imaginaire de Lautréamont.* The Montreal Museum of Fine Arts, *Salvador Dalí,* 1990, no. 49 (ill.), as *Imaginary Portrait of Lautréamont.*

REFERENCES: Comte de Lautréamont, Isidore Ducasse, *Oeuvres complètes: Chants de Maldoror, poèsies, lettres,* ed. by Edmond Jaloux, Paris, 1940,

frontispiece (drawing cropped). A. M. Hammacher, *Phantoms of the Imagination: Fantasy in Art and Literature from Blake to Dalí,* tr. by Tony Langham and Plym Peters, New York, 1981, pp. 126–27, fig. 108. Robert Descharnes and Gilles Néret, *Salvador Dalí, 1904–1989,* tr. by Michael Hulse, Cologne, 1994, vol. 1, *The Paintings, 1904–1946,* pl. 666 (frontispiece to Ducasse 1940); vol. 2, *The Paintings, 1946–1989,* p. 757, no. 666.

54. THE IMAGE DISAPPEARS

1938
Pen and black ink on ivory wove paper; 64.7 x
50.8 cm (25 1/2 x 20 in.)
Inscribed, signed, and dated, lower left: *Fait
expressément pour étoner* [sic] *Galutzka / Gala*
(Done especially to amaze Galutzka / Gala)[7]
Salvador Dalí 1938
A Gift from Lindy and Edwin Bergman, 1986.861

PROVENANCE: Julien Levy, Bridgewater,
Massachusetts, by 1939; sold to Lindy and Edwin
Bergman, Chicago, 1961; given to the Art
Institute, 1986.

EXHIBITIONS: Probably New York, Julien Levy
Gallery, untitled group exhibition, 1939, no. 19.
Possibly The Art Institute of Chicago, *The Nine-
teenth International Exhibition of Watercolors*,
1940, no. 108. Possibly New York, Julien Levy
Gallery, *A Decade of Painting, 1929–1939*, 1940,
nos. 46–48, as *Drawing*. The Art Institute of

Chicago, *Chicago Collectors*, 1963, no cat. nos.,
p. 5, as *Self-Portrait with Hidden Image of
Vermeer Interior*. Chicago 1966, no. 17, as
Disappearing Self-Portrait after Vermeer.
Chicago 1984–85, no cat. nos., p. 135 (ill.),
as *The Image Disappears* (*Self-Portrait*).
Staatsgalerie Stuttgart, *Salvador Dalí, 1904–
1989*, 1989, traveled to Zurich, exh. cat. by
Karin v. Maur, no. 208 (ill.).

THIS DRAWING IS ONE OF SEVERAL RELATED to the 1938 painting *The Image Disappears* (fig. 4). These drawings explore various stages of Dalí's "paranoiac-critical" interpretation of Jan Vermeer's *Woman in Blue Reading a Letter* (c. 1662–64, Amsterdam, Rijksmuseum; Arthur K. Wheelock, Jr., *Jan Vermeer*, New York, 1988, pl. 17), by means of which he produced a secondary reading of Vermeer's original image of the figure of a girl standing by a curtain in a room with a checkered floor. Dalí so adjusted the sweeping strokes and hatchings of his drawing that they form the head of a bearded man in profile, with the woman's shoulder and upper arm forming the man's nose, her head forming his right eye, and the curtain framing her, the man's long hair.[8] Dalí had been a passionate admirer of Vermeer's paintings since his student days. In this drawing, the head in a sense takes precedence over Vermeer's subject; details such as the letter the woman reads and the table by which she stands are virtually absorbed into the second image of the man's head. Dalí was more interested in the tonal than in the linear character of drawing here, and it is largely through contrasts of light and shade that he succeeds in creating the double image of a head that can also be read as a girl in a room.

Breton called Dalí's "paranoiac-critical method" an "instrument of primary importance" for Surrealism (André Breton, "What Is Surrealism?" in *What Is Surrealism?: Selected Writings*, ed. by Franklin Rosemont, New York, 1978, p. 136), valuing both its associa-

tional and critical possibilities. By the late 1930s, Dalí had perfected his technique of drawing and painting images susceptible to alternative readings. The virtuoso *Endless Enigma* (1938, Madrid, Museo Nacional Reina Sofía; Descharnes and Néret 1994, vol. 1, pl. 687) has no less than six alternative readings. At about the time he was working on *The Image Disappears*, Dalí also subjected Jean François Millet's *Angelus* (1857–59, Paris, Musée d'Orsay) to an extended critique, which drew on Sigmund Freud's essay *Leonardo da Vinci and a Memory of His Childhood* (1910). Dalí was especially struck by Freud's reference to the hidden or "unconscious" presence of a vulture in Leonardo's *Virgin and Child with Saint Anne* (c. 1510, Paris, Musée du Louvre), and used his own "paranoiac-critical" method to uncover unconscious ideas masked by symbolic images in the *Angelus* (lost at the beginning of the war, Dalí's manuscript was finally published as *Le Mythe tragique de l'angelus de Millet*, Paris, 1963). * * *

Figure 4. Salvador Dalí, *The Image Disappears*, 1938, oil on canvas, 55.9 x 50.8 cm, Figueres, Fundació Gala-Salvador Dalí, gift of Dalí to the Spanish state [photo: © Fundació Gala-Salvador Dalí].

55. THE LAMPS (LES LAMPES)

May 1937
Oil on canvas; 102.9 x 129.5 cm (40$\frac{1}{2}$ x 51 in.)
Signed and dated, lower right: *P. DELVAUX / 5–37*
Inscribed on stretcher: *Delvaux Les Lampes / Col.
~~Penrose~~ Mesens*
The Lindy and Edwin Bergman Collection,
113.1991

PROVENANCE: London Gallery;[1] sold to Gordon
Onslow Ford, London and New York, c. 1939;[2] on
loan to the Julien Levy Gallery, New York, by 1942;
on loan to the Wadsworth Atheneum, Hartford,
Connecticut, from 1942;[3] sold to the Allan
Frumkin Gallery, Chicago, by 1958; on loan to
The Minneapolis Institute of Arts, November 25
to December 22, 1958;[4] sold to Lindy and Edwin
Bergman, Chicago, 1959.

EXHIBITIONS: Brussels, Palais des beaux-arts,
Paul Delvaux, 1938, no. 2. London Gallery, *Paul
Delvaux*, 1938, no. 12, as *The Women and the
Lamps* (a checklist of this exhibition was published
in *London Bulletin* 3 [June 1938], p. 3). Possibly
Hartford, Connecticut, Wadsworth Atheneum,
Painters of Fantasy, 1942, no cat.[5] Possibly New
York, Julien Levy Gallery, *Paul Delvaux: Paintings*,
1946–47, no cat. nos.[6] Possibly New York, Julien
Levy Gallery, *Paul Delvaux*, 1949.[7] The University
of Chicago, Bergman Gallery, *Avant-garde
Chicago*, 1968, no cat. nos., n. pag. (ill.), as
Women with Lamps. Chicago 1984–85, no cat.
nos., p. 138 (ill.).

REFERENCES: *Beaux Arts* (Brussels) 8, 269 (25
Feb. 1938), p. 15 (ill.). *London Bulletin* 3 (June
1938), p. 5 (ill.), as *The Women and the Lamps*.
Peggy Guggenheim, *Out of this Century: The
Informal Memoirs of Peggy Guggenheim*, New

THE MYSTERIOUS CHARACTER OF THIS PAINT-ing by Delvaux naturally invites the idea of a dream. The nude women are themselves sleep-walkers, moving across and away from the viewer; the nearest is virtually within the spectator's space. Unlike the conventional nude of Western painting, though, who mostly appears as passive object, she hurries, taking long strides. It seems natural to talk of her in the singular, for she is an individual multiplied, rather than many women. She does, however, appear in two guises: in the first, one arm modestly hides her breasts, while the other arm is mysteriously invisible, but might be imagined in the typical pose of a *Venus pudica*, the "modest Venus" of classical Greek sculpture, shielding the lower part of her body. In her second appearance (see the three figures prowling in a wide circle on the rock-strewn plain between the stone platform and the mountains), she abandons the modest gesture and now carries an oil lamp like those resting on the platform. These changes suggest that she has passed through some initiatory ritual, under the dark arches, toward which the two foreground figures are headed.[8]

The nature of this ritual may be hinted at by the bas-relief scenes on the triumphal arch. These scenes are sexual in character and do not seem to relate obviously to classical mythology, or if they do, it is in unexpected or even subversive ways. Is it Daphne, in the upper scene who, half tree-trunk, seems to be looming aggressively over the kneeling, nude woman beside her? And in the lower scene, what are we to make of the passionate embrace between two women, the figure on the right arched backward like the Uffizi *Niobe*? Several of these nudes are from Delvaux's own earlier paintings; they have, as it were, usurped the figures of classical mythology. The only male among the stone reliefs is the young man with a broken arm, reclining alone in the pediment of the triumphal arch.

Perhaps, considering the climate in Europe at the time, there is a contemporary significance to Delvaux's strange melding of modern women with the classical nude and Ingres's luxurious bodies. As Matthew Gale has suggested (in conversation with the author), the striding nudes recall the vestal virgins who protected the sacred flame of the Roman goddess of the hearth. The details of decay – the broken entablature, the apparent abandonment of the buildings, the grass between the paving stones – might point to the women as guardians of a doomed civilization. The eerie repetition of the nudes lifts the scene beyond an erotic dream into a realm of anxiety, an anxiety fueled perhaps by the possibility of a nightmare return of a European conflict that had seen Belgium helpless in the face of German invasion in 1914. By 1937, the threat of a new war with Germany hung over the old world, with the fear that a repetition of the terrible conflict of World War I would end in the collapse of civilization. The contrast in Delvaux's painting between the decaying past and the bleak, stony, primeval landscape beyond seems to embody this nightmare. The women, as the last guardians and only survivors, perhaps presage André Breton's appeal in *Arcane 17* to "strip man of the power of which

York, 1946, p. 221, as *Women with the Lamps* (in the 1979 edition, p. 160, this reference was changed to *The Call of the Night*). Paul-Aloïse De Bock, *Paul Delvaux: Der Mensch, der Maler*, Hamburg, 1965, p. 35, pl. 3. Paul-Aloïse De Bock, *Paul Delvaux: L'Homme, le peintre, psychologie d'un art*, Brussels, 1967, p. 69, fig. 27, p. 289, no. 27. E[nrico] C[rispolti], "Paul Delvaux," in *Alternative Attuali 3*, L'Aquila, Castello Spagnolo, 1968, exh. cat., p. 1.113. José Vovelle, *Le Surréalisme en Belgique*, Brussels, 1972, pp. 198, 206, as *Femmes et lampes*. Arch. Digest 1973, p. 23 (photo of Bergman home). Xavier Marret, "Paul Delvaux, le temps suspendu," *Vie des arts* (Montreal) 17, 70 (Spring 1973), p. 49. Ludwig Schreiner, *Kataloge der niedersächsischen Landesgalerie Hannover*, vol. 3, *Die Gemälde des neunzehnten und zwanzigsten Jahrhunderts*, Munich, 1973, pt. 1, p. 105, as *Frauen und Lampen*. "Lighting Effects in Painting," *International Lighting Review* (Amsterdam) 25, 4 (1974), p. 121, as *Women and Lamps*. Michel Butor, Jean Clair, and Suzanne Houbart-Wilkin, *Delvaux*, Brussels, 1975, p. 174, no. 83 (ill.). Jacques Sojcher, *Delvaux et la passion puérile*, Paris, 1991, fig. 8.

Figure 1. Paul Delvaux, *Women and Lamps*, April 1937, watercolor and pen and black ink on paper, laid down on board, 48.2 x 64.5 cm, private collection [photo: courtesy of Christie's, London].

he has sufficiently proved his misuse, and put that power in the hands of women" (André Breton, *Arcane 17*, New York, 1944, reprint, Paris, 1965, p. 64). For it was women's ideas and women's values alone that were needed: a feminine system in the world, rather than the masculine one responsible for the war. The distant figures bearing lamps could then be interpreted not only as having emerged from a sexual initiation, as was first suggested, but also as carrying beacons of promise in a devastated world – the wise virgins, perhaps, of biblical parable, who kept their lamps ready.

An ink and watercolor drawing (fig. 1), dated just one month before *The Lamps*, is clearly a preliminary study for the painting and reveals intriguing changes in the final composition. The figures in the drawing are more differentiated and in some ways more sexualized than those in the painting. The figure approaching the arch is dressed in a black body stocking, and the hair of both women is less tamed and dressed. The arch, moreover, presents a single high-relief carving of a nude rather than the ambiguous mythological scenes found in the painting. In the drawing, the foreground figure stands

fully within the picture's space, while in the painted version, because the edge of the frame cuts across her legs, she appears to emerge from the spectator's space. Finally, the artist replaced a ruin, which stands in the plain between stone pavement and hills, with the circling nudes bearing lamps in the painting.

Ruins appear frequently in Delvaux's paintings of the 1930s and 1940s. Their presence seems to reflect "an awareness of how the meanings of images are deeply bound up with the past – the past of civilization . . . and the lived past of the individual (as it might be explored through psychoanalysis)" (David Scott, *Paul Delvaux: Surrealizing the Nude*, London, 1992, p. 46). In his rare comments, Delvaux mentioned the importance of childhood memories: "These objects (lamps, trains) come from my childhood. Impressions received during childhood are the strongest: they are what I saw with a certain wonder" (quoted in Antoine Terrasse, *Paul Delvaux*, Paris, 1972, p. 13).

It is not just a matter, then, of a simple dream image here, but of a complex of memory, dream, desire, and anxiety. If the mystery evoked by Delvaux's picture is like that of a dream, it is perhaps because the very idea of dream allows a suspension of the normal laws of logic and reality in order to express other truths. * * *

56. TWO NUDE WOMEN (DEUX FEMMES NUES)

1942
Gouache, possibly casein, on panel; 64.8 x 46.4
cm (25½ x 18¼ in.)
Signed, dated, and inscribed: *J Dubuffet / 1942*
(lower right); *à Marie Louise / Destombes*
(center right)[1]
The Lindy and Edwin Bergman Collection,
114.1991

PROVENANCE: P. Destombes, Paris. Kleemann
Galleries, New York, by 1955.[2] Dr. Louis L. Heyn,
Los Angeles; sold April 1980 to the Margo Leavin
Gallery, Los Angeles; sold that same month
to the Galerie Baudoin Lebon, Paris;[3] sold to a
private collector, Paris, 1980.[4] Galerie Baudoin
Lebon, Paris, by 1983; sold to Jeffrey Hoffeld and
Co., Inc., New York, 1983;[5] sold to Lindy and
Edwin Bergman, Chicago, 1984.

EXHIBITIONS: New York, Kleeman Galleries,
Six French Painters, 1955, no. 12 (ill.), as

Musiciennes. The University of Chicago, David
and Alfred Smart Gallery, *Jean Dubuffet: Forty
Years of His Art*, 1984–85, traveled to Saint
Louis, no. 1 (Chicago only).

REFERENCES: Max Loreau, *Catalogue des
travaux de Jean Dubuffet*, vol. 1, *Marionettes de
la ville et de la campagne*, Paris, 1966, p. 34,
no. 18 (ill.).

IN 1942, DUBUFFET DECIDED FOR THE THIRD time to devote himself to painting, having abandoned the attempt twice before. In the 1920s, while many among those with whom he associated only spoke of giving up art, Dubuffet had actually done so. As he put it, "there's more art in the remarks of the hairdresser's assistant, in his life, in his head, than among the specialists," who missed, according to Dubuffet, the "joy and certainty" that he perceived in the lives of ordinary working people (Paris, Musée des arts décoratifs, *Rétrospective Jean Dubuffet*, 1960, exh. cat., p. 32). He thus became a wholesale wine merchant. In 1934, Dubuffet made a second attempt to create a form of popular, communal art by starting a theater, making masks of his friends, and carving wooden marionettes, but once again decided to return to commercial life.

The circumstances that led to Dubuffet's definitive return to painting in the 1940s are obscure. Although his paintings of the period appear to express spontaneity and a childlike enjoyment of everyday life, these qualities were hard won and of very pointed significance within the cultural politics of that difficult period. Paris was occupied by the Germans; in 1942, a large exhibition of works by the sculptor Arno Breker – whose anodyne nudes and heroic male figures annexed the classical tradition to Nazi ideology – was held at the Orangerie, while an exhibition of works by Wassily Kandinsky was closed by the German authorities. At the same time, under the banner of "business as usual," the Germans sought to maintain Paris's traditional veneer of glamour. The eruption of the primitive in Dubuffet's vision of Paris and its inhabitants (which was close in spirit to Brassaï's photographs of Paris graffiti; see, for example, *Minotaure* 3–4 [Dec. 12, 1933], pp. 6–7) was profoundly opposed to such prevailing concepts of beauty. It was also fueled by the discovery of the cave paintings at Lascaux in 1940, which helped to authorize a source of art different from and older than that of the Greeks, and one, moreover, that was French. Assumptions about what was barbarous and what was civilized had been thoroughly shaken.

The directness, simplicity, and apparent naiveté of Dubuffet's work – nudes, country scenes with graceless cows and bird's-eye views of fields, Paris streets and the metro with childlike figures – sprang not from ignorance but from a conviction of the hollowness and irrelevance of the Western tradition of painting and its conventions of beauty, which he dubbed an "imposture." Like Dada and Surrealist artists, he valued the untaught art of children and the insane, as well as so-called primitive art.

Two Nude Women is like a naive version of twin pin-ups; the exaggerations of the erotic exemplified by the simplified distortions of huge eyes, breasts, Cupid's bow lips, and slender bodies are belied by the women's grotesquely large hands. Traces of a fiercer red paint beneath the thick, fleshy pink and the flat, complementary green, erupt in the genitals of the left-hand figure. By contrast with a small group of paintings of nude women playing musical instruments, dating from the same period and sharing many of the features of *Two Nudes* (for example, Dubuffet's *Musicians* of 1942; Loreau, vol. 1, p. 34, no. 20, ill.), the women here are inactive; they maintain an ironic relation to the tradition of the nude as passive object of pleasure. Dubuffet may still have been working from the model at this point. In subsequent paintings of the female body, few traces of this process survive. In *Great Coal Nude* of 1944 (Loreau, vol. 1, p. 174, no. 326, ill.), for instance, the artist was primarily inspired, while painting the body, by the memory of seeing huge blocks of mineral on display outside at the Jardin des Plantes in Paris. As Georges Limbour remarked, "it would thus be wrong to seek in this great block of coal any human signification" (Georges Limbour, "Jean Dubuffet ou l'imagination de la matière," *Servir* [Lausanne], 24 and 31 May, 1945, reproduced in Loreau, vol. 1, p. 240). When he showed his paintings at his first solo exhibition at the Galerie René Drouin in Paris in 1944 – an exhibition that caused a public outcry – Dubuffet acknowledged that his manner of drawing was quite exempt from normal displays of skill, which, in his opinion, "extinguished spontaneity."

In *Two Nudes*, the paint is of a dry-paste consistency, uncharacteristic of oil, and is built up in a series of matte layers. The contour lines around the figures are not part of a preliminary sketch, but rather serve to reinforce the design. The surface appears to be unvarnished, and there are passages of retouching over the cracks within the flesh colors. * * *

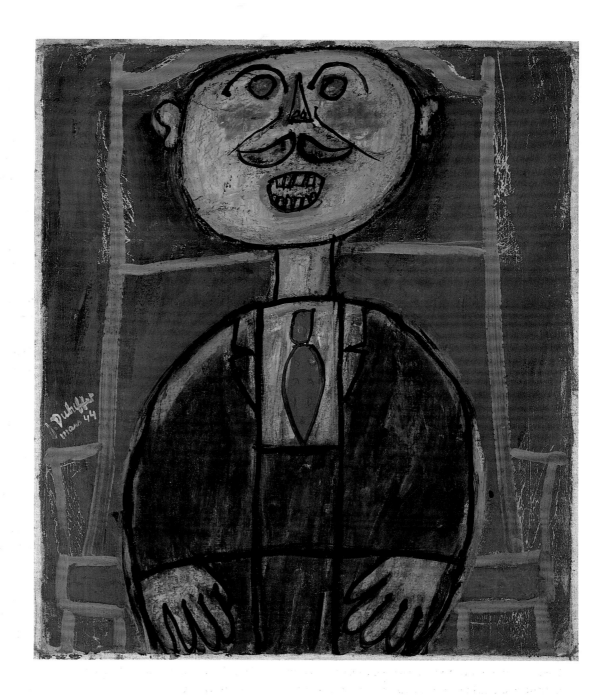

57. LITTLE SNEERER (PETIT RICANEUR)

March 1944
Oil on canvas, 54.6 x 45.7 cm (21½ x 18 in.)
Signed and dated, middle left: *J. Dubuffet / mars 44*
The Lindy and Edwin Bergman Collection, 115.1991

PROVENANCE: Reverdy collection, Algiers. Galerie Gianna Sistu, Paris; sold to Daniel Varenne, Geneva, and B. C. Holland, Inc., Chicago, 1981;[6] sold to Lindy and Edwin Bergman, Chicago, 1982.

EXHIBITIONS: Paris, Galerie René Drouin, *Exposition de tableaux et dessins de Jean Dubuffet*, 1944, no. 38. The University of Chicago, David and Alfred Smart Gallery, *Jean Dubuffet: Forty Years of His Art*, 1984–85,

traveled to Saint Louis, no. 2. Chicago 1986, no. 7.

REFERENCES: Lorenza Trucchi, *Jean Dubuffet*, n. p., 1965, fig. 41. Max Loreau, *Catalogue des travaux de Jean Dubuffet*, vol. 1, *Marionettes de la ville et de la campagne*, Paris, 1966, p. 130, no. 232 (ill.).

For discussion, see no. 58.

58. HEAD OF A MAN (TÊTE D'HOMME)

1945
Brush and black ink and gray wash, with wiping on cream wove paper; 65.4 x 48.9 cm (25³/₄ x 18⁷/₈ in.)
Signed and dated, top right: *J. Dubuffet 1945*
The Lindy and Edwin Bergman Collection, 117.1991

PROVENANCE: Sold Sotheby's, London, July 4, 1973, no. 265, to Waddington and Tooth Galleries, Ltd., London; sold to a private collector; sold to Waddington and Tooth Galleries, Ltd., London, 1975;[7] sold to Lindy and Edwin Bergman, Chicago, 1977.

REFERENCES: Max Loreau, *Catalogue des travaux de Jean Dubuffet*, vol. 1, *Marionettes de la ville et de la campagne*, Paris, 1966, p. 207, no. 398 (ill.).

ITTLE SNEERER (NO. 57), LIKE A COMPANION piece of the same date, *Little Bawler* (*Petit Hurleur*; Loreau, vol. 1, p. 130, no. 231, ill.), was made while Dubuffet was working on the series *Marionettes of Town and Country*. The link with street graffiti here is clear, not just in the simplified, caricature-like form, but also in the streaks and incisions on the surface. The sharp, red detail of the tie and the ruddy blobs for cheeks also recall children's painting. Daniel Cordier described such types in Dubuffet's work as *bonhommes* (fellows): "This image that the child improvises in its first drawings covers the walls of towns, school books, roads and pavements, universal symbol of man's curiosity about himself" (Daniel Cordier, *Les Dessins de Jean Dubuffet*, Paris, 1960, n. pag.).

Dubuffet's interest, though, was in the absence of individuality in such "universal" images, and he wrote to Jean Paulhan in 1944: "My system depends in fact upon the identical character of all men; for me there is only a single man in the universe, whose name is Man, and if all painters signed their works with this name: picture painted by a man, see how pointless any questioning would appear" (London, Barbican Art Gallery, *Aftermath, France 1945–54: New Images of Man*, 1982, exh. cat., p. 75). *Head of a Man* (no. 58) takes this process of stripping away individual character even further; the human form is reduced to, or perhaps concentrated into, a masklike face – the ears, for instance, are represented as flat protrusions with holes in them, as they are in an Aztec mask and in the carnival masks Dubuffet's friend Georges Limbour once chillingly described (Georges Limbour, "Eschyle, le carnaval et les civilisés," *Documents* 2, 2 [1930], p. 97). The symmetrical rectangle that descends from the teeth even recalls the bared fangs of an ancient Mexican deity.

Nothing could be further from these de-individualized images than the idealized form usually conjured up by the notion of a "universal" humanity, at least in the Greco-Roman tradition. Yet even if Dubuffet's figures are without dignity, they are not without a kind of grandeur. The frontal symmetry of both *Head of a Man* and *Little Sneerer* invites, especially in the latter, a comparison with architecture. The Sneerer is seated in a chair that frames him and fills the canvas, and his own form is governed by simple geometric shapes. This mode of representation suggests a parallel with Georges Bataille's Critical Dictionary entry on "Architecture" (*Documents* 1, 2 [1929], p. 117). Here the idea that architecture is the expression of the social being, just as physiognomy is the expression of the individual being, is given a revolutionary twist:

In effect, only the ideal being of society, that which orders and prohibits with authority, is expressed in architectural compositions properly so-called. Thus the great monuments rise like barriers, opposing the logic of majesty and authority to all troublesome elements: it's in the form of cathedrals and palaces that Church or State address and impose silence on the multitudes.

So, Bataille argued, whenever "architectural composition" is found in sites other than monuments, whether physiognomy, music, or painting, it implies the presence of human or divine authority. But with the transformations of modern painting, the collapse of the classical order, and the deformation of the human form, such ideas are contradicted. Modern paintings open the way to "the expression of psychological processes incompatible with social stability" (Georges Bataille, ibid.). So Dubuffet's demotic Man, his very origin in the defacement of architecture (graffiti), seems to erect his own counter-architecture to the authority of the ideal.

The relationship of the figure to the support in *Head of a Man* is quite different from that in *Little Sneerer*. Rather than seeming to stand out from a background, the thinned-down ink etches the head into the paper. This is an important stage on the way to Dubuffet's *hautes pâtes*, the thick-paste paintings of the late 1940s, in which figures are cut into a deep medium. The artist called the style of his 1942–44 paintings "theatrical," a description that seems appropriate to both *Little Sneerer* and the slightly later *Head of a Man*: "The idea is to represent things by boldly simplified, exaggerated and even burlesque means, the coloring brutal, the outlines excessively marked, the lines black and very conspicuous" (Jean Dubuffet, "Memoir on the Development of My Work from 1952," in Peter Selz, *The Work of Jean Dubuffet*, New York, The Museum of Modern Art, 1962, exh. cat., p. 137). Dubuffet saw these very bold lines, whether black strokes or incisions in the paint, as a kind of *humanization* of the subject, by contrast with an overall treatment of the picture surface that *dehumanized* the subject. However, he admitted that these contrary claims were often present at one and the same time, resulting "in paintings that have something of each"; *Little Sneerer* and *Head of a Man* seem, indeed, to possess elements of these opposite extremes: the humanized and the dehumanized. * * *

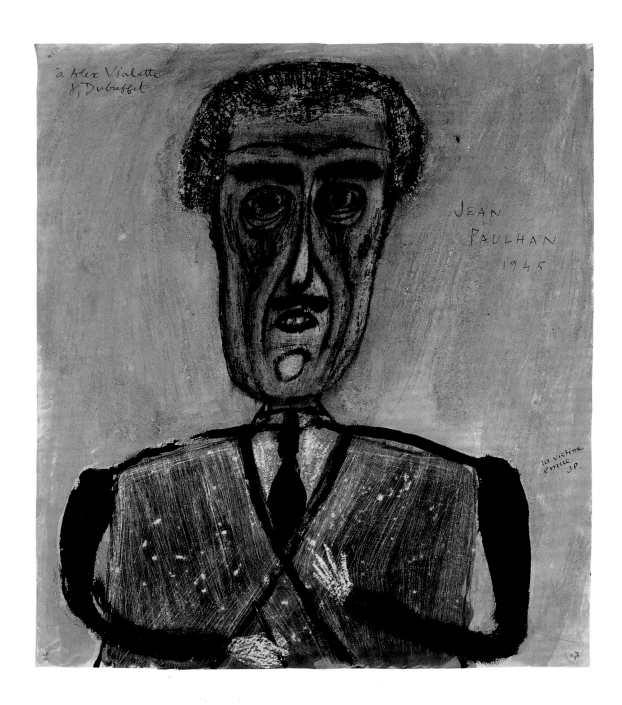

59. PORTRAIT OF JEAN PAULHAN

1945
Brush and black ink, gray and yellow wash with
scratching on white paper; 37.5 x 32.1 cm (14³/₄ x
12⁵/₈ in.)
Signed, dated, and inscribed: *à Alex Vialette / J.
Dubuffet* (top left); *Jean / Paulhan / 1945* (middle
right); *la victime / émue / JP.* (lower right)

The Lindy and Edwin Bergman Collection,
116.1991

PROVENANCE: Sold by B. C. Holland, Inc.,
Chicago, through the Allan Frumkin Gallery,
New York, to Lindy and Edwin Bergman,
Chicago, 1981.

EXHIBITIONS: The University of Chicago,
David and Alfred Smart Gallery, *Jean Dubuffet:
Forty Years of His Art*, 1984–85, traveled
to Saint Louis, no. 5. Chicago 1986, no. 8.

REFERENCES: Max Loreau, *Catalogue des
travaux de Jean Dubuffet*, vol. 2, *Mirobolus,
Macadam et Cie*, Paris, 1966, p. 27, no. 20 (ill.).

EAN PAULHAN (1884–1968) HAD LONG BEEN AT the center of literary and intellectual life in France when he met Dubuffet in 1943 and became a close friend and supporter. He had edited the important journal *La Nouvelle Revue française* between 1925 and 1940, and during the German Occupation he was a member of the underground Comité national des écrivains and a founder of the clandestine journal *Les Lettres françaises*. Prominent in the French intellectual resistance to the Occupation, Paulhan after the war opposed the draconian literary purges of former collaborators, which he saw as dangerously close to reverse fascism. Dubuffet strongly supported Paulhan's position and shared his skepticism about the rhetoric of liberation and patriotism (see Susan J. Cooke, "Jean Dubuffet's Caricature Portraits," in *Jean Dubuffet, 1943–1963*, Washington, D.C., Hirshhorn Museum and Sculpture Garden, 1993, exh. cat.).

Paulhan introduced Dubuffet to the dealer René Drouin and wrote the preface to Dubuffet's first exhibition at the Drouin gallery in 1944. In 1945, the two men went to Switzerland, where Dubuffet began his research into what he called *art brut* (raw art), visiting Saint Moritz, Lausanne, and Geneva. The artist's interest in "outsider art" and, in particular, the art of the insane went back to the 1920s, when he was given Hans Prinzhorn's *Bildnerei der Geisteskranken* (1922). It was an interest shared with the Surrealists, as well as with Paulhan; André Breton in fact became closely involved with Dubuffet from 1948 in the Compagnie de l'art brut. Switzerland was a rich source for the study of the art of the insane. Dr. Walter Morgenthaler had published a book on his patient Adolf Wölfli, *Ein Geisteskranker als Kunstler* (Bern, 1921); in Geneva, Dubuffet saw Professor Ladame's collection of drawings by sick people; and in Lausanne he got to know Aloïse Corbaz, who had been diagnosed with schizophrenia and hospitalized in 1918. From 1941 until her death in 1964, "her amorous and operatic fantasies found expression in a colourful and prolific artistic production" (London, Hayward Gallery, *Outsiders: An Art without Precedent or Tradition*, 1979, exh. cat., p. 38).

Dubuffet's own collection of *art brut* is today housed in Lausanne (in the Château de Beaulieu, where the collection was formally inaugurated in 1976). He chose this term, as he wrote in 1945 to René Auberjonois, in preference to another he considered, *art obscur* (obscure art), because "the art of the professionals did not seem to me more clairvoyant, more lucid, but rather the opposite" (Jean Dubuffet, *Prospectus et tous écrits suivants*, vol. 2, ed. by Hubert Damisch, Paris, 1967, p. 240). Dubuffet defined *art brut* as "works carried out by people unscathed by artistic culture, in which, therefore, mimicry, contrary to what happens with the intellectuals, has little or no part, such that their authors take everything (subjects, choice of materials, means of transposition, rhythms, types of writing, etc.) from their own sources and not from the clichés of classical or fashionable art" (ibid., vol. 1, pp. 201–02).

It seems to have been immediately on his return from the 1945 trip to Switzerland that Dubuffet made his series of portraits of Paulhan; thirteen are listed in Loreau's catalogue raisonné. Done from memory, these furious experiments in a variety of media and formats seem an attempt to bypass conscious control. Resemblance was barely a side issue, as Paulhan acknowledged in his ironic note inscribed on this portrait, *la victime émue* (the shocked victim). In an undated letter to Paulhan, Dubuffet wrote, "Yesterday I did a portrait of you (drawing) which gave me great pleasure, Lili [Dubuffet's wife] said yes it was like you but the Michaux [Henri Michaux, the writer] said that they would never have thought it could be you" (Paris, Grand Palais, *Jean Paulhan à travers ses peintres*, 1974, exh. cat., n. pag.). It is possible that Aloïse's imaginary portraits, with their emphasis on the head in contrast to the small arms and tiny hands, had some influence on Dubuffet's depictions of Paulhan from memory.

These works were the prelude to a series of portraits of his friends – writers, literary critics, and artists, including Paulhan, Francis Ponge, and Georges Limbour – which occupied Dubuffet almost exclusively from 1946 to 1947. In October of 1947 he exhibited more than seventy of these portraits, again at the Galerie René Drouin. Dubuffet thought of them as effigies rather than likenesses, and attacked critics who, he claimed, described them as "an enterprise of psychological penetration," emphasizing instead that they were "anti-psychological, anti-individualist" (Paris, Musée des arts décoratifs, *Dubuffet*, 1960, exh. cat., p. 36). As Dubuffet's cover for the catalogue proclaimed, they were not from life but had a "likeness extracted, cooked and conserved" in the memory of the artist. "People," the artist announced in the same catalogue, "are more beautiful than they think: long live their true face."

* * *

AFTER WORLD WAR I (1914–18), IN WHICH ERNST served as an artilleryman in the German army, he decided to commit himself full-time to being an artist. He now joined the Dadaists rather than the Expressionists with whom he had had links earlier. In this drawing, he clearly aligned himself with Dada's resolute antinationalism, its resistance to the utopian pretensions of Expressionism, and its disillusionment with the promise of a technologically improved world, which the war had so horrifically betrayed through the use of machines for wholesale destruction.

This drawing's dual inscription in German and French was a deliberately antinationalist gesture, in line with the multilingual Dada magazines published in Zurich during the war. The polemical implications of such a gesture are evident, for instance, in the poet and critic Guillaume Apollinaire's alarm at receiving the journal *Dada*, which contained German texts, fearing that its possession would appear to compromise his patriotism. For Ernst, as for the Paris Dadaists, the war had definitively banished such nationalist or patriotic sentiments. As Ernst's friend the poet Paul Eluard wrote:

In February 1917, the surrealist painter Max Ernst and I were at the front, hardly a mile away from each other. The German gunner, Max Ernst, was bombarding the trenches where I, a French infantryman, was on the lookout. Three years later, we were the best of friends, and ever since we have fought fiercely side by side for one and the same cause, that of the total emancipation of man (Paul Eluard, "Poetic Evidence," in Herbert Read, *Surrealism*, London, 1936, p. 181).

Although postwar Dada in Cologne was relatively short-lived, its exhibitions and publications were rich in Dada humor and invention. The native Cologne Dadaists Ernst

61. SELF-CONSTRUCTED LITTLE MACHINE (SELBSTKONSTRUIERTES MASCHINCHEN)

1919/20

Graphite with pen and black ink on tan wove paper; 46.6 x 31.5 cm (18⁵/₁₆ x 12⁷/₁₆ in.)

Signed, lower right: *dadamax ernst*

Inscribed, lower left: *selbstkonstruiertes maschinchen in diesem verrührt er / meersalat leitartikel leidtragende und eisensamen / in zylindern aus bestem mutterkorn sodaß vorne die / entwickelung und rückwärts die anatomie zu sehen ist / der preis stellt sich dann um 4 mark höher* (self-constructed little machine in which he mixes sea salad, editorial mourner and iron sperm into cylinders of the best ergot so that the development can be seen in front and the anatomy in back the

price is then about 4 marks higher)

Inscribed, lower center: *petite machine construite par lui-même / il y mélange la salade de mer la sperme / de fer le périsperme amer de l'une côté / nous voyons l'évolution de l'autre l'ana- / tomie ça coute 2 sous plus cher* (a little machine constructed by himself in which he mixes sea salad iron sperm bitter perisperm on one side we see the evolution on the other the anatomy it costs 2 cents more)

The Lindy and Edwin Bergman Collection, 119.1991

PROVENANCE: Robert Pudlich, Düsseldorf. The Hanover Gallery, London; sold to Lindy and Edwin Bergman, Chicago, 1959.

and Johannes Theodor Baargeld were joined by Jean Arp, who had been a member of Zurich Dada since its foundation in 1916. Trapped in Cologne without a passport, Ernst was unable to attend the exhibition of his Dada collages and drawings at the Au Sans Pareil gallery in Paris in 1921, where this drawing was first shown. This exhibition was hailed by André Breton as a revelation for its emphasis on a poetry based on startling juxtapositions, thus foreshadowing an important aspect of Surrealism.

In this and related drawings (see *Ernst Katalog*, vol. 2, 1975, esp. p. 160, no. 317, ill.), Ernst brought together, in a kind of enforced marriage, references to language and to machines. In this instance, Ernst's drawing may be divided into two sections: on the left is a mechanical object terminating in a funnel, which spouts a roulette wheel rendered in a mildly Cubist manner; on the right is a construction built from the elements of a mechanically reproducible typeface. The latter structure stands precariously on teetering legs, like a collapsible house of cards. It has been subject to multiple readings: Hal Foster (1991, p. 73) likened it to an "animate camera or gun," while first Werner Spies *(Ernst Collages* 1991 [1974], p. 46) and then William Camfield (in New York 1993, pp. 72, 335 n. 100) suggested that the stacked forms spell out the letters *MAX*, reading from the bottom up. (The *A* in the center seems to be a stencil, whose transverse lines Ernst transformed into drooping pipes; he then repeated the same letter twice, more cleanly, to form an *X* above.) Such self-referential imagery is not uncommon in Ernst's Dada works (see, for example, the collage self-portrait of 1920 in the Arnold H. Crane collection, Chicago; *Ernst Collages* 1991 [1974], fig. 152).

Dada's aim to "begin at zero" (Richard Huelsenbeck, "Dada Lives!" in Robert Motherwell, ed., *The Dada Painters and Poets,* New York, 1951, p. 280) questioned the very roots of communication. In Zurich and Berlin, the Dada phonetic poem had stripped language down to its basic components of sound. Here by mingling word and image so thoroughly, Ernst denied their separate function and created from their original elements a comic, derisory, mock-mechanical new language. He thus expressed very effectively both the post-war sense of the debasement of language, prostituted by warmongering and nationalistic rhetoric, and the skepticism at the claims advanced by modernist artists for a "new language."

The seemingly nonsense inscription on this drawing introduces a conjunction of the natural and the mechanical that is both disturbing and funny. Unlike the Berlin Dadaists, who often used images of robots to introduce a more sinister, dehumanized, or mechanized aspect of modernity, Ernst here humanized the machine, parodying the Futurists' strident assertions of the climactic power of the new machine-man, invincible centaur of the modern age. Like Marcel Duchamp and Francis Picabia, he subverted the technological authority of the machine by endowing it in his inscription with a fallible emotional ("mourner") and sexual ("iron sperm") character.

The reference in the drawing to an anthropomorphized machine is especially evident in the "legs" of the construction on the right, its erotic function alluded to in the emission from the upright pipe on the left, which squirts numbered slots like those of a roulette wheel. Ernst thus introduced the idea of chance, so central to Dada. The "slots" are rubbings from printer's blocks, like the letters that form the machine. The fact that the inscription is handwritten, rather than printed or stenciled, further obscures the difference between the individual and the ready-made, the hand drawn and the mechanically reproduced, the artist and the technician.

* * *

New York, The Solomon R. Guggenheim Museum, *Max Ernst: A Retrospective*, 1975, no. 25 (ill.) and p. 25. Paris, Galeries nationales du Grand Palais, *Max Ernst*, 1975, no. 29 (ill.). London, Hayward Gallery, *Dada and Surrealism Reviewed*, 1978, no. 5.12 (ill.), as *Small Machine Made by Himself.* Boston, Institute of Contemporary Art, *Dada: Berlin, Cologne, Hannover*, 1980–81, traveled to Fort Worth, no cat. nos., n. pag. Chicago 1984–85, no cat. nos., p. 142 (ill.). Chicago 1986, no. 15. Tübingen 1988–89, no. 9 (ill.) and p. 47. New York, The Museum of Modern Art, *Max Ernst: Dada and the Dawn of Surrealism*, 1993, traveled to Houston and Chicago, no. 37, pl. 43, pp. 72, 81, 91 (Chicago only).

REFERENCES: Rubin 1968, fig. 83 and p. 96. Dore Ashton, "The End and the Beginning of an Age," *Arts Magazine* 43, 3 (Dec. 1968–Jan. 1969), p. 46 (ill.). Uwe M. Schneede, *Max Ernst*, tr. by R. W. Last, New York, 1973, fig. 35. *Ernst Katalog*, vol. 2, 1975, pp. xi, 161, no. 318 (ill.). Hal Foster, "Armor fou," *October* 56 (Spring 1991), pp. 73–74 (ill.), 75, 77; repr. in Stephen Melville and Bill Readings, eds., *Vision and Textuality*, Durham, North Carolina, 1995, pl. 64, pp. 221–23. Cologne, Museum Ludwig, *Max Ernst: Das Rendezvous der Freunde*, 1991, exh. cat., p. 74. *Ernst Collages* 1991 (1974), p. 47. Hal Foster, *Compulsive Beauty*, Boston, 1993, pp. 153–54 (ill.).

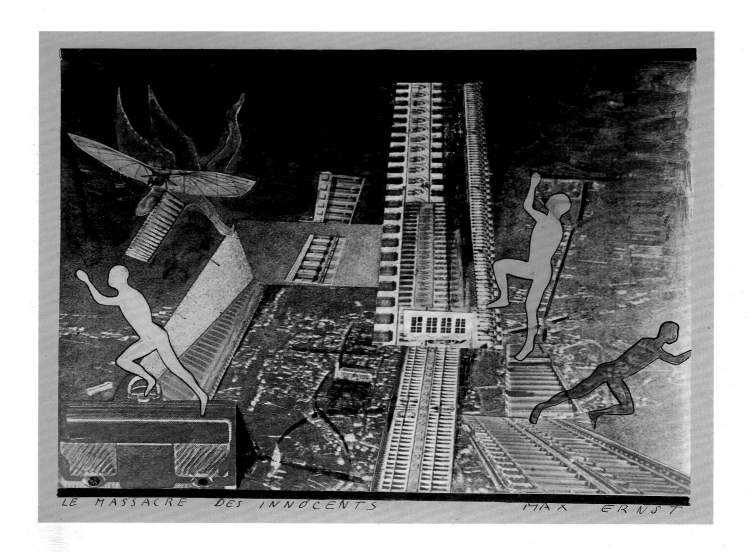

62. THE MASSACRE OF THE INNOCENTS
(LE MASSACRE DES INNOCENTS)

1920
Collage composed of black-and-white photographs, with watercolor, gouache, and black ink, laid down on tan wove wood-pulp paper; 21.5 x 28.9 cm (8½ x 11⅜ in.)
Titled and signed: *LE MASSACRE DES INNOCENTS* (lower left); *Max Ernst* (lower right)
The Lindy and Edwin Bergman Collection, 120.1991

PROVENANCE: Simone Kahn, Paris, by 1921 to at least 1936;[1] Galerie Furstenberg, Paris; sold to Lindy and Edwin Bergman, Chicago, 1965.

EXHIBITIONS: Paris, Au Sans Pareil, *Exposition Dada Max Ernst*, 1921, no. 31. New York, The Museum of Modern Art, *Fantastic Art, Dada, Surrealism*, 1936–37, no. 348. New York, Sidney Janis Gallery, *International Dada, 1916–1923*, 1953, no. 87. Düsseldorf Kunsthalle,

Dada: Dokumente einer Bewegung, 1958, traveled to Frankfurt, no. 285 (ill.). Amsterdam, Stedelijk Museum, *Dada*, 1958–59, no. 278. Paris, Musée national d'art moderne, *Max Ernst*, 1959, no. 125. New York, The Museum of Modern Art, *Max Ernst*, 1961, traveled to Chicago, no. 192. London, The Tate Gallery, *Max Ernst*, 1961, no. 22 (ill.). Cologne, Wallraf-Richartz-Museum, *Max Ernst*, 1962–63, traveled to Zurich, no. 146, pl. 9 and p. 27. Chicago 1966, no. 28. Chicago 1967–68, no cat. Städtische Kunstgalerie Bochum, *Die Fotomontage: Geschichte und Wesen einer Kunstform*, 1969, no. 51. New York, The Solomon R. Guggenheim Museum, *Max Ernst: A Retrospective*, 1975, no. 57 (ill.). London, Hayward Gallery, *Dada and Surrealism Reviewed*, 1978, no. 5.26 (ill.). Boston, Institute of Contemporary Art, *Dada: Berlin, Cologne, Hannover*, 1980–81, traveled to Fort Worth, no cat. nos., n. pag. Chicago 1984–85, no cat. nos., p. 142, pl. 17. Chicago 1986, no. 16. Tübingen 1988–89, no. 43, pl. 36,

fig. 102, pp. 27, 74, 76–77, 117, 192, 204, 208–09. Washington, D.C., National Gallery of Art, *On the Art of Fixing a Shadow: One Hundred and Fifty Years of Photography*, 1989–90, traveled to Chicago and Los Angeles, no. 198 (ill.). New York, The Museum of Modern Art, *Max Ernst: Dada and the Dawn of Surrealism*, 1993, traveled to Houston and Chicago, exh. cat. by William A. Camfield, no. 99, pl. 100, pp. 20, 93.

REFERENCES: Franz Roh and Jan Tschichold, eds., *Foto-Auge, 76 Fotos der Zeit*, Stuttgart, 1929, reprinted and tr. as *Photo-Eye: 76 Photos of the Period*, New York, 1973, pl. 33. "Dada à Paris," *Cahiers d'art* 1–4 (1934), p. 111 (ill.). "Au delà de la peinture," *Cahiers d'art* 6–7 (1936), p. 164 (ill.). Paris, Galerie beaux-arts, *Dictionnaire abrégé du surréalisme*, 1938, p. 36 (ill.). Herta

THIS IS ONE OF SEVERAL WORKS DATING TO 1920/21 in which Ernst used photomontage to link images of flight to World War I. The artist combined here an aerial view of Soissons, France, where he had been stationed for a time with the German artillery in 1915, with photographs of the facades of buildings shot from various angles, which were cropped and pasted down to resemble railroad tracks. In the upper-left corner is a "flying machine" made from a photograph of a Lilienthal glider (obtained from Georg Paul Neumann, *Flugzeuge*, Bielefeld and Leipzig, 1917, p. 1; cited in New York 1993, p. 341 n. 97), pasted over an angel cut from a reproduction of *The Virgin Adoring the Christ Child* by Stefan Lochner (fig. 1; see Charlotte Stokes, "Dadamax: Ernst in the Context of Cologne Dada," in *Dada/Dimensions*, ed. by Stephen C. Foster, Ann Arbor, 1985, p. 126), one of Ernst's favorite painters. Three figures in profile flee or are flung toward the edges of the collage, contributing to the sense of confusion and violence.

The impression given by this collage is not so much that the angel-glider is wreaking destruction alone, but rather that it is part of a dislocated scene in which the spectator's dramatic bird's-eye view is actually that of a participant in the action. The spectator indeed views the scene from the vantage point of a pilot, perhaps engaged in a dogfight with the angel. There is not, however,

a single viewpoint but dizzyingly many, and the facade/tracks read as both collapsed houses and runways. A contradiction emerges here: How can we reconcile the multiple, decentered viewpoints of a collage like this one with the reading, suggested above, that the spectator is at the center of the action and is the putative consciousness through which the scene is perceived? It is not quite enough to argue that the multiple viewpoints elide with or can be explained by the changing perspectives of a pilot in a darting, diving airplane. The impression of a governing vision, an overseeing, superior identity is too strong.

Ernst did not in fact alter the position of the Lochner angel, who is depicted in the original flying down to warn the shepherds of Christ's birth; now, divorced from its context, it appears to tumble from the sky, like Icarus. The three male figures, however, which are stencils of a figure in Ernst's *Young Man Burdened with a Flowering Faggot* (fig. 2), cut from an anatomical diagram in the *Bibliotheca Paedagogica* (Leipzig, 1914), have been altered from their original positions. In the earlier collage, Ernst kept the figure in the position of the diagram, where it was intended to demonstrate the muscles

Figure 1. Stefan Lochner, *The Virgin Adoring the Christ Child*, 1440s, oil on panel, 35 x 21.3 cm, Munich, Alte Pinakothek.

Wescher, "Collage," *Art d'aujourd'hui* (May–June 1954), p. 18, fig. 2. John Anthony Thwaites, "Dada Hits West Germany," *Arts Magazine* 33, 5 (Feb. 1959), pp. 31 (ill.), 32. Harriet Janis and Rudi Blesh, *Collage: Personalities, Concepts, Techniques*, Philadelphia, 1962, p. 104, fig. 118. Simón Marchán, "Max Ernst o la pintura de la ambigüedad," *Goya* 81 (Nov.–Dec. 1967), p. 155 (ill.). John Russell, *Max Ernst: Life and Work*, New York, 1967, pl. 11, pp. 61, 114. Gina Pischel, *A World History of Art*, New York, 1968, p. 667 (ill.). Rubin 1968, fig. 89 and p. 96. Herta Wescher, *Collage*, tr. by Robert E. Wolf, New York, 1968, pl. 126 and p. 164, as *The Slaughter of the Innocents*. Max Ernst, *Ecritures*, Paris, 1970, pp. 261 (ill.), 263. Uwe M. Schneede, "Max Ernst's Enlarged Surrealism," *Homage to Max Ernst, Special Issue of the XXᵉ Siècle Review*, Paris, 1971, p. 23 (ill.). *Arch. Digest* 1973, p. 21 (photo of Bergman home). Uwe M. Schneede, *Max Ernst*, tr. by R. W. Last, New York, 1973, fig. 76 and p. 40. *Ernst Katalog*, vol. 2, 1975, p. 199, no. 391 (ill.). Edward Quinn, *Max Ernst*, New York, 1977, fig. 78. Düsseldorf, Kunstsammlung Nordrhein-Westfalen, *10x Max Ernst: Eine didaktische Ausstellung zum Verständnis seiner Kunst*, 1978–79, exh. cat., p. 22 (ill.). Robert Short, *Dada and Surrealism*, London, 1980, fig. 48. Eugene Sochor, "Aviation and Art Have Evolved Together in This Century," *International Civil Aviation Organization Bulletin* 7–8 (July–Aug. 1982), p. 82 (ill.). New York, The Museum of Modern Art, *De Chirico*, 1982, pp. 114 (ill.), 119. *Ernst Collages* 1991 (1974), pl. 36, fig. 162, pp. 26, 75–77, 117, 229, 240, 244–45. Paris, Musée national d'art moderne, *André Breton: La Beauté convulsive*, 1991, exh. cat., no cat. nos., pp. 143 (ill.), 486. Karl Riha and Jörgen Schäfer, eds., *Fatagaga-Dada: Max Ernst, Hans Arp, Johannes Theodor Baargerd und der Kölner Dadaismus*, Giessen, 1995, p. 52, fig. 11.

stretching as the figure reached up, one foot on a stand. In *The Massacre of the Innocents*, the figures appear to be fleeing.

Young Man Burdened with a Flowering Faggot alludes to the selection of Joseph to marry the Virgin Mary, and the title of *The Massacre of the Innocents* refers to Herod's slaughter of all children under the age of two after the Flight into Egypt, although the innocents to whom Ernst refers are civilians of all ages. The Christian references in Ernst's work are frequent, if ambiguous, in this period, and are especially significant in connection with the imagery of flight.

Commentaries on this collage have rightly stressed that it neither describes nor simply denounces war. The horror of the trenches for both sides was unquestionable, but the aerial aspects of the war had made it unlike any previous war. Before 1914, the possibilities of flight elicited both exhilaration and modernist irony about its metaphysical challenge. Christ, as the poet and critic Guillaume Apollinaire blithely wrote in his 1912 poem "Zone," still "holds the world record for altitude." Christ, as aviator, is joined in Apollinaire's poem by other leg-

endary or mythological beings, who "hover as close to the airplane as they can . . ." (Guillaume Apollinaire, "Zone," in *Alcools,* tr. by Donald Revell, Hanover and London, 1995, p. 5).

Within three years, Apollinaire's irony had become much darker; the world had changed, and the apparently unlimited and liberating possibilities of aviation had instead been transformed into an unprecedented capacity for destroying civilian populations. Of all forms of mechanical progress soured by the war, perhaps the plane was the most poignant. As Apollinaire wrote in 1915: "Don't cry over the horrors of war / Before the war we only had the surface / of the earth and the seas / After the war we shall have the abysses / Under the ground and aerial space . . ." (Guillaume Apollinaire, "Guerre" [War], in *Calligrammes: Poèmes de la paix et de la guerre (1913–1916)*, Paris, 1925).

The medium of collage is particularly well suited to presenting both the disembodied and the multiple viewpoints of this new world. Other Dadaists, as well as Russian artists such as Kazimir Malevich and Aleksandr Rodchenko, incorporated or juxtaposed aerial perspectives and photographs in their works. But Ernst's *aérographies* (as he inscribed the related collage *The Cormorants* [1920, Paris, Simone Breton-Collinet; *Ernst Katalog*, vol. 2, 1975, p. 200, no. 392, ill.]) were among the first and the most acute in their expression of the complex and contradictory sensations associated with aviation. * * *

Figure 2. Max Ernst, *Young Man Burdened with a Flowering Faggot*, c. 1920, gouache and ink on printed reproduction, 11.1 x 15.2 cm, private collection [photo: New York, The Museum of Modern Art, *Max Ernst: Dada and the Dawn of Surrealism*, 1993, pl. 60].

63. UNTITLED (BIRDS)

1924
Oil and sand on linen mounted on Masonite
pressed-wood board, with cork frame
by the artist; without frame: 19.1 x 29.2 cm
(7¹/₂ x 11¹/₂ in.)
Signed, lower right: *max ernst*
The Lindy and Edwin Bergman Collection,
121.1991

PROVENANCE: Galerie Edouard Loeb, Paris;
sold to Lindy and Edwin Bergman, Chicago, 1959.

EXHIBITIONS: New York, The Museum of
Modern Art, *Max Ernst*, 1961, traveled to
Chicago, no. 18, as *Birds*. Chicago 1986, no. 17,
as *Birds*.

REFERENCES: *Ernst Katalog*, vol. 2, 1975,
pp. xi–xii, 381, no. 730 (ill.).

THIS WORK BELONGS TO A GROUP OF PAINT-
ings of birds, most of which were made between
1924 and 1926, according to Spies (*Ernst Katalog*,
vol. 2, 1975, pp. 381–91, nos. 728–50, ills.; vol. 3, 1976, p.
131, nos. 1044–45, ills.). Dated by Spies to 1924 (ibid.,
vol. 2, 1975, p. 381, no. 730, ill.), this work is especially
close to Ernst's *Birds*, also of 1924, and *Two Birds* of
around 1925 (ibid., vol. 2, 1975, pp. 385–86, nos. 738,
740, ills.), all three of which were given very similar cork
frames by the artist. Although these works are generally
thought to be executed on sandpaper, in this case at
least, as Cynthia Kuniej Berry has observed, "close ex-
amination of the unframed painting reveals otherwise"
(see Cynthia Kuniej Berry, Examination Report,
August 27, 1993, in curatorial files). In her report, the
painting is described as "executed on a fine, lightweight,
plain weave linen," on which the paint was "generously
applied with active brushwork in textured, opaque
masses with thick impasto," while "the remainder of the
surface is covered with a thin, even layer of sand" (ibid.).
Ernst indeed applied paint thickly to create the forms of
the birds and then scraped through to reveal colored lay-
ers below, employing what he called his *grattage* tech-
nique. The ribbed flecks of brown and black paint
skillfully connote feathers. The circular heads of the
birds appear in many of Ernst's works from the period,
such as *100,000 Doves* (1926, Paris, private collection;
Ernst Katalog, vol. 3, 1976, p. 121, no. 1025, ill.), in which
the circular form also is transformed into an eye or a
breast. The undulation of the picture's surface seems in-
strinsic to the work and gives the effect of a relief, al-
though it may have also resulted from environmental
changes (see Kuniej Berry 1993 above). Ernst used sim-
ilar carved cork frames, often with varying designs, in
other works of the same subject (*Ernst Katalog*, vol. 2,
1975, pp. 385–91, nos. 738–40, 744–46, 749, 751, ills.;
vol. 3, 1976, pp. 131, 136, nos. 1045, 1055, ills.). ✳ ✳ ✳

T HIS COLLAGE WAS ORIGINALLY PUBLISHED
in 1930 as plate 68 in Ernst's second collage-novel,
A Little Girl Dreams of Taking the Veil (*Rêve d'une
petite fille qui voulut entrer au Carmel*). Ernst's first col-
lage-novel had been published in 1929 as *The Hundred
Headless Woman* (*La Femme 100 têtes*), and his third
would appear in 1934 as *A Week of Goodness* (*Une
Semaine de bonté*). These collage-novels marked the cul-
mination of Ernst's concern with constructing sequences
of images, and contributed to the revival of interest in
dream images in Surrealist circles at the end of the 1920s.
The "narrative" of these collage-novels indeed has the
illogical structure and affective power of a dream. The
collages consist of cuttings from "the most banal of the
pre-photography illustrated penny novels" (Tanning,
in Ernst 1982, p. 5), and from popular books of natural
history, science, and games. In his compilation of
Ernst's sources, Werner Spies reproduced an engraving
of the construction of one of the legs of the Eiffel Tower,
which forms the background here (*Ernst Collages* 1991
[1974], fig. 751); on the left side of the composition,
a snake from a natural history album is suspended as
though from a crane.

In the novel, each collage is accompanied by a short
text, usually dramatized as speech. In this case, the lit-
tle girl of the title, torn by conflicting desires, at various
points splits into two characters: Marceline and Marie.
The novel plays with blasphemous ingenuity on the
sexualized language of "taking the veil," with Christ
referred to as "the celestial bridegroom." * * *

64. MARCELINE AND MARIE

1929/30
Collage composed of printed, cut elements, with
touches of watercolor, laid down on cream wove
paper; 23.9 x 16.7 cm (9³/₈ x 6⁹/₁₆ in.)

Signed, lower left: *max ernst*
Inscribed, on back: *Marceline et Marie (d'une
seule voix): "Il me semble que le ciel descend dans
mon coeur . . ."* (Marceline and Marie [of one
voice]: "It seems to me the sky is falling into my
heart . . .")

The Lindy and Edwin Bergman Collection,
122.1991

PROVENANCE: Bodley Gallery, New York; sold
to Lindy and Edwin Bergman, Chicago, 1960.

EXHIBITIONS: New York, Bodley Gallery, *Yves
Tanguy: Ten Gouaches and One Drawing;
Max Ernst: Twenty-four Original Collages for "Rêve
d'une petite fille qui voulut entrer au Carmel,"*
1960, not in cat. New York, D'Arcy Galleries,
*Surrealist Intrusion in the Enchanters' Domain:
International Surrealist Exhibition,* 1960–61,
no. 50, as *Marceline et Marie.* New York, The
Solomon R. Guggenheim Museum, *Max Ernst:
A Retrospective,* 1975, no. 146 (ill.), as *Marcelle
and Marie* (in unison): "I feel as though hea-
ven is descending into my heart . . ." (Marcelle et
Marie [d'une voix]: "Il me semble que le ciel

descend dans mon coeur . . ."). Paris, Galeries
nationales du Grand Palais, *Max Ernst,* 1975, no.
179, as *Marcelle et Marie (d'une voix): "Il me
semble que le ciel descend dans mon coeur. . . ."*
Chicago 1984–85, no cat. nos., p. 143 (ill.).
Tübingen 1988–89, no. 161, fig. 320.

REFERENCES: I[rving] H. S[andler], "Reviews
and Previews," *Art News* 58, 9 (Jan. 1960), p. 14.
Ernst Katalog, vol. 4, 1979, pp. ix, 47, no. 1655
(ill.). Max Ernst, *A Little Girl Dreams of Taking
the Veil,* tr. by Dorothea Tanning, New York,
1982, pp. 150–51 (ill.). *Ernst Collages* 1991
(1974), fig. 380.

65. UNTITLED (LOPLOP PRESENTS)

1932
Collage composed of photograph, graphite drawing, gouache, printed marble paper, *frottage*, and cut paper elements, painted, colored, and scratched with crayon on ivory wove paper; 50 x 64.6 cm (19⅝ x 25⅜ in.)

Signed, lower right: *max ernst 1932*

The Lindy and Edwin Bergman Collection, 123.1991

PROVENANCE: Galerie du Dragon, Paris; sold to Lindy and Edwin Bergman, Chicago, 1960.

EXHIBITIONS: New York, The Museum of Modern Art, *Max Ernst*, 1961, traveled to Chicago, no. 218a, p. 17, as *Loplop Introduces*. New York, The Museum of Modern Art, *The Art of Assemblage*, 1961–62, traveled to Dallas and San Francisco, no. 93 (ill.), as *Loplop Introduces*. Waltham, Massachusetts, Brandeis University, Rose Art Museum, *The Painter and the Photograph*, 1964–65, traveled to Bloomington, Iowa City, New Orleans, Albuquerque, and Santa Barbara, no. 12 (ill.), p. 26, as *Loplop Introduces*. Gary Artists' League, *Indiana Sesquicentennial Collectors' Art Exhibit*, 1966, no cat. Chicago 1967–68, no cat. New York 1968, no. 104, fig. 189 and p. 129, as *Loplop Introduces*. Philadelphia,

Institute of Contemporary Art, University of Pennsylvania, *Against Order: Chance and Art*, 1970, no cat. nos., n. pag. (ill.), as *Loplop Introduces*. Kalamazoo Institute of Arts, Genevieve and Donald Gilmore Art Center, *The Surrealists: A Fifth Anniversary Fund Exhibition*, 1971, no cat. nos., p. 5, as *Loplop Presents*. Chicago 1973, no cat. nos., n. pag., as *Loplop Introduces*. New York, The Solomon R. Guggenheim Museum, *Max Ernst: A Retrospective*, 1975, no. 153 (ill.), as *Loplop Presents (Loplop présente)*. Paris, Galeries nationales du Grand

graph paper and exposing it 250 times for each image. When the photographs were developed the drawings appeared white on a black ground" (Spies 1983, p. 48). There were also variants and later versions, of which the image in this collage is one.

The photograph of the female torso on the left is reputed to be by Man Ray; certainly the cropping of the photograph and the raking light are familiar Man Ray devices. The black Loplop handprints play on the negative-positive photographic processes. The juxtaposition of the butterflies and the nudes suggests that both are collector's items; this leads to the equally disquieting possibility of equivalent taxonomic arrangements of such objects in a natural-history or photograph album.

* * *

THIS COLLAGE UNITES ELEMENTS THAT APPEAR in several other works with closely related themes from the same period: Ernst's *Butterfly Collection* (1931, Ludwigshafen, Wilhelm-Hack-Museum; Spies 1983, pl. 16a), for example, includes similar butterflies cut from colored paper, mounted on a rectangle between two Loplop handprints (for more on Loplop, see entry no. 66); and his *Of the Glass* (1932, Stuttgart, private collection; Spies 1983, pl. 21) contains a *frottage*-photogram similar to the *frottage* of two nudes at center. This image is also close to several of the illustrations Ernst made for the English edition of René Crevel's *Mr. Knife and Miss Fork* (Paris, 1931; *Ernst Katalog*, vol. 4, 1979, p. 84, no. 1727, p. 92, no. 1742, p. 93, no. 1745, ills.). For this publication, Ernst created nineteen *frottages* from which "the Man Ray studio prepared an edition of photograms, by placing each sheet face-down on light-sensitive photo-

Palais, *Max Ernst*, 1975, no. 192, as *Loplop présente*. London, Hayward Gallery, *Dada and Surrealism Reviewed*, 1978, no. 11.16 (ill.), as *Loplop présente (Loplop Introduces)*. The Cleveland Museum of Art, *The Spirit of Surrealism*, 1979, no. 22 (ill.), as *Loplop Introduces*. Chicago 1984–85, no cat. nos., pp. 102, 146, pl. 31, as *Loplop Introduces*. Chicago 1986, no. 18, as *Loplop Presents*. Tübingen 1988–89, no. 193, pl. 77 and p. 72, as *Loplop présente*.

REFERENCES: Harriet Janis and Rudi Blesh, *Collage: Personalities, Concepts, Techniques*, New York, 1962, fig. 121, as *Loplop Introduces*. Uwe M. Schneede, *Max Ernst*, tr. by R. W. Last, New York, 1973, fig. 241, as *Loplop Introduces*. Edward Quinn, *Max Ernst*, tr. by Kenneth Lyons, New York, 1977, fig. 210, as *Loplop Introduces (Loplop présente)*. *Ernst Katalog*, vol. 4, 1979, p. 147, no. 1852 (ill.), as *Loplop présente*. Werner Spies, *Max Ernst: Loplop, the Artist in the Third Person*, tr. by John W. Gabriel, New York, 1983, pl. 20, pp. 26, 31, as *Loplop Introduces*. *Ernst Collages* 1991 (1974), pl. 77 and pp. 72, 128, 242, as *Loplop Presents*. Lu Bro, *Figure and Form*, vol. 1, *Skills and Expression*, Dubuque, Iowa, 1992, fig. IV.22, as *Loplop Introduces*.

66. UNTITLED (LOPLOP PRESENTS)

1932
Collage composed of botanical lithograph and graphite on cream wove paper; 63.4 x 49.6 cm (25 x 19½ in.)
Signed, lower right: *max ernst / max ernst*
The Lindy and Edwin Bergman Collection, 124.1991

PROVENANCE: Julien Levy Gallery, New York; Bodley Gallery, New York; sold to Lindy and Edwin Bergman, Chicago, 1960.

EXHIBITIONS: Possibly Philadelphia, Gimbel Galleries, *Max Ernst, Surrealist Exhibition*, 1937, no. 12, as *Personnage*.[2] New York, The Museum of Modern Art, *Max Ernst*, 1961, traveled to Chicago, no. 211 (ill.), pp. 16–17. London, The Tate Gallery, *Max Ernst*, 1961, no. 101 (ill.), as *Loplop Introduces*. Chicago 1967–68, no cat. New York, The Solomon R. Guggenheim Museum, *Max Ernst: A Retrospective*, 1975, no. 138 (ill.), as *Loplop Presents (Loplop présente)*. Paris, Galeries nationales du Grand Palais, *Max Ernst*, 1975, no. 171 (ill. as no. 174), as *Loplod* [sic] *présente*. Chicago 1984–85, no cat. nos., p. 146

(ill.), as *Loplop Introduces*. Tübingen 1988–89, no. 198, pl. 88, as *Loplop présente*.

REFERENCES: Patrick Waldberg, *Surrealism*, tr. by Stuart Gilbert, Geneva, 1962, p. 3 (ill.), as *Loplop Presents*. Uwe M. Schneede, *Max Ernst*, tr. by R. W. Last, New York, 1973, fig. 233, as *Loplop Introduces*. Günter Metken, "Sich die Kunst vom Lieb halten Loplop, die Staffeleifigur Max Ernsts," *Pantheon* 36, 11 (Apr.–June 1978),

Figure 3. From *Flore des serres
et des jardins*, Ghent, 1847, vol. 3,
pl. 169 [photo: courtesy of
The Newberry Library, Chicago].

T HE WORD "LOPLOP" FIRST APPEARED IN
Ernst's 1929 collage-novel *The Hundred Headless
Woman* (*La Femme 100 têtes*). The artist's identifi-
cation with birds, however, goes back to his childhood,
when a pet cockatoo died the same night that his baby
sister was born. Loplop, also known as "Bird Superior,"
appears frequently in works of the early 1930s; Ernst
referred to him (always in the masculine gender) as being
"attached to my person" and as a "private phantom"
who visited him almost every day. As the artist's alter
ego, Loplop "presented" him with images, enabling him
to act as "spectator" at the birth of his works. Loplop is
thus linked to the Surrealist notion of inspiration, where-
by, through a partly unconscious mechanism, "the
plastic work's elaboration can be freed from the sway of
the so-called conscious faculties" (Max Ernst, "Inspi-
ration to Order," in *Max Ernst: Beyond Painting and
Other Writings by the Artist and His Friends*, New York,
1948, p. 20).

The Loplop collages often take the form of a picture
within a picture. Here, a simple geometrized Loplop acts
as an easel, supporting the collage-drawing. The core of
this image is a brilliantly colored lithograph of *Steno-
carpus cunninghami* (fig. 3) from the botanical album
Flore des serres et des jardins (Ghent, 1847). Ernst must
have seen the transformative possibilities of this exotic
image, which he inverted and then extended. Thin pen-
cil lines emerge from the foliage, which metamorphoses
into the legs of a woman, though the head that grows
from stamenlike forms is that of a bird. The original
lithograph thus became the ornamental heart of a crea-
ture that hovers, like the leafy sea-dragon of the South
China Sea, between plant, bird, and human. * * *

fig. 3 and p. 144, as *Loplop stellt vor. Ernst
Katalog*, vol. 4, 1979, p. 152, no. 1862 (ill.), as
Loplop présente. Gaëton Picon, *Surrealists and
Surrealism, 1919–1939*, tr. by James Emmons,
Geneva, 1977, fig. 4, as *Loplop Introduces*.
Whitney Chadwick, *Myth in Surrealist Painting,
1929–1939*, Ann Arbor, Mich., 1980, fig. 87,
pp. 87, 89, 94–95, as *Loplop Presents*. Werner
Spies, *Max Ernst: Loplop, the Artist in the Third
Person*, tr. by John W. Gabriel, New York, 1983,
pl. 27, fig. 155, pp. 23, 91, 94, as *Loplop
Introduces. Ernst Collages* 1991 (1974), pl. 88
and p. 242, as *Loplop présente*.

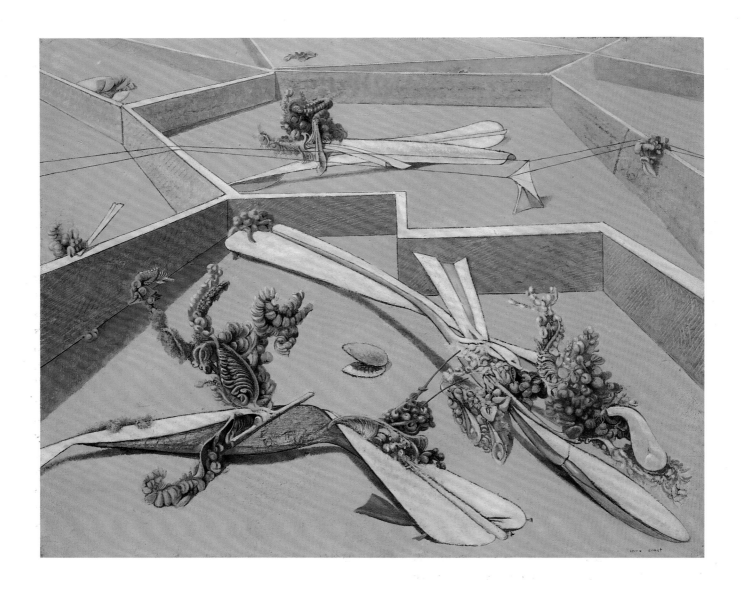

67. GARDEN AIRPLANE-TRAP

(JARDIN GOBE-AVIONS)

1935
Oil on linen; 58.4 x 73 cm (23½ x 28¾ in.)
Signed, lower right: *max ernst*
The Lindy and Edwin Bergman Collection,
125.1991

PROVENANCE: Mrs. L. M. Maitland, Los
Angeles. Walter Maitland, Drake, Colorado; sold
to the Richard Feigen Gallery, Chicago, 1962;
sold to Lindy and Edwin Bergman, Chicago, 1962.

EXHIBITIONS: Pittsburgh, Carnegie Institute,
The 1935 International Exhibition of Paintings,
1935, no. 304, pl. 97, as *Garden Aeroplane-
Catcher*. London, The Mayor Gallery, *Surrealist
Paintings by Max Ernst*, 1937, no. 3, as *Jardin
gobe-avions*. Chicago, Richard Feigen Gallery,
Recent Acquisitions, 1962, no. 14 (ill.). Chicago,
Museum of Contemporary Art, *Modern Masters
from Chicago Collections*, 1972, no cat. nos.,
n. pag. New York, The Solomon R. Guggenheim
Museum, *Max Ernst: A Retrospective*, 1975,
no. 170 (ill.) and p. 49. Chicago 1984–85,
no cat. nos., pl. 22 and pp. 63, 146. Chicago
1986, no. 19.

REFERENCES: *Cahiers d'art* 10, 5–6 (1935),
p. 105 (ill.). Herbert Read, ed., *Surrealism*, Lon-
don, 1936, pl. 32. Max Ernst, *Max Ernst: Beyond
Painting and Other Writings by the Artist and
His Friends*, New York, 1948, p. 51 (ill.). Herbert
Read, *Art Now: An Introduction to the Theory
of Modern Painting and Sculpture*, London, 1948,
pl. 124; rev. ed., 1960, pl. 142. John Russell,
Max Ernst: Life and Work, New York, 1967,
fig. 65, pp. 114–16. *Ernst Katalog*, vol. 4, 1979,
pp. x, 325, no. 2189 (ill.). Werner Spies, *Max
Ernst: Loplop, the Artist in the Third Person*,
tr. by John W. Gabriel, New York, 1983, fig. 167.
Berkeley, California, University Art Museum,
Anxious Visions: Surrealist Art, 1990, pl. 155,
pp. 119–21. *The Art Institute of Chicago:
Twentieth-Century Painting and Sculpture*,
Chicago, 1996, p. 69 (ill.).

THIS IS ONE OF THE MAJOR CANVASES IN Ernst's *Garden Airplane-Trap* series, which includes about a dozen works, painted between 1934 and 1936. These paintings were given immediate exposure in a 1935 issue of *Cahiers d'art* (see References), which reproduced the Bergman picture, and in a 1936 issue of the Surrealist journal *Minotaure* (8 [1936], p. 8), which illustrated another painting in the series.

From an elevated position with an emphatic perspective, the viewer gazes on an apparently boundless landscape, divided by walls into enclosures that are geometrical, although without an obvious, systematic order. The scale of this landscape is impossible to determine: it could be vast or miniature, a bizarre city-desert or a child's game. This ambiguity matches that of the beached or battling creatures "trapped" in the maze, whose scale is equally uncertain. The title may read "airplanes" or "airships," but Ernst's subjects look more like wood or paper gliders, their mechanical character compromised by the vegetal and animal growths that are beginning to encrust them.[3] They belong in spirit to, and perhaps helped to inspire, Benjamin Péret's prose poem "La Nature dévore le progrès et le dépasse" (*Minotaure* 10 [Winter 1937], pp. 20–21), which was illustrated with a photograph of a locomotive abandoned to the creepers of a virgin forest. The character of the brightly colored, organic growth is equally ambiguous: it looks sometimes like flora, as in the burgeoning red flower to the right, at other times like fauna, as in the brilliant butterfly emerging from the crocodilian form on the left. The winged creature in the foreground sprouts insect feelers from its blue head and thus evokes the praying mantis that haunted the Surrealist imagination. Recent issues of *Minotaure* had presented articles by Roger Caillois on the mantis and on other leaf-and-stick insects, whose capacity for mimesis challenged basic distinctions between animate and inanimate nature (Roger Caillois, "La Mante religieuse," *Minotaure* 5 [February 1934], pp. 23–26; and idem, "Mimétisme et psychasthénie légendaire," *Minotaure* 7 [June 1935], pp. 5–10).

There is a parallel here with the *frottage* Ernst made to illustrate Franz Kafka's "Odradek" (*Minotaure* 10 [Winter 1937], p. 17), a short story about an uncanny being who takes different forms, laughs as though he has lungs, with a sound like dead leaves, and for long periods remains dumb as the wood of which he appears to be made. In *Garden Airplane-Trap*, Ernst fashioned the walls of the maze with the *grattage* technique he had developed in the 1920s to create the effect of wood graining. These meandering partitions also resemble the obsessional and irrational architecture in drawings by "fous et naïfs" (madmen and untrained artists), like those presented by Paul Eluard in "Juste Milieu" (*Minotaure* 11 [Spring 1938], p. 49). The whole painting seems to express a sublime confusion between the categories that are customarily used to order the world. * * *

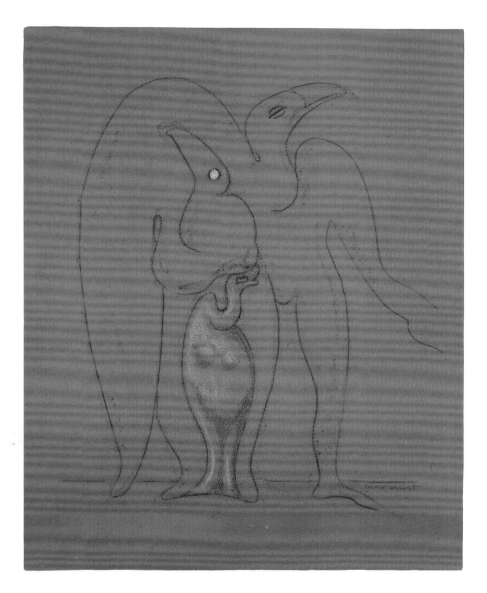

T HE LINEAR AND INTRICATELY INTERLOCKED forms of the "bird people" (*le peuple des oiseaux*) in this drawing are fairly close to those in a study (1942, Westchester, New York, private collection; *Ernst Katalog*, vol. 5, 1987, p. 60, no. 2418, ill.) for Ernst's large canvas *Surrealism and Painting* (1942, Houston, Menil Foundation; ibid., p. 61, no. 2419, ill.). According to Werner Spies (ibid., p. VIII), the Bergman drawing may indeed be one of a number of studies for this painting. Spies elsewhere noted (ibid., p. 55, under no. 2408) that this drawing is also closely related to Ernst's contribution (ibid., p. 55, no. 2408, ill.) to a portfolio of works sold during World War II by the Surrealist journal *VVV* (see the advertisement for this portfolio in *VVV* 2–3 [Mar. 1943], p. 136). Ten nearly identical but individual drawings, on different highly colored papers, are known (ibid., pp. 55–60, nos. 2408–17, ills.). With the exception of one significantly larger drawing (ibid., p. 57, no. 2411, ill.), these are all similar in size to the Bergman drawing. This and the work in the Dallas Museum of Fine Arts (ibid., p. 58, no. 2413, ill.) are distinguished from the other known drawings by the absence of shadows cast on the ground by the birds. * * *

68. UNTITLED (THE BIRD PEOPLE)

1942
Colored crayons on orange wove paper; 45.5 x 35.5 cm (17⁷/₈ x 14 in.)

Signed, lower right: *max ernst*

The Lindy and Edwin Bergman Collection, 126.1991

PROVENANCE: Holland-Goldowsky Gallery, Inc., Chicago; sold to Lindy and Edwin Bergman, Chicago, 1958.

EXHIBITIONS: New York, The Museum of Modern Art, *Max Ernst*, 1961, traveled to Chicago, no. 227, as *Untitled Drawing*. Chicago 1984–85, no cat. nos., p. 147 (ill.), as *Study for "Surrealism and Painting."* Chicago 1986, no. 20, as *Untitled (Study for Surrealism and Painting)*.

REFERENCES: *Ernst Katalog*, vol. 5, 1987, pp. viii, 58, no. 2414 (ill.).

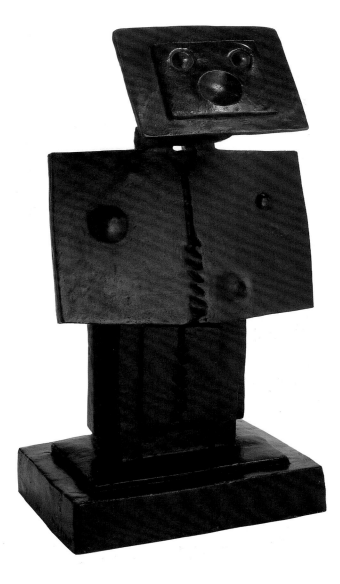

69. AN ANXIOUS FRIEND
(UN AMI EMPRESSÉ)

1944
Bronze (cast in 1957 at the Modern Art Foundry, New York, in an unnumbered edition of nine or ten, from 1944 plaster original); 66.7 x 34.9 x 43.2 cm (26¼ x 13¾ x 17 in.)
Dated and signed, on side of base: *1944 max ernst*
The Lindy and Edwin Bergman Collection, 127.1991

PROVENANCE: Alexander Iolas Gallery, New York; sold to the Bodley Gallery, New York, 1958; sold to Lindy and Edwin Bergman, Chicago, 1963.

EXHIBITIONS: New York, Alexander Iolas Gallery, *Max Ernst*, 1958, no cat. nos., n. pag. Possibly New York, D'Arcy Galleries, *International Surrealist Exhibition*, 1960–61, no. 53. New York, Bodley Gallery, *Max Ernst: Paintings, Collages, Drawings, Sculpture*, 1961, no cat. nos., n. pag. Chicago, Hyde Park Art Center, *New Acquisitions from South Side Collectors*, 1964, no cat. Gary, Indiana University Northwest, *First International Folk and Art Festival*, 1969, no cat. Chicago 1984–85, no cat. nos., p. 149 (ill.).

REFERENCES: Robert Motherwell, ed., *Max Ernst: Beyond Painting and Other Writings by the Artist and His Friends*, New York, 1948, pp. 89 (ill. of plaster original; Bridgewater, Mass., Mr. and Mrs. Julien Levy), 109 (ill. of plaster original

in Ernst's Long Island studio). Houston, Contemporary Arts Museum, *The Disquieting Muse: Surrealism*, 1958, exh. cat., no cat. nos., n. pag. (Bridgewater, Mass., Mr. and Mrs. Julien Levy). Eduard Trier, *Max Ernst*, Recklinghausen, 1959, p. 56 (ill.; New York, Mr. and Mrs. Joseph Slifka). Marcel Jean and Arpad Mezei, *The History of Surrealist Painting*, tr. by Simon Watson Taylor, New York, 1960, p. 309 (ill.; Bridgewater, Mass., Mr. and Mrs. Julien Levy). William Rubin, "Max Ernst," *Art International* 5, 4 (May 1, 1961), p. 37 (ill.; New York, Mr. and Mrs. Joseph Slifka). New York, The Museum of Modern Art, *Max Ernst*, 1961, traveled to Chicago, no. 163 (ill.; New York, Mr. and Mrs. Joseph Slifka). Paris, Le Point Cardinal, *Max Ernst: Oeuvre Sculpté, 1913–1961*, 1961, exh. cat., no. 26 (ill.; unspecified cast). University of California, Santa Barbara, The Art Gallery, *Surrealism: A State of Mind, 1924–1965*, 1966, exh. cat., no. 60 (ill.; Bridgewater, Mass., Mr. and Mrs. Julien Levy). New York, The Jewish Museum, *Max Ernst: Sculpture and Recent Painting*, 1966, exh. cat. ed. by Sam Hunter, no. 95 (ill.; New York, private collection). John Russell, *Max Ernst: Life and Work*, New York, 1967, fig. 130 (unspecified cast), as *A Solicitous Friend*. Rubin 1968, fig. 251 (ill.; New York, Mr. and Mrs. Joseph Slifka) and p. 262. Uwe M. Schneede, *Max Ernst*, tr. by R. W. Last, New York,

1973, fig. 351 (unspecified cast), as *A Solicitous Friend*. *Bulletin of The Art Institute of Chicago* 68 (July–Aug. 1974), cover ill. (Houston, DeMenil family). Houston, Institute for the Arts, Rice University, *Max Ernst: Inside the Sight*, 1974, exh. cat., no. 96 (ill.; Houston, DeMenil family). New York, M. Knoedler and Co., Inc., *Surrealism in Art*, 1975, exh. cat., no. 60 (ill.; New York, private collection). New York, M. Knoedler and Co., Inc., *Three Surrealist Sculptors: Arp, Ernst, Giacometti*, 1976, exh. cat., no cat. nos., n. pag. (unspecified cast). Julien Levy, *Memoir of an Art Gallery*, New York, 1977, pp. 271, 273 (ills. of plaster original between pp. 160 and 161). Munich, Haus der Kunst, *Max Ernst Retrospektive*, 1979, exh. cat., no. 271 (ill.; Bundesministerium des Innern, Germany), fig. 169 (plaster original in Ernst's Long Island studio). Edward Quinn, *Max Ernst*, New York, 1977, no. 313 (ill.; unspecified cast in Ernst's garden at Seillans), as *A Solicitous Friend*. *Ernst Katalog*, vol. 5, 1987, pp. ix, 91, no. 2472, 1 (ill.; unspecified cast). Ulrich Bischof, *Max Ernst 1891–1976: Beyond Painting*, Cologne, 1988, pp. 80–82 (ill.; Duisburg, Wilhelm Lehmbruck Museum), as *A Solicitous Friend*. Edinburgh, Fruitmarket Gallery, *Max Ernst: The Sculpture*, 1990, exh. cat., no. 12 (ill.; California, Mr. and Mrs. James Nathan).

Side view.

Back view.

IN THE SUMMER OF 1944, MAX ERNST, DORO-
thea Tanning, and the dealer Julien Levy rented a
house on the cove of Great River, Long Island. Levy
(1977, pp. 270–71) later described how Ernst turned the
garage into a studio, where

he poured his plaster of Paris into ingenious molds. His
molds were of the most startling simplicity and original-
ity – shapes found among old tools in the garage plus
utensils from the kitchen. . . . One evening he picked up a
spoon from the table, sat looking at it with that abstracted,
distant sharpness one finds in the eyes of poets, artists,
and aviators. He carefully carried it to his garage. It
would be the mold for the mouth of his sculpture, An
Anxious Friend.

In the course of this year, both Ernst and Levy made
chess sets (*Ernst Katalog*, vol. 5, 1987, p. 89, no. 2470.1,
ill.), and Ernst worked on the large sculpture *The*
King Playing with the Queen (ibid., pp. 85–86, nos.
2465–65.1, ill.). This preoccupation with chess, which
inspired Levy to mount an exhibition that winter ex-
clusively devoted to chess, is only faintly reflected in the
Bergman sculpture. The squat, spare, geometrized
forms of *An Anxious Friend* are the formal counterpart
to the lunar curves of the horned, cosmic figure of *Moon-*

mad (ibid., pp. 92–93, no. 2473, ills.), which belongs to
the same summer. There is a tension in *An Anxious*
Friend between a strong, three-dimensional sculptural
presence and persistent signs of two-dimensionality.
This is most obvious in the sculpture's thin, rectangular
components and in the emphatic frontality of the figure's
forward-thrusting face, but also in the jagged split down
the center of the central and lower slabs. This seems to
hint at a schizophrenic division in the figure, and indeed
the back of the sculpture – far from being, as one would
expect in a fully three-dimensional sculpture, a back
that is continuous and consistent with the front – is
revealed to be another figure. This second figure, con-
cealed behind the first, has a smaller body and rectan-
gular head with a protruding, beaklike mouth. The
possible associations suggested by this second head are
manifold, ranging from the mythological to the psycho-
logical. This second head recalls, for instance, certain
Mesoamerican sculptures that portray the dual identity
of a deity, or the totem animal or bird with which many
Native American societies identify.

In his *Memoir of an Art Gallery* (1977), Levy pub-
lished a photograph of Ernst and André Breton standing
beside the plaster original of *An Anxious Friend* in the
overgrown garden at Great River (fig. 4). The sculpture
is balanced on an ornamental classical pedestal, with
which it quite comically contrasts in what appears to be
a parody of Constantin Brancusi's elaborate, custom-
made bases. ✳ ✳ ✳

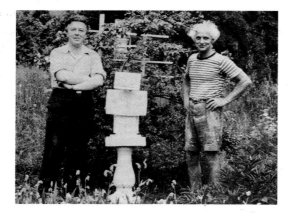

Figure 4. From left to right, André Breton,
Max Ernst's sculpture *An Anxious Friend*
(1944, plaster original), and Ernst in Great
River, Long Island, summer 1944 [photo:
Julien Levy, *Memoir of an Art Gallery*, 1977,
between pp. 160 and 161].

LANDSCAPE IS ONE OF A PAIR OF SMALL OIL PAINT-ings on glass (the location of the other one is un-known) shown at Ernst's 1961 exhibition at the Bodley Gallery, in which the artist returned to the technique of decalcomania. Introduced among the Surrealists by Oscar Dominguez around 1936, decalcomania was a form of automatism, not unlike Ernst's *frottage* technique, in which wet paint was applied to a surface over which a sheet of paper was laid, pressed down, and peeled off. The resulting unfore-seen and unplanned configurations of paint prompted visions of strange caverns or landscapes, open to further interpretation by the artist. André Breton published "D'une décalcomanie sans objet préconçu" in *Minotaure* (8 [1936], pp. 18–24), in which several examples – by Yves Tanguy, Dominguez, and Breton himself, among others – were reproduced.

Ernst had used the technique to striking effect in can-vases of the late 1930s and early 1940s, such as *Totem and Taboo* (1941, Munich, Bayerische Staatsgemäldesamm-lugen, Staatsgalerie moderner Kunst; *Ernst Katalog*, vol. 5, 1987, p. 42, no. 2383, ill.). As John Russell wrote, decalco-mania was ideal for "the evocation of substances which are soft, porous, spongey, long-decayed, equivocal, and sinis-ter" (John Russell, *Max Ernst: Life and Work*, New York, 1967, p. 126). The brilliance of the colors on glass, moreover, evokes dense and swampy tropical vegetation. In *Blue Mountain and Yellow Sky* (1959, location unknown; Ed-ward Quinn, *Max Ernst*, New York, 1977, fig. 385), Ernst used a similar technique. Paintings on glass by Ernst are rare, but at least one other example exists (*The Sea*, 1925, Mönchengladbach, Germany, Viktor Achter; *Ernst Katalog*, vol. 3, 1976, p. 97, no. 980, ill.). * * *

70. LANDSCAPE

1957
Oil on glass; 11.1 x 20.6 cm (4³/₈ x 8¹/₄ in.)
Signed, lower right: *max ernst*
The Lindy and Edwin Bergman Collection,
128.1991

PROVENANCE: Bodley Gallery, New York; sold to Lindy and Edwin Bergman, Chicago, 1962.

EXHIBITIONS: New York, Bodley Gallery, *Max Ernst: Paintings, Collages, Drawings, Sculpture*, 1961, no cat. nos., n. pag.

72. SELF-PORTRAIT

1927–28
Oil on linen; 49.5 x 36.2 cm (19¹⁄₂ x 14¹⁄₄ in.)
Signed, titled, and dated, on back: *a. gorky / Self-portrait / 1927–28* (upper right); *Gorky* (along upper edge of canvas)
The Lindy and Edwin Bergman Collection, 130.1991

PROVENANCE: Mr. and Mrs. Hans Burkhardt, Los Angeles, by 1963; Sotheby's, New York, May 22, 1975, no. 602A (ill.), withdrawn; Sotheby's, New York, June 8, 1977, no. 47 (ill.); sold to the Allan Stone Gallery, New York;[1] sold to Lindy and Edwin Bergman, Chicago, 1977.

EXHIBITIONS: The Pasadena Art Museum, *Paintings by Arshile Gorky*, 1958, no cat. Art Center in La Jolla, California, *Arshile Gorky Paintings and Drawings, 1927–1937: The Collection of Mr. and Mrs. Hans Burkhardt*, 1963, no. 19. New York, The Solomon R. Guggenheim Museum, *Arshile Gorky, 1904–1948: A Retrospective*, 1981–82, traveled to Dallas and Los Angeles, exh. cat. by Diane Waldman, no. 9 (ill.), p. 20.

REFERENCES: Jarvis Barlow, "Paintings by Arshile Gorky at Art Museum," *Pasadena Star-News*, January 12, 1958, sec. *Scene-10* (ill.). Jules Langsner, "Art News from Los Angeles," *Art News*

56, 10 (Feb. 1958), p. 47 (ill.). Cathy S. Silver, "Gorky, When the Going Was Rough," *Art News* 62, 2 (Apr. 1963), p. 61. Jon Reuschel, "Reviews: Arshile Gorky, Art Center in La Jolla," *Artforum* 1, 11 (May 1963), p. 47. Jean-Luc Bordeaux, "Arshile Gorky: His Formative Period (1925–1937)," *American Art Review* 1, 4 (May-June 1974), pp. 98, 100 (ill.). Hayden Herrera, "The Artist's Self-Image: Self-Portraits by Arshile Gorky," in The University of Texas at Austin, University Art

G ORKY DREW OR PAINTED MORE THAN A
dozen self-portraits during the early stages of his
career, following his emigration from Armenia to
the United States in 1920. Many of these, in keeping with
his general practice at the time, emulate the style of the
modern masters he particularly admired – most notably,
Paul Cézanne, Pablo Picasso, and Henri Matisse. In this
self-portrait, Gorky is clearly "*with* Cézanne" (Julien
Levy, *Arshile Gorky*, New York, 1966, p. 15). A compari-
son with Cézanne's *Self-Portrait with a Beret* of around
1898/99 (fig. 1) reveals several shared features: the
chunky, uneven brush stroke; the angle of the head; the
critical, self-searching gaze; the sober clothes; and dis-
creet white collar. In an interview for the *New York
Evening Post*, Gorky was quoted as saying,

*Cézanne is the greatest artist, shall I say, that has lived.
The old masters were bound by convention and rule
to painting certain things – saints, the Madonna, the
crucifixion. Modern art has gone ahead widely and devel-
oped as it never had a chance to in the hands of the old
masters.* ("Fetish of Antique Stifles Art Here," *New York
Evening Post*, Sept. 15, 1926; cited in Jordan and
Goldwater 1982, pp. 19–20)

Gorky also sought his image in self-portraits through
Picasso and Matisse, poignantly demonstrating in this
genre his long, self-imposed apprenticeship to the mod-
ern masters. * * *

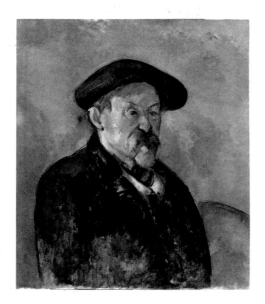

Figure 1. Paul Cézanne, *Self-Portrait
with a Beret*, c. 1898/99, oil on canvas,
64 x 53.5 cm, Boston, Museum of
Fine Arts, Charles H. Bayley Picture and
Painting Fund and Partial Gift of
Elizabeth Paine Metcalf [photo: courtesy
of the Museum of Fine Arts, Boston].

Museum, *Arshile Gorky: Drawings to Paintings*,
1975–76, traveled to San Francisco; Purchase,
New York; and Utica, New York, exh. cat., fig. 3,
pp. 43, 45–46. Hayden Herrera, "Gorky's Self-
Portraits: The Artist by Himself," *Art in America* 64,
2 (Mar.–Apr. 1976), pp. 58–59, 64 n. 6, fig. 4.
Jim M. Jordan and Robert Goldwater, *The Paintings
of Arshile Gorky: A Critical Catalogue*, New York
and London, 1982, pp. 20–21, 135–36, no. 10 (ill.).
Lisa Corrin, "Toward Armenia: Notes of a Journey,"
in London, Whitechapel Art Gallery, *Arshile Gorky,
1904–1948*, 1989–90, exh. cat., pp. 165, 167 (ill.).

73. CARNIVAL

1943
Crayon with graphite and scraping on off-white wove paper; 57.8 x 73.2 cm (22³/₄ x 28⁷/₈ in.)
Signed and dated, lower right: *A. Gorky / 43*
The Lindy and Edwin Bergman Collection, 131.1991

PROVENANCE: Julien Levy, Bridgewater, Connecticut; sold to Lindy and Edwin Bergman, Chicago, 1961.

EXHIBITIONS: Possibly New York, Julien Levy Gallery, *Arshile Gorky*, 1945, no cat. nos., as *Drawing*. Possibly New York, Julien Levy Gallery, *Gorky Drawings*, 1947, no cat. The Art Institute of Chicago, *Chicago Collectors*, 1963, no cat. nos., p. 5. Chicago 1967–68, no cat. College Park, Maryland, University of Maryland Art Department and Art Gallery, J. Millard Tawes Fine Arts Center, *The Drawings of Arshile Gorky*, 1969, exh. cat. by Brooks Joyner, no. 18, fig. 24, p. 14. New York, M. Knoedler and Co., Inc., *Gorky: Drawings*, 1969, exh. cat. by Jim M. Jordan, no. 68 (ill.). Chicago 1973, no cat. nos., n. pag. Chicago,

Museum of Contemporary Art, *Drawings by Five Abstract Expressionist Painters*, 1976, no cat. nos., n. pag. Ithaca, Cornell University, Herbert F. Johnson Museum of Art, *Abstract Expressionism: The Formative Years*, 1978, traveled to New York and Tokyo, exh. cat. by Robert Carleton Hobbs and Gail Levin, no. 60 (ill.). The University of Chicago, The David and Alfred Smart Gallery, *Abstract Expressionism: A Tribute to Harold Rosenberg, Paintings and Drawings from Chicago Collections*, 1979, no. 10. New York, The Solomon

ACCORDING TO JIM JORDAN, THIS DRAWING was "undoubtedly the inspiration" for the painting known as *Virginia Landscape*, also of 1943 (fig. 2; Jordan and Goldwater 1982, pp. 82–83). It belongs to a moment when, staying on his in-laws' farm in Virginia in 1943, Gorky turned to nature and nature's creative forces as a point of reference. André Breton's 1945 celebration of Gorky contains a still-timely warning, however, against making too literal a reading of a landscape in his work:

Those who love easy solutions will find slim pickings here: despite all warnings, they will continue in their attempts to discover still lifes, landscapes, and figurations in these compositions, simply because they do not have the courage to recognize the fact that all human emotions tend to be precipitated in hybrid *forms. By "hybrid" I mean to signify the end result produced by the contemplation of a natural spectacle blended with the flux of childhood and other memories provoked by intense concentration upon this spectacle by an observer endowed with quite exceptional emotional gifts. It should, indeed, be emphasized that Gorky is unique among Surrealist painters in remaining in direct contact with nature by standing* in front of it *in order to paint. He is not concerned, however, with translating nature as an* end in itself, *but rather with extracting from it sensations capable of acting as* springboards *towards the deepening, in terms of consciousness as much as of enjoyment, of certain spiritual states.* (André Breton, "Arshile Gorky," in *Surrealism and Painting*, tr. by Simon Watson Taylor, New York, 1972, p. 200)

Breton emphasized the play of analogies in Gorky's work, which reveals completely new threads of association between disparate things.

Gorky's interest in Joan Miró is apparent here, though it would not be easy to pin down specific sources for *Carnival*. Willem de Kooning recalled that Gorky expressed admiration for Miró's *Still Life with Old Shoe* (1937, New York, The Museum of Modern Art; New York, The Museum of Modern Art, *Joan Miró*, 1993–94, exh. cat. by Carolyn Lanchner, no. 145, ill.), which was shown by Pierre Matisse in the late 1930s (Jordan and Goldwater 1982, p. 75). Like many works by Gorky, *Carnival* is a composite of memories, experiences, and associations – both personal and artistic – powered by the tension between precisely outlined bud- and bodylike forms, and free, gestural passages. As Diane Waldman has written, Gorky could be described as "the last Surrealist and the first Abstract Expressionist" (New York 1981–82, p. 60). * * *

Figure 2. Arshile Gorky, *Virginia Landscape*, 1943, oil on canvas, 86.36 x 116.84 cm, New York, Seibu Corporation of America [photo: courtesy of William Beadleston, Inc., New York].

R. Guggenheim Museum, *Arshile Gorky, 1904– 1948: A Retrospective*, 1981–82, traveled to Dallas and Los Angeles, exh. cat. by Diane Waldman, no. 159 (ill.), p. 54. Chicago 1984–85, no cat. nos., pl. 29, pp. 102, 152. Chicago 1986, no. 22.

REFERENCES: Jim M. Jordan and Robert Goldwater, *The Paintings of Arshile Gorky: A Critical Catalogue*, New York and London, 1982, pp. 82–83.

THE CONFUSION OVER THE TITLE OF THIS drawing dates back to the catalogue for the 1969 exhibition at M. Knoedler and Co., Inc., in New York, in which it was reproduced on the same page as several studies for *The Betrothal* (1947, New Haven, Yale University Art Gallery, The Katharine Ordway Collection; Jim M. Jordan and Robert Goldwater, *The Paintings of Arshile Gorky: A Critical Catalogue*, New York and London, 1982, p. 519, no. 340, ill.). The unclear placement of captions on this page makes it appear that this work is also one of those studies.

The drawing does, however, bear a generic similarity to these studies and particularly to the painting *The Betrothal II* (1947, New York, Whitney Museum of American Art; Jordan and Goldwater 1982, p. 516, no. 339, ill.). Both works contain thinly stretched, rectangular forms, and sexual and anatomical references. A comparison may also be drawn between the Bergman drawing and Gorky's painting *Nude* (1946, Washington, D.C., Smithsonian Institution, Hirshhorn Museum and Sculpture Garden; Jordan and Goldwater 1982, p. 472, no. 307, ill.); in both works there is a similar pelvic shape at lower left and vertebral form through the center. The juxtaposition of the internal and the external hinted at in this drawing, in terms of the body and its organs, had become central to Gorky's sexualized imagery by the end of his life. It is even reflected in the title of one of his works of these years, *The Liver Is the Cock's Comb* (1944, Buffalo, Albright-Knox Art Gallery; Jordan and Goldwater 1982, pp. 432–35, no. 281, ill.).

This mingling of the surface and the organic interior of a body is traceable to an anatomical study dating to

74. UNTITLED

1945–46
Pen and brush and black ink with touches of crayon and graphite on brown wrapping paper; 70.8 x 35.4 cm (27 7/8 x 13 15/16 in.)

The Lindy and Edwin Bergman Collection, 132.1991

PROVENANCE: Harold Diamond, New York;[2] sold to B. C. Holland, Inc., Chicago, 1976; sold to Lindy and Edwin Bergman, Chicago, 1976.

EXHIBITIONS: Probably New Orleans, Tulane University, Newcomb College, *Drawings by Arshile Gorky*, 1962–63, traveled to Pittsburgh; Nashville; Joplin, Missouri; Northampton, Massachusetts; and Huntington, West Virginia, no cat. Tokyo, Seibu Department Store, *Drawings by Arshile Gorky*, 1963, no. 35 (ill.). Probably LeMars, Iowa, Westmar College, *Drawings by Arshile Gorky*, 1963, traveled to Saint Louis, no cat. The Arts Club of Chicago, *Drawings by Arshile Gorky*, 1963, no cat. Probably Bloomington, Indiana, *Drawings by Arshile Gorky*, 1964, traveled to Aurora, New York; DeKalb, Illinois; and New York, no cat. Badischer Kunstverein in Karlsruhe, *Arshile Gorky: Zeichnungen*, 1964, traveled to Hamburg, Berlin, and Essen, no. 35 (ill.). York, City Art Gallery, *Arshile Gorky: Drawings*, 1964–65, traveled to London, Nottingham, Bristol, and Edinburgh, no. 36 (ill.). Brussels, Palais des beaux arts, *Arshile Gorky*, 1965. Rotterdam, Museum Boymans-Van Beuningen, *Arshile Gorky: Schilderijen en Tekeningen*, 1965, no. 97. Vienna, Museum des 20. Jahrhunderts, *Arshile Gorky*, 1965, no. 35. Lisbon, Sociedad nacional de belas artes, Galeria de arte moderna, *Desenhos de Gorky*, 1965,

1931/32, which Matthew Spender suggested is based on Amé Bourdon's seventeenth-century anatomical drawings (Matthew Spender, "Origines et développement de l'oeuvre dessiné de Arshile Gorky," in Lausanne, Musée cantonal des beaux-arts, *Arshile Gorky: Oeuvres sur papier, 1929–1947*, 1990, exh. cat., pp. 20–21). Three of Bourdon's drawings were reproduced by Michel Leiris in an article entitled "L'Homme et son intérieur" (*Documents* 5 [1930], pp. 261–66). These troubling images, Leiris wrote, possess an extraordinary beauty linked to the fact that "the human body is there revealed in its most intimate mystery, its secret places, as the theater of subterranean reactions" (p. 261). One of the illustrations in Leiris's article (p. 263), a reproduction from Bourdon's *Nouvelles tables anatomiques* (1678), renders the body partially intact, and partially flayed and dissected. Leiris's writings influenced such Surrealist artists as André Masson, whose painting *Décoration murale* (1930) was reproduced in the same issue of *Documents* (5 [1930], pp. 288–89), and was, Spender argued, a source for Gorky's first biomorphic shapes. The simpler and more open quality of the curvilinear organic forms in this drawing by Gorky is also particularly reminiscent of the work of Joan Miró.

Perhaps the most famous instance of an anatomized image, interlocking interior and exterior, is Marcel Duchamp's *Bride Stripped Bare by Her Bachelors, Even* (also known as *The Large Glass*) of 1915–23 (Philadelphia Museum of Art; Philadelphia Museum of Art, *Handbook of the Collections*, 1995, p. 316, ill.). The connection between Gorky's Betrothal series and Duchamp's painting *The Bride* (which closely resembles the core of the upper part of the *Large Glass* and which Gorky saw hanging in Julien Levy's apartment in 1937) was noted by Levy:

It is not without reason that Gorky's most elaborate series of paintings in 1947 was given the title Betrothal. *The delicate central figure in* Betrothal I, *shaped like a peacock feather, might be Duchamp's "bride," her wedding into Gorky's family celebrated. She, as the anatomy of an idea, will merge and interact and become transformed in this new world of Gorky's multiple images.* (Julien Levy, *Arshile Gorky*, New York, 1966, p. 32)

Even if this drawing is not a direct study for the Betrothal series, it shares with these paintings, as with Duchamp's *Bride*, a highly sexualized imagery of interpenetration and transformation. * * *

no. 35. Oslo, Kunstnernes Hus, *Tegninger av Arshile Gorky*, 1966, no. 35. Lund, Sweden, Lunds Konsthall, *Teckningar av Arshile Gorky*, 1966, no. 35. Basel, Kupferstichkabinett der öffentlichen Kunstsammlung, *Zeichnungen von Arshile Gorky, 1905–1948*, 1966, no. 38. Zagreb, Galerija Suvremene Umjetnosti, *Arshile Gorky*, 1966, no. 38. Belgrade, Galerija Doma Omladine, *Arshile Gorky*, 1966, no cat. Rome, Galleria nazionale d'arte moderna, *Arshile Gorky (1905–1948): Disegni*, 1967, no. 39 (ill. upside down). Buenos Aires, Centro de artes visuales del instituto

Torcuato Di Tella, *"Sobre papel": Obras de Arshile Gorky*, 1967, no. 38. Museo de bellas artes de Caracas, *Sobre papel: Obras de Arshile Gorky*, 1968, no. 38. Bogotá, Biblioteca Luis-Angel Arango del banco de la república, *Dibujos de Arshile Gorky*, 1968, no. 38. Mexico City, Universidad nacional autónoma de México, Museo universitario de ciencias y arte, *Sobre Papel: Obras de Arshile Gorky y Robert Motherwell*, 1968, no. 38.[3] New York, M. Knoedler and Co., Inc., *Gorky: Drawings*, 1969, exh. cat. by Jim M. Jordan, no. 143. New York, The Solomon R. Guggenheim Museum, *Arshile Gorky, 1904–1948: A Retrospective*, 1981–82,

traveled to Dallas and Los Angeles, exh. cat. by Diane Waldman, no. 192 (ill.). Chicago 1984–85, no cat. nos., p. 152, as *Study for "The Betrothal."* Chicago 1986, no. 24, as *Untitled (Study for "The Betrothal")*.

REFERENCES: Julien Levy, *Arshile Gorky*, New York, 1966, pl. 139. Rubin 1968, p. 404. Paris, Artcurial, *L'Aventure surréaliste autour d'André Breton*, 1986, exh. cat. by José Pierre, p. 98 (ill.).

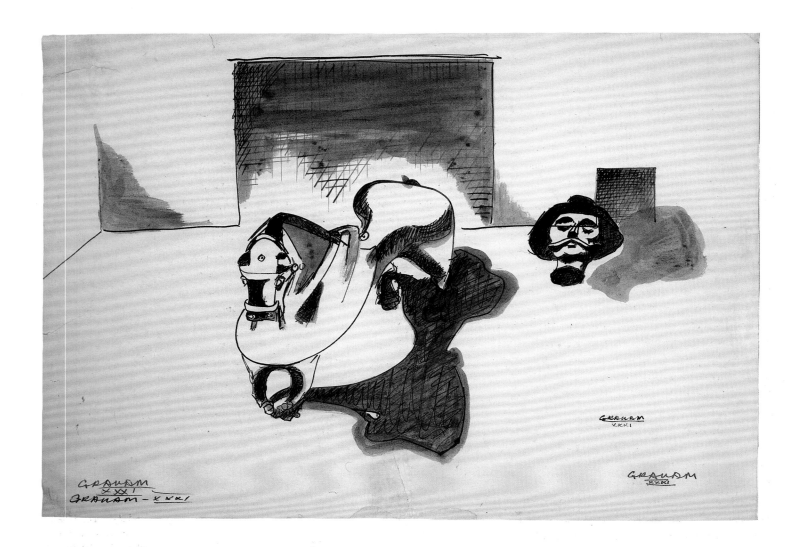

75. UNTITLED

1931
Pen and black ink, and brush and brown wash, on
cream wove paper, laid down on Japanese paper;
26.7 x 37.9 cm (10½ x 14⅞ in.)
Signed and dated: *GRAHAM / XXXI / GRAHAM
– XXXI* (lower left); <u>*GRAHAM*</u> */ XXXI /
GRAHAM / XXXI* (lower right)

The Lindy and Edwin Bergman Collection,
133.1991

PROVENANCE: Rose Fried Gallery, New York;
sold to Lindy and Edwin Bergman, Chicago, 1963.

THE MOTIF OF THE HORSE, WHICH APPEARED frequently in Graham's work during the late 1920s and early 1930s, seems to have had multiple associations for the artist, many of which were autobiographical. Graham (born Ivan Gratianovitch Dombrowski in Warsaw) had served as a cavalry officer in the Circassian Regiment of the Russian army, fighting on the Russian front against Romania during World War I and winning the Cross of Saint George for equestrian valor in 1916. In this drawing the horse is depicted as part carousel horse, part armored steed. The numerous images of horses Graham collected – many of equestrian statues – include a postcard of carousel horses and a photograph of a sixteenth-century Mexican sculpture, showing a Spanish knight on a creature with the helmeted head of a horse and the body of a jaguar (fig. 1). This creature is very close in appearance to the horse in this drawing.

Informed by developments in Paris, Graham's work tended at this time to be eclectic. In this drawing, the shape of the squat, dramatically foreshortened horse is interlocked with that of its heavy shadow to create an almost abstract configuration, while the strange, room-like space and the conjunction of horse and severed head point to an awareness of Surrealism. Although Graham was not an adherent of Surrealism, maintaining that it "was a literary movement not to be adapted to painted images" (Dorothy Dehner, "John Graham: A Memoir," *Leonardo* 2, 3 [1969], p. 291), he shared with its practitioners an interest in the unconscious and particularly admired the work of Giorgio de Chirico. Both Graham and his friend Arshile Gorky made works based on de Chirico's painting *The Fatal Temple* (1914, Philadelphia

Museum of Art; Maurizio Fagiolo dell'Arco, *L'opera completa di de Chirico, 1908–1924*, Milan, 1984, no. 61, ill.). In Graham's painting *Blue Abstraction* (1931, Washington, D.C., The Phillips Collection; Washington, D.C., The Phillips Collection, *John Graham: Artist and Avatar*, 1987–88, exh. cat., no. 18, p. 101, ill.), for instance, de Chirico's classical bust is transformed into a floating head. Even more relevant is an earlier de Chirico-inspired painting of around 1929 known as *Merry-Go-Round* (New York, Noah Goldowsky; Dehner 1969, fig. 1), which includes both a carousel horse and a severed head, thus directly prefiguring this 1931 drawing. There is, moreover, an element of self-dramatization in the head included in the Bergman drawing, which suggests a familiarity with Salvador Dalí's paintings of 1929, likewise featuring self-portraits in the form of severed heads. From de Chirico, Graham also derived his interest in the idea of "enigma" in art, writing in his *System and Dialectics of Art* (1937): "What is the value of the strange, enigmatic, and absurd in art? The value of the strange and absurd lies in their suggestion of a possible unknown, supernatural, life eternal" (Marcia Epstein Allentuck, ed., *John Graham's "System and Dialectics of Art,"* Baltimore, 1971, p. 144). * * *

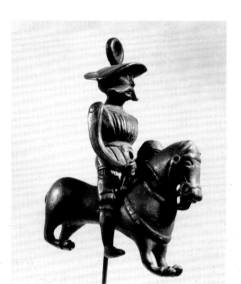

Figure 1. Photograph of Mexican sculpture, Papers of John Graham, Archives of American Art, Smithsonian Institution, Washington, D.C.

Figure 2. Back of no. 76.

76. UNTITLED

1944
Graphite on tan laid paper; 33 x 20 cm
(13 x 7⅞ in.)
Signed and dated, center left: *Ioannus / Magus /
Servus / Domini / XXXXIV* (John / Magician /
Servant / of the Lord / XXXXIV)[1]
Inscribed, lower left: ☿
Inscribed on back: see fig. 2.

The Lindy and Edwin Bergman Collection,
134.1991

PROVENANCE: Rose Fried Gallery, New York;
sold to Lindy and Edwin Bergman, Chicago, 1962.

EXHIBITIONS: The Arts Club of Chicago,
John Graham, 1963–64, traveled to Minneapolis,
no. 28, as *Joannus Magus*. The Arts Club of
Chicago, *Drawings: 1916/1966*, 1966, no. 39,
as *Joannus Magus*. Washington, D.C., The Phillips
Collection, *John Graham: Artist and Avatar*,

1987–88, traveled to Purchase, New York;
Newport Beach, California; Berkeley; and
Chicago, no cat. no., p. 68, as "in a notebook"
(Chicago only).

REFERENCES: Anne Carnegie Edgerton,
"Symbolism and Transformation in the Art of
John Graham," *Arts Magazine* 60, 7 (1986),
fig. 10, p. 63.

THIS DRAWING AND THE POSSIBLE STUDY (no. 77) for *Donna Ferita* (*Wounded Woman*, fig. 5) are among the most fully worked drawings related to the large-scale oil portraits of women that Graham exhibited in 1946. These paintings were simultaneously shown in New York that year at Rose Fried's Pinacotheca Gallery and in the windows of the Arnold Constable department store. Photographs of the window display (Washington 1987–88, p. 56, ill.) show fashionably dressed mannequins arranged in front of Graham's paintings, their archaic serenity in strong contrast to the mannequins' sleek modernity. Among the paintings visible is *Donna Ferita* (*Wounded Woman*), at center, which he later renamed *Marya* (fig. 5).

As Anne Carnegie Edgerton has argued, Graham worked from a comparatively small repertoire of images, which underwent a variety of transformations. He often traced over photographs, and would then retrace and modify the resulting drawings. But, as Edgerton pointed out, "Graham did not trace because he could not draw: he was a very accomplished and inventive draftsman" (Edgerton 1986, p. 61).

One source Edgerton suggested for this drawing is Jacometto Veneziano's *Portrait of a Young Man* (before 1498) in The Metropolitan Museum of Art, New York (Edgerton 1986, p. 63; Federico Zeri and Elizabeth E. Gardner, *Italian Paintings: A Catalogue of the Collection of The Metropolitan Museum of Art, Venetian School*, New York, 1973, pl. 38). A photographic enlargement of the Veneziano portrait, onto which is taped a sheet of tracing paper with a partial tracing, was found among Graham's papers (fig. 3). But this and other related drawings are not precise copies of their source. A num-ber of significant adjustments to the original are evident in the case of the Bergman drawing: the eyes are rounded and the whites exaggerated to emphasize the staring gaze; the slightly androgynous appearance of Veneziano's *Young Man*, with its smooth and hairless cheeks, is enhanced by the suggestion of female nakedness; and the head is given Graham's characteristic protruding ears, which appear in a more extreme form in the other female portrait in the Bergman collection (no. 77). These drawings, based on the Veneziano portrait, culminate in the *Pystis Sophia* (1955, New York, private collection; Edgerton 1986, fig. 12), an image of female wisdom inscribed with alchemical symbols.

Another important source for this untitled drawing is a photograph of a slightly cross-eyed woman, which Graham inscribed on the back *Ebreni, my first bride* (fig. 4). Eleanor Green has suggested (in Washington 1987–88, pp. 63–64) that it is the origin of Graham's painting *Woman in Black* (*Donna Venusta*) of 1943/56 (Pittsburgh, The Carnegie Museum of Art; ibid., pp. 63–64, no. 42, ill.). The photograph bears strong similarities to the Bergman portrait, particularly in the faint widow's peak of the hair and in the cupid's-bow lips. Edgerton's argument that these portraits are primarily characterized by the transformation of gender should not be discounted, however, for this drawing remains rather androgynous in character. Moreover, the figure's shoulder is inscribed below the signature with the sign for Mercury, who is often associated with the union of opposites (see *Apotheosis*, no. 78 below).

The writing on the back of the drawing, visible through the thin paper, contributes, like the dog Latin of the inscription on the front, to the impression that the sheet is from an old, perhaps alchemical, manuscript. The drawing is actually on the reverse of an early nineteenth-century bill of sale for agricultural goods (fig. 2), itself of no significance; what attracted Graham was probably the fact that the sheet of paper was thin enough to trace through. ✳ ✳ ✳

Top, figure 3. Photographic enlargement of Jacometto Veneziano's *Portrait of a Young Man*, over which is taped a sheet of tracing paper with partial tracing, Washington, D.C., Papers of John Graham, Archives of American Art, Smithsonian Institution [photo: Edgerton 1986, fig. 11].

Bottom, figure 4. Photograph inscribed on back *Ebreni, my first bride*, Washington, D.C., Papers of John Graham, Archives of American Art, Smithsonian Institution.

THIS DRAWING IS OFTEN INCLUDED IN A GROUP
of studies for Graham's large painting *Donna Ferita*
(*Wounded Woman*), later renamed *Marya* (fig. 5).
Like the painting, this drawing represents a *donna ferita*,
a wounded woman, although in the painting the wound is
on the woman's wrist rather than on her neck. The paint-
ing departs markedly from the drawing in other respects
as well. For instance, the woman in *Donna Ferita* is not
shown frontally, as in the drawing, but in a three-quarter
view closer to that of the slightly earlier female portrait in
the Bergman collection (no. 76).

As in the 1944 Bergman drawing (no. 76), Graham in-
scribed this work with the signature of his alchemical alter
ego, "John the magician servant of the Lord," over the
planetary sign for Mercury. At the base of the woman's
neck, he added the phrase, again in dog Latin, *Qui bene
castigat bene amat* (Who punishes well loves well), which
may reflect some of the cruelty in Graham's personality,
but could also be an attempt at the reconciliation of oppo-
sites, probably in a sexual context. The neck wound re-
sembles the opening of a mouth, becoming a metaphor of
sexual displacement.

This study may involve a change of gender. It was
traced either from other drawings in the series or, as Anne
Carnegie Edgerton proposed, from a photograph found in
Graham's archive of an actor dressed as Hercules, that is,
in a lion's skin, in a production of the opera *Astarté* (fig. 6).
A related, full-face drawing (fig. 7) shows not only the
lion's mask from the photograph, but a neck wound simi-
lar to that in the Bergman drawing. The significance of
Astarté, in Edgerton's argument, is that the opera hinges
upon cross-dressing: Hercules and Omphale exchange
clothes and deceive the god Pan. Edgerton suggested that
for Graham this story held a special meaning:

*When Heracles put on Omphale's clothes, he put on her fem-
ininity. . . . Each "became" the opposite sex to some degree by
this symbolic putting on of the other's garments. This im-
plies a reversal of roles in terms of dominance and submis-*

77. UNTITLED

1945
Graphite with traces of red crayon on yellow
tracing paper; 39.7 x 26 cm (15⅝ x 10¼ in.)
Signed and dated, center left: *GRAHAM /
Ioa[nnr?] / Ioannus / Magus / Servus / Domini /
XXXXV / ☿* (Graham / John / John / Magician /
Servant / of the Lord / XXXXV)
Dated, center right: *XXXXV*
Inscribed, lower left: *QUI BENE CASTIGAT BENE
AMAT* (Who Punishes Well Loves Well)

The Lindy and Edwin Bergman Collection,
135.1991

PROVENANCE: Rose Fried Gallery, New York;
sold to Lindy and Edwin Bergman, Chicago, 1963.

EXHIBITIONS: Possibly New York, The
Pinacotheca, *Drawings by John Graham*, no. 2,
as *Donna Ferita*. New York, The Museum of
Modern Art, *John Graham: Paintings and Draw-
ings*, 1968–70, traveled to Athens, Georgia;
Grinnell, Iowa; Auburn, Alabama; Houston; San

Antonio; Seattle; Chicago; and Hanover, New
Hampshire, no. 11, as *Study for La Donna Ferita
(The Wounded Woman)*. Chicago 1973, no cat.
nos., n. pag., as *He Who Chastizes Well Loves
Well*. Chicago 1986, no. 27, as *Qui Bene Castigat
Bene Amat (Study for "La Donna Ferita")*.
Washington, D.C., The Phillips Collection, *John
Graham: Artist and Avatar*, 1987–88, traveled

sion, but also symbolizes wholeness in terms of the union of opposites. (Edgerton 1986, p. 62)

Graham himself willingly displayed his female side on numerous occasions by cross-dressing – as he did, for example, when he wore the clothes of his late wife, Marianne (Edgerton 1986, p. 63).

The striking feature of the crossed eyes is common to the whole group of drawings; apart from the photograph of his first wife mentioned above (fig. 4), who was slightly cross-eyed, suggested sources for this motif include Giorgio de Chirico's *Euripides* (1921, New York, The Museum of Modern Art; Maurizio Fagiolo dell'Arco, *L'opera completa di de Chirico, 1908–1924*, Milan, 1984, p. 116, no. D60, ill.) and Raphael's *Pensive Woman* (*La donna gravida*) of around 1506 (Florence, Galleria Pitti; Mina Gregori, *Paintings in the Uffizi and Pitti Galleries*, tr. by Caroline Hufton Murphy and Henry Dietrich Fernandez, Boston, 1994, pl. 206). The latter is certainly in key with the deliberate references in Graham's paintings of this time to the format and style of Italian Renaissance portraiture. The prevalence of the crossed eyes in Graham's portraits, though, suggests that this feature had a symbolic meaning for the artist: it could be another example of the "union of opposites," or, more convincingly, it might allude to the figure's remoteness from our world, and the idea that she is involved in a process of introspection and internal enlightenment. She represents both the supernatural and the mortal.

A similar drawing, *Study after Celia* of 1944/45, in The Museum of Modern Art in New York, lacks the disturbing attributes of this study, such as the neck wound. As John Elderfield pointed out, drawings such as these — in their combination of modeling and flat, linear qualities — owe a debt to Jean Auguste Dominique Ingres and reflect Graham's "role in fostering what was virtually an Ingres revival in the early 1940s" (John Elderfield, *The Modern Drawing: One Hundred Works on Paper from The Museum of Modern Art*, New York, 1983, pp. 178–79, ill.).

* * *

Bottom left, figure 5. John Graham, *Donna Ferita (Wounded Woman)*, later renamed *Marya*, 1944, oil on canvas, 121.9 x 121.9 cm, New York, Allan Stone Gallery [photo: courtesy of the Allan Stone Gallery].

Top right, figure 6. The actor Alvarez as Hercules in *Astarté*, from *Le Théatre*, c. 1901, Washington, D.C., Papers of John Graham, Archives of American Art, Smithsonian Institution.

Bottom right, figure 7. John Graham, *Untitled*, n.d., pencil on vellum, 43.5 x 35.2 cm, Windermere, Florida, private collection [photo: Edgerton 1986, fig. 6].

to Purchase, New York; Newport Beach, California; Berkeley; and Chicago, not in cat. (Chicago only).

REFERENCES: Anne Carnegie Edgerton, "Symbolism and Transformation in the Art of John Graham," *Arts Magazine* 60, 7 (1986), fig. 4, pp. 60–61, as *Qui Bene Castigat Bene Amat (Study for Donna Ferita)*. "An Eccentric Revived: John Graham – Painter of Cross-Eyed Beauties and Mystic Signs," *Life*, Oct. 4, 1968, p. 55 (ill.).

78. APOTHEOSIS

1955–57
Oil paint and graphite with smudging on tan
wove paper, laid down on Japanese paper; 126.9 x
92.4 cm (50 x 36³/₈ in.)
Signed and dated, upper right (fig. 8): *IΩANNHΣ /
ΨYXHΠOMΠOΣ / OXΛOΛOIΔOPOΣ /
SUMQUISUM / XXXXXV / LVII*
Inscribed along upper-left edge:
EΣKATOBIBEΛOI
Inscribed, left of head (fig. 9):
*APOTEOSIDELEROE / IOANNUS SAN GER-
MANUS DUX / PHOTIUS MAGUS SERVUS
DOMINI / MYTADOLOS*

*PORPHIROGENATUS / GLAPHIROS MAKARIUS
/ ΨYXOΠOMΠOΣ OXΛOΛOIΔOPOΣ / DOCTOR
JURIS UTRIUSQUE / ET ST GEORGIIEQUITUS /
SEMPER IDEM)*
Inscribed along lower left edge: *APOTHEOSIS*
Inscribed three times, left of head: 666
Inscribed three times, right of head: 999
The Lindy and Edwin Bergman Collection,
136.1991

PROVENANCE: Gallery Mayer, New York; sold
to Lindy and Edwin Bergman, Chicago, 1960.

EXHIBITIONS: New York, Gallery Mayer, *John
D. Graham*, 1960, no. 10. The Arts Club of
Chicago, *John Graham*, 1963–64, traveled to

Minneapolis, no. 14.[2] Chicago 1967–68, no
cat. New York, The Museum of Modern Art, *John
Graham: Paintings and Drawings*, 1968–70,
traveled to Athens, Georgia; Grinnell, Iowa;
Auburn, Alabama; Houston; San Antonio; Seattle;
Chicago; and Hanover, New Hampshire,
no. 25 (ill.). Chicago 1973, no cat. nos., n. pag.
New York, Whitney Museum of American
Art, *Twentieth-Century American Art from Friends'
Collections*, 1977, no cat. nos., n. pag.
Chicago 1986, no. 29. Washington, D.C., The
Phillips Collection, *John Graham: Artist and
Avatar*, 1987–88, traveled to Purchase, New York;

POTHEOSIS IS A SELF-PORTRAIT IN WHICH Graham drew together his ideas about occult knowledge and the exceptional character of the artist. He believed that artists are alone, with children and "primitive" people, in their access to the unconscious. In 1937 Graham described the unconscious as "the creative factor and the source and the storehouse of power and of all knowledge, past and future" (John D. Graham, "Primitive Art and Picasso," *Magazine of Art* 30, 4 [1937], p. 237). His emphasis on the unconscious as the repository of primordial wisdom and his prodigal use of signs and symbols drawn from mystical, mythological, Western, and non-Western sources link him to Carl Jung more than to Sigmund Freud. Graham's awareness of Jung is evident in such statements as "[Picasso] delved into the deepest recesses of the Unconscious, where lies a full record of all past racial wisdom" (ibid., p. 260). In *Apotheosis* Graham drew especially upon Jung's concept of the unconscious and its relation to the alchemists' Mercurius, as described in Jung's essay "The Philosophical Tree," which was first published in 1945:

As I have said, the confrontation with the unconscious usu-
ally begins in the realm of the personal unconscious . . . and
from there leads to archetypal symbols which represent the
collective unconscious. The aim of the confrontation is to
abolish the dissociation. In order to reach this goal, either
nature herself or medical intervention precipitates the
conflict of opposites without which no union is possible.
This means not only bringing the conflict to consciousness;
it also involves an experience of a special kind, namely,
the recognition of an alien "other" in oneself. . . . The

alchemists, with astonishing accuracy, called this barely
understandable thing Mercurius, in which concept they in-
cluded all the statements which mythology and natural
philosophy had ever made about him: he is God, daemon,
person, thing, and the innermost secret in man; psychic
as well as somatic. . . . This elusive entity symbolizes the
unconscious in every particular, and a correct assessment
of symbols leads to direct confrontation with it. (Carl G. Jung, *Alchemical Studies,* tr. by R. F. C. Hull, Princeton, 1967, p. 348)

The bush behind the figure, with flesh-colored apples, is the *arbor philosophicus*, the philosophical tree, a frequent symbol, as Jung noted, for the alchemical process itself.

In *Apotheosis* the artist portrayed himself as a heroic, virile warrior, and he crammed the picture with references to alchemy, as well as with his personal, idiosyncratic signs and symbols. The inscriptions on this drawing consist mostly of a string of epithets in Greek, Latin, and Italian, referring to Graham's noble origins and achievements. In disguised form, these fantastic, self-awarded titles express Graham's belief that, as an artist, he occupied an exalted status and was endowed with sacred and magical powers. His late notebooks contain many similar inscriptions in various combinations (see Eleanor Green, in Washington, D.C. 1987–88, p. 130). Some of the terms remain obscure as a result of a mistake or a deliberate neologism on Graham's part. For

Newport Beach, California; Berkeley; and Chicago, no. 62 (ill.), p. 87.

REFERENCES: Fairfield Porter, "John Graham: Painter as Aristocrat," *Art News* 59, 6 (1960), p. 41 (ill.). Irving Hershel Sandler, "New York Letter," *Art International* 4, 9 (1960), p. 29. Thomas B. Hess, "Eccentric Propositions," in *The Grand Eccentrics: Five Centuries of Artists outside the Main Currents of Art History*, ed. by Thomas B. Hess, *Art News Annual* 32 (Oct. 1966), p. 10 (ill.). Jack Kroll, "Beyond the Fringe," *Newsweek*, Nov. 7, 1966, p. 112 (ill.). Eila Kokkinen,

"Ioannus Magus Servus Domini St Georgii Equitus," *Art News* 67, 5 (1968), p. 66. "Painting: The Eyes Have It," *Time*, Sept. 13, 1968, p. 72. "An Eccentric Revived: John Graham – Painter of Cross-Eyed Beauties and Mystic Signs," *Life* 65, 14 (1968), p. 52 (ill.). Marcia Epstein Allentuck, ed., *John Graham's "System and Dialectics of Art,"* Baltimore, 1971, p. 69 (ill.). Barbara Rose, "Arshile Gorky and John Graham: Eastern Exiles in a Western World," *Arts Magazine* 50, 7 (1976), pp. 68 (ill.), 69. Hayden Herrera, "John Graham: Modernist Turns Magus," *Arts Magazine* 51, 2 (1976), p. 104 (ill.). Paul Brach, "John Graham: Brilliant Amateur?," *Art in America* 75, 12 (1987), p. 133 (ill.). Suvan Geer, "A Magus Seeking

Enlightenment," *Art Week* 18, 43 (1987), p. 7 (ill.). Peter Frank, "Jan Dibbets and John Graham," *Diversion* (July 1988), p. 109 (ill.). Jane Addams Allen, "Graham: Genius or Fake?," *Washington Times*, July 11, 1988, p. E3 (ill.). Jo Ann Lewis, "Modernism's Madman," *Washington Post*, July 24, 1988, p. G5 (ill.). Edward J. Sozanski, "'Artist and Avatar,' A D.C. Retrospective of John Graham Art," *Philadelphia Enquirer*, Aug. 4, 1988, p. 3-C (ill.). Ellen G. Landau, *Jackson Pollock*, New York, 1989, p. 80 (ill.).

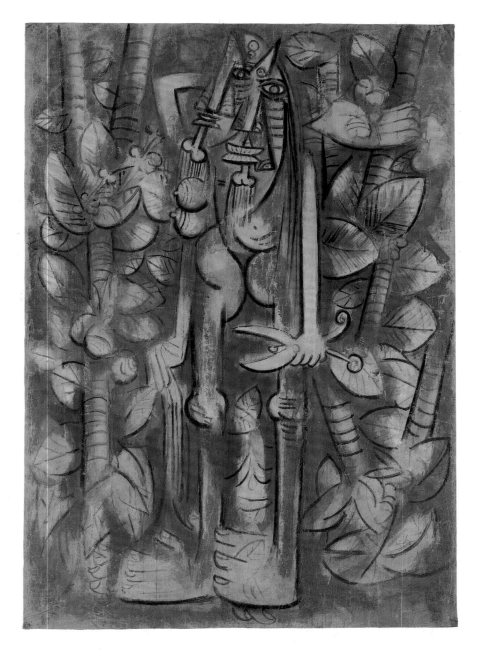

IKE MANY OF THE SURREALISTS, WIFREDO Lam (fig. 1) left France after the Occupation of Paris. He boarded a ship in Marseilles in March 1941 and arrived in Havana sometime in late July or early August. For Lam, however, this was not the exile that it was for André Breton or André Masson, both of whom went to the United States. Lam was returning home, and from this moment he rediscovered an artistic universe for which his long sojourn in Europe had, in a sense, been preparing him. Born of a Chinese father and a mother of African and Spanish origin, he had left Cuba in 1923 for Spain, where he had acquired formal, academic training, and eventually moved to Paris in 1938, where his encounter with Pablo Picasso was decisive. He absorbed the modernist interest in African art, which did not hamper him in any sense from responding directly to the particular Afro-Cuban traditions of his homeland. This rich legacy continued to imbue his work, even after 1952, when he once again established his main residence in Paris.

Not only did Lam draw inspiration from the tropical nature that overwhelmed him on his return to Cuba, but he also reached his homeland at a propitious moment, at a time when Cuban scholars were beginning to study Afro-Cuban religion and culture, thus richly encouraging his own predisposition toward the "primitive." In Cuba, groundbreaking research on Afro-Cuban culture was being carried out by Fernando Ortiz and Lydia Cabrera, both of whom Lam came to know. As Valerie Fletcher has written, "Because slavery had not effectively ceased until 1886, African religions, lan-

79. STUDY FOR "THE JUNGLE"

1942
Tempera, with touches of pastel, on tan wove paper laid down on canvas;[1] 177.4 x 121.9 cm (69¹⁵/₁₆ x 48 in.)
Signed and dated, lower right: *Wi Lam / 1942*
The Lindy and Edwin Bergman Collection, 138.1991

PROVENANCE: Sold by the artist to Lindy and Edwin Bergman, Chicago, 1956.

EXHIBITIONS: The Art Institute of Chicago, *The United States Collects Pan-American Art*, 1959, no. 28 (ill.), as *Jungle*. Chicago, Museum of Contemporary Art, *Modern Masters from Chicago Collections*, 1972, no cat. nos., n. pag., as *The Jungle*. Madrid, Museo nacional de arte contemporáneo, *Exposición Antologica "Homenaje a Wifredo Lam," 1902–1982*, 1982, traveled to Brussels and Paris, no. 31 (ill.), as *La Jungla*; French cat. publ. as *Wifredo Lam, 1902–1982*, 1983, no. 39 (ill.), as *La Jungle*.

Chicago 1984–85, no cat. nos., pp. 14, 161, pl. 8, as *The Jungle*.

REFERENCES: Alain Jouffroy, *Lam*, Paris, 1972, p. 30 (ill.), as *Personnage avec ciseaux*. Michel Leiris, *Wifredo Lam*, New York, 1972, pl. 29, as *Figure with Shears*. Alain Jouffroy, *Le Nouveau Nouveau Monde de Lam*, Pollenza-Macerata, 1975, p. 89 (ill.). Max-Pol Fouchet, *Wifredo Lam*, Paris, 1976, pl. 48, as *La Jungle*. Sebastià Gasch,

guages, mythologies, rituals, music, and dance remained particularly strong in Cuba" (Valerie Fletcher, "Wifredo Lam," in Washington, D.C., Hirshhorn Museum and Sculpture Garden, *Crosscurrents of Modernism, Four Latin American Pioneers: Diego Rivera, Joaquín Torres-García, Wifredo Lam, Matta*, 1992, exh. cat., p. 179). Lam may have drawn, furthermore, upon family memories, for his godmother, Mantonica Wilson, was a priestess of the Yoruba-derived religion Santería.

There was, then, a transformation in Lam's work after 1941; Gerardo Mosquera argued that this change was

not a formal one: the artist was to continue always to be in debt to Picasso, Gonzàlez, Matisse, African geometricism and the classical tradition of Western art. What was important was the change of direction. . . . under the impulse of Surrealism he began to develop his personal world in such a way that it led to a more introspective handling of those forms. The rediscovery of Cuba brought about the eclosion of everything African in his own cultural formation, the emergence of his Caribbean Weltanschauung and of its relationship with his natural and social environment. (Gerardo Mosquera, "Modernity and Africania: Wifredo Lam on His Island," in Barcelona, Fundació Joan Miró, *Wifredo Lam*, 1993, exh. cat., p. 178)

Lam also benefited from the fact that Surrealism was far more closely allied to the Négritude movements in the Antilles, in its attitude to poetry, society, and politics, than to the negrophilia fashionable in Paris in the 1920s and early 1930s. In Martinique, Breton, Lam, and Masson, on their voyage from France in 1941, had met the poet Aimé Césaire, who had, with several others, just founded the review *Tropiques* (published in Fort-de-France from 1941 to 1945). A Surrealist "avant la lettre," Césaire's poetic formation, with its emphasis on the writings of Arthur Rimbaud and Lautréamont, had much the same roots as that of Breton. Breton, in turn, was impressed by the quality of the texts in the first issue of *Tropiques* and lent his full support to its contributors. As Césaire's wife, Suzanne, later explained, Surrealism was the "tight-rope of our hope" (see her essay "1943: Le Surréalisme en nous," *Tropiques* 8–9 [Oct. 1943], p. 18).

Especially noteworthy is Benjamin Péret's contribution to a 1943 issue of *Tropiques* in the form of a preface to Césaire's poem "Cahier d'un retour au pays natal," which was illustrated by Lam. This text eloquently illuminates Lam's work as well as Césaire's poem. "For the first time," Péret wrote,

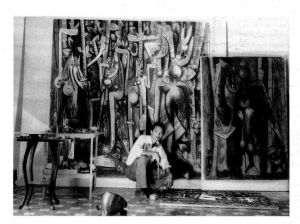

Figure 1. Wifredo Lam in his studio, Havana, c. 1943.

Wifredo Lam a París, Barcelona, 1976, p. 89, no. 9 (detail ill.), as *The Jungle*. Lucien Curzi, *Wifredo Lam*, Bologna, 1978, p. 17, no. 15 (ill.), as *L'uomo con la forbice*. Max-Pol Fouchet, *Wifredo Lam*, tr. by Kenneth Lyons, Barcelona, 1986, fig. 32, as *The Jungle*. Caracas, Museo des bellas artes, *Wifredo Lam, pintura y obra gráfica, 1938–1976*, 1986–87, exh. cat., p. 17 (ill.), fig. 5, as *Personaje con tijeras*. Luis Miguel La Corte, "Imagen de Wifredo Lam," *Arte* [1987], p. 32 (ill.), as *Personaje con tijeras*. Julia P. Herzberg, "Wifredo Lam," *Latin American Art* 2, 3 (Summer 1990), p. 20, as *The Jungle*. New York, The Studio Museum in Harlem, *Wifredo Lam and His Contemporaries, 1938–1952*, 1992–93, exh. cat., pp. 35, 37 (ill.), fig. 10, as *The Jungle (Personage with Scissors)*. Lou Laurin-Lam, *Wifredo Lam: Catalogue Raisonné of the Painted Work, Vol. I, 1923–1960*, Lausanne, 1996, p. 87, fig. 43, p. 325, no. 42.122, as *Personnage aux Ciseaux (La Jungle)*.

a tropical voice resounds in our language, not to mediate an exotic poetry, trinket of bad taste and mediocre interior, but to burst out in an authentic poetry issuing from the rotting trunks of orchids and the electric butterflies devouring carrion. . . .

His poetry has the sovereign allure of the great breadfruit trees and the obsessive accent of the voodoo drums. In it, black magic heavy with poetry is opposed to the point of rebellion against the religions of the slavers where all magic is mummified, all poetry dead forever. (quoted in *Tropiques* 6–7 [Feb. 1943], p. 60)

This study belongs to a series of works related to *The Jungle* (fig. 2), Lam's masterpiece and major statement about his rediscovery of African Cuba. The Bergmans bought the work directly from Lam, whom they visited in Havana in 1956. In a letter to Edwin Bergman of April 1956, Lam called the work "etude for *La Jungle*," a confusing bilingual title probably resulting from an inadequate attempt at translation, for Lam did not speak English. On November 13 of that year, Lam wrote that the painting had been sent to Chicago, but was not responsive to Edwin Bergman's request, in an earlier letter of August 21, for information about its "meaning and symbolism." "About this picture I have very little to say," Lam wrote, "because in other letters that I have written to you I have explained the materials that I have used in it" (earlier correspondence, now lost, had identified the picture for customs purposes).

The Jungle was apparently painted in twenty days, between December 1942 and January 1943 (see Antonio Nuñez Jiménez, "Genesis de la jungle," *Plástica latino-américana: Revista de la Liga de Arte de San Juan* [Mar. 1983], p. 18, cited in Julia P. Herzberg, "Wifredo Lam: The Development of a Style and World View, the Havana

Figure 2. Wifredo Lam, *The Jungle*, 1943, gouache on paper mounted on canvas, 239.4 x 229.4 cm, New York, The Museum of Modern Art, Inter-American Fund [photo: © 1997 The Museum of Modern Art, New York].

Years, 1941–1952," in New York 1992–93, p. 50 n. 36). The works leading up to it include fifty preparatory gouaches, shipped to Pierre Matisse in October 1942 for Lam's first New York exhibition, and studies subsequent to these gouaches, executed between October and December. In a letter to Edwin Bergman of June 28, 1956, Lam referred to this study as being "of the period of *The Jungle*," and it is closely related to two other works probably dating from these months: *Woman* (1942, private collection; New York 1992–93, no. 11, ill.) and *Untitled* (1942, Maryland, Dr. Alberto Martinez-Piedra; New York 1992–93, no. 15, ill.).

Although Lam described the Bergman piece as "one of the preparations for *La Jungle*" (letter to Edwin Bergman of April 1956), to which it bears a close general resemblance, there is no exact counterpart to its subject in the larger work. There appear to be several figures standing in the center of the study – judging from the two faces, three arms, and multiple feet – but Lam may have intended only one "hybrid," a common motif in his work. The most central of the figures holds a pair of scissors in her left hand and her hair in her right hand, with her arms draped at her sides. The second figure, slightly behind the first and to the left, reaches a grotesquely enlarged hand behind her head to grasp testicle-shaped fruit. Complete in its own right, the study is related both to the figure carrying giant scissors and to the more centrally placed long-masked figure in the final version. While in *The Jungle* the scissors are held upright at the upper edge of the painting, in this study the big, crab-claw blades with the finely curled finger holes are held in a threatening horizontal position. The clear threat of

castration in the study is made more specific with the detail of the thumb protruding between the blades of the scissors. In spite of the spherical breasts and long hair, there is a certain confusion of gender in these figures. Their bodies are entangled with the dense screen of exuberant vegetation, the plant stems echoing their limbs, the leaves and fruit their kneecaps, breasts, and buttocks. Photographs of Lam's garden in the Havana suburb of Marianao show the origins of some plant details in the tall trunks and globular fruit of the papaya (see Fouchet 1976, p. 15, figs. l–n).

Lam disturbingly juxtaposed in this picture the fecundity of nature with the threat of emasculation. The way in which his imagery acts as a projection of male fears and desires finds a parallel in one of the first great pictures of "primitivized" sexuality, Picasso's *Demoiselles d'Avignon*, an image of five prostitutes (1907, New York, The Museum of Modern Art; New York, The Museum of Modern Art, *Pablo Picasso: A Retrospective*, 1980, exh. cat., p. 99, ill.). The latter painting was clearly an important source for *The Jungle*; Lam indeed suggested a similar identity for his own figures. Contrasting his *Jungle* with that of Henri Rousseau, Lam explained:

He was a formidable painter! But he doesn't belong to my natural chain. He doesn't condemn what happens in the jungle. I do. Look at my monsters, the gestures they make. The one on the right offers her haunch, obscene like a great prostitute. Look also at the scissors being brandished. My idea was to represent the spirit of the Blacks in the situation in which they found themselves. I showed, through poetry, the reality of acceptance and of protest. (quoted in Fouchet 1976, p. 199)

The sexual exploitation to which Lam refers, at a time when Cuba was the playground for the West, also acts for him as an allegory for cultural and political exploitation:

I decided that my painting would never be the equivalent of the pseudo-Cuban music for nightclubs. I refused to paint cha-cha-cha. I wanted with all my heart to paint the drama of my country, but by thoroughly expressing the Negro spirit, the beauty of the plastic art of the Blacks. In this way I could act as a Trojan horse that would spew forth

hallucinating figures with the power to surprise, to disturb the dreams of the exploiters. (quoted by Fletcher in Washington, D.C. 1992, pp. 179–81)

The sexualized imagery expresses both the material exploitation of Cuba and the threat of emasculation posed to the West by the more "primitive" society.

Lam's relationship with his Cuban contemporaries highlights the radical nature of his imagery. Some of his subjects were not new: artists such as Marcelo Pogolotti had treated explicitly political themes during the 1930s in a modernist manner, especially the exploitation of the sugarcane workers, and Mario Carreño painted *Sugarcane Cutters* in 1943 (New York, The Museum of Modern Art; New York 1992–93, p. 52, ill.) in a dynamic, Futurist style. Lam collaborated with his contemporaries on projects in Havana, but refused to exhibit in the "Modern Cuban Painters" show at The Museum of Modern Art, New York, in 1944, apparently as a result of a personal difference with José Gómez Sicre, the author of the book on Cuban painting that accompanied the show (see Giulio V. Blanc, "Cuban Modernism: The Search for a National Ethos," in New York 1992–93, p. 67; and José Gómez Sicre, *Cuban Painting of Today*, Havana, 1944; Sicre's book was not an exhibition catalogue; a checklist of the show "Modern Cuban Painters" was published with an essay by Alfred Barr, Jr., in the *Museum of Modern Art Bulletin* 11, 5 [1944], pp. 8–14). But Lam's embrace of Afro-Cuban themes, such as the Santería-inspired figures featured in this and other Bergman works, opened up a new perspective, as Gerardo Mosquera has argued, and influenced a number of artists, notably René Portocarrero in his *Little Devil* (*Diablito*) series (Mosquera, in Barcelona 1993, pp. 173–82). * * *

80. UNTITLED

1947
Pen and brush and black ink, and watercolor, on
ivory wove paper; 48 x 31.9 cm (18¹⁵/₁₆ x 12⁹/₁₆ in.)
Signed and dated, lower right: *Wi Lam 1947*
Inscribed on back: *7703 / Matisse B*²
The Lindy and Edwin Bergman Collection,
137.1991

PROVENANCE: Sold by the artist to the Pierre
Matisse Gallery, New York, 1948;[3] sold to Lindy
and Edwin Bergman, Chicago, 1967.

EXHIBITIONS: New York, Pierre Matisse
Gallery, *Wifredo Lam*, 1948, not in cat.[4] Chicago
1984–85, no cat. nos., p. 161 (ill.). Chicago
1986, no. 32. New York, The Bronx Museum

of the Arts, *The Latin American Spirit: Art and
Artists in the United States, 1920–1970*,
1988–90, traveled to El Paso, San Diego, and
Vero Beach, Florida, no. 109 (ill.).

ALL PREVIOUS PUBLISHED REFERENCES TO this drawing have dated it to 1941, based on what appears to be a misreading of the date inscribed on this work. Correspondence with the Pierre Matisse Foundation, New York,[5] and comparison of the work to similar drawings dating to 1947 strongly suggest that 1947, rather than 1941, is the correct date (see, for example, the group of 1947 drawings reproduced in Paris, Galerie Lelong, *Wifredo Lam*, 1991, pp. 5, 10–11, 13, 16–19, and 24–29; the date "1947," inscribed on the drawings reproduced on pp. 28–29, appears almost identical to that on the Bergman drawing). This group of closely comparable works, executed in Cuba in 1947, also feature flying creatures in an undefined pictorial space, dominated by the figure of a hammer- or ax-headed woman with emaciated, bare breasts and horns protruding from her head, neck, and arms. This figure is related to, but easily distinguished from, the maned, horse-headed woman that appears in many of Lam's works, and may be related to the African wood carvings in his collection. As Valerie Fletcher wrote, Lam "continued to find inspiration in the African wood carvings in his collection, such as the Bambara horse, BaKota reliquary, Dogon container with ancestor figures, Yoruba figure, and Baule masks and figures" ("Wifredo Lam," in Washington, D.C., Hirshhorn Museum and Sculpture Garden, *Crosscurrents of Modernism, Four Latin American Pioneers: Diego Rivera, Joaquín Torres-García, Wifredo Lam, Matta*, 1992, exh. cat., p. 177).

The small, round, horned heads of the flying spirits and of the creature suspended upside down from the woman may be identified with the *orisha* (divinity or spirit who mediates between humans and nature) Elegguá, the god of doors and crossroads, "of destiny, chance, decisions, and justice," according to Afro-Cuban Santería beliefs (Fletcher, in Washington 1992, p. 182; and Gerardo Mosquera, "Modernity and Africania: Wifredo Lam on His Island," in Barcelona, Fundació Joan Miró, *Wifredo Lam,* 1993, exh. cat., p. 178). Elegguá is the only god of Santería "whose fundamental image Lam adopted and described almost literally in most of his pictures" (Mosquera, in Barcelona 1993, p. 178). There may be a connection between the artist's preference for this *orisha*, god of chance and the unpredictable, and his technical experiments with washes that introduced chance effects linked to automatism into his work. Lam appears to have drawn either in ink on wet paper to achieve the bleeding effects here, or, perhaps more likely, on dry paper and added areas of watery color and black wash to achieve the veiled effects, which act as a shorthand for a tropical jungle atmosphere. * * *

81. LADDER TO THE LIGHT
(LA LUMIÈRE QUI MONTE)

1951
Oil on linen; 150.2 x 100.6 cm (59⅛ x 39¹³/₁₆ in.)
Signed and dated, lower right: *Wi Lam / 1951*
A Gift from Lindy and Edwin Bergman, 1960.778

PROVENANCE: Sold by the artist, Paris, to
Lindy and Edwin Bergman, Chicago, 1958; given
to the Art Institute, 1960.

EXHIBITIONS: London, Institute of Contem-
porary Art, *Exhibition by the Cuban Painter
Wifredo Lam*, 1952, no. 1, as *Escala para una luz*
(*The Light That Goes Up*). Paris, Galerie Maeght,
Derrière le miroir: Lam, 1953, intro. by
Michel Leiris, no. 13. Malmö, Sweden, Galerie
Colibri, *Wifredo Lam*, 1955, no. 1 (ill.). Lou
Laurin-Lam, *Wifredo Lam: Catalogue Raisonné of
the Painted Work, Vol. I, 1923–1960*, 1996, p.
441, no. 51.14 (ill.), and p. 452 (photo of artist
with a group of works).

REFERENCES: Wifredo Lam, "Oeuvres récentes
de Wifredo Lam," *Cahiers d'art* 26 (1951),
p. 187 (ill.). Michel Leiris, *Wifredo Lam*, New York,
1972, pl. 97, as *The Light That Rises*. Max-Pol
Fouchet, *Wifredo Lam*, Paris, 1976, pl. 433.

THIS WORK SEEMS TO HAVE HAD SEVERAL variant titles: an early published reference to it gave the title in Spanish as *Escala para una luz*, with the English translation *The Light That Goes Up* (see London 1952, no. 1); in a letter of 1958, Lam referred to the painting in French as *Echelles pour une lumière* (*Ladders for a Light* or *Ladders for Illumination*; letter of December 5, 1958, to Edwin Bergman); and Lam's "inventory sheet"[6] for the painting listed the title in both French and English as *La Lumière qui monte* and *Ladder to the Light*. All of these titles, together with some distinctive motifs in this painting, may refer not only to Afro-Cuban Santería beliefs, but also to the European mystical tradition of Ramon Llull (c. 1235–1316), Robert Fludd (1574–1637), and Jakob Böhme (1575–1624; see also Joan Miró's *Viticulture*, no. 99). The title *Ladder to the Light*, in particular, conveys the notion of rising stages toward enlightenment. The diagonal of the shaft that traverses the composition vertically recalls a leaning ladder, and the elongated white diamond on the right may allude to crossing beams of light, a shape that also appears in Fludd's diagrams, created by crossing triangles of projection (see, for example, William H. Huffman, *Robert Fludd and the End of the Renaissance*, London, 1988, fig. 2).

These references to a Western tradition of initiation and enlightenment are here brilliantly absorbed into the dominant imagery based on Santería beliefs. Often highly abstract and ambiguous, these Santería-inspired elements are set dramatically against a dark, loosely painted background, haunted by ghostly, imprecise shapes. The diagonal shaft, which is also like a staff, may represent the "lightning spear" of Changó, the Yoruba god of thunder. It is crossed by horned and ax-headed spikes, which may also stand for the rungs of the ladder named in the picture's title. The little round shapes on the shaft, suggesting schematic heads, may refer to Elegguá, an *orisha* (divinity or spirit who mediates between humans and nature) often present in Lam's work. One of Elegguá's roles, that of guardian of the roads, may be evoked by the brown horizontal strip that crosses the picture behind the central shaft. The brown, angled form that juts across the upper-right portion of the canvas suggests the presence of a huge figure, whose elbow is represented supporting the shaft or spear. The pink, fleshy forms at the upper right and lower left may be versions of the horse-woman, a motif found frequently in Lam's work. This horse-woman figure derives from the Santería notion that the worshiper is possessed by the *orisha* in a manner comparable to a horse mounted by its rider (see Julia P. Herzberg, "Wifredo Lam," *Latin American Art* 2, 3 [Summer 1990], p. 20). The evidently sexual quality of the pink forms, however, hints at a more personal kind of illumination. There is the suggestion of a breast at the upper right and of buttocks or breasts at the left, forms that rhyme with the circular "heads" on the horizontal shaft and thus introduce a double reading of these round shapes. * * *

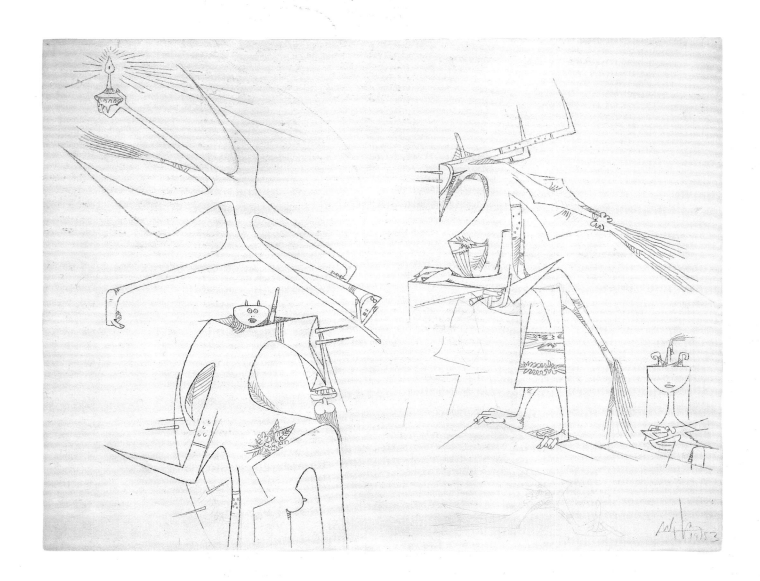

82. UNTITLED

1953
Graphite on cream wove paper; 50 x 64 cm
(19 $^{11}/_{16}$ x 25 $^{3}/_{16}$ in.)
Signed and dated, lower right: *Wi Lam / 1953*
The Lindy and Edwin Bergman Collection,
139.1991

PROVENANCE: Sold by the artist to Lindy and
Edwin Bergman, Chicago, 1967.[7]

EXHIBITIONS: Possibly Havana, Cuba,
Universidad de la Habana, Pabellón de ciencas
sociales, *Wifredo Lam*, 1955, no. 25 or 26, as
Dibujo con tinta.

THIS DRAWING IS NOT IN ITSELF A STUDY FOR a painting, although its imagery presents parallels with that of some of Lam's paintings of the same period: a horned figure with a knife, similar to that on the right side of this drawing, appears in *Caribbean Rooster* (*Coq caraïbe*) of 1953 (Lima, Peru, Instituto de arte; Max-Pol Fouchet, *Wifredo Lam*, Paris, 1976, pl. 106); and the hammer-headed figure on the lower left reappears in a painting of 1955 entitled *Figure* (Caracas, Venezuela, Collection A. Scanonne; Fouchet 1976, pl. 114). A precedent for the left side of this composition appears in the earlier painting *Zoomorphic Figures* (*Figures zoomorphes*) of 1947 (fig. 3). In that work, a winged figure with extended arms, similar to the one at upper left in this drawing, hovers over two other totem-like forms, one of which closely resembles the creature with a hammer-head topped by a small, horned face, at lower left in the drawing. Here the swooping figure at upper left has limbs that are curiously interchangeable, and seem to double with another form that has scimitar-shaped wings and a tail. It holds up a lamp in one hand, recalling in its dramatic gesture the central figure in Pablo Picasso's *Guernica* of 1937 (Madrid, Museo del Prado, Casón de Buen Retiro). Another painting by Lam, *The Night Lamp* of 1945 (New York, collection Santo Domingo), represents a kind of altar with the night lamp as the central offering to the *orishas* Oshún, Elegguá, and Changó, to entreat them to give enlightenment (Julia P. Herzberg, "Wifredo Lam, the Development of a Style and World View: The Havana Years, 1941–1952," in *Wifredo Lam and His Contemporaries, 1938–1952*, New York, The Studio Museum in Harlem, 1992–93, exh. cat., p. 46, ill.). The tail of this figure also resembles a broom with bound handle, which was one of

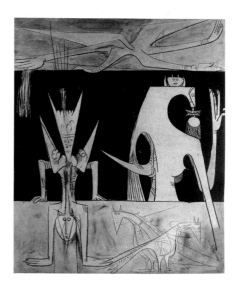

Figure 3. Wifredo Lam, *Zoomorphic Figures*, 1947, charcoal and oil on canvas, 155 x 126 cm, Havana, Museo nacional de bellas artes [photo: courtesy of S.D.O. Wifredo Lam, Paris].

the sacred implements of the Santería priest or priestess. The standing figure at right of center carries a large knife under his arm, which suggests that he may represent Ogun, the god of iron.

It is worth noting that, while the attributes and characteristics of the Afro-Cuban Santería gods, or *orishas*, were very specific and elaborate, there was no tradition of their two-dimensional representation, other than in some syncretic adaptations of images of Christian saints. The pictorial representation of these deities was thus a new development. It is interesting in this regard to compare Lam's versions of these divinities with those of artists such as Hector Hyppolite of Haiti, whose painting of *Ogoun Feraille* was bought by André Breton on his visit there in 1945 (André Breton, *Surrealism and Painting*, tr. by Simon Watson Taylor, New York, 1972, p. 311, ill.). Hyppolite was an untrained artist, but an initiate of Santería, and he tended to represent the deities as human figures surrounded by their attributes. Lam, by contrast, not only drew upon a sophisticated pictorial repertoire, especially in his paintings, but also upon his knowledge of African masks and idols, to represent the gods as supernatural beings. His inventiveness in this respect is indeed remarkable.

This meticulously finished and precise drawing is a work in its own right. There is also a very close untitled reworking of it dating to 1968, the year after this drawing was bought by the Bergmans (see Paris, Galerie Lelong, *Wifredo Lam*, 1991, preface by Catherine David, no. 29, ill.). * * *

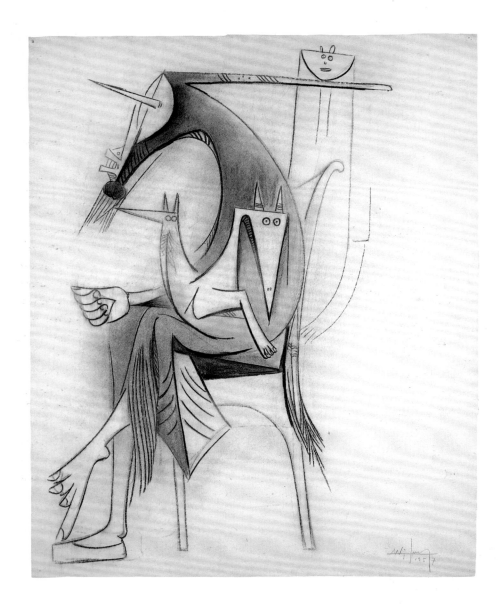

THE THEME OF MOTHER AND CHILD, OR maternity, may be traced in Lam's work back at least to the early 1940s (see New York, The Studio Museum in Harlem, *Wifredo Lam and His Contemporaries, 1938–1952,* 1992–93, exh. cat., pp. 32–34, figs. 3–4); it is also linked to the seated women of Lam's earlier Paris period (see Max-Pol Fouchet, *Wifredo Lam*, Paris, 1976, figs. 28, 35, 307, 310–11, 314). The idea of spiritual possession associated with the horse-headed woman and derived from Afro-Cuban sources is here merged with a traditional Western subject. Both mother and child are shown as possessing a double. The chair and the single shod foot introduce a note of domesticity in marked contrast to other elements of the composition, such as the masklike faces, exaggerated hand, and naked foot. The curve of the horse-woman's body, with its delicate suggestion of volume, provides a fitting womblike enclosure for the child. * * *

83. MOTHER AND CHILD

1957
Charcoal and pastel on ivory wove paper; 73.3 x 58.3 cm (28⅞ x 22¹⁵/₁₆ in.)
Signed and dated, lower right: *Wi Lam / 1957*
The Lindy and Edwin Bergman Collection, 140.1991

PROVENANCE: Sold by the artist to Lindy and Edwin Bergman, Chicago, 1958.

EXHIBITIONS: Chicago 1967–68, no cat. Chicago 1973, no cat. nos., n. pag. Chicago 1986, no. 33. New York, The Bronx Museum of the Arts, *The Latin American Spirit: Art and Artists in the United States, 1920–1970,* 1989–90, traveled to El Paso, San Diego, and Vero Beach, Florida, no. 112 (ill.).

REFERENCES: Dorothy Chaplik, *Latin American Art: An Introduction to Works of the Twentieth Century,* Jefferson, North Carolina, 1977, pp. 7–8 (ill.).

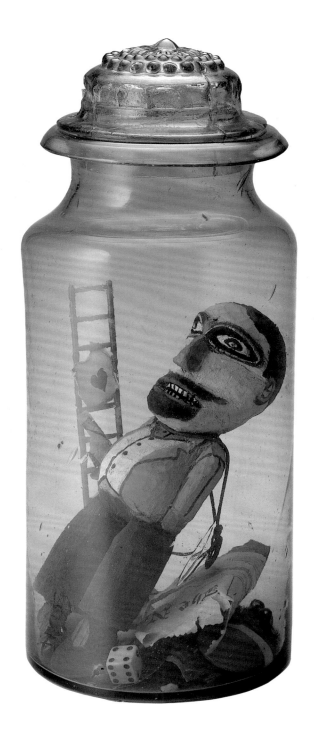

THIS UNUSUAL OBJECT WAS PRESENTED AS A gift, sometime in the early 1950s (the scrap of newspaper in the jar is from the *New York Times* and is dated 1952), to New York collector and dealer Harold Diamond, who understood it to be autobiographical. It shows Lindner "surrounded by the symbols of his compulsion to habitually gamble" (letter from Joan Wolff of the Allan Stone Gallery, New York, to Edwin Bergman, of April 17, 1975). The contents of the jar (which was probably originally designed to hold sweets) – dice, fragments of playing cards, poker chips – makes this reading indisputable. The arrangement of these items was "intended to be random – topsy-turvy – as Lindner felt life to be" (ibid.). The string noose around the figure's neck, his fierce, bearded face, and a revolver cut out of paper and attached to the plastic ladder hint at a Wild West setting. The ladder is apparently a symbol of the artist's hope of overcoming his gambling habit (ibid.). It is doubtful that the figure is literally a self-portrait, because it bears no obvious resemblance to Lindner himself. It is, however, quite similar to the figure in Lindner's earlier painting *The Gambler* (fig. 1), which belongs to his friend the artist Saul Steinberg. The figure in the painting indeed resembles Steinberg, who is shown sporting a mustache and sometimes a beard in photographs taken at the time. Both Steinberg and Lindner explored the subject of gambling in works of this period.

Gaming and the idea of games are brought together in the toylike character of this piece. The importance of

84. THE GAMBLER

c. 1952
Green glass jar with molded glass stopper, containing a carved and painted wood figure, a pair of dice, plastic poker chips, a scrap of

newspaper, torn pieces of playing cards, string, a plastic ladder, several painted metal bells, and a penny; 37.2 x 15.2 cm (14⅝ x 6 in.)
The Lindy and Edwin Bergman Collection, 141.1991

PROVENANCE: Harold Diamond, New York; sold to the Allan Stone Gallery, New York;[1] sold to Lindy and Edwin Bergman, Chicago, 1975.

EXHIBITIONS: Chicago, Museum of Contemporary Art, *Richard Lindner: A Retrospective Exhibition*, 1977, no cat. nos., p. 29.

REFERENCES: *Arch. Digest* 1973, p. 19 (photo of Bergman home).

toys for Lindner has been emphasized by both Dore Ashton (Dore Ashton, *Richard Lindner*, New York, 1969, pp. 19–21) and Wieland Schmied. The latter wrote:

We shall understand the nature of this man better knowing that he owns a big collection of everyday as well as unusual toys, gathered from all the corners of the world and assembled carefully on shelves in his bachelor's apartment. There are dolls and masks, clocks and bells, photographs and fetishes, artists and motorcyclists. (Wieland Schmied, "Richard Lindner and the Human Being as a Toy," *Studio International* 176, 906 [Dec. 1968], p. 253)

For Lindner, a German Jew, the world of toys had a poignant and deadly resonance. He grew up and began his training as an artist in Nuremberg, which had been a center for the manufacture of toys since the fourteenth century, "the very city . . . where more phantasy and inventiveness were put to the production of toys, than in any other city of the world" (ibid., p. 255). This city was also the site, however, of the Nazi Party Conventions and the Nuremberg laws against the Jews, "events which affected Lindner's and millions of others' lives more horribly than any previous discriminatory decrees, even during the Reformation" (ibid.).

In 1933, after Hitler's rise to power, Lindner fled to Paris and in 1941 he emigrated to the United States, where he settled in New York. Although he did not have his first exhibition until 1954 at the Betty Parsons Gallery, it is likely that he became aware of the work of the Surrealist circle in New York somewhat earlier. He may have seen Peggy Guggenheim's "Art of This Century" exhibition in 1942, which featured Joseph Cornell's objects, Laurence Vail's Bottles, and Marcel Duchamp's *Boîte-en-valise* (*Box in a Valise*). He could also have met

Cornell while working for *Vogue* as a commercial illustrator – Cornell was a freelance contributor to *Vogue*.

Glass containers or bottles have been manipulated in many ways over the years, both in the context of popular or "outsider" art and by twentieth-century artists exploring the possibilities opened up by the notion, introduced by Duchamp, of the "assisted readymade" and by the collage of "real" materials, which had its origins in Cubism. Examples range from the bottles with painted exteriors by René Magritte and Vail to the popular pastime of constructing model ships inside narrow-necked bottles. Among Cornell's earliest works of the 1930s are stoppered glass bottles filled with heterogeneous but associated objects (for example, *Untitled* [*Grasshopper Bottle*] of c. 1933, New York, Castelli Feigen Corcoran; New York 1980–82, fig. 12). Lindner's *Gambler*, however, differs from Cornell's work in the crude caricatural carving of the figure and in its acute sense of desperation and claustrophobia. There is irony here in the mismatch between the grim subject and the playful notion of a world-in-a-bottle toy; and there is pathos in the work's association with a bottle carrying a message out to sea. The green glass gives the scene an underwater gloom, and the spectacle of a figure trapped in a glass jar raises the specter of human forms preserved, in glass containers filled with formaldehyde, as medical curiosities. * * *

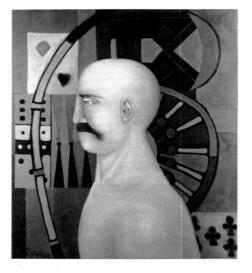

Figure 1. Richard Lindner, *The Gambler*, 1951, oil on canvas, 76.2 x 66 cm, New York, Saul Steinberg [photo: courtesy of Anouk Papadiamandis].

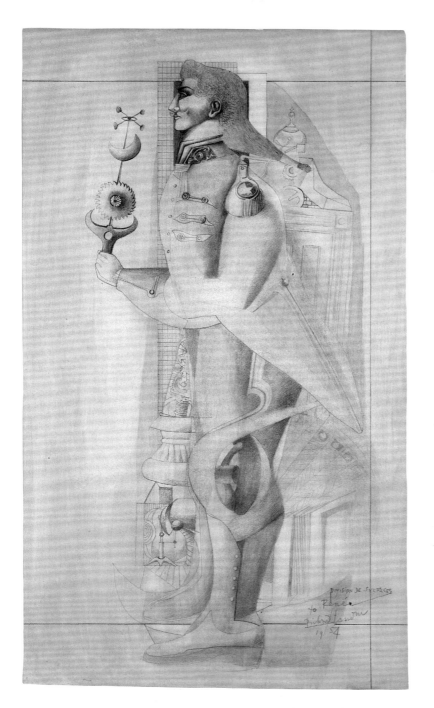

THE TITLE OF THIS METICULOUS DRAWING may refer to the vertical strip resembling graph paper behind the figure, which could be an allusion to the traditional method of squaring a drawing before transferring it onto another surface. In front of the figure's shins, Lindner drew a small fragment of floor with perspectival lines to indicate depth. These references to traditional forms of picture-making are in marked contrast to other elements of the picture, such as the background to the figure, which consists of oblong compartments not unlike a Cubist collage. Some of these areas, such as the one in front of the figure's legs, are further fragmented into a cluster of images, suggesting architectural and machine components. To the right of the figure, these oblong planes are fashioned into frames: the frame of a door behind the figure's shoulder, and intimations of picture frames behind the legs. Radiating from the man's calfs are a series of strips, patterned with a herringbone design, that recall the fanlike arrangement of forms in certain Cubist drawings by Juan Gris (for example, Gris's *Guitar* of 1913, Staasgalerie Stuttgart, Graphische Sammlung; London, Whitechapel Art Gallery, *Juan Gris*, 1992, exh. cat., p. 194, ill.). Their position next to the only part of the figure that is explicitly mechanical – the knee, which has been replaced by a cog – suggests an ironic reference to Futurism, for nothing could be further from the dynamism of a Futurist sculpture like Umberto Boccioni's *Unique Forms of Continuity in Space* of 1913 (see, for example, the bronze cast in New York, The Museum of Modern Art; George Heard Hamilton, *Painting and Sculpture in Europe, 1880–1940*, New York, 1967, fig. 171) than this static and hieratic figure.

85. DIVISION OF SURFACES
(DIVISION DE SURFACES)

1954
Graphite and watercolor, with smudging, on cream wove card; 70.6 x 40 cm (27³/₄ x 15³/₄ in.)
Signed and dated, lower right: *Richard Lindner / 1954*
Inscribed, lower right: *DIVISION DE SURFACES / to René*[e?]

The Lindy and Edwin Bergman Collection, 142.1991

PROVENANCE: Galleria Galatea, Milan; sold to B. C. Holland, Inc., Chicago, 1972;[2] sold to Lindy and Edwin Bergman, Chicago, 1972.

EXHIBITIONS: Chicago 1973, no cat. nos., n. pag. Chicago, Museum of Contemporary Art,

Richard Lindner: A Retrospective Exhibition, 1977, no cat. nos., p. 27.

REFERENCES: *Arch. Digest* 1973, p. 19 (ill.; Bergman residence).

This drawing exemplifies Lindner's work of the period, in which he frequently depicted figures of authority in extravagant uniforms. One of the most dramatic instances of this is the 1953 painting *The Meeting* (New York, The Museum of Modern Art; Dore Ashton, *Richard Lindner*, New York, 1969, pl. 1), in which the sumptuously clad figure of King Ludwig II of Bavaria is shown facing the artist's friend Saul Steinberg across a room peopled largely by impassive figures in more contemporary dress. The epaulets and embroidered collar of the mustached figure in this drawing, together with the hint of an imperial helmet in the background to the right, suggest a similar reference. Lindner had been familiar, since his own childhood in Bavaria, with the mad king and the fantastic castles he had built for himself during the nineteenth century. Lindner's fascination with Ludwig, which lay not only in the king's theatrical extravagance, but also in his genuine patronage of the arts (ibid., pp. 25–28), was shared by several other twentieth-century artists. Salvador Dalí based his 1939 ballet production *Bacchanale* on Ludwig; and Joseph Cornell, between 1941 and 1952, worked on a box on this subject (see *Untitled [The Life of King Ludwig of Bavaria]*, New York, estate of Joseph Cornell; New York 1980–82, no. 104, ill.).

Wieland Schmied accounted for Lindner's preoccupation with this eccentric king in a way that partly applies to Cornell as well. Schmied saw Ludwig as an image of eternal childhood, a Peter Pan who refused to grow up: "What is it that attracted Richard Lindner, apparently from an early stage, so greatly to the person of Ludwig II? It is the introverted man who remained ever a child and refused to step into the world of adults, who only lived his dreams and could fulfill every desire, who loved the theater, art, and decor above all else" (Wieland Schmied, "Richard Lindner, Nürnberg und Ludwig II," in Kunsthalle Nürnberg, *Richard Lindner*, 1986, exh. cat., n. pag.).

Another of Lindner's major motifs at the time, boys with machines, is brought into play here. The boys in Lindner's works (see, for example, Ashton 1969, pls. 22, 23, 43, and 51) are often engrossed with little machines of obscure purpose, and their apparent innocence contrasts with the presence of corseted women who seem to flaunt their sexuality and threaten corruption. In *The Meeting*, Ludwig is juxtaposed with one such corseted woman. In *Division of Surfaces*, the figure holds a kind of mechanical scepter and is himself partly a machine. Other mechanical contraptions appear in the background. Even the frogging of the uniform has the precision of a machine. It is possible that the boys with machines may be a metaphorical allusion to masturbation – much like Marcel Duchamp's bachelors, who "grind their own chocolate" – a conclusion that would be appropriate for this image of the self-obsessed king. Although the effect of the drawing overall bears little resemblance to Duchamp's *Large Glass* of 1915–23 (Philadelphia Museum of Art; Philadelphia Museum of Art, *Handbook of the Collections*, 1995, p. 316, ill.) or related works, the technique, not unlike that of a technical draftsman, recalls Duchamp's adoption of machine drawing in 1912/13. Lindner's conflations of man and machine are indeed more Dada than Futurist in spirit. Dore Ashton noted that Duchamp was one of the few artists to whom Lindner acknowledged a debt, and that Lindner was familiar with both Dada and Duchamp before his arrival in America (Ashton 1969, p. 40). Lindner also recalled being impressed in the 1930s with Francis Picabia's *The Spanish Night (La Nuit Espagnole)* of 1922

(New York, private collection; ibid., p. 40, ill.), the influence of which is visible in his painting *The Target* of 1959 (Chicago, Museum of Contemporary Art; ibid., pl. 72).

The drawing as a whole has a delicate precision, which is strikingly different from the bold, flat manner of Lindner's paintings, and which is well suited to the fine detail of the mechanical contraption in the figure's hand and of the tiny, archaic machine glimpsed in a mysterious, hollow space to the left of the figure's shins. The man himself gazes past the top of his machine-scepter, which suggests devices for measuring time and the phases of the moon, with the rapt attention of a daydreamer, absorbed in his own world. It is impossible to tell whether Lindner specifically intended to depict Ludwig, devising new fantasies to entertain himself, or a more generic figure, meditating on time and mortality.

Contemporary associates of Lindner in New York were also working with machine imagery. His friend Hedda Sterne made a series of paintings in 1949 featuring absurd machines (see New York, The Queens Museum, *Hedda Sterne: Forty Years*, 1985, exh. cat., nos. 8–9, ill.), but the work of Walter Murch during the 1940s and 1950s reveals the closest correspondences. At that time Murch was painting refined still lifes of clock interiors and other mechanical objects (see, for example, New York, Hillwood Art Gallery, Long Island University, *Walter Murch: Paintings and Drawings*, 1986–87, exh. cat., pp. 6, 18–19, 35–36, 43, 58–59). The eerie quality of those paintings may well have been influenced by Cornell, whom Murch met through Julien Levy in the late 1930s. Lindner and Murch both taught at the Pratt Institute in New York in the early 1950s, did commercial work for *Fortune* magazine and *Harper's Bazaar*, and had connections with the Betty Parsons Gallery in New York, where Murch had exhibited since 1941 and Lindner was to receive his first show in 1954.

Lindner's work, with its sharply defined forms, often garish colors, machine imagery, and repertoire of somewhat theatrical personages and types (Ludwig, uniformed man, corseted woman, boy with mechanical toy, Lolita or Lulu), appealed to the younger generation of artists in the United States associated with Pop art. However, although Lindner drew inspiration from Hollywood and Times Square, there remains a strong element of German Expressionist doom and menace in his figures. The distinctly American character of contemporary art, whether Abstract Expressionism or Pop art, was much debated in this postwar period, and Lindner's ambivalent position in this regard aroused considerable interest. Robert Indiana commented in a letter to Ashton that he thought Lindner had "moved from a European to an American feeling," but finally concluded that he was "inescapably, inevitably International" (Ashton 1969, p. 52). * * *

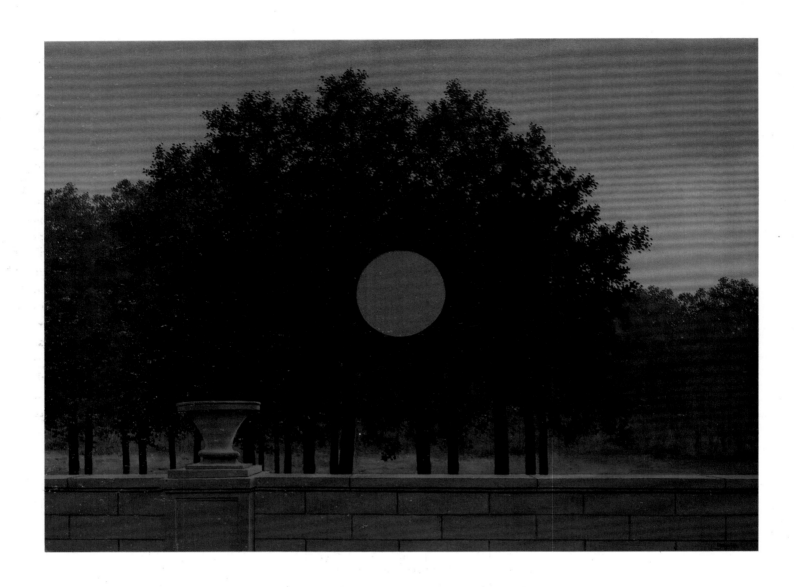

86. THE BANQUET (LE BANQUET)

1958
Oil on canvas; 97.3 x 130.3 cm (38¼ x 51¼ in.)
Signed, lower right: *magritte*
Inscribed on back, upper right, on original lining:
"LE BANQUET" / magritte[1]
The Lindy and Edwin Bergman Collection, 143.1991

PROVENANCE: Alexander Iolas Gallery, New York;
sold to Grace Hokin, Chicago;[2] sold through the
B. C. Holland-Goldowsky Gallery, Chicago, to Lindy
and Edwin Bergman, Chicago, 1961.

EXHIBITIONS: Charleroi, Palais des beaux-arts,
*XXXIIe Salon [du] cercle royal artistique et littéraire
de Charleroi*, 1958, no. 151. New York, Alexander
Iolas Gallery, *René Magritte*, 1958, no cat. New York,
Alexander Iolas Gallery, *René Magritte*, 1959, no cat.
Little Rock, Arkansas Arts Center, *Magritte*, 1964,
no cat. nos., n. pag. (ill.). The University of Chicago,
The Renaissance Society, *Magritte*, 1964, no. 1.
New York, The Museum of Modern Art, *René Magritte*,
1965–66, traveled to Waltham, Massachusetts;
Chicago; Pasadena, California; and Berkeley, Cali-
fornia, no. 66 (ill.). Chicago 1984–85, no cat. nos.,
pp. 170–71, pl. 41. London, The South Bank Centre,
Magritte, 1992–93, traveled to New York, Houston,
and Chicago, not in cat. (Chicago only).

REFERENCES: James R. Mellow, "In the Galleries:
Magritte," *Arts* 32, 8 (1958), p. 58. Sidney Tillim,
"In the Galleries: René Magritte," *Arts* 33, 7 (1959),
p. 51 (ill.). Anthony Bower, "Another Aspect of Little
Rock," *Art in America* 52, 6 (1964), p. 138 (instal-
lation photo). Possibly Henri Michaux, "En rêvant à
partir de peintures énigmatiques," *Mercure de*

THIS CANVAS IS THE LAST, LARGEST, AND most impressive of four oil paintings of this title; the three other paintings are all dated to 1957 (ill. in *Magritte Catalogue*, vol. 3, 1993, pp. 267–68, nos. 851–52, and p. 272, no. 857). There are also five versions of this image in gouache, starting in 1956 and extending to 1964 (ill. in ibid., vol. 4, 1994, p. 193, no. 1421, p. 198, no. 1429, p. 273, no. 1563, and pp. 275–76, nos. 1566 and 1568). Magritte first realized the idea and conceived the title for this series in the first of these gouaches, completed in 1956 shortly after he announced to Mirabelle Dors and Maurice Rapin, in a letter of November 9, 1956, that "Le Banquet" was one of his latest "finds" (ibid., vol. 3, 1993, p. 267). The little sketch in this letter shows the main motif of the sun visible before a clump of trees set in an unspecified landscape. In the first oil version (as in the earlier related image, *The Sixteenth of September*, 1956, location unknown; ibid., vol. 3, 1993, p. 254, no. 834, ill., which shows the crescent moon on a large tree), the clump of trees is set in a meadowlike clearing dotted with large stones. In the second oil version of *The Banquet*, as in the Bergman canvas, the woodland glade is replaced with a stone parapet or balustrade, whose top is lit by the sun's rays. This feature suggests a parklike setting, a domesticated concept of nature suited to Magritte's deadpan, realist style. The proportions of the objects in relation to one another also differ from canvas to canvas; in the picture under discussion, the sun looms larger in relation to the trees than in other versions and appears therefore closer to the viewer. It is interesting that, although the motif in

essential respects is identical, significant variations mark each version as a distinct image.

The Banquet series is a development of another series on which Magritte had started working in February 1956 and which he called *The Place in the Sun*. In these pictures, Magritte focused on the Surrealist idea of displacement, but with a particular twist. One object was superimposed on another larger one to which it was unrelated. The original series included an image of a seated scribe superimposed on an apple (ibid., vol. 3, 1993, pp. 252–53, no. 833, ill.) and Sandro Botticelli's *Primavera* silhouetted against a figure in a bowler hat seen from behind (ibid., vol. 3, 1993, p. 258, no. 837, ill.). Magritte's approach in these pictures resembled what he referred to as "Objective stimulus," a term he applied to those instances in which he replaced an object familiar to a particular context with one related to it but out of place, as he did in his 1933 painting *Elective Affinities* of a huge egg in a birdcage (Paris, E. Perier; Sarah Whitfield, *Magritte*, London, The Hayward Gallery, 1992, exh. cat., no. 60, ill., n. pag.). As he explained to Rapin, *"The Place*

France 352, 1214 (Dec. 1964), p. 596. Hernan Galilea, *La Poesía superrealista de Vicente Aleixandre*, Santiago, 1971, pp. 37, 147 (ill.). *Arch. Digest* 1973, p. 22 (photo of Bergman home). *Saturday Review* 1980, p. 58 (photo of Bergman home). Lori Rotenberk, "A Surrealist Treasure Finds New Home at Art Institute," *Chicago Sun-Times*, Nov. 7, 1991, p. 20 (installation photo). *Magritte Catalogue*, vol. 3, 1993, p. 283, no. 868 (ill.), and pp. 87, 93, 280, 297.

in the Sun is if you like an 'Objective stimulus' with the difference that the image which comes 'on' another has a still greater charge of strangeness" (ibid., vol. 3, 1993, p. 253). In a subsequent letter to Dors and Rapin, Magritte wrote of *The Sixteenth of September,* "I have continued with my 'Places in the Sun' but by now the title is no longer suitable for a big tree in the evening with a crescent moon above it!" (ibid., vol. 3, 1993, p. 254). The object that would have been hidden (crescent moon, sun) is now visible, hiding part of the object that would have hidden it.

These works are striking examples of Magritte's interest in the categories of the visible and the invisible. In a letter to André Bosmans of September 25, 1964, Magritte explained:

With regard to "the invisible," I understand that which is not visible, for example; heat, weight, pleasure, etc.

There is the visible that is seen: *the apple on the face in* The Great War, *and the* visible that is hidden: *the face* *hidden by the visible apple. In* The Banquet *the sun hidden by the curtain of trees is, itself, visible.* (René Magritte, *Lettres à André Bosmans, 1958–1967,* ed. by Francine Perceval, Brussels, 1990, p. 383)

According to the above criteria, the sun hidden by trees is an example of the "visible that is hidden." In the *Banquet* series, Magritte carried the implications of these reflections one step further: he actually rendered the sun visible by creating a visual conundrum, in which the sun is not displaced from its customary context, but rendered strange.

At this time Magritte seems to have been interested, moreover, in the varying quality of light at different times of day. Of the second version of *The Sixteenth of September* (1956, Antwerp, Koninklijk Museum voor Schone Kunsten; ibid., vol. 3, 1993, p. 257, no. 836, ill.), he wrote to Dors and Rapin on August 6, 1956: "I have just painted the moon on a tree in the gray-blue colors of evening" (ibid.). In the Bergman version of *The Banquet,* the strong red glow of the setting sun is framed by the darkening landscape, a naturalistic effect that further dramatizes the "charge of strangeness" (Magritte, quoted in ibid., vol. 3, 1993, p. 253).

The Bergman painting also has a strong formal quality, with the sun as a pure circle in the center, balanced by the strong architectural horizontal of the balustrade. In this respect, the picture recalls Max Ernst's Forest series of the late 1920s (*Ernst Katalog,* vol. 3, pp. 180–209, nos. 1140–96, ills.), where the circular forms of sun or moon work pictorially in both an abstract and figurative sense. * * *

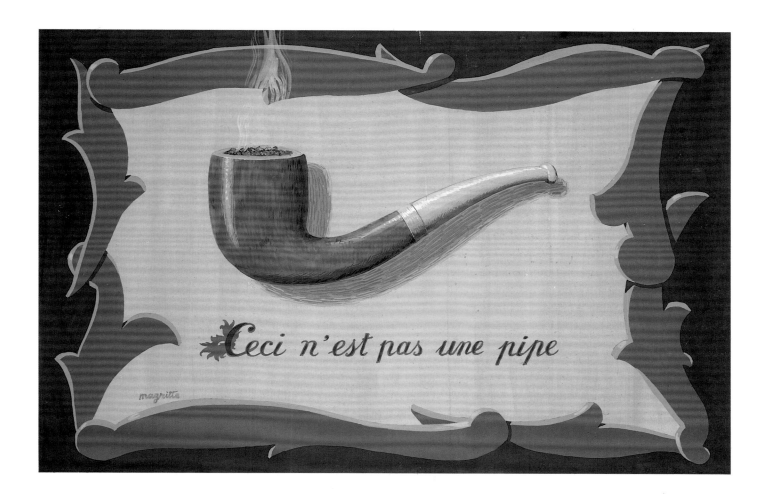

87. THE TUNE AND ALSO THE WORDS
(L'AIR ET LA CHANSON)

1964
Gouache over traces of graphite on cream wove paper; 36.2 x 54.8 cm (14¼ x 21⅝ in.)
Signed and inscribed: *magritte* (lower left); *Ceci n'est pas une pipe* (lower center)
Inscribed on back, lower right: *L'Air et la Chanson*
The Lindy and Edwin Bergman Collection, 144.1991

PROVENANCE: Alexander Iolas Gallery, Paris, by 1964; sold to the Hanover Gallery, London, by 1969. E. Hammer Gallery, Paris; sold to the Pace Gallery, New York, October 1973;[3] sold *Museum of Contemporary Art Third Benefit Auction*, Chicago, Nov. 15, 1975, no. 43, as *Ceci n'est pas une pipe*, to Lindy and Edwin Bergman, Chicago.

EXHIBITIONS: Paris, Alexander Iolas Gallery, *Magritte: Le Sens propre*, 1964, no. 38. Possibly New York, Alexander Iolas Gallery, *Magritte: Le Sens propre*, 1965, no cat. London, Hanover Gallery,

Poetic Image, 1969, no cat. nos., n. pag. (ill.). London, Hanover Gallery, *Pen, Pencil, and Paper*, 1970, no cat. nos., n. pag. (ill.). Basel, Galerie Beyeler, *Surréalisme et peinture*, 1974, no. 46, as *Ceci n'est pas une pipe*. Chicago, Museum of Contemporary Art, *Words at Liberty*, 1977, no cat. nos., pp. 8 (ill.), 17, as *Ceci n'est pas une pipe*. Chicago 1984–85, no cat. nos., fig. 1, pp. 85, 172, as *The Air and the Song*. Chicago 1986, no. 34, as *The Air and the Song*. Chicago, Museum of Contemporary Art, *Toward the Future: Contemporary Art in Context*, 1990, pamphlet, no cat. nos., n. pag, as *The Air and the Song*.

REFERENCES: Paul Nougé, "Pour Illustrer Magritte," *Le Fait accompli* 34–35 (Apr. 1970), n. pag. (ill.). Suzi Gablik, *Magritte*, Greenwich, Conn., 1971, pp. 128, 201, pl. 111, as *The Air and the Song*. A. M. Hammacher, *René Magritte*, New York, 1973, p. 33, fig. 35, as *The Air and the Song*. Maurizio Fagiolo dell'Arco, ed., *Surrealismo, omaggio a André Breton: La Création d'un mythe*

collectif, Rome, 1976, exh. cat., p. 156 (ill.). Robert Short, *Dada and Surrealism*, London, 1980, p. 110, fig. 105, as *Ceci n'est pas une pipe* (*This Is Not a Pipe*). Petra von Morstein, "Magritte: Artistic and Conceptual Representations," *Journal of Aesthetics and Art Criticism* 41, 4 (1983), pp. 372–73, as *The Air and the Song*. Laurie Edson, "Disrupting Conventions: Verbal-Visual Objects in Francis Ponge and René Magritte," *L'Esprit créateur* 24, 2 (Summer 1984), pp. 28–29, as *The Air and the Song*. Laurie Edson, "Confronting the Signs: Words, Images, and the Reader-Spectator," *Dada/Surrealism* 13 (1984), p. 91, as *The Air and the Song*. René Magritte, *Lettres à André Bosmans, 1958–1967*, ed. by Francine Perceval, Brussels, 1990, pp. 392, 394. *Magritte Catalogue*, vol. 3, 1993, p. 129, as no. 1570; vol. 4, 1994, p. 277, no. 1570 (ill.), as *L'Air et la chanson* (*The Tune and also the Words*).

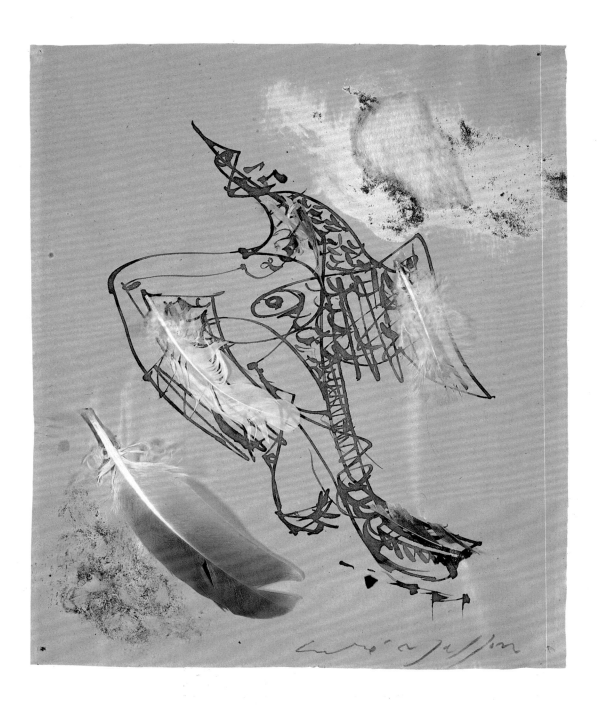

89. UNTITLED

1925/27
Collage composed of feathers and cotton, with
quill pen and brown ink, and brush and
white gouache on tan wove paper; 25 x 20.7 cm
(9⅞ x 8½ in.)

Signed, lower right: *André Masson*
Inscribed on back, upper left: *31.31*
The Lindy and Edwin Bergman Collection,
146.1991

PROVENANCE: André Breton, Paris; Galerie
Furstenberg (Simone Collinet), Paris; sold
to Lindy and Edwin Bergman, Chicago, 1960.

EXHIBITIONS: Chicago 1984–85, no cat. nos.,
p. 183 (ill.). Chicago 1986, no. 35.

I N THIS COLLAGE-DRAWING OF A BIRD, MASSON placed two white feathers within the animal's wings, and a third, larger, brown quill at a short distance from its body, as though it were the artist's pen, the actual instrument of the drawing. The wing on the left lacks the dashes of plumage drawn over the rest of the bird's body, and is instead articulated around a circular form. Masson's incorporation of real feathers in this drawing is also an extension of this motif in his paintings. In a closely comparable oil of 1925, *A Bird* (fig. 2), the same circular form reads as the conjunction of a bird's wing with the chest and arm of a human body, traces of which are visible in the drawing. A large, isolated feather is also depicted at the lower left of the painting.

Masson's incorporation of real feathers into this work has a close parallel in an untitled drawing of November 24, 1924, by Joan Miró (Paris, Musée national d'art moderne, Centre Georges Pompidou; New York, The Museum of Modern Art, *Joan Miró*, 1993, exh. cat. by Carolyn Lanchner, p. 127, app. 8, ill.). In Masson's own practice, however, the addition of real elements to the picture's surface seems to have begun with the sand paintings, the earliest of which date to 1926. The signature on this collage-drawing also compares closely with that on works of 1926–27, and there is a similar conjunction of ink and real feathers in a collage of 1927, known as *Drawing (Battle of Fishes and Birds)* now in Bern (Kunstmuseum Bern, *Masson: Massacres, Métamorphoses, Mythologies*, 1996, exh. cat., p. 20, no. 4, ill.). It is possible, therefore, that the Bergman collage-drawing dates closer to 1927 than to 1925.

Describing the work of this period, Masson wrote:

1925–28: themes: wounded birds, birds wounded with arrows. Birds enclosed in cut glass, ecstatic, transfigured....

Feathers. *In some of the sand paintings feathers are pasted. In other canvases they are primordial elements,* *accompanied by large strokes of charcoal and by patches (painted). Sometimes a natural object: a pebble, and even a painted feather among the real ones: in trompe l'oeil.* (André Masson, *Métamorphose de l'artiste,* vol. 1, Geneva, 1956, pp. 20–23)

The quill affixed to the Bergman drawing echoes the image of the feathered arrow that Masson included in his paintings of wounded birds, as in the 1925 *Bird Pierced by Arrows* (Presinge, Switzerland, private collection; New York, The Museum of Modern Art, *André Masson*, 1976–77, exh. cat., p. 113, ill.). The very presence of real feathers in the drawing suggests the violent site of a fight rather than flight, a tragic and aggressive theme that is typical of Masson's vision. In Carl Einstein's reading of Masson's work, birds and other animals become totems with which man identifies, and which take his place as victim (Carl Einstein, "André Masson, étude ethnologique," *Documents* 2 [May 1929], pp. 93–102). The metamorphosis of man into bird or animal takes on a dramatic significance, as "these animals are the identifications into which the events of death are projected, in order not to suffer death oneself" (ibid., p. 102). The ecstatic flight of the bird could thus embody a form of tragic union with nature. * * *

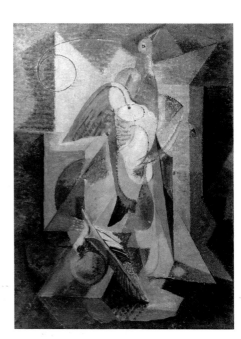

Figure 2. André Masson, *A Bird*, 1925, oil on canvas, 55 x 38 cm, Paris, Musée national d'art moderne, Centre Georges Pompidou.

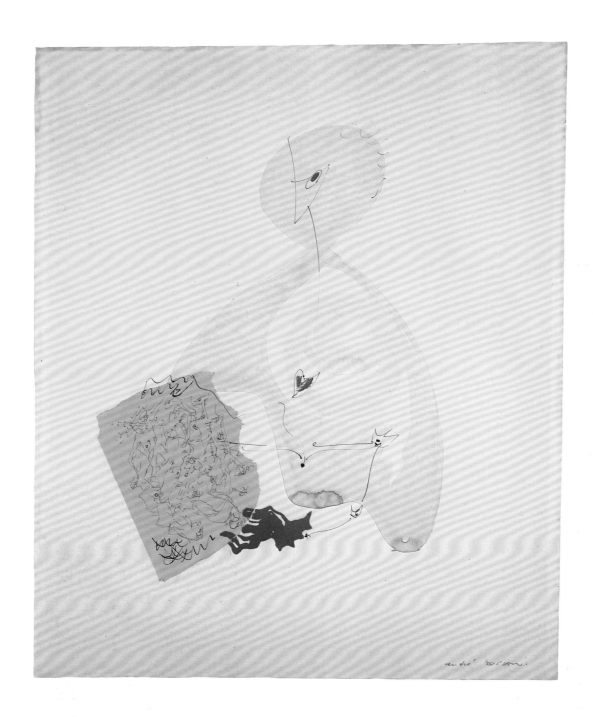

90. UNTITLED

1926/27
Watercolor, gouache, pen and black ink, torn
and pasted paper on cream wove paper; 62.5 x
50.5 cm (24⅝ x 19⅞ in.)
Signed, lower right: *André Masson*
A Gift from Lindy and Edwin Bergman, 1984.641

PROVENANCE: Galerie Furstenberg (Simone
Collinet), Paris; sold to Lindy and Edwin
Bergman, Chicago, 1964; given to the Art
Institute, 1984.

EXHIBITIONS: Saint-Etienne, France, Musée
d'art et d'industrie, *Cinquante ans de "collages":
Papiers collés, assemblages, collages du cubisme
à nos jours*, 1964, traveled to Paris, no. 119, as
Personnage. Chicago 1967–68, no cat. New York,
The Museum of Modern Art, *André Masson*,
1976–77, traveled to Houston and Paris, no cat.
nos., p. 21 (ill.), as *Child Looking at a Drawing*;
French cat., 1977, no cat. nos., p. 21 (ill.), as
L'Enfant regardant un dessin. Chicago 1984–85,
no cat. nos., p. 183 (ill.), as *Blue Personage/Child*

Looking at a Drawing. The Art Institute of
Chicago, *Joseph Cornell and Twentieth-Century
Collage*, 1985, no cat.

REFERENCES: Florence de Mèredieu, *André
Masson: Les Dessins automatiques*, Geneva, 1988,
fig. 59, p. 52, as *L'Enfant regardant un dessin*.

THE DATE OF 1925 PREVIOUSLY GIVEN FOR this collage is probably too early, because Masson rarely introduced collage elements into his work until 1926/27, although the pasted-in drawing itself could date from 1924/26. The origins of this collage seem fortuitous – the personage is suggested by a spot of spilled, blue watercolor, extended and then enhanced with a few ink lines. The figure does resemble a 1926 drawing of a bird, which appears to hold a letter in one claw (fig. 3), a drawing that Florence de Mèredieu compared to Paul Klee's lithograph of 1920, *A Guardian Angel Serving a Little Breakfast* (fig. 4; Mèredieu 1988, p.29; Klee's lithograph was reproduced in *La Révolution surréaliste* 1, 3 [1925], p. 19). Masson, who is known to have admired Klee's doodlelike "walking" line, used the latter's heart motif in both of these drawings. The bird-like head and the idea of a picture within a picture can also be compared with similar motifs in Max Ernst's *Loplop Presents* collages of the early 1930s (see nos. 65 and 66), where the bird is the artist's alter ego.

The automatic drawing constituting the collage element in this work may have been done after the paper was torn, since it is so clearly contained within the torn paper's irregular edges. Somewhat unusually among Masson's automatic drawings, it seems to encompass a multitude of figures, like his so-called Massacre drawings of the early 1930s (see, for example, Kunstmuseum Bern, *Masson: Massacres, métamorphoses, mythologies,* 1996, exh. cat., pp. 28–31, nos. 17, 20–23, ills.), and could be interpreted as a scene of violence. In the Massacre drawings, however, each figure has a much clearer individual identity. Here the meandering line and broken, irregular marks seem to be closer to the type of automatism found in Masson's work from 1924 to 1926. The rudimentary signs indicating the features of the personage, however, resemble those in drawings of 1927. The torn drawing is pasted over the portion of paper covered with a blue wash, but the personage's hands – in black ink at the paper's top edge and red paint below – overlap the torn drawing, suggesting that the elaboration of the personage was the third and final stage of this work. The startling red of the hand recalls the splashes of red paint in the sand paintings of 1926–27, where it often indicates shed blood (see, for example, *Battle of Fish*, 1926, New York, The Museum of Modern Art; ibid., p. 23, no. 9, ill.).

* * *

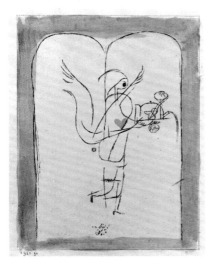

Left, figure 3. André Masson, *The Bird*, 1926, colored pencils on paper, 61 x 45 cm, Archives Galerie Louise Leiris [photo: Florence de Mèredieu, *André Masson: Les Dessins automatiques*, Geneva, 1988, p. 29, no. 32].

Right, figure 4. Paul Klee, *A Guardian Angel Serving a Little Breakfast*, 1920, lithograph and watercolor, 19.9 x 14.6 cm, The Art Institute of Chicago, Buckingham, A. Kunstadter Family Foundation, and Frances S. Schaffner Principal funds, 1970.270.

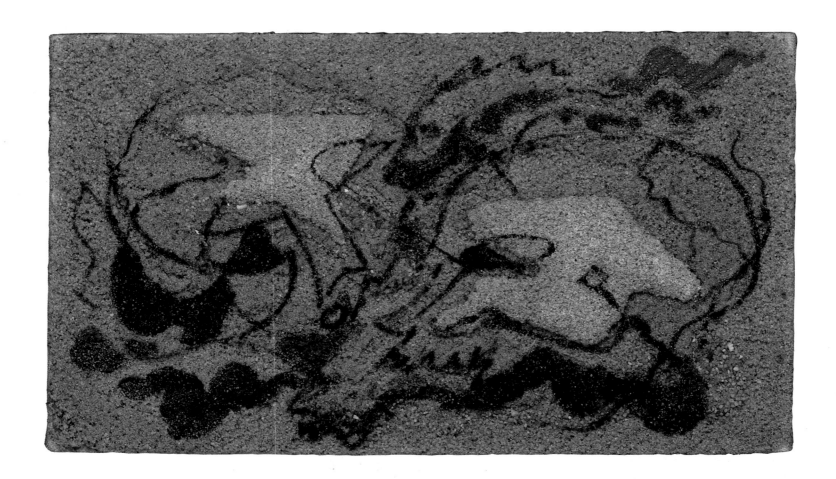

91. UNTITLED (TWO DEATH'S HEADS)

1927
Oil and sand on canvas; 14.3 x 24.1 cm (5⅝ x 9½ in.)
Signed on back of canvas (now covered by backing board): *André Masson*
The Lindy and Edwin Bergman Collection, 147.1991

PROVENANCE: Sold by the artist to the Galerie Louise Leiris, Paris, September 1927;[1] sold to a private collector, 1959; sold to the Galerie Louise Leiris, Paris, June 1964;[2] sold to the Galerie Claude Bernard, Paris, 1965;[3] sold to Lindy and Edwin Bergman, Chicago, 1967.

EXHIBITIONS: London, Marlborough Fine Art Limited, *André Masson: Retrospective Exhibition*, 1958, no. 4, as *Deux têtes de mort*. Paris, Musée national d'art moderne, *André Masson*, 1965, no. 116, as *Deux têtes de mort*. New York 1968, no. 199, fig. 95, as *Deux têtes de mort*. New York, The Museum of Modern Art, *André Masson*, 1976–77, traveled to Houston and Paris, no cat. nos., pp. 22, 25 (ill.), 124, as *Two Death's Heads*; French cat., 1977, no cat. nos., pp. 22, 25 (ill.), 124, as *Deux têtes de mort*. London, Hayward Gallery, *Dada and Surrealism Reviewed*, 1978, no. 9.47 (ill.), as *Deux têtes de mort*. Chicago 1984–85, no cat. nos., p. 184 (ill.), as *Two Death's Heads*. Chicago 1986, no. 36, as *Two Death's Heads*.

REFERENCES: Roger Vitrac, "André Masson," *Cahiers d'art* 10 (1930), p. 526 (ill.), as *Sable*. Rubin 1968, fig. 150, as *Two Death's-Heads*. Jean Paul Clébert, *Mythologie d'André Masson*, Geneva, 1971, p. 34, as *Deux têtes de mort*. Paris, Musée national d'art moderne, *Salvador Dalí, rétrospective, 1920–1980*, 1979–80, exh. cat., p. 410 n. 28, as *Deux têtes de mort*.

M ASSON DEVELOPED THE PROCESS OF sand painting while living by the sea at Sanary-sur-mer in the south of France during the winter of 1926–27. The technique was related to the idea of automatism and sprang from a recognition, as he explained, of "the gap between my drawings and my oil paintings – the gap between the spontaneity and lightning rapidity of the former and the thought that inevitably went into the latter. I suddenly hit on the solution while I was at the seaside, gazing at the beauty of the sand with its myriad of nuances and infinite variations from the dull to the sparkling" (quoted in Chicago 1984–85, p. 184, from Georges Duby, "Chronologie d'André Masson,"*Cahiers du sud* 48, 361 [June–July 1961]). Elsewhere Masson described his "recipe for sand pictures":

On a surface previously spread with glue, handfuls of sand from various sources are thrown. Chance presides. Successive layers of different grains create values. A few bistre lines, sometimes a patch of sky blue above, a bloody trace below. Also they are all almost monochrome. (André Masson, *Métamorphose de l'artiste*, vol. 1, Geneva, 1956, p. 22)

Masson later gave an even more detailed description of the processes he used in the making of his sand paintings, a description that conveys vividly the sense of discovery involved and the role played by automatism:

I began by placing flat on the ground a piece of canvas. Onto it I threw puddles of glue, which I manipulated, and they took on the aspect of Leonardo da Vinci's wall. Then I spread sand, I shook the canvas again so that there were explosions, puddles, sometimes I raked it with a knife, I obtained something that had no meaning but could provoke it. . . . All with the speed of lightning. I took sand of different sizes, I put on more glue, in successive layers, which ended up as a kind of wall, a very uneven wall, and then these layers at a given moment suggested forms, although usually irrational ones. With a little oil paint, I added some lines, but as quickly as possible, and then, already a *little calmer, some touches of color.* (Cited in Musée d'art moderne de la ville de Paris, *André Masson: 200 Dessins*, 1976, exh. cat., n. pag.)

Interestingly, there is a similar allusion to Leonardo's wall in Max Ernst's account of the invention of *frottage* in "Beyond Painting" (*Max Ernst: Beyond Painting, and Other Writings by the Artist and His Friends*, New York, 1948, pp. 3–11). As Masson suggested above, the sand paintings vary considerably in the density of their textured surfaces: in some, areas of canvas are left blank, whereas here the picture's surface is thickly covered. In this work two white patches of paint, resembling starfish, are transformed by black outlines into the bony highlights of two skulls. Other oil and sand paintings of 1926/27 include death's heads. Of these, Masson's *Death's Head* of 1927 (location unknown; Otto Hahn, *Masson*, New York, 1965, p. 39, ill.) is the closest to the Bergman example.

The theme of the death's head recalls the long tradition in art of the *memento mori*, in which the skull serves as an obvious reminder of mortality. Masson must also have been familiar with Paul Cézanne's late still lifes with jawless skulls. The death's head is broadly related to other themes in Masson's work at the time, such as the battles of animals and fish. This subject may have had a more personal bearing on mortality for Masson, however, in connection with the decline and death, in May 1927, of his friend Juan Gris. * * *

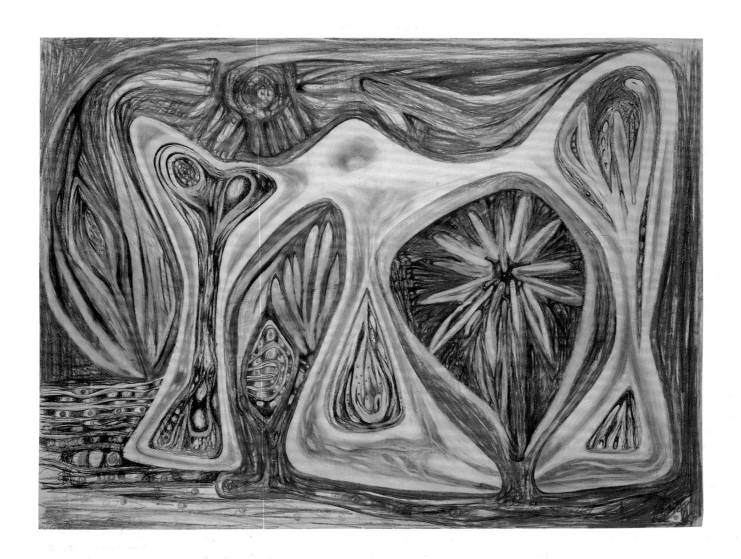

92. UNTITLED

1938/39
Crayon and graphite, with smudging and
erasing, on ivory wove paper; 49.9 x 65 cm
(19⅝ x 25⅝ in.)
Inscribed on back, upper left: *Reg. 36*
The Lindy and Edwin Bergman Collection,
148.1991

PROVENANCE: Peter Watson.[1] Robert Elkon
Gallery, New York; sold to Lindy and Edwin
Bergman, Chicago, 1962.

EXHIBITIONS: New York, Robert Elkon Gallery,
*Twentieth-Century Master Drawings and
Watercolors*, 1961, no cat. The University of
Chicago, The Renaissance Society, *Matta*, 1963,
no. 16. Chicago 1984–85, no cat. nos., p. 95,
fig. 3, and p. 188.

REFERENCES: *Art International* 5 (Dec. 1961),
p. 16 (ill.).

Matta was trained as an architect in his native Chile and moved to Europe in 1933 to escape what he experienced as a stuffy and narrow provincialism. He worked in Le Corbusier's office in Paris, but as work was sporadic, he often took the opportunity to travel, making contacts and discoveries that were to orient him definitively toward Surrealism. In Madrid in 1934 he met the poet Federico García Lorca; and in London in 1936 he met René Magritte and Roland Penrose. He was first exposed to Surrealist ideas through the 1936 issue of *Cahiers d'art* devoted to the Surrealist object. This issue also included an article on Marcel Duchamp (Gabrielle Buffet, "Coeurs volants," *Cahiers d'art* 11, 1–2 [1936], pp. 34–43), an encounter that was as decisive for him as the encounter with Giorgio de Chirico's paintings had been for artists such as Max Ernst.

In 1937 he met André Breton through Salvador Dalí. Breton bought two of Matta's drawings, and included four dating from 1937 in the 1938 *Exposition internationale du surréalisme* at the Galerie beaux-arts in Paris (exh. cat. nos. 124–127). In the catalogue to the exhibition, these drawings were each entitled *Scenario*, numbered one through four, and bore the following highly idiosyncratic subtitles, which are redolent of Matta's ideas about a cosmic morphology and sometimes include terms coined by the artist: *Succion panique du soleil* (*Panic Suction of the Sun*), *Pulsions infusoires du soleil* (*Infusionary Pulsions of the Sun*), *Le Sperme du temps collé aux déchirures du jour* (*The Sperm of Time Glued to the Tears of the Day*), and *Elasticité des intervalles* (*Elasticity of Intervals*).

Even though it is dated a little later, this brilliantly colored drawing may well belong to this same group of works, for Matta produced drawings in the same style through 1938. The forms are constructed with bands or strands of color, and seem to wrap around and press against each other; the constant shifting and interpenetration of these shapes create a dramatically uncertain sense of scale, from the microscopic to the cosmic, as suggested by the titles listed above the drawings included in the 1938 Galerie beaux-arts exhibition. Some parts of this drawing – such as the colorful area enclosed within the white, bonelike form to the right – resemble seeds and parts of plants. Gordon Onslow Ford, a young English painter whom Matta met shortly before he joined the Surrealists, recalled him in 1939 studying leaves and flowers through a magnifying glass (Gordon Onslow Ford, "Notes sur Matta et la peinture [1937–1941]," in Paris, Musée national d'art moderne, *Matta*, 1985, exh. cat., p. 31). At the lower left, a patch of horizontal lines resembles a geological section, while other forms recall both flowers and suns.

Onslow Ford also described the role of Surrealist automatism in these works, writing of the 1938 drawing *The Red Sun* (fig. 1): "The drawing started with an automatic pencil line. One line led to another, and a drama took form that was worked up with a few carefully chosen colored pencils" (Gordon Onslow Ford, *Creation*, Basel, 1978, p. 42). The Bergman drawing is more abstract than *The Red Sun*, in which certain forms are clearly distinguishable: a woman's body at lower left, plant growth below, and an expanding red sun above. In its abstraction, it is closer to other drawings of 1938, such as *Space Travel* (also known as *Star Travel*; Gordon Onslow Ford, on deposit at the San Francisco Museum of Modern Art; Onslow Ford 1978, p. 47, ill.) and another untitled drawing owned by Acquavella Contemporary Art, Inc., New York (fig. 2). It especially resembles the latter, which shows a very similar pattern of expanding red forms enclosing other organic shapes.

The automatism of these drawings differs from the gestural spontaneity preferred by André Masson and Joan Miró in the early years of Surrealism. Here, the repetitive lines have something of the obsessional character found in the work of untaught and outsider artists, such as Adolf Wölfli or Ramón Martinez, in whom André Breton was interested. Most striking, though, is the sense of pulsating forms interacting with the surrounding space in a "landscape" that may be read on either a minute or a massive scale. * * *

Left, figure 1. Matta, *The Red Sun*, 1938, colored pencil and graphite on paper, 48.8 x 64.1 cm, Inverness, California, Gordon Onslow Ford [photo: Richard Allen; courtesy of Suzanne Royce and Associates, San Francisco].

Right, figure 2. Matta, *Untitled*, 1938, colored pencil on paper, 49.5 x 64.7 cm, New York, Acquavella Contemporary Art, Inc.

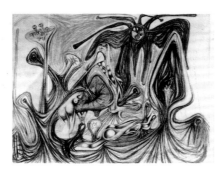

93. UNTITLED
(PSYCHOLOGICAL MORPHOLOGY)

1939
Oil on canvas; 73 x 92.1 cm (28³/₄ x 36¹/₄ in.)
Signed and dated, lower right: *Matta 39*
The Lindy and Edwin Bergman Collection,
149.1991

PROVENANCE: Leo Castelli Gallery, New York;
sold to the Sidney Janis Gallery, New York.[2]
Ruth Moskin Gallery, New York.[3] Gres Gallery,
Washington, D.C.; sold to Lindy and Edwin
Bergman, Chicago, 1960.

EXHIBITIONS: The University of Chicago,
The Renaissance Society, *Matta*, 1963, no. 2,
as *Inscape (Psychological Morphology)*. Houston,
University of St. Thomas, Fine Arts Gallery,
*Out of This World: An Exhibition of Fantastic
Landscapes from the Renaissance to the Present*,
1964, no. 69 (ill.), as *Psychological Morphology*.
Waltham, Massachusetts, Brandeis University,
Rose Art Museum, *Matta: The First Decade*,
1982, no. 10, as *Inscape (Psychological Morphol-
ogy)*. Chicago 1984–85, no cat. nos., pp. 188–
89, pl. 43, as *Psychological Morphology (Inscape)*.

REFERENCES: William Rubin, "Arshile Gorky,
Surrealism, and the New American Painting," *Art
International* 7, 3 (1963), p. 34 (ill.), as *Psycho-
logical Morphology*; reprinted in New York, The
Metropolitan Museum of Art, *New York Painting
and Sculpture: 1940–1970*, 1969–70, exh. cat.,
p. 385 (ill.), as *Psychological Morphology*.

WHEN MATTA PRESENTED HIS CONCEPT OF psychological morphology to the Surrealists during the autumn of 1938, an uncomprehending André Breton requested that he put his ideas in writing.[4] The resulting text, entitled "Morphologie psychologique" (cited in Paris, Musée national d'art moderne, *Matta*, 1985, exh. cat., pp. 30–31), shows that one of his sources was Salvador Dalí, whose own passionate interest in morphology was expressed on a number of occasions in the Surrealist journal *Minotaure* (see, for example, "Première loi morphologique sur les poils dans les structures molles," *Minotaure* 9 [1936], pp. 60–61). Morphology – the study of the structures, homologies, and metamorphoses of form in animals, plants, and even language – was a natural arena for the Surrealists and a rich source of inspiration for the visual artists associated with the movement. Broadly speaking, rather than pursuing the moral and psychological implications of Dalí's division of forms into hard and soft, Matta tried to convey a maximum conflation of forms, an idea expressed in the characteristic linguistic mergings and neologisms of his writing: "the object, at each risk of interpenetration may oscillate from pointvolume to momenteternity, from attractionrepulsion to pastfuture, from lightshadow to matter movement" (Matta, "Morphologie psychologique," cited in Paris 1985, p. 30). Not only figures and objects, but also space and time are convulsed and pulsate in this new "graphique des transformations" (graphic art of transformations; ibid.).

Matta absorbed ideas from many sources. He was influenced by Albert Einstein's General Theory of Relativity and by the Russian mystical philosopher P. D. Ouspensky's *Tertium Organum* (1911), which Matta and Gordon Onslow Ford read at the same time (see Paris 1985, pp. 27–28). Ouspensky defined four stages of spiritual development related to different perceptions of spatial dimension. He described the fourth and highest stage of perception in terms that must have appealed to Matta's interest in space as a psychological dimension: "A feeling of four-dimensional space. A new sense of time. The live universe. Cosmic consciousness. Reality of the infinite" (Ouspensky, cited in Charlotte Douglas, "Beyond Reason: Malevich, Matiushin, and Their Circles," in Los Angeles County Museum of Art, *The Spiritual in Art: Abstract Painting, 1890–1985*, 1986–87, exh. cat., p. 187). There are echoes of all these sources in Matta's short text, "Mathématique sensible – architecture du temps," a response to Le Corbusier's *Mathématique raisonnable*; in it he proposed architectural spaces and objects formed and deformed by human psychological needs and desires, rather than conditioned by rational and utilitarian considerations. Matta described the unexpected psychological dimensions of soft spaces: "We need walls like wet sheets which lose their form and wed our psychological fears" (Matta Echaurren, "Mathématique sensible – architecture du temps," *Minotaure* 11 [Spring 1938], p. 43). Matta and Onslow Ford were also fascinated by the mathematical objects photographed by Man Ray, which were included in the *Exposition surréaliste d'objets* at the Charles Ratton Gallery, Paris, in 1936 (Paris, Musée national d'art moderne, *André Breton: La Beauté convulsive*, 1991, exh. cat., p. 302, ills.), and which Breton described on this occasion as "surprising concretizations of the most delicate problems of geometry in space" (ibid., p. 229). But it was not a matter of simply translating scientific, pseudoscientific, or mystical ideas into visual form. Matta's psychological morphologies and "inscapes" are essentially visual: only on canvas can these mental and physical universes come into being.

The two-stage process that led to paintings such as this was described by Onslow Ford in relation to a canvas closely related to the Bergman painting, now known as *Morphology of Desire* (1938, Gordon Onslow Ford, on deposit at the San Francisco Museum of Art; Paris 1985, pp. 90–91, ill.), but reproduced in 1939 as *Morphologie psychologique 37* (André Breton, "Des tendances les plus récentes de la peinture surréaliste," *Minotaure* 12–13 [May 1939], ill. between pp. 17 and 23): in the first stage, "the canvas was begun with multicolored marks of the palette knife and the rapid manipulation of paint, to create in a few minutes an automatic base. *Second stage*: the automatic ground was considered at leisure and, over days and weeks, the subject took shape [*s'esquissa*] in the painting and was brought to light to reveal a gelatinous field of blue-space-time-matter where a drama was played out between personages and objects" (Onslow Ford, in Paris 1985, p. 29). In the Bergman painting, Matta has only lightly worked over the initial automatic manipulation of paint, compared to other paintings of the period: sexual imagery is visible in male and female forms (for instance, the vertical shape at right and the opening at lower center), and other objects are faintly detectable, such as a tree at upper left and a female profile at lower left. These readings are not intended as definitive, for the configurations in this and other paintings of the period are meant to remain ambiguous. Rather, they are indications of the complexity of Matta's imagery, which shifts freely between abstraction and the figurative evocation of objects, people, and landscapes; it was in the tension between these modes of representation and the ensuing images that the "jamais vu" (the never seen), as Onslow Ford recalled (in ibid., p. 28), might be found. * * *

94. UNTITLED (FLYING PEOPLE EATERS)

1942
Graphite and colored crayons, with smudging
and erasing, on ivory wove paper; 58.8 x 73.9 cm
(23 1/8 x 29 1/8 in.)
The Lindy and Edwin Bergman Collection,
151.1991

PROVENANCE: Pierre Matisse Gallery,
New York; sold to Lindy and Edwin Bergman,
Chicago, 1960.

EXHIBITIONS: Possibly New York, Pierre
Matisse Gallery, *Matta*, 1942, no. 2, as *Dioses y
perros (Gods and Dogs)*. Possibly The Arts
Club of Chicago, *Matta*, 1944, no. 1–5, 7, or 11.
The University of Chicago, The Renaissance
Society, *Matta*, 1963, no. 20. Paris, Musée

national d'art moderne, *Matta*, 1985, exh. cat.,
no. 46 (ill.), as *Flying People Eaters*.

REFERENCES: G[ermana] Ferrari, ed.,
*Entretiens morphologiques: Notebook No. 1,
1936–1944*, London, 1987, p. 233 (ill.),
as *Flying People Eaters*.

Figure 3. Matta, *Years of Fear*, 1942,
oil on canvas, 111.7 x 142.2 cm, New York,
The Solomon R. Guggenheim Museum
[photo: Robert E. Mates; © The Solomon
R. Guggenheim Foundation, New York].

THIS IS ONE OF SEVERAL DRAWINGS MATTA made between 1940 and 1943, containing figures floating or flying, that convey the idea of airborn attack. Here, brightly colored monsters attack pink-fleshed humans, and the engagement is clearly sexual in nature, as well as sinister and somewhat satirical. The fleshy figures are female, and other forms are male: two blue, single-horned, horselike creatures with phallic tongues; and the black and gray form to the left bristling with what appear to be male genitalia. Given Matta's absorption in Marcel Duchamp's work at the time (see *Drive in the Knife*, no. 95, below), there may be a connection here with the latter's representation of male sexual assaults on the female in such works as the watercolor *The King and Queen Traversed by Swift Nudes at High Speed* (1912, Philadelphia Museum of Art) and the drawing *The Bride Stripped Bare by the Bachelors* (1912, Paris, Musée national d'art moderne, Centre Georges Pompidou; New York, The Museum of Modern Art, *Marcel Duchamp*, 1973–74, exh. cat., nos. 77 and 79, ills.). At the upper right is a splayed figure resembling an airplane, which is probably a reference to the war in Europe, from which Matta had taken refuge in New York and whose relentless bombing raids were widely reported in the United States press. Matta inscribed on the back of another 1942 drawing, *There Was Blood in the Clouds* (Paris, private collection; Paris 1985, p. 126, ill.), a poem in English confirming this link and making a grim analogy between bombs and eggs:

There was blood in the clouds
There was a pilot
Who met a harpie
They fought
They struggle
They love
And change themselves into
A XX Century heaven dream
Who laid eggs on the earth

Some of these drawings were preliminary studies for figureless oil paintings (although the space in this drawing is only lightly indicated, it does resemble that of Matta's more abstract paintings). Germana Ferrari suggested, for example, that an untitled pastel of 1940 in the collection of Gordon Onslow Ford is a study for the painting *Invasion of the Night* (1942, San Francisco Museum of Modern Art; Ferrari 1987, pp. 106–07, ills.), a relationship she established by describing the painting as a mirror image of the study. She also demonstrated that the pastel drawing *A Pajarito* (*To the Little Bird*, 1940, New York, A. Alpert) is related in the same manner to a painting of 1941–42 entitled *Endless Nudes* (Paris, private collection; ibid., pp. 114–15, ills.).

The Bergman drawing might be matched, though less specifically, with *Years of Fear*, a painting from the same year (fig. 3). There may be a link between the flying form at upper right in the drawing and the space-structure at left in the painting; there are also parallels with the forms consisting of spidery lines radiating like webs or rays from centers framed by geometric shapes. In the Bergman drawing, however, these patterns suggest surveillance as they surround the figures, while in the painting they construct planes of space, which alternate with more loosely painted areas to create a complex, multidimensional arena. There is an interesting contrast between the drawings, which are thickly populated with figures and objects and therefore conceived on a finite scale, and the paintings, which emphasize limitless, cosmic expanses. * * *

95. DRIVE IN THE KNIFE
(PLENTER LE COUTEAU)

May 1943
Oil on canvas; 25.4 x 35.7 cm (10 x 14¹/₁₆ in.)
Inscribed on back: *PM 84 May 43 Plenter* [sic] *le couteau* (on stretcher, upper right); *MATTA 1943 / "Plenter* [sic] *le couteau" oil / ST-1467 19 x 14"* (on Pierre Matisse Gallery label)

The Lindy and Edwin Bergman Collection, 152.1991

PROVENANCE: Sold by the artist to the Pierre Matisse Gallery, New York, April 30, 1944;[5] sold to the Allan Frumkin Gallery, Inc., Chicago, 1964;[6] sold to Lindy and Edwin Bergman, Chicago, 1965.

EXHIBITIONS: The Arts Club of Chicago, *Matta*, 1944, no. 25.

MATTA'S IDIOSYNCRATIC SPELLING OF *plenter* (for *planter*), one of the words in the title of this work, is characteristic; he may have had in mind a verbal play on the phrase *planter le drapeau* (hoist the flag) as a subversive, antipatriotic gesture. The title otherwise appears to have no direct relation to the image, except to underline its gestural drama, and perhaps to highlight the two solid, axlike shapes that stand out against swirling paint masses and lines.

This painting can be linked to a series of works, begun in 1942, in which Matta explored the perspectival and spatial ideas in Marcel Duchamp's great painting on glass, *The Bride Stripped Bare by Her Bachelors, Even*, also known as *The Large Glass* (1915–23, Philadelphia Museum of Art; Philadelphia Museum of Art, *Handbook of the Collections*, 1995, p. 316, ill.). The two artists were particularly close during the World War II period, which they spent, along with other Surrealists, in New York. *The Large Glass* must lie behind the concept of *Les Grands Transparents*, the title of Matta's illustration to Breton's "Prolegomènes à un troisième manifeste du surréalisme ou non" (*VVV* 1 [June 1942], pp. 18–26). In this article Breton spoke of man's unease in the presence of a cosmic vastness unmediated by the presence of a God, not despairingly but as a salutary recognition of the limits of human rationality and self-importance. In the section subtitled "Les Grands Transparents," Breton conjured a universe close to Matta's: "Man is perhaps not the center, the *focus* of the universe. One may go so far as to believe that there exist above him, on the animal level, beings whose behavior is as alien to him as his own must be to the may-fly or the whale" (ibid., p. 25).

Romy Golan has shown how Matta's evolving ideas of psychological and metaphorical space during this period draw upon Duchamp's work (Romy Golan, "Matta, Duchamp et le mythe: Un Nouveau Paradigme pour la dernière phase du surréalisme," in Paris, Musée national d'art moderne, *Matta*, 1985, exh. cat., pp. 37–51). The strange, part-human, part-mechanical structure in Duchamp's 1912 painting *Bride* (Philadelphia Museum of Art; Pontus Hulten, ed., *Marcel Duchamp: Work and Life*, Cambridge, Mass., 1993, p. 98, ill.), for instance, may have prompted Matta's combinations of solid and transparent shapes in paintings of this period. It has also been suggested that the sweeping, weblike lines, prominent in *Drive in the Knife*, echo the lines of cracks in *The Large Glass* (Golan, in Paris 1985, p. 42). This seems a plausible explanation for the odd role of these lines in Matta's paintings, where they sometimes appear to mimic perspectival marks and at other times appear to wander irrationally in space. This idea of transparency is further emphasized in *Drive in the Knife* through patches of bare canvas. * * *

96. MEDRAUMONDE

1945/46
Graphite, with smudging and erasing, and colored crayons on cream wove paper; 50.5 x 37 cm (19⅞ x 14¹¹/₁₆ in.)
Inscribed: *el pan Doro / al Lionel* (center right); *a la Margarita* (lower right); *aaa* (twice, at center left and upper center); *xxx* (twice, at center left and center); *vvv* (twice, at center left); *A* (lower left); *B* (lower center)
Inscribed on back: *MEDRAUMONDE* (across center); *335* (upper left, upside down)
The Lindy and Edwin Bergman Collection, 150.1991

PROVENANCE: Possibly Lionel and Margaret Abel, New York. Bodley Gallery, New York; sold to Lindy and Edwin Bergman, Chicago, 1968.

EXHIBITIONS: Possibly New York, Bodley Gallery, *Matta: From 1942 to 1957*, 1960, no cat. nos., n. pag., as *Color Drawing*. Chicago 1986, no. 39, as *Medraumonde Armond*.

THE TITLE MEDRAUMONDE IS TAKEN FROM the word scribbled roughly in capital letters on the back of the drawing, although it is not clear that this rather than the inscription on the front of the drawing, *el pan Doro*, should be regarded as the title. *Medraumonde* is a thinly disguised form of the French curse "*merde au monde*," with a hint of Alfred Jarry's famous variation, "*merdre*," in the spelling; the "a" is written over an "e," helping to conflate the separate words into one. The inscription *el pan Doro* literally translates as "gilded bread"; however, it was Matta's habit to divide or elide words in order to elicit further meanings, as he did, for example, in the slightly later paintings *Je m'honte* (1948–49, Houston, Dominique de Menil) and *Je m'arche* (1949, The University of Chicago, The David and Alfred Smart Museum of Art; Paris, Musée national d'art moderne, *Matta*, 1985, exh. cat., nos. 81 and 83, ills.). Here if we read the inscription as two words, as has been suggested by Matthew Gale, it produces *el pandoro*, a male Pandora. There may therefore be a reference to the contemporary development of atomic power and its catastrophic use at the end of World War II, an unleashing of evil for which the comparison with Pandora's transgressive curiosity is appropriate.

The inscriptions *al Lionel* at right of center and *a la Margarita* along the bottom edge of the drawing probably refer to Lionel and Margaret Abel, a couple that befriended Matta during his residency in New York from 1939 to 1948. Lionel Abel was a prominent art critic in the 1940s, who later recounted his experience in New York with Matta and the Surrealists in a chapter of his book *The Intellectual Follies: A Memoir of the Literary Venture in New York and Paris* (New York, 1984, pp. 88–115).

Stylistically the drawing belongs to the mid-1940s, as comparable figures begin to appear in Matta's work by 1944 at the earliest. A sheet of figure studies dated 1945–46 (New York, Allan Frumkin Gallery; Paris 1985, no. 56, ill.) offers a series of close comparisons. The Bergman drawing is divided by a horizontal line at center into distinct upper and lower zones or scenes, although there are hints of an indistinct but continuous architectural or spatial framework throughout the drawing. At the upper center of each half is a circular, cosmic shape. The inscribed names, *Lionel* and *Margarita*, and the gendered figures suggest that this division, clearly based

on Duchamp's *Large Glass* (1915–23, Philadelphia Museum of Art; Philadelphia Museum of Art, *Handbook of the Collections*, 1995, p. 316, ill.), is, like Duchamp's, separated into male and female areas. Although the upper and lower sections of *The Large Glass* use different perspectival systems, here there is no such distinction between the two areas. There is, however, a reference to different representational systems in the points of the v-shaped dotted line at left of center marked *aaa*, *vvv*, and *xxx*, notations that are repeated to the right but in a different configuration, perhaps in relation to a perspectival view rather than a plan or a diagram. Such use of diverse modes of representation was characteristic of Duchamp, whose importance for Matta the latter acknowledged in his 1943 painting *The Bachelors Twenty Years After* (private collection; G[ermana] Ferrari, ed., *Entretiens Morphologiques: Notebook No. 1, 1936–1944*, London, 1987, p. 185, ill.).

As Valerie Fletcher noted, Matta's elongated figures may have derived from the totems of Northwest Coast Native American cultures, as well as from Alberto Giacometti's *Invisible Object* of 1934, a cast of which he owned (see Valerie Fletcher, "Matta," in Washington, D.C., Hirshhorn Museum and Sculpture Garden, *Crosscurrents of Modernism: Four Latin American Pioneers, Diego Rivera, Joaquín Torres-García, Wifredo Lam, Matta*, 1992, exh. cat., pp. 249 and 253 n. 34). In the upper section, a nude couple at left appears to be simultaneously embracing and juggling yellow blades, similar to the forms that adorn the solitary figure in the 1947 painting *The Pilgrim of Doubt* (New York, private collection; Washington, D.C. 1992, no. 91, ill.). To the right the male figure undertakes indeterminate activities in front of a table, perhaps holding a sword above a turbulent pile of vaguely organic forms. In the lower half, a woman with outstretched arms, in a crucifixion pose typical of Matta's work (see, for example, *A Grave Situation*, 1946, Chicago, Museum of Contemporary Art; Washington, D.C. 1992, no. 90, ill.), rises from (or perhaps sinks in) a bed or pyre. Whether this is a scene of immolation or triumph is unclear, but there is nonetheless a pervasive air of violence and sexual tension in the drawing. * * *

THE TITLE OF THIS WORK, WITH ITS TYPICALLY idiosyncratic orthography, probably plays on the Spanish phrase "*el común de la gente*," meaning "the general run of people." If so, it seems to be a satirical comment on the nature of fame. Figures appear to plunge vertically to earth, like a Fall of the Angels, flanked by two cosmic bodies, perhaps sun and moon. The vigorous technique includes *frottage*, that is, rubbings with Conté crayon, and repeated, jabbing pencil marks.

* * *

97. THE COMMONALITY OF THE FAMOUS (EL COMÚN DES NOMBRADOS)

c. 1951
Graphite and crayon, with smudging, on cream wove paper; 25.1 x 33.2 cm (9⁷/₈ x 13¹/₈ in.)
Inscribed, lower right: *el comun des-nombrados*
Inscribed on back: *K1309* (lower center); *3C* (lower right)

The Lindy and Edwin Bergman Collection, 153.1991

PROVENANCE: Possibly Alexander Iolas Gallery, New York. Bodley Gallery, New York; sold to Robert Elkon, New York, December 1960;[7] sold to Lindy and Edwin Bergman, Chicago, 1961.

EXHIBITIONS: Possibly New York, The Museum of Modern Art, *Matta*, 1957–58, traveled to Minneapolis and Boston, no. 35, as *Drawing*. Chicago 1986, no. 41.

98. ALPHABET DEAF (STILL) AND (ALWAYS) BLIND (ALPHABET SOURD [ENCORE] ET [TOUJOURS] AVEUGLE)

1957
Collage composed of gouache on cut-and-pasted, wove, corrugated, and foil papers, laid down on cardboard; 33.4 x 24.1 cm (13⅛ x 9½ in.)
Signed, titled, and dated: *Mesens* (lower left); *ALPHABET SOURD (encore) / ET (toujours)*

AVEUGLE (lower center); *15/1957.* (lower right)
Inscribed on back: *At the entry of this work / in the collection of Edwin / and Lindy BERGMAN, / I / make the promess [sic] to give / them a collage when they / will already possess five / of them. Bargain or joke? / But very sincerely, / E. L. T. Mesens / 13th May 1959. / 13th April 1959.*
The Lindy and Edwin Bergman Collection, 154.1991

PROVENANCE: Galerie Furstenberg (Simone Collinet), Paris; sold to Lindy and Edwin Bergman, Chicago, 1959.

EXHIBITIONS: Paris, Galerie Furstenberg, *Une Exposition de collages par E. L. T. Mesens*, 1958, no. 27. Brussels, Palais des beaux-arts, *E. L. T. Mesens: Collages*, 1959, no. 59.

E. L. T. MESENS (AS HE WISHED TO BE CALLED) was a poet, gallery director, art dealer, magazine editor, and artist, as well as a founding member of Surrealism in Belgium (see José Vovelle, *Le Surréalisme en Belgique*, Brussels, 1972, p. 221; and London, Hayward Gallery, *Dada and Surrealism Reviewed*, 1978, exh. cat. by Dawn Ades, p. 331). A lifelong friend of René Magritte, Mesens increasingly turned to dealing and organizing exhibitions as his primary activities, while continuing to publish, edit, and produce the occasional collage. He assisted Roland Penrose (see no. 105 below) with the London *International Surrealist Exhibition* in 1936, and in 1938 he settled in London to become managing director of the London Gallery, which was partly owned by Penrose. Here he launched and edited *The London Bulletin*, which ran from 1938 to 1940, when the London Gallery closed; initially a glorified gallery catalogue, this "became one of the most important documents to cover the interplay between Continental Surrealism and British avant-garde tendencies during the late Thirties" (George Melly, "E.L.T. Mesens: The W. C. Fields of Surrealism," unpublished memoir). After World War II, Mesens reopened the London Gallery, but in 1950 it folded, its cellars full of unsalable works by Ernst, Magritte, Miró, and Schwitters.

Mesens made his first collage in 1924, but produced works only intermittently over the next thirty years. As he later recalled, "Between 1924 (date of the first collage) and 1954, I only produced one or two works a year. In 1954: 12 works. Since then I refuse to make more then 45 works a year" (questionnaire administered by the Archives de l'art moderne, Brussels, on April 10, 1962; quoted in Vovelle 1972, p. 224). In 1954 Mesens saw some of his collages of the 1920s and 1930s on display at the Venice Biennale and was impressed, as he put it, by their "power to hold their own" (quoted in Jacques Brunius, "Rencontres fortuités et concertées," in Knokke-Le-Zoute, Belgium, XVIᵉ Festival Belge d'été, Salle "La Reserve," *E. L. T. Mesens*, 1963, exh. cat., n. pag.). Thus surprised and encouraged, he set to work again and continued to produce collages for the rest of his life.

The inscription at lower right in the Bergman collage, *15/1957*, indicates that this work is the fifteenth Mesens produced in 1957. The title refers to *Alphabet sourd et aveugle* (Brussels, 1933), a collection of Mesens's poetry, based on the twenty-six letters of the alphabet, that was published with a collage of 1928 as a frontispiece. The book indeed includes twenty-six poems, one for each letter of the alphabet. The lines of each poem all start with the chosen letter, as in "Adulte /à ne point / admirer / aidant / au commerce d' / adages / armé pour ne point être / aimé" (ibid., p. 11). The titles of Mesens's book and of the Bergman collage seem to refer to man's deafness and blindness to the poetic possibilities of the letters of the alphabet, and by extension of the world around us. As Paul Eluard wrote in his preface to Mesens's book:

The letter devours the word as a straight line extends a drawing infinitely. Pure abstraction in and of itself, it is only truly concrete and objective for those idiots who have a brute perception of it. It is in considering this psychic blindness that Mesens calls his alphabet: deaf blind.

This aside, we are grateful to him for imposing on us these beautiful initials which again determine, after having replaced them, the emblem, the symbol, and the image, these beautiful initials which will one day be succeeded by those of a language common to all sensations – to all men.

As Vovelle has remarked, "the evocation of the human figure [in Mesens's work] is always approximate" (Vovelle 1972, p. 234), and it consists in this collage of a silhouette resembling a wooden *bilboquet* (a weighted toy figure), an object that frequently appears in Magritte's paintings from 1925, where it evidently stands at times for the human figure and is occasionally further anthropomorphized with the addition of eyes. The striking frontal symmetry of collages such as this one suggests, moreover, the work of Mesens's friend Enrico Baj, especially his series of *Generals* of 1959–61 (see Herbert Lust and Enrico Crispolti, *Enrico Baj: Dada, Impressionist*, Turin, 1973, pp. 84–92, nos. 544–82, ills.).

Alphabet Deaf (Still) and (Always) Blind is an appropriately blank figure, lacking eyes and with only one ear – a bitter comment on man's general insensitivity to music and art. However, the almond-shaped ovals in place of mouth and nose are shaped like eyes and set up a visual rhyme with the silver leaf-ear, suggesting a new, simple language "common to all sensations." The corrugated paper is perhaps intended to introduce the sense of touch. The gold leaf on the figure's chest may be an extension of the idea of the leaf-ear. It is certainly formally effective in emphasizing the image's frontality, but it is unclear whether the leaf is intended to stand for anything else—such as a badge, medal, jewel, or heart—which reminds us that the figure has no particular gender. The silver and gold paper may come from the linings of cigarette packets—a neat and obsessional hoarder, Mesens had drawers full of flattened Wills' Gold Flake packets. Such materials, delicate and adaptable, were also utilized by Kurt Schwitters (see nos. 109 and 110), who was one of the many artists once associated with Mesens's London Gallery. * * *

JOAN MIRÓ

SPANISH, 1893–1983

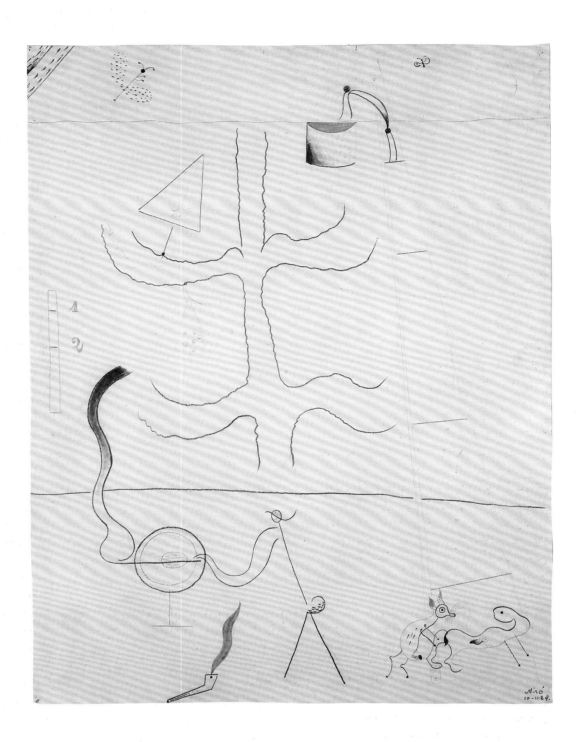

99. VITICULTURE

November 10, 1924
Black crayon and watercolor, with graphite and
incising, on cream wove paper; 62.9 x 48.2 cm
(24³/₄ x 19 in.)
Signed and dated, lower right: *Miró / 10-11-24*.

The Lindy and Edwin Bergman Collection,
155.1991

PROVENANCE: Pierre Matisse Gallery, New
York, and E. V. Thaw and Co., Inc., New York; sold
to Herbert Ferber.[1] Charles Collingwood, New
York.[2] Dain Gallery, New York; sold to Lindy and
Edwin Bergman, Chicago, 1972.

EXHIBITIONS: Probably Paris, La Galerie
Pierre, *Exposition Joan Miró*, 1925, as one of "15
dessins" (15 drawings).[3] Chicago 1984–85, no
cat. nos., p. 196, as *Untitled* (ill.). Chicago 1986,
no. 42, as *Untitled*.

THIS DRAWING ILLUSTRATES A CRUCIAL phase in Miró's career, characterized by his "moving away from pictorial conventions (that poison)," as he put it (Margit Rowell, ed., *Joan Miró: Selected Writings and Interviews*, tr. by Paul Auster and Patricia Mathews, Boston, 1986, p. 86), and by the increasing importance of drawing in his work. As he wrote in a letter of August 10, 1924, to fellow Surrealist Michel Leiris: "In spreading out my canvases, I have noticed that the ones that have been painted touch the spirit less directly than the ones that are simply drawn (or that use a minimum of color)" (ibid.).

At this time, Miró filled many notebooks with sketches that proved to be the basis for even the most apparently spontaneous and "automatic" of his works on canvas of 1924–25 (see, for example, *Oh! un de ces messieurs qui a fait tout ça* [*Oh! One of Those Gentlemen Who Has Done All That*] of 1925, Paris, Galerie Maeght; Rosa María Malet, *Joan Miró*, Barcelona, 1983, no. 28, ill.), as well as for large, finished drawings such as this one. These notebooks in fact include a preparatory sketch for the Bergman drawing (fig. 1), which Miró titled *Viticulture*, the French term for the cultivation of grapes, especially for wine.

The sketch and the Bergman drawing are very similar: a great vine, spreading across a wall, is espaliered to catch the sun; a figure stands on top of a ladder to the right of the vine collecting grapes into a drum or basket; below, someone tends a brazier, while beside him a pipe, drawn in Cubist style, flames. At lower right in the drawing, the animals couple a little more colorfully than in the sketch, while in the sky Miró added some winged creatures, which he also included in a drawing of November 11, 1924, entitled *The Wind* (private collection; New York 1993–94, p. 127, app. 7, ill.). In the Bergman drawing, the vine has a thicker, more knobbly outline, as though to indicate it has been pruned over many years, and the grapes are reduced in number and incised sharply into the paper in tiny, regular circles. The vine's leaves, quite florid and realistic in the sketch, are schematized in the drawing into a triangle very similar to that found at upper left in *The Tilled Field*, the important painting completed earlier that year (1923–24, New York, Solomon R. Guggenheim Museum; New York 1993–94, p. 111, no. 27, ill.).

The Bergman drawing belongs to a group of large, partly colored drawings on paper that are closely related to Miró's canvases with elements drawn over a monochrome ground, such as *The Hermitage* of 1924 (New York 1993–94, p. 123, no. 36, ill.). In these works, Miró refined a pictorial sign language, using seemingly rudimentary, simple, linear notations for objects and landscape, with sticklike human figures, not unlike those in prehistoric cave drawings. Although imaginary Bosch-like creatures and constructions inhabit paintings such as *The Tilled Field*, where the tree sprouts an eye and an ear, it is notable that in the Bergman drawing there is nothing inherently fantastic in the scene.

It is possible that this composition represents not just the grape harvest but also the pruning and burning of cuttings—in other words, the whole process of the cultivation of the vine, an activity of importance in the life at his family farm in Montroig, and one with a long tradition in Western representations of the seasons, such as the medieval cycles of the months. Miró actually used vine charcoal in some of his drawings of this period. Some aspects of the drawing point to a specific source in medieval philosophy, the work of the Catalan Christian mystic Ramon Llull (c. 1235–1316). Llull used ladders as a symbol for his "art," with each rung marking a progression up from the vegetable and animal kingdoms to the divine world. The numbered scale at the left may be a partly ironic metaphor linking the height of the vine to the achievements of Miró's own art. The ladder thrusts dramatically upward, from the very earthly animals at bottom to the figure at its top. The figure's

crescent-shaped body is rather insectlike, suggesting some resemblance to the flying creatures on either side of it, and echoing the moon-shaped, purple liquid in the drum beside it. Ladders appeared frequently in Miró's work, beginning with *The Farm* (1921–22, Washington, D.C., National Gallery of Art; New York 1993–94, p. 107, no. 22, ill.), as did references to the elements (earth, air, fire, and water), which were so central to the medieval philosophy of nature (see David Hopkins, "Ramon Lull [*sic*], Miró, and Surrealism: The Link with Medieval Philosophy," *Apollo* 139 [Dec. 1993], pp. 391–94). Indeed, the composition of *Viticulture* may have originated in part in two sketches of a ladder, inscribed *Echelle,* on a page in a notebook dating to 1923/24 (folio 617 a, notebook F. J. M. 591–668 i 3129–3130; Barcelona, Fundació Joan Miró, *Obra de Joan Miró: Dibuixos, pintura, escultura, ceràmica, tèxtils,* 1988, p. 77, no. 198, ill.).

To proffer a connection between Miró and Llull is not to imply that Miró was in any direct sense subscribing to mystical ideas. It is rather that, as Hopkins put it, "Miró's works partake of the organizational logic" found in the diagrams that illustrate the writings of Llull, Robert Fludd (1574–1637), and Jakob Böhme (1575–1624; see also my discussion of Wifredo Lam's *Ladder to the Light*, no. 81), and "that he shares precisely their view of the universe as an integrated, codified system, informed by secret 'correspondences'" (Hopkins, p. 392). In this drawing, the objects, figures, and creatures are arranged according to a strange geometry, in visual rhymes that hold the composition together without being "realistic." Miró's familiarity with the hermetic beliefs that gave an invisible structure to the world thus allowed him to invest his sign language with an arcane symbolism without having to depart from nature.

* * *

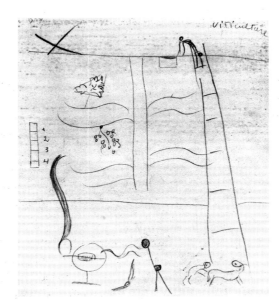

Figure 1. Joan Miró, *Viticulture*, 1924, graphite on paper, 19.1 x 16.5 cm, Barcelona, Fundació Joan Miró (folio 616 a, notebook F. J. M. 591–668 i 3129–3130) [photo: © F. Català-Roca].

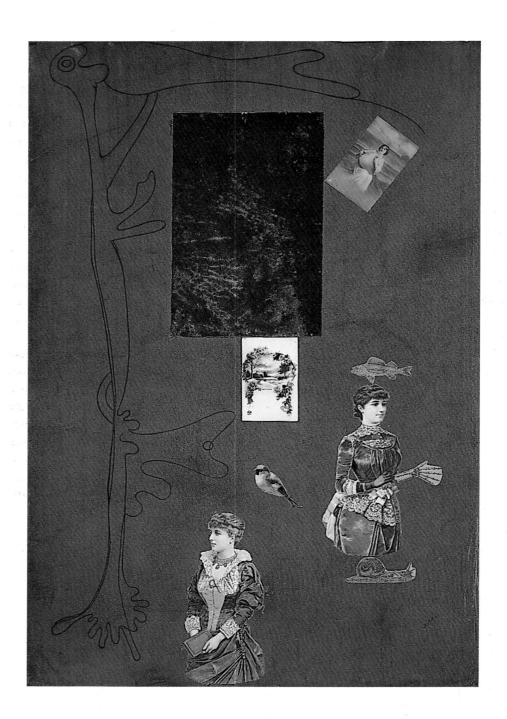

100. DRAWING-COLLAGE

August 30, 1933
Collage composed of cut-and-pasted, commercially printed papers, postcards, and sandpaper, with graphite and black crayon, on tan wove paper; 106.5 x 71.9 cm (41⁷/₈ x 28¹/₄ in.)
Signed, lower right: *Miró.*
Signed and dated on back, upper left:
Joan Miró / 30 8 33
The Lindy and Edwin Bergman Collection, 156.1991

PROVENANCE: G. David Thompson, Pittsburgh;[4] sold to the Galerie Beyeler, Basel, 1959;[5] sold to the Sidney Janis Gallery, New York, 1960;[6] on loan to the Galerie Chalette, New York, 1964;[7] sold to Lindy and Edwin Bergman, Chicago, 1966.

EXHIBITIONS: Basel, Galerie Beyeler, *Miró: Peintures, gouaches, lithos, tapis,* 1960, no. 8, as *Composition.* New York, Sidney Janis Gallery, *Twentieth-Century Artists,* 1960, no. 43 (ill.), as *Composition.* Sala de la cacharrería del ateneo de Madrid, *Miró,* 1964, no cat. nos., n. pag., as *Collage.* New York, Sidney Janis Gallery, *Two Generations: Picasso to Pollock,* 1967, no. 33 (ill.), as *Composition.* New York 1968, no. 240, fig. 190, and p. 129, as *Composition.* New York, Acquavella Galleries, Inc., *Joan Miró,* 1972, no. 21 (ill.), as *Composition.* Chicago 1973, no cat. nos., n. pag., as *Composition.* Saint Louis, Washington University Gallery of Art, *Joan Miró: The Development of a Sign Language,* 1980, traveled to Chicago, no cat. nos., pp. 32–33, 63 n. 97, 66, and fig. 24. Chicago 1984–85, no cat. nos., p. 197 and pl. 44, as *Composition.* Chicago 1986, no. 43, as *Composition.* Kunsthaus Zürich, *Joan Miró,* 1986–87, traveled to Düsseldorf, no. 74 (ill.). New York, Solomon R. Guggenheim Museum, *Joan Miró: A Retrospective,* 1987, no. 60 (ill.).

THIS WORK EXEMPLIFIES MIRÓ'S EXTENSIVE and varied use of collage, which intensified in the late 1920s and early 1930s. The range of Miró's work in this medium was especially striking during this period and included a 1929 series of sparse collages, incorporating sandpaper or tarboard, as well as a group of collages, dating to early 1933 (fig. 2), intended as preparatory studies for paintings. The latter included newspaper clippings of machinery and ordinary tools (see Barcelona, Fundació Joan Miró, *Obra de Joan Miró: Dibuixos, pintura, escultura, ceràmica, tèxtils*, 1988, pp. 155–58, nos. 591–605, 607–08, ills.). Shortly thereafter, in August of 1933, Miró began a new type of collage incorporating drawing, of which the Bergman work is an example. Jacques Dupin noted the very playful and humorous quality of these works and how Miró's choice of images differed markedly from the collages of early 1933 that directly preceded them: "Now it was not pictures of machines and everyday objects that Miró collected, but old picture postcards showing bashful lovers or *femmes fatales* in the delectable bad taste of the beginning of the century. He also raided children's books for flying fish, snails, a butterfly, a derby hat, the terrestrial globe set in the firmament, etc." (Dupin 1962, p. 255). In an article published in 1934, Christian Zervos reported that Miró had created this most recent series of works by alternating collage and drawing, first pasting a paper fragment onto a sheet of paper, which then "led him to draw a form, which in turn obliged him to paste on another image" (Christian Zervos, "L'Oeuvre de Joan Miró de 1917 à 1933," *Cahiers d'art* 1–4 [1934], p. 18; cited in Wescher 1979, p. 191).

William Rubin noted the direct influence exerted on Miró's drawing-collages by Max Ernst's 1932 Loplop series (see, for example, nos. 65–66 in this catalogue), which combined collaged prints and photographic reproductions with hand-drawn forms (New York 1968, p. 129). Another influence on Miró may have been an article Paul Eluard published in *Minotaure* (nos. 3–4 [Dec. 1933], pp. 85–100) entitled "Les Plus Belles Cartes postales," with reproductions of a number of postcards from his own collection and an analysis of their themes. Miró might have seen the article in preparation before he left Paris for Spain in early July of 1933 (see New York 1993–94, pp. 330–31), and he was probably familiar with Eluard's postcard collection, which included a wide array of suggestive, mildly pornographic, and fantastic montages, many of which could be read as double images. Miró included two postcards typical of the group in the Bergman collage, together with two Edwardian cutout ladies.

The snail, fish, and skeletal hand in the Bergman drawing-collage may have been extracted from a natural history plate and a medical textbook, and, as creatures laid bare for scientific study, they are wonderfully at odds with the stuffed decorativeness of the woman to whom they have been attached. There is an evident collision between the pretty, sentimental ladies of the cutouts and Miró's grotesque and sardonic drawing towering over them to the left, representing an emphatically

REFERENCES: Jacques Dupin, *Joan Miró: Life and Work*, tr. by Norbert Guterman, New York, 1962, pp. 255, 528, no. 359 (ill.). Harriet Janis and Rudi Blesh, *Collage: Personalities, Concepts, Techniques*, Philadelphia, 1962, p. 90, no. 98 (ill.), as *Composition*. Nicholas Calas, "Surrealist Heritage?," *Arts Magazine* 42 (Mar. 1968), p. 27 (ill.), as *Composition*. John Ashbery, "Growing Up Surreal," *Art News* 67 (May 1968), p. 44 (ill.), as *Composition*. Ellen Mandelbaum, "Surrealist Composition: Surprise Syntax," *Artforum* 6 (May 1968), pp. 33, 35 (ill.), as *Composition*. Herta Wescher, *Die Collage: Geschichte eines künstlerischen Ausdrucksmittels*, Cologne, 1968, p. 191 and pl. 27, as *Komposition*; Eng. ed. tr. by Robert E. Wolf, New York, 1979, p. 191 and pl. 27, as *Composition*. *Arch. Digest* 1973, p. 21 (photo of Bergman home). New York, Sidney Janis Gallery, *Twenty-Five Years of Janis, Part I: From Picasso to Dubuffet, from Brancusi to Giacometti*, 1973, exh. cat., no. 82 (ill.), as *Composition*. *U. of C. Magazine* 1982, p. 23 (photo of Bergman home). Robert Storr, "No Joy in Mudville: Greenberg's Modernism Then and Now," in Kirk Varnedoe and Adam Gopnik, eds., *Modern Art and Popular Culture: Readings in High and Low*, New York, 1990, p. 173, fig. 198, as *Untitled (Composition)*.

male figure, with protruding beak, possibly reminiscent of Ernst's Loplop. The very violence of the contrast between the different visual modes—scientific diagram; obsessively polished, kitsch realism; and biomorphic distortion—undermines the value of the images as representation, and they become almost abstract elements of color and line in the overall design. The rectangle of sandpaper, in its grating immediacy and "abstraction," draws attention to this quality, as well as adding another discordant note.

In 1968 Miró requested that the title of a work from this series in the collection of The Museum of Modern Art, New York, be changed to *Drawing-Collage* (see William Rubin, *Miró in the Collection of The Museum of Modern Art*, New York, 1973, pp. 62–63, ill.). Miró had earlier criticized Pierre Matisse in a letter of February 7, 1934, for exhibiting some of his works under the title *Composition*, which he believed "evokes abstract things in a dogmatic or superficial sense" (Margit Rowell, ed., *Joan Miró: Selected Writings and Interviews*, tr. by Paul Auster and Patricia Mathews, Boston, 1986, p. 124). * * *

Figure 2. Joan Miró, preparatory collage of February 11, 1933, cut-and-pasted photomechanical reproductions and graphite on paper, 46.8 x 63 cm, New York, The Museum of Modern Art, gift of the artist [photo: © 1997 The Museum of Modern Art, New York].

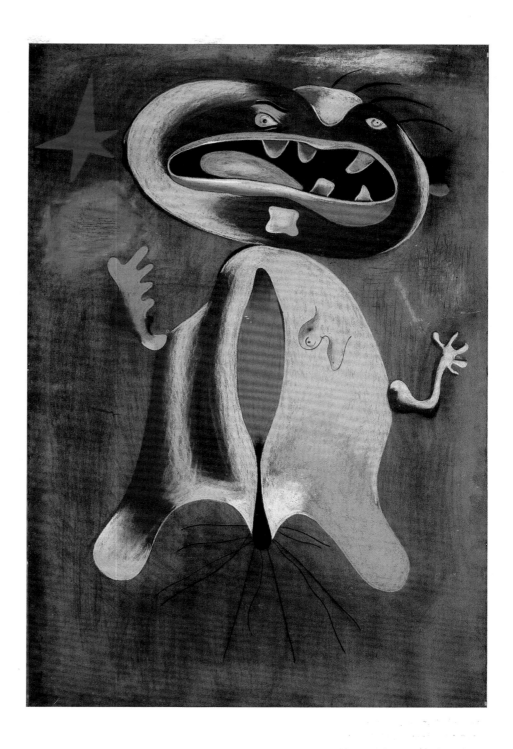

101. WOMAN (FEMME)

October 1934
Pastel, charcoal, and graphite, with smudging and scraping, on tan wove paper; mounted along edges to a wood stretcher; 107.1 x 71.4 cm (42 1/8 x 28 1/8 in.)
Signed, titled, and dated on back, upper center: *Joan Miró (femme) Oct. 1934*
The Lindy and Edwin Bergman Collection, 157.1991

PROVENANCE: Pierre Matisse Gallery, New York, by 1958. Harold and Mary Weinstein, Chicago, by 1961; sold to Lindy and Edwin Bergman, Chicago, 1967.

EXHIBITIONS: Possibly New York, Pierre Matisse Gallery, *Miró: Paintings, Gouaches*, 1941, no. 23. Possibly New York, Pierre Matisse Gallery, *Miró*, 1942, no. 19, 20, 21, or 22, as *Pastel*. New York, Pierre Matisse Gallery, *Miró: "Peintures sauvages," 1934 to 1953*, 1958, no. 2 (ill.). The Art Institute of Chicago, *Treasures of Chicago Collectors*, 1961, no cat. nos., n. pag. New York, Acquavella Galleries, Inc., *Joan Miró*, 1972, no. 25 (ill.). Saint Louis, Washington University Gallery of Art, *Joan Miró: The Development of a Sign Language*, 1980, traveled to Chicago, no cat. nos., pp. 36, 66, fig. 28 (Chicago only). Chicago 1984–85, no cat. nos., p. 199 and pl. 45. Chicago 1986, no. 45. New York, Solomon R. Guggenheim Museum, *Joan Miró: A Retrospective*, 1987, no. 78 (ill.) and p. 153.

REFERENCES: Jacques Dupin, *Joan Miró: Life and Work*, tr. by Norbert Guterman, New York, 1962, pp. 264, 530, no. 382 (ill.). Barcelona, Fundació Joan Miró, *Obra de Joan Miró: Dibuixos, pintura, escultura, ceràmica, tèxtils*, 1988, p. 472 (ill.).

WOMAN BELONGS TO A SERIES OF FIFTEEN figurative pastels Miró began in October 1934 in Montroig and finished that November in Barcelona, fourteen of which have been identified (see Dupin 1962, pp. 529–30, nos. 371–82, ills.; Jacques Dupin, *Miró*, tr. by James Petterson, New York, 1993, p. 186, no. 201, ill.; and Guy Weelen, *Miró*, tr. by Robert Erich Wolf, New York, 1989, p. 104, no. 135, ill.). Jacques Dupin called this series of tortured images the "first manifestation" of Miró's *tableaux sauvages* (savage paintings), the raw, often troubled works that would occupy the artist through the Spanish Civil War and World War II (Dupin 1993, p. 186).

Miró wrote to New York dealer Pierre Matisse (who since 1932 had been handling Miró's sales in the United States) in a letter of October 12, 1934, of his problem finding titles for those "works that take off from an arbitrary starting point and end with something real" (Margit Rowell, ed., *Joan Miró: Selected Writings and Interviews*, tr. by Paul Auster and Patricia Mathews, Boston, 1986, p. 124). He did give titles to all of the pastels in this series, however, "since they are based on reality – but the titles will be unpretentious and very ordinary: figure, personage, figures, personages" (ibid.). In a letter to Matisse of December 17 of that year, in preparation for a forthcoming exhibition in New York, Miró requested the very simplest frames for his works, so that they could stand out in all their "power and strength," as they did in the whitewashed serenity and simplicity of his studio (ibid., p. 125).

An extraordinary energy in the Bergman pastel springs from the tension between the hideous grimace of the figure, which may express demonic aggression or pain, and her exaggerated sexuality. The central, red, almond-shaped womb-vulva resembles a wound, while the spidery explosion of hairs extending from the genital area may portend birth. Miró's *Woman* may have an origin in popular art, in the grotesque figures of the Catalan carnival or in Mallorcan *xiurells*, white clay figures with painted decorations (see, for example, Walter Erben, *Miró*, Buenos Aires, 1961, pl. 29; and Fundació Pilar i Joan Miró a Mallorca and Centro Atlántico de Arte Moderno, *Joan Miró: Territorios creativos*, 1996, p. 33). But she may also take on an allegorical dimension, personifying the Catalan nation – the colors of its flag, red and gold, are among the colors used – which in just this month of October 1934 had been violently repressed, following its attempt to assert independence.　＊ ＊ ＊

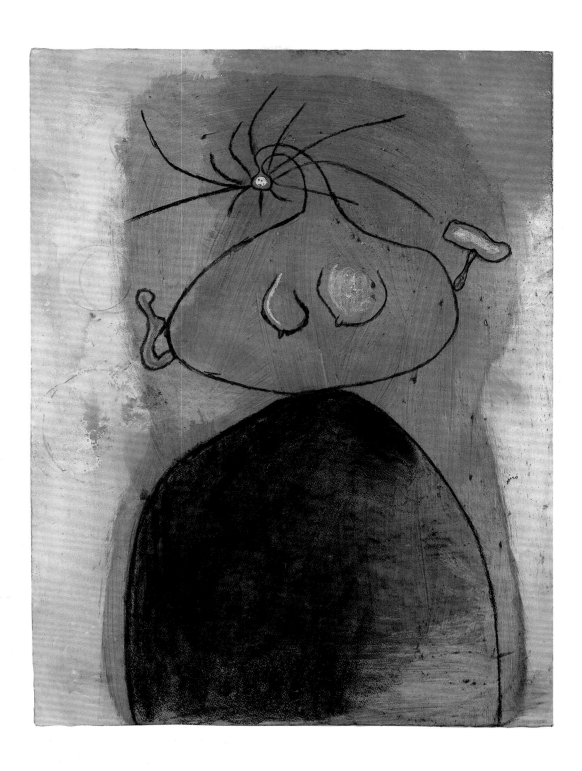

102. STANDING WOMAN (FEMME DEBOUT)

December 14, 1937
Oil and oil wash, with charcoal, on cream wove
paper; mounted along edges to a wood stretcher;
76.7 x 57.3 cm (30¼ x 22½ in.)
Signed, center right: *Miró*
Signed, titled, and dated on back: *Miró. "Femme
debout" 14/12/37* (in graphite)
Inscribed on back: *PM/JM 274 / Woman Standing
/ Oil on paper* (in crayon)

The Lindy and Edwin Bergman Collection,
158.1991

PROVENANCE: Pierre Matisse Gallery,
New York, by 1938; sold to Philip Isles, New York,
October 1964;[8] sold to the Pace Gallery,
New York, December 1983;[9] sold to Lindy and
Edwin Bergman, Chicago, 1984.

EXHIBITIONS: New York, Pierre Matisse
Gallery, *Joan Miró: Recent Works*, 1938, no. 7.
New York, Pierre Matisse Gallery, *Summer*

Exhibition by French Moderns, 1939, no. 2,
as *Woman Standing*. New York, Pierre Matisse
Gallery, *Miró: "Peintures sauvages," 1934
to 1953*, 1958, no. 10 (ill.). Chicago 1984–85,
no cat. nos., p. 200 (ill.).

REFERENCES: Marcel Jean and Arpad Mezei,
The History of Surrealist Painting, tr. by Simon
Watson Taylor, New York, 1960, p. 151 (ill.). René
Passeron, *Histoire de la peinture surréaliste*,
Paris, 1968, p. 219, fig. 120.

MIRÓ MADE THIS WORK IN PARIS, WHERE he had arrived in November of 1936 and where he had decided to remain because of the violent and unstable situation in Spain due to the Civil War. In February 1938, not long after the completion of this work, Miró wrote a letter to his dealer Pierre Matisse that sums up his major concerns at the time. He was now "on the right track," he wrote, with his *Self-Portrait I* (October 1937–March 1938, New York, The Museum of Modern Art; New York 1993–94, p. 228, no. 146, ill.), a dramatic frontal head with eyes like flaming stars, which he had destroyed several times and which he believed "sums up my life." He added, "Also, I am working on a series of drawings of nudes, which I started a year ago with the models at the academy [a reference to the Académie de la Grande Chaumière in Paris, where he attended life-drawing classes in the spring of 1937], and which I am now continuing in the studio" (Margit Rowell, ed., *Joan Miró: Selected Writings and Interviews*, tr. by Paul Auster and Patricia Mathews, Boston, 1986, p. 158).

Standing Woman may be one of the nudes he worked on during the struggle with *Self-Portrait I*. Some of the drawings from the academy (fig. 3) show the figures' extremities, specifically their heads and hands, dramatically shrunken as here. There is little trace in the Bergman piece of the actual appearance of the model, although Miró was relatively faithful to the model's academic pose, and the drawing of the breasts seems still inflected with the amplitude of an actual body. The tiny head, its spiky hair radiating like the lines with which Miró often surrounded the genitals of his figures, is supported by the egglike oval of the woman's nude upper torso and by the large mass of the black, bell-shaped skirt, which balance precariously on top of one another like boulders.

Both colors and image in this work recall part of a poem Miró had written the previous year: "dark-haired mama / in the hollow sockets of a limbo-tomb / breathes blue / in the black void of despair" (Rowell 1986, p. 138). In the spring of 1937, he had completed *Still Life with Old Shoe* (January 24–May 29, 1937, New York, The Museum of Modern Art; New York 1993–94, p. 227, no. 145, ill.), a painting that was a response to the tragedy of the Spanish Civil War. And in April of 1937, Miró, like Picasso, had been commissioned by the Republican Government to paint a mural for the Spanish Pavilion at the Paris World's Fair. This work, which is now destroyed, was entitled *The Reaper* or *Catalan Peasant in Revolt* (see Jacques Dupin, *Miró*, tr. by James Petterson, New York 1993, pp. 212–13, figs. 235–36). The artist's anxiety about the Civil War in Spain may be reflected in this somber work as well. * * *

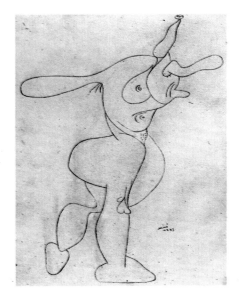

Figure 3. Joan Miró, *Drawing*, 1937, graphite on paper, 27 x 20 cm, private collection [photo: Dupin 1993, p. 209, fig. 232].

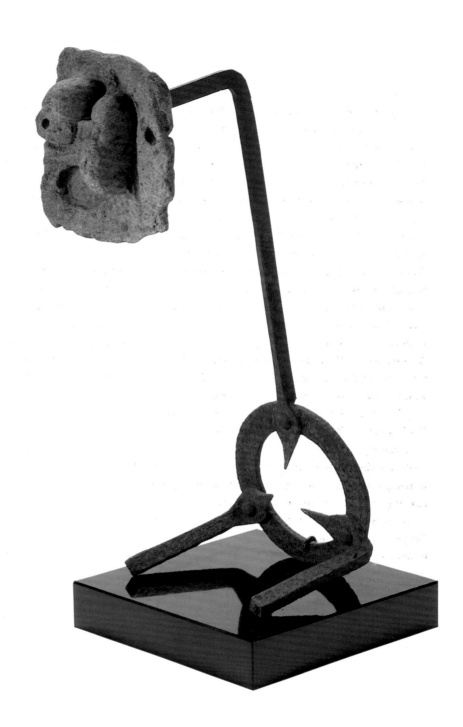

103. UNTITLED (HEAD)

1956
Glazed and fired ceramic, and iron;
45.1 x 16.5 x 27.9 cm (17³/₄ x 6¹/₂ x 11 in.)
Signed, along lower left edge of face:
Miró / ARTIGAS
The Lindy and Edwin Bergman Collection,
159.1991

PROVENANCE: Galerie Maeght, Zurich; sold
to Jeanne Frank, New York, 1974;[1] sold to
James Goodman, Inc., New York, 1978;[2] sold to
Lindy and Edwin Bergman, Chicago, 1978.

EXHIBITIONS: Tokyo, National Museum of
Modern Art, *Joan Miró Exhibition – Japan, 1966*,
1966, traveled to Kyoto, no. 139 (ill.), as
Tête (Head). Chicago 1986, no. 47, as *Head on
an Iron Stem*.

REFERENCES: José Pierre and José Corredor-
Matheos, *Miró und Artigas: Keramik*, Bern, 1974,
p. 209, no. 89 (ill.), as *Tête. Saturday Review*
1980, p. 58 (photo of Bergman home). Francesc
Miralles, *Llorens Artigas: Catàleg d'obra*,
Barcelona, 1992, p. 274, no. 638 (ill.), as *Tête*.

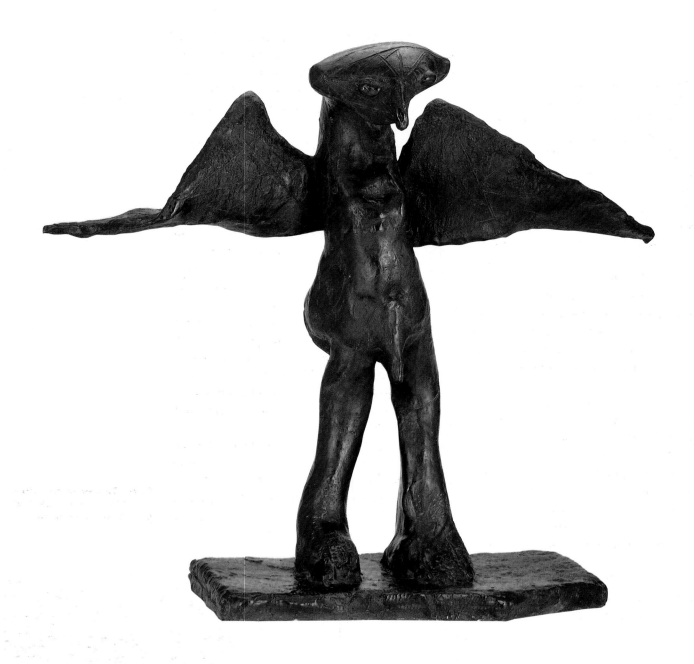

108. MAN OF THE NIGHT (HOMME DE LA NUIT)

1954
Patinated bronze (cast by C. Valsuani, in an unnumbered edition of eleven); 73 x 82.5 x 31.1 cm (28³/₄ x 32¹/₂ x 12¹/₄ in.)
Signed and inscribed on the top of the base, along the back: *G. Richier* (at right); *CIRE / C. VALSUANI / PERDUE* (stamped, at left)
The Lindy and Edwin Bergman Collection, 166.1991

PROVENANCE: G. Contemporary Paintings; sold to B. C. Holland Gallery, Chicago, 1962;[1] sold to Lindy and Edwin Bergman, Chicago, 1962.

EXHIBITIONS: The Arts Club of Chicago, *Germaine Richier*, 1966, no. 6 (ill.).

REFERENCES: Waldemar George, "Germaine Richier," *Prisme des arts* 2 (Apr. 15, 1956), p. 37. Denys Chevalier, "Un Grand sculpteur: Germaine Richier," *Prestige français et mondanités* 19 (Sept. 1956), pp. 60–65. "Germaine Richier: La Puissance et le malaise," *Le Monde*, Oct. 13, 1956. Paris, Musée national d'art moderne, *Germaine Richier*, 1956, exh. cat., p. 12, no. 61 (Geneva, Gérard Cramer). New York, Martha Jackson Gallery, *The Sculptures of Germaine Richier*, 1957, exh. cat., n. pag. (Paris 1956 installation photograph). Paul Guth, "Encounter with Germaine Richier," *Yale French Studies* 19–20 (1957–58), p. 82. Franz Schulze, "Art News from Chicago," *Art News* 57 (Oct. 1958), p. 45 (ill.; Chicago, Joseph and Jory Shapiro), as *Little Bat Man*. The Arts Club of Chicago, *Surrealism Then and Now*, 1958, exh. cat., n. pag., no. 38 (ill.; Chicago,

Joseph and Jory Shapiro). Claude Roger-Marx, "Cette Héritière inspirée des grands maîtres: Germaine Richier," *Le Figaro littéraire* (Aug. 8, 1959), p. 10 (ill. of Richier with *Man of the Night*). Antibes, Musée Grimaldi, Chateau d'Antibes, *Germaine Richier*, 1959, exh. cat., no. 54 (Paris, Galerie Creuzevault), as *Homme de la nuit* (grand). Paris, Musée Rodin, *Histoires naturelles*, 1959, exh. cat., n. pag., no. 139, pl. 16 (Philippe Leclerc). "Report from Paris," *Pictures on Exhibit* 23 (Dec. 1959), p. 33 (ill; Paris, Galerie Creuzevault). Jean Cassou, *Germaine Richier*, New York, 1961, n. pag., no. 21 (ill.; unspecified cast). London, Hanover Gallery, *Sculpture*, 1962, exh. cat., n. pag., no. 39 (ill.; unspecified cast), as *Grand Homme de la nuit*. Vienna, Museum des 20. Jahrhunderts, *Idole und*

THIS WORK IS OFTEN REFERRED TO AS LARGE *Man of the Night*, probably to distinguish it from a closely related, but smaller version (see Chicago, Allan Frumkin Gallery, *The Sculpture of Germaine Richier: First American Exhibition*, 1954, exh. cat., no. 19 [ill.], as *Man of the Night*). The sculpture seems originally to have been simply called *Man of the Night*; the qualification "large" first appeared in parentheses, following the title, in the 1959 exhibition at the Musée Grimaldi, Chateau d'Antibes, the first major retrospective of Richier's work to follow her death earlier that year. It would seem, therefore, that this qualification should not be considered an integral element of the title.[2] Three other, smaller sculptures, bearing the same title and date as the Bergman cast are recorded in the catalogue of a recent retrospective (see Paris 1996, p. 207, nos. 65–68). The ones reproduced (nos. 65 and 67) are of a distinctly different design.

During the 1950s, Richier created various hybrids by "crossing the human species with other organisms, animal and vegetable" (David Sylvester, "On Germaine Richier," in London, Hanover Gallery, *Germaine Richier*, 1955, exh. cat., n. pag.). Sylvester perceived these sculptures as an assault on the human body, a test of what it can endure and still remain human (see fig. 1). As Sylvester noted, "for Richier the assertion of the human image does not depend on creating . . . fine, noble effigies of unadulterated man. For her, the assertion of the human image is achieved through its denial. Hers is a human image challenged, battered, ruined, and still obstinately human" (ibid.). Paul Guth's description of

Man of the Night in his studio interview with Richier, draws attention, moreover, to another kind of tension in this work, between the figure's winged and earthbound qualities: "We come to *The Man of the Night*. He has a bat's head, triangle-shape. Stumps of wings rise from his back. He grips the earth with leaden paws. He has to! If he hadn't such heavy paws his wings would bear him aloft" (Guth 1957–58, p. 82).

Here the most human aspects of the figure are the lower part of the body and its heavy, lumpen limbs. The tension between the figure's lower half and the raised wings may refer to the struggle to remain "human," to which Sylvester alluded, and which characterized an anxious postwar Europe. The wings, which we might at first associate with the elevated and aspiring in man, are upon further observation clearly those of a bat and, like the head, the least rather than the most human aspect of the figure. Furthermore, the outspread wings here recall the image that, in Western tradition, symbolizes human sacrifice and divine redemption most vividly: the Crucifixion. Finally, the entire surface of the sculpture is scarred by a web of interlocking, incised lines, an effect Richier possibly derived from her drawing technique of this period (see Paris 1996, pp. 198–99, nos. 118–19, ills.). In *Man of the Night*, Richier suggested that there is no simple opposition between the base and the elevated, the earthbound and the heavenly, the human and the animal. * * *

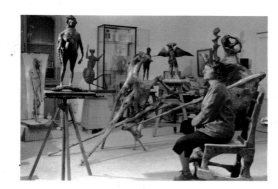

Figure 1. Germaine Richier in her studio, Paris, 1956 [photo: Brassaï; Paris, F. Guiter Collection, © F. Guiter].

Dämonen, 1963, exh. cat., no. 127 (ill.). W. Hofmann, "Idole und Dämonen," *Quadrum* (Brussels) 15 (1963), p. 157 (installation photograph). Kunsthaus Zürich, *Germaine Richier*, 1963, exh. cat., no. 68, pl. 15. Haags Gemeentemuseum, *Verzameling Bär, Zürich: beeldhouwwerken en tekeningen*, 1965, exh. cat., pp. 6 (ill.) and 17, no. 94 (Kunsthaus Zürich). Kunsthaus Zürich, *Sammlung Werner und Nelly Bär*, 1965, pp. 199 and 259 (ill.; Kunsthaus Zürich). Paris, Galerie Creuzevault, *Germaine Richier, 1904–1959*, 1966, exh. cat., n. pag., no cat. nos. (ill.; Paris, Galerie Creuzevault), as *L'Homme de la nuit* (grand). Kunsthaus Zürich, *Der Skuplturensaal Werner Bär im Kunsthaus Zürich*, 1970, exh. cat., pp. 104–07, 143 (ill.; Kunsthaus Zürich), as *L'Homme de la nuit* (grand). *Arch. Digest* 1973, p. 21 (photo of Bergman home). *Saturday Review* 1980, p. 57 (photo of Bergman home). Roland Penrose, *Scrapbook, 1900–1981*, London, 1981, p. 184, fig. 459 (Sussex, Roland Penrose). Ionel Jianou, Aube Lardera, and Gérard Xuriguera, *La Sculpture moderne en France depuis 1950*, Paris, 1982, p. 178. Chicago 1984–85, exh. cat., p. 210, no cat. nos. (ill.; Chicago, Joseph and Jory Shapiro). A. M. Hammacher, *The Evolution of Modern Sculpture: Tradition and Innovation*, New York, 1988, p. 238 (ill.; Otterlo, Rijksmuseum Kröller-Müller). Humlebaek, Denmark, Louisiana Museum of Modern Art, *Germaine Richier*, 1988, exh. cat., pp. 27, 32–33, no. 27 (ill.; Otterlo, Rijksmuseum Kröller-Müller). Paris, Fondation Maeght, *Germaine Richier: Rétrospective*, 1996, exh. cat., pp. 108, 125–27, 207, no. 64 (ill.; Holland, private collection).

109. UNTITLED

c. 1946
Collage composed of cut paper, fabric, cotton,
and wooden elements, with oil paint, tacks,
and nails, on wood-pulp board prepared with oil
paint; 29.5 x 22.8 cm (11⅝ x 9 in.)
Signed and inscribed on back: *Kurt Schwitters*
[. . .] / *rot und rost* [?] / *white frame* [?] (lower
center); *co* [. . .] *h* [. . .] (upper center)

The Lindy and Edwin Bergman Collection,
168.1991

PROVENANCE: Sidney Janis Gallery, New York.[1]
G. David Thompson, Pittsburgh; sold Parke-
Bernet Galleries, Inc., New York, March 24,
1966, no. 77 (ill.), as *Construction*. Richard Gray
Gallery, Chicago; sold to Lindy and Edwin
Bergman, Chicago, 1967.

EXHIBITIONS: Chicago, Worthington Gallery,
*Kurt Schwitters: Dada, Collages, Drawings,
Objects*, 1982, no cat. nos., p. 40 (ill.). Chicago
1984–85, no cat. nos., p. 213 (ill.), as *Untitled
(Construction)*.

110. FOR THE MODERN

1947
Collage composed of cut, torn, and painted paper
elements, on wood-pulp board, laid down on
tan wove paper; 22.6 x 18.1 cm (8⁷/₈ x 7¹/₈ in.)
Signed, dated, and titled, lower left: *Kurt
Schwitters 1947 / for the modern*

The Lindy and Edwin Bergman Collection,
167.1991

PROVENANCE: G. David Thompson,
Pittsburgh.[2] Charlotte Weidler, by 1960. Martha
Jackson Gallery, New York;[3] sold to Holland-
Goldowsky Gallery, Inc., Chicago;[4] sold to Lindy
and Edwin Bergman, Chicago, 1960.

EXHIBITIONS: New York, Martha Jackson
Gallery, *New Forms – New Media I*, 1960, no. 65.
Chicago, Worthington Gallery, *Kurt Schwitters:
Dada, Collages, Drawings, Objects*, 1982, no cat.
nos., p. 42 (ill.).

YVES TANGUY

FRENCH, 1900–1955

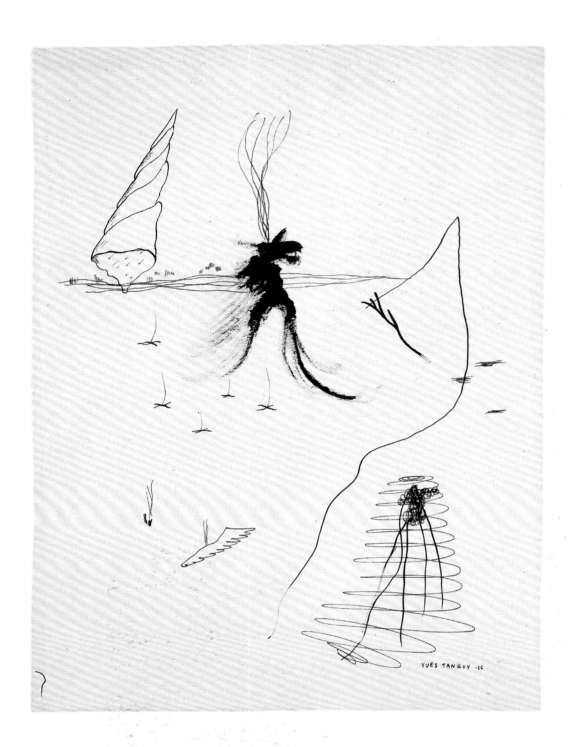

111. UNTITLED

1926
Pen and brush and black ink on cream wove
paper, laid down on tan card; 33.4 x 25.5 cm
(13⅛ x 10 in.)
Signed and dated, lower right:
YVES TANGUY · 26
The Lindy and Edwin Bergman Collection,
169.1991

PROVENANCE: Galerie Furstenberg (Simone
Collinet), Paris; sold to Lindy and Edwin
Bergman, Chicago, 1962.

EXHIBITIONS: Chicago 1973, no cat. nos.
Chicago 1984–85, no cat. nos., p. 219 (ill.).

Tanguy's automatic drawings, with their typically open fields, linear freedom, and vigorous, varied technique, of which the Bergman work is an excellent example, clearly signaled his adherence to the Surrealist movement. Tanguy had seen two of Giorgio de Chirico's paintings in the window of Paul Guillaume's gallery in Paris at the end of 1923 and had decided then and there to become a painter. His early paintings were figurative, inspired by popular imagery and film. After meeting André Breton in the winter of 1925–26, he began to make automatic drawings, which provided the impetus for a new series of paintings devoted to the haunting, imaginary landscapes for which he became known. Tanguy's automatic drawings are thus the hinge between the frankly naive paintings of the autodidact and his own distinctive Surrealist style.

The tension between the free, unpremeditated gesture and recognizable figuration, which is so noticeable in André Masson's automatic drawings (see, for example, no. 88), takes on a distinctive form here. Tanguy distributed the marks and lines more sparsely over the paper than did Masson, and the space in Tanguy's drawing is visibly that of a landscape.

The Bergman drawing shares certain features with the 1927 painting *Finish What I Have Begun* (*Finissez ce que j'ai commencé*, fig. 1): the typically high horizon line, which suggests a deep space, evoking both earth and sea; the peaked mountain shape; and the contrast between the rough, formless marks and the precisely delineated objects, such as the shell at upper left in the drawing. Tanguy's works are characterized by an ambiguity between ground, sky, and sea, which he achieved at times by creating a deliberate confusion between the elements:

earth, air, and water. At the upper left in this drawing, for example, a shell appears to hover above tufts of weeds or grass, suggesting an undersea world, while a disembodied bird's wing, suggesting earth or sky, floats incongruously in the lower part of the drawing. Tanguy may have been influenced in this respect by such earlier Dada examples as Hans Arp's wood relief *Birds in an Aquarium* of around 1920 (New York, The Museum of Modern Art; Bernd Rau, *Jean Arp: The Reliefs, Catalogue of Complete Works*, 1981, p. 21, no. 31, ill.) and Max Ernst's *Celebes* of 1921 (London, Tate Gallery; Houston, The Menil Collection, *Max Ernst: Dada and the Dawn of Surrealism*, 1993, exh. cat., pl. 117), in which creatures or objects are shown inhabiting the wrong element. In his paintings, Tanguy often heightened this sense of uncertainty by indeterminate washes and streaks of oil that blurred the horizon line, an effect illustrated by the two Tanguy paintings (nos. 112 and 113) in the Bergman collection. In this drawing spatial ambiguity is created by the meandering line on the right, which seems to jut above a horizon and then wander down the paper, suggesting the face of an overhanging cliff. * * *

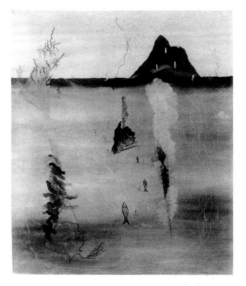

Figure 1. Yves Tanguy, *Finish What I Have Begun*, 1927, oil on canvas, 100 x 81 cm, New York, private collection [photo: Kay Sage and Pierre Matisse, *Yves Tanguy: A Summary of his Works*, New York, 1963, fig. 31].

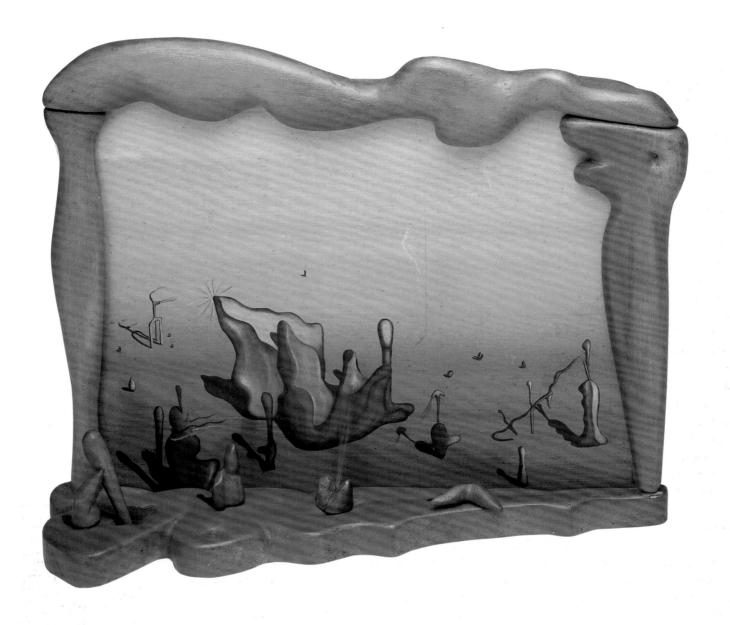

112. THE CERTITUDE OF THE NEVER SEEN
(LA CERTITUDE DU JAMAIS VU)

1933
Oil on board in carved and freestanding wooden frame with gesso, with five carved objects in wood, one with fine hair; 22.2 x 26 x 7 cm (8⅝ x 10¼ x 2¾ in.)
The Lindy and Edwin Bergman Collection, 170.1991

PROVENANCE: Georges Hugnet, Paris, by 1946. Roland Penrose, Sussex. William N. Copley, Paris, by 1962; sold Sotheby's, New York, November 5 or 6, 1979, no. 37 (ill.), to Lindy and Edwin Bergman, Chicago; on loan to the Art Institute, 1988–89.

EXHIBITIONS: Paris, Galerie Pierre Colle, *Exposition surréaliste: Peintures, dessins, sculptures, objets, collages*, 1933, no. 68 or 69, as *L'Opinion des oiseux* or *Objets*. Paris, Galerie l'oeil, *Minotaure*, 1962, no. 50. New York 1968, pp. 102–03, no. 311, fig. 139. Chicago 1984–85, no cat. nos., p. 6, pl. 1, and p. 220. Chicago 1986, no. 52.

REFERENCES: Domingo Lopez Torres, "Aureola y estigma del surrealismo," *Gaceta de arte* 2, 19 (Sept. 1933), p.1 (installation photograph by Man Ray). E. Tériade, "Aspects actuels de l'expression plastique," *Minotaure* 5 (May 12, 1934), p. 46, fig. 4. André Breton, *Yves Tanguy*, tr. by Bravig Imbs, New York, 1946, p. 33 (ill.). Kay Sage and Pierre Matisse, *Yves Tanguy: A Summary of His Works*, New York, 1963, p. 85, no. 139 (ill.). Patrick

Waldberg, *Yves Tanguy*, Brussels, 1977, pp. 294, 329, 351 (ill.). Paris, Musée national d'art moderne, *Yves Tanguy: Rétrospective, 1925–1955*, 1982, exh. cat., pp. 108, 198, no. 54 (ill. alone and in Paris 1933 installation photograph). Staatliche Kunsthalle Baden-Baden, *Yves Tanguy*, 1982–83, exh. cat., pp. 70–71, 253, no. 52 (ill.). Phyllis Tuchman, "In Detail: David Smith and *Cubi XXVIII*," *Portfolio* 5 (Jan.–Feb. 1983), p. 80 (ill.). Jennifer V. Mundy, "Tanguy, Titles, and Mediums," *Art History* 6 (June 1983), p. 207. Jennifer Mundy, "Surrealism and Painting: Describing the Imaginary," *Art History* 10 (Dec. 1987), p. 501, pl. 32. Paris, Musée national d'art moderne, *André Breton: La Beauté convulsive*, 1991, exh. cat., p. 207 (Paris 1933 installation photograph).

AN INSTALLATION PHOTOGRAPH TAKEN BY Man Ray (fig. 2) of the historic 1933 *Exposition surréaliste: Peintures, dessins, sculptures, objets, collages* at the Galerie Pierre Colle shows *The Certitude of the Never Seen* hanging on the wall above Tanguy's painting *The Obsession with Prophecy* (*L'Obsession de la prophétie*, 1933, private collection). The Bergman work is not listed by its current name in the catalogue, but may have been included under the generic term *Objets*. Alternatively, it may have been exhibited under the title *The Opinion of the Birds* (*L'Opinion des oiseaux*), which was no. 68 in the 1933 exhibition catalogue. Significantly, the 1963 catalogue of Tanguy's paintings indicates that no work entitled *L'Opinion des oiseaux* has yet been identified (Sage and Matisse 1963, p. 85, no. 140). When reproduced in *Minotaure* the following year, however, the Bergman work bore the title by which it is now known (fig. 3).

As Jennifer Mundy argued, the "supernatural resonance" of this and a number of other Tanguy titles clearly reveals his interest in "other-world references" (Mundy 1983, p. 207). Mundy pointed to Charles Richet's *Traité de métapsychique* (1922) as the source for several titles of paintings in Tanguy's 1927 exhibition at the Galerie surréaliste in Paris; for Tanguy, as for Breton, the meeting point of the real and the imaginary, the physical and the dream or spirit world, was of supreme interest.

The Certitude of the Never Seen is a particularly appropriate title for a work by Tanguy, given the immaculate precision with which he painted objects that have never existed under sea or sky, set in a space that resembles a landscape, but where the elements – earth, water, or air – are indeterminate. For a time the landscape in Tanguy's paintings had a clear horizon line, but here, and with increasing frequency later, the graded atmospheric washes have no clear break. The casting of shadows by the objects plays an important role in affirming their materiality. While the objects in Tanguy's paintings may be figures from dreams, they also bear a resemblance to the rocks of the Breton coast where Tanguy grew up, to the ancient dolmens that litter the landscape there, and at times to ghostlike materializations.

In this object-painting, the idea of a "concrete imaginary," that is, the materialization of figures of the imagination, takes palpable form in the five wooden shapes placed on an irregular wooden ledge, which is like an extension of the painted landscape.[1] This ledge, together with the three other pieces of shaped and polished wood that surround the painting, does not function like a normal frame, which marks the division between the picture's illusionary space and the "real" space of the spectator, but instead extends the former into the latter. While the organic shape of the left-hand piece of wood forming the frame resembles upright forms within the painting, and the top portion is cloudlike, the form to the right is carved like a bird, whose scale disconcertingly miniaturizes the landscape. Another, less elaborate object-painting, an untitled work of 1933 (fig. 4), has a similarly carved frame, with a less obvious reference to a bird, and with fewer objects disposed in the foreground.

The holes that are cut into the frame's ledge are intended as negative shapes, like holes in a rock, rather than as sockets for the objects. The paired objects to the left, of which the elongated, leaning form is somewhat like an ancient Celtic "standing stone," and the triple lump next to them, resemble forms in the painting behind them that have painted cast shadows, mirroring the wooden objects. The repetition of the forms and the use of shadows hints at the idea that the painted forms are "shadows" of the wooden objects, as well as themselves casting shadows. To the right a shape like a starfish bulges and drapes over the edge. One of the most intriguing of the wooden forms is the double-peaked object sprouting hair. A number of works of the same period, such as *Roux en hiver* (*Winter Russet*) and an untitled drawing (Paris 1982, nos. 51 and 55, p. 108, ills.) show a similar erect object from which fine lines radiate, suggesting beams from a lighthouse. In the painted portion of the Bergman piece, there are also forms that emit wavy lines, suggesting hair or light. These lines in the background, though, probably refer to some organic, transparent, primordial material. The placement of the object's fine hairs pointing up into the heart of the picture also suggests a paintbrush. The associations connected with these objects, from dolmen to starfish, thus

Figure 2. Man Ray, installation photograph of the *Exposition surréaliste: Peintures, dessins, sculptures, objets, collages* at the Galerie Pierre Colle, Paris, June 7–18, 1933 [photo: courtesy of Telimage, Paris].

imply violent disjunctions of scale, which contribute to the disorienting power of the piece.

While on the one hand this object-painting can be approached from within the internal logic of Tanguy's imagery, on the other it clearly relates to the "Surrealist object," which began to occupy an important role in Surrealist ideas and practice in the early 1930s. André Breton had first suggested the construction of the strange objects that appear in dreams in his 1924 text "Introduction to the Discourse on the Paucity of Reality" (André Breton, *What is Surrealism?*, ed. and intro. by Franklin Rosemont, bk. 2, New York, 1978, pp. 17–28). He imagined putting these objects into circulation in order to destabilize the familiar and utilitarian: "Perhaps in that way I should help to demolish these trophies which are so odious, to throw further discredit on those creatures and things of 'reason'" (ibid., p. 26). While a few isolated instances of such poetic constructions appeared through the 1920s, the Surrealist object became a particular focus of Surrealist activity only during the regeneration of the movement following the crisis of 1929 and the excommunication of many former members. The third issue of *Le Surréalisme au service de la révolution* (Dec. 1931) presented a number of different attitudes to the object. Tanguy contributed to this issue "Poids et Couleurs" (Weights and Colors), a short text illustrated with drawings of seven objects, of various textures, colors, and weights: one is described as containing lead and as rolling on its base, but always return-

ing to the vertical; another as filled with mercury and covered with bright red straw; and a third as consisting of hair and blue crayon, which was supposed to be used to write on a blackboard – the only object envisaged as having a function. Although Tanguy referred to nontraditional sculptural materials like cotton, mercury, and pink celluloid (for nails) in the above description, he did not employ readymade or found objects, as Salvador Dalí had recommended for the construction of the Surrealist object. In his imaginary constructions and actual objects, Tanguy could therefore be seen as somewhat closer to Alberto Giacometti than to Dalí. *The Certitude of the Never Seen*, with its horizontal ledge pitted with indentations and its movable objects ambiguous in scale, could be compared in particular with Giacometti's flat sculptures, such as *Project for a Garden* of 1932 (Paris 1982, p. 199).

The Bergman piece also presents similarities to Jean Arp's multipart sculptures from the early 1930s, like the *Head with Annoying Objects* of 1930–32 or *Sculpture to Be Lost in the Forest* of 1932 (see Margherita Andreotti, *The Early Sculpture of Jean Arp*, 1989, pp. 196, 207, figs. 78–79, 81). In these, small objects of biomorphic appearance are placed on top of a larger object, and can be moved around at will.

Although Tanguy's excursions into three dimensions are relatively few and far between, they are unmistakably motivated by what Dalí called the "desire for the object" (Salvador Dalí, "The Object as Revealed in Surrealist Experiment," *This Quarter* 5, 1 [Sept. 1932], p. 199), which inspired Surrealist experiments with materials and constructions of all kinds, and has had an enduring influence on twentieth-century art. * * *

Left, figure 3. Yves Tanguy, *The Certitude of the Never Seen*, as reproduced in *Minotaure* 5 (May 12, 1934), p. 46.

Right, figure 4. Yves Tanguy, *Untitled*, 1933, oil on board, laid down on panel, 21 x 27 cm, Japan, private collection.

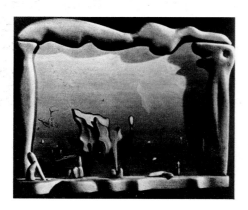

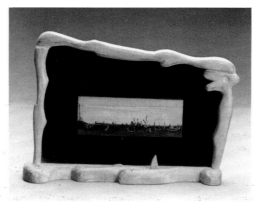

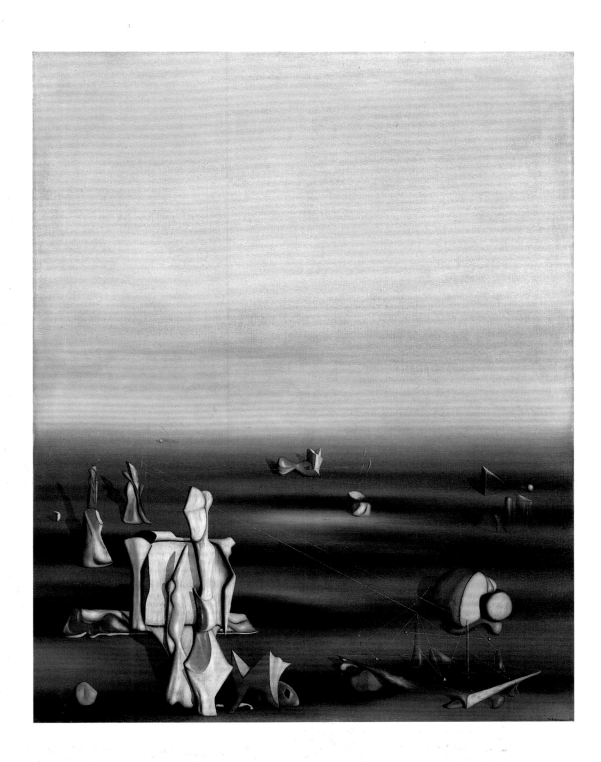

113. UNTITLED

1940
Oil on canvas; 91.2 x 71.3 cm (35⁷/₈ x 28¹/₈ in.)
Signed and dated, lower right: *YVES TANGUY 40*
The Lindy and Edwin Bergman Collection,
171.1991

PROVENANCE: Peggy Guggenheim, London.[2]
Ella Winter Stewart, London;[3] sold to Richard
Feigen Gallery, Chicago; sold to Lindy and Edwin
Bergman, Chicago, 1958.

EXHIBITIONS: Chicago 1984–85, no cat. nos.,
p. 97, pl. 27, and p. 221.

REFERENCES: Kay Sage and Pierre Matisse,
Yves Tanguy: A Summary of His Works, New York,
1963, p. 120, no. 261 (ill.), as *Title Unknown*.
Arch. Digest 1973, p. 22 (photo of Bergman
home). Patrick Waldberg, *Yves Tanguy*, Brussels,
1977, p. 128.

115. UNTITLED

1948
Pen and black ink, with brush and gray wash,
incising, and rubbing, on ivory wove paper;
35.5 x 25.4 cm (14 x 10 in.)

Signed and dated, lower left: *P. Tchelitchew 48*
A Gift from Lindy and Edwin Bergman, 1980.753

PROVENANCE: Robert Elkon Gallery, New York;
sold to B. C. Holland, Inc., Chicago, 1974.[1]
Gallery Bernard (Herbert and Virginia Lust),
Greenwich, Connecticut; sold to Lindy and Edwin
Bergman, Chicago, 1974; given to the Art
Institute, 1980.

PAVEL TCHELITCHEW WAS BORN IN RUSSIA but, abroad at the time of the 1917 Revolution, never returned, and "lived," as Julien Levy put it, "in precarious exile, commuting between the the cosmopolitan centers of the West: designing for the theater in Berlin, for the ballet with Diaghilev in Monte Carlo, exhibiting his early paintings in Paris, painting a portrait of Edith Sitwell in London, creating [the 1938–39 painting] *Phenomena* in New York" (Julien Levy, *Memoir of an Art Gallery*, New York, 1977, pp. 241–42). He moved on the margins of the Surrealist group in New York (see Martica Sawin, *Surrealism in Exile and the Beginning of the New York School*, Cambridge, Mass., 1995, p. 212). Charles Henri Ford, editor of *View* magazine, devoted the May 1942 issue of *View* jointly to Yves Tanguy and Tchelitchew. Despite such associations, the work of Tchelitchew is closer to that of a group of "Neo-Romantic" painters working in Paris (including Eugene Berman and his brother Léonid, Christian Bérard, and Kristians Tonny) whom Julien Levy showed at his gallery, and who often contributed to the decor of fashionable balls, as well as working in theater design. Levy characterized the work of these artists as "*Neo-Renaissance* . . . ; romantic only in the trappings of melancholy and ruin, poverty and nostalgia, that was an integral part of their life at this time, and not untrue of the human situation in general" (Levy 1977, p. 108).

This drawing is one of a series of anatomies, dating from the mid- to late 1940s, in which Tchelitchew explored his idea of the "interior landscape" of the human body. In successive drawings he treated the human head as made of transparent layers, which could be peeled back to reveal muscle, bone, and eventually blood vessels, thus evoking what Lincoln Kirstein called a "living mechanism and individual universe" (Lincoln Kirstein, ed., *Pavel Tchelitchew: Drawings*, New York, 1947, p. 22). Tchelitchew's friend the art critic Parker Tyler described the artist's obsession in these works with "the secrets of the body in terms of a subliminal physique; the latter is still behind a veil but each new work removes part of the veil. Everything in nature is now transposed to man's anatomy" (Parker Tyler, *The Divine Comedy of Pavel Tchelitchew*, New York, 1967, p. 447). There are evident connections here with the work of both Matta and Gordon Onslow Ford, whose "psychological morphologies" were also interior landscapes of a kind, although far less tied to the human body in conception and appearance (see, for example, no. 93 above).

In spite of some recourse to automatism, Tchelitchew's technical concerns ran along very traditional paths. The distance between him and the Surrealists is clearly signaled in his text "On Drawing" (published in Kirstein 1947, pp. 5–10), in which he discriminated between types of drawing (sketch versus finished drawing, for instance) and discussed the criteria for quality and good draftsmanship – concerns in theory alien to the Surrealists for whom the quality of imagination counted for more than technical skill. Automatism, for Tchelitchew, was of use as a supplementary technique, rather than as the primary means through which to explore the unconscious: "Hatchings," he wrote, "have their neat, classic allocation of predetermined design, but the wash or smear when masterfully applied, can provide the apparently accidental relaxation and rightness of a lucky throw, which is here, then, skill rather than chance" (ibid., p. 7). According to Tchelitchew, the draftsman's skill is built upon traditional methods of observation, perception, and copying from nature:

Just as every dream is relevant if rightly read, since its loose fragments refer to some waking experience, so the spontaneous draughtsman's rapid line is supported by intuition based on past observation. . . . This automatism is governed and guaranteed by a repetition of studies, a framework of factual knowledge slowly gained by close and loving familiarity – by dissection, by analysis, by increasing sensitivity of touch and penetration in observation, and by main patience. (ibid., p. 9)

This drawing displays an extraordinary synthesis of different techniques of draftsmanship. These reflect the artist's anxiety as he groped for a way to convey knowledge of the human head, as well as the limits of this knowledge, whether scientific or artistic. The doubled and tripled contour lines heighten the semitransparency of the head and suggest its appearance in the round. Beneath the specific features of the head, the underlying structure of a skull is visible, somewhat obscured by the ink that is blotted and smeared in a superficially automatic way, particularly where the base of the cranium joins the spinal cord. The approximate and indecisive marks and smudges in this drawing contrast with the medical accuracy Tchelitchew achieved in other drawings of the same year, such as *Skull and Vertebrae* (New York, Ruth Ford; Kirstein 1994, p. 94, pl. 22), and indicate an impasse in representing the interior and the exterior of the body. Tchelitchew here merged, in a disturbing and almost uncanny way, the surface concavities of the skin with the hints of muscle and bone beneath. * * *

LAURENCE VAIL

AMERICAN, 1891–1968

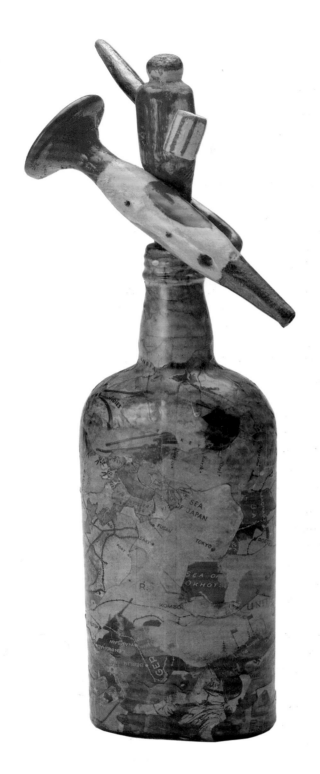

IN THE 1942 CATALOGUE OF PEGGY GUGGENHEIM'S collection, Laurence Vail (Peggy Guggenheim's first husband) was represented by a collage screen and a number of bottles dated to 1941 (Peggy Guggenheim, ed., *Art of This Century: Objects, Drawings, Photographs, Paintings, Sculpture, Collages, 1910 to 1942*, New York, 1942, p. 123). Vail was a flamboyant member of bohemian circles in Europe during the 1920s and 1930s. His peripatetic career and his somewhat detached approach to it is well captured in the brief biographical note in this catalogue: "American painter, writer, collagist. Born Paris, 1891. Self-taught, independent. Lived Paris, Kitzbühel, Venice, Oxford, Megève until 1941. Now Connecticut" (ibid.); Vail was also quoted here as saying, "I used to throw bottles and now I decorate them" (ibid.). This elliptical comment probably refers to his wild and sometimes violent behavior; in one incident he was jailed for smashing wine bottles against the mirrors of a Paris bistro (see Jacqueline Bograd Weld, *Peggy, the Wayward Guggenheim*, New York, 1986, pp. 64–65). As illustrated by the Bergman piece, Vail used bottles (more often gin or whisky bottles) as the basis for intricate collages and often adorned them with bizarre stoppers, thus transforming everyday materials into Surrealist objects.

René Magritte had also started painting wine bottles, probably in the autumn of 1940, following his return from France to Brussels, but his works are very different in character: in some cases, he transformed the bottle into a woman's body; while in others he decorated the bottles with motifs from his own paintings or pastiches of the work of other artists, such as Pablo Picasso (see London, The South Bank Centre, *Magritte*, 1992–93, exh. cat., n. pag., nos. 158–164, ills.).[2] Both Magritte and Vail, however, appealed to what Edward James described in a letter to Magritte as the taste of New Yorkers for that sort of

116. UNTITLED

c. 1947
Collaged and lacquered bottle, with carved and painted wooden stopper; 36.5 x 15.5 x 7.6 cm (14³/₈ x 6¹/₈ x 3 in.)
The Lindy and Edwin Bergman Collection, 173.1991

PROVENANCE: Given by the artist to Yvonne Hagen, New York, in the early 1960s.[1] James Goodman Gallery, New York; sold to Lindy and Edwin Bergman, Chicago, 1980.

REFERENCES: *U. of C. Magazine* 1982, p. 25 (photo of Bergman home).

"fantasy" (letter from Edward James to Magritte of May 23, 1941, quoted in London 1992–93, n. pag., under no. 158). James's comment can be understood in the context of a more generalized and less rigorous interpretation of Surrealism in the United States, where the term Surrealist was applied to all kinds of fanciful and imaginative products. There was certainly a tendency in the United States to emphasize the lighter, more playful side of Surrealism rather than the darker Surrealist investigations into the unconscious. Joseph Cornell, for example, identified with what he called the "white magic" of the Surrealist works he admired, such as Max Ernst's collages, eschewing, by implication, their more nightmarish side (New York 1980–82, p. 38). It could also be the case that the bottles appealed to a fashionable New York demand for unusual objects for interior decor.

The opening show at Guggenheim's gallery – whose name, Art of This Century, had been invented by Vail – was followed by an exhibition scheduled for the 1942 Christmas season, entitled "Objects by Joseph Cornell, Marcel Duchamp's Box Valise, Laurence Vail Bottles." Critic Clement Greenberg, always skeptical of Surrealism, focused on the formal aspect of both Cornell and Vail's work in his review of the show for *The Nation* (December 26, 1942):

In Vail's bottles and even in Cornell's objects Surrealism encourages a tendency it often opposes – the abstract. The bottles do not owe their beauty to the things represented on the scraps of pictures Vail cuts out of magazines and pastes around the glass, but rather to the way the bottle shape is married to the color and design of the collage. (Clement Greenberg, "Review of a Joint Exhibition of Joseph Cornell and Laurence Vail," in John O'Brian, ed., *Clement Greenberg: The Collected Essays and Criticism, Volume I, Perceptions and Judgments, 1939–1944,* Chicago, 1986, p. 131)

Surrealist art for Greenberg was too close to literature, and not sufficiently responsive to the particular qualities of the medium in its own right. His appreciation of Vail's bottles is based upon their derivation from post-Cubist painting, but also upon an idea that this kind of object could be developed as an autonomous form of art, rather than as an ornament:

Vail's bottles do not appear at their best in a gallery. They are too intimate as yet and belong rather to one's private surroundings; there they lose all associations of ornament and become, even more than Chinese vases, autonomous and dramatic, competing with pictures and sculpture. (ibid.)

In a preface for the catalogue of his 1945 exhibition of over fifty bottles at Art of This Century, Vail further clarified his interest in bottles as an artistic medium:

I still occasionally, and quite frequently, and very perpetually, empty a bottle. This is apt to give one a guilty feeling. Is it not possible, I moaned and mooned, that I have neglected the exterior (of the bottle) for the interior (of the bottle). Why cast away the empty bottle? The spirits in the bottle are not necessarily the spirit of the bottle. The spirit of the spirits of the bottle are potent, potential, substance that should not be discarded, eliminated in spleen, plumbing and hangover. Why not exteriorize these spirits on the body of the bottle Hence these bottles. (Laurence Vail, "Anent Me, Laurence Vail, Bottle Maker," in New York, Art of This Century, *Laurence Vail,* 1945, exh. cat., n. pag.)

Despite the bottles' intimate character and highly personal origins, the collages adorning them often do reveal a coherent theme. On this bottle, for example, the collage fragments are torn maps, which, taken with the swastika, the cross of Lorraine, a cartoon image of a soldier, and the profusion of arrows, must refer to military campaigns in World War II. The geographical references show, among other things, the extent of the advances of the three powers forming the Axis (Germany, Italy, and Japan) toward the end of 1942. The painted soldier with his arm raised, which is part of the wooden stopper, perhaps mocks the rhetorical poses of the European dictators. The large, trumpet component of the stopper reinforces these associations through its invocation of martial music.

* * *

INTRODUCTION

1. *Saturday Review* 1980, p. 59.
2. *U. of C. Magazine* 1982, p. 25.
3. Lindy Bergman, in conversation with the author, January 1994.
4. See *Saturday Review* 1980, p. 58, ill.; and *U. of C. Magazine* 1982, p. 25, ill.
5. See Dubuffet's talk at the Arts Club, entitled "Anticultural Positions," reproduced in facsimile in New York, Richard L. Feigen and Co., *Dubuffet and the Anticulture*, 1969–70, exh. cat., between pp. 8 and 9.
6. See Dennis Adrian, "The Artistic Presence of Jean Dubuffet in Chicago and the Midwest," in The University of Chicago, The David and Alfred Smart Gallery, *Jean Dubuffet: Forty Years of His Art*, 1984–85, exh. cat., pp. 27–30.
7. Lindy Bergman (note 3).
8. Letter from Lou Laurin-Lam, July 7, 1961. All letters cited in this introduction are in the possession of the Bergman family.
9. *Trade Winds/Storm Warning* is reproduced in Ashton 1974, p. 109.
10. Letter from Joseph Cornell of September 20, 1959; and Lindy Bergman (note 3). The collage Cornell gave Carol, *Julie Spinasse*, c. 1959, is in her collection.
11. Letter from Joseph Cornell, November 8, 1959.
12. Letter from Joseph Cornell of April 5, 1965.
13. Lindy Bergman (note 3) and Robert Bergman, in conversation with the author, January 1994.

ARP

1. This sculpture is also accompanied by a certificate of authenticity, which consists of a black-and-white photograph of the work, bearing on the back the following inscription in Arp's hand: *Je soussigné / Jean Arp certifie / que la sculpture / reproduite au verso / s'intitulant "Torse- / Chorée" est le no. / 2 d'une édition / de 5 bronzes. / Meudon, 17.VII.62 / Arp* (I the undersigned / Jean Arp certify / that the sculpture / reproduced on the verso / called "Torse- / Chorée" is no. / 2 of an edition / of 5 bronzes. / Meudon, 17.VII.62 / Arp).
2. According to a letter from Edouard Loeb's nephew Albert Loeb to Adam Jolles of January 27, 1995, in curatorial files.
3. It appears that some dealers may have imposed this gold, reflective finish on Arp's bronzes to make them more attractive to potential buyers. See Poley 1978, p. 42 n. 71; and Andreotti 1989, pp. 22–23 n. 64, p. 154 nn. 29–31. That Arp originally intended *Torso-Kore* to have a matte finish is demonstrated by the signed photograph of this sculpture that accompanied it when it was purchased (see note 1). *Torso-Kore* will eventually be repatinated in accordance with the artist's original intentions as part of a larger program of conservation of works in the Bergman collection.
4. This collage is now hung in accordance with the orientation of the label Arp affixed to its back (see above inscription).
5. *Oiseau hippique* has various hooks on its back, none recent, which allow for these various orientations.

BALTHUS

1. According to a letter from Olive Bragazzi, Director of the Pierre Matisse Foundation, to Adam Jolles of April 5, 1995, in curatorial files.
2. According to a letter from the Galerie Claude Bernard to Adam Jolles of April 6, 1995, in curatorial files.
3. According to a letter from Virginie Monnier to Adam Jolles of April 7, 1995, in curatorial files.

BRAUNER

1. Hoctin (1963, p. 60) gave the location of this painting as Galerie Rive Gauche, Paris, even though by 1963, the date of Hoctin's article, the work was already in the Bergman collection.
2. Although the 1951 Hanover Gallery exhibition listed this picture as *Acolo*, when the Bergmans bought it in 1960 it changed hands as *Agolo*.

BRETON

1. Comparison with the photograph of this work (fig. 1) in the 1937 issue of *Minotaure* (10 [Winter 1937], p. 59) reveals that some of the metal components of this "bouquet" are no longer in their original position.

NOTES

CADAVRES EXQUIS

1. Based on Breton's signed authentication of this work on the back (see inscription).

2. In the Bergman documentation, the name of Simone Collinet, Breton's first wife, is given in parentheses after that of the gallery from which the work was purchased. This may simply refer to the fact that Simone Collinet was the owner and director of the Furstenberg gallery. It is also possible that one or more of the *cadavres exquis* purchased by the Bergmans came from her personal collection, since she is listed as the owner of several similar works in Spies 1976, pp. 212–13, nos. 1202–03.

3. See note 1. In this case, the Bergman documentation sheet on this work also specifies "from the collection of André Breton."

4. See note 2.

5. See note 1.

6. See note 2.

CALDER

1. A letter from Grace Hokin to Edwin Bergman of February 23, 1970, enclosed an illustrated article of February 5, 1970 [place of publication unknown], showing Hokin with this sculpture.

2. Ellen Deutsch of the Perls Galleries, New York, confirmed that the Bergman piece was the one reproduced in this catalogue (phone conversation with Adam Jolles of February 10, 1995).

3. See note 1.

4. According to Sandy Rower, Director, The Alexander and Louisa Calder Foundation, New York, in a phone conversation with Adam Jolles of February 8, 1995. Rower also pointed out that another of the Art Institute's pieces in this series, *Antlers* (1979.354), was originally named *A Detached Person*.

5. Ibid.

CARRINGTON

1. See a letter of August 25, 1995, from Mariana Perez Amor, Director, Galería de arte mexicano, to Adam Jolles, in curatorial files. This letter, written on behalf of Carrington, reported a recent conversation with the artist about the Bergman painting.

DE CHIRICO

1. See a letter of February 1, 1995, from Sam Trower, Richard L. Feigen and Co., Inc., to Adam Jolles, in curatorial files.

2. The only difference between the drawing and its reproduction in *Le Mystère laïc* seems to be the addition of a light, gray wash to some of the areas in shadow. Cocteau's essay is dated December 1927 (p. 81) and the printing of the book was completed on May 30, 1928 (see the book's colophon). Only one of the five illustrations is dated: the one reproduced opposite p. 12, which shows two mannequins and is inscribed 1928. However, several drawings similar to the Bergman one are dated 1926 (Roger Vitrac, *Georges de Chirico*, Paris, 1927, p. 49; and Waldemar George, *Giorgio de Chirico*, Paris, 1928, pl. II). In a letter to Richard Feigen of May 7, 1965, Julien Levy stated that the Bergman drawing could "certainly be attributed to 1926." He added, "In that year I saw a portfolio of similar drawings just completed by de Chirico, in the Paris apartment of Léonce Rosenberg (Galerie de l'Effort Moderne)."

CORNELL

1. For a more extensive treatment of Cornell's relationship to Surrealism, see Dawn Ades, "The Transcendental Surrealism of Joseph Cornell," in New York 1980–82, pp. 15–39.

2. According to a letter of February 14, 1964, from John Bernard Myers, director, Tibor de Nagy Gallery, New York, to Edwin Bergman.

3. In a letter to Edwin Bergman of July 1964, Julien Levy wrote that this was "among the very first shadow boxes he [Cornell] ever made, and was included in my first one-man show for him in December of 1932." Levy may have been referring here to the joint exhibition of works by Cornell and etchings by Picasso that was held at the Levy Gallery from November 26 to December 30, 1932. As Robert Bergman suggested in his own documentation of this box, it seems more likely, however, that Levy intended to refer to the first one-man show of Cornell's work held at the Levy Gallery in December of 1939. The small catalogue accompanying this exhibition included an essay by Parker Tyler, who may have owned the box at that time.

4. According to a letter of March 20, 1981, from Tamara Toumanova to Edwin Bergman.

5. According to the staff of the Copley Foundation, New York, in a telephone conversation of May 5, 1995, with Adam Jolles. See also Bill Copley, "Joseph Cornell," in New York, Castelli, Feigen, Corcoran, *Joseph Cornell Portfolio*, 1976, exh. cat., n. pag.; and Copley's unpublished memoir, *Portrait of the Artist as a Young Art Dealer*, William N. Copley Papers, Archives of American Art, Smithsonian Institution, Washington, D.C., reel 2709, pp. 14–16, 28–30.

6. According to a fax of February 1, 1995, from Sam Trower of Richard L. Feigen and Co., Inc., New York, to Adam Jolles, in curatorial files.

7. According to a fax of March 13, 1995, from Melissa Stegeman, National Gallery of Art, Washington, D.C., to Adam Jolles, in curatorial files, the box was originally loaned to the exhibition *American Art at Mid-Century: Part I*, but was instead mounted in the 1973–74 Cornell show at the National Collection of Fine Arts, Smithsonian Institution, Washington, D.C. The box was returned to the National Gallery of Art at the end of this exhibition, where it remained in storage until January 1976.

8. See note 6.

9. See note 5.

10. According to a fax of May 3, 1995, from Sam Trower of Richard L. Feigen and Co., Inc., New York, to Adam Jolles, in curatorial files.

11. According to a fax of April 20, 1995, from Cynthia Chin, The Metropolitan Museum of Art, New York, to Adam Jolles, in curatorial files, Feigen loaned this box to the museum with fourteen others, none of which were exhibited.

12. According to a fax of April 19, 1995, from Melissa Stegeman, National Gallery of Art, Washington, D.C., to Adam Jolles, in curatorial files, the box was returned to the National Gallery of Art at the end of the 1973–74 Cornell exhibition, where it remained in storage until April 1976.

13. See Cynthia Kuniej Berry, Examination Report, The Art Institute of Chicago, July 30, 1993, copy in curatorial files. It is unclear when and how the original cubes were lost. According to Robert Bergman, the current replacement cubes were purchased by Lindy and Edward Bergman during a vacation in Sara-sota, Florida. See typed notes by Robert Bergman of June 1996, copy in curatorial files. *Homage to the Romantic Ballet* will be eventually restored with cubes closer to the original ones, as part of a larger program of conservation of works in the Bergman collection.

14. See note 5.

15. According to the fax from Sam Trower cited in note 6.

16. See note 11.

17. See note 6.

18. Ibid.

19. According to the fax cited in note 12, *Untitled (Bird)* was returned to the National Gallery of Art at the end of the 1973–74 Cornell exhibition, where it remained until September 1976.

20. According to Sidney Bergen, director, ACA Galleries, New York, in a phone conversation of April 26, 1995, with Adam Jolles.

21. According to Allan Frumkin, in a phone conversation of January 11, 1995, with Adam Jolles.

22. According to a fax of April 18, 1995, from Sam Trower of Richard L. Feigen and Co., Inc., New York, to Adam Jolles, in curatorial files.

23. See note 20.

24. According to a fax of April 26, 1995, from Jeanne Havemeyer of B. C. Holland, Inc., Chicago, to Adam Jolles, in curatorial files.

25. According to a fax of April 19, 1995, from Sam Trower of Richard L. Feigen and Co., Inc., New York, to Adam Jolles, in curatorial files.

26. See note 20.

27. See note 21.

28. Cornell referred to this box as "Sun and Beach" on his undated invoice for this transaction.

29. Cornell referred to this box as "Soap Bubble Set" in the undated invoice mentioned above (note 28).

30. See note 21.

31. According to Allan Stone in a telephone conversation of March 14, 1995, with Adam Jolles.

32. Robert Bergman, in conversation with Margherita Andreotti, June 10, 1996. See also Butler 1974, p. 305. This work was apparently dated to 1972 when it was exhibited in 1973–74, but given an earlier date of c. 1969 in New York 1980–82.

DALÍ

1. In a letter to Edwin Bergman of February 27, 1969, Albert Field of the Salvador Dalí Archives, Astoria, New York, relayed the artist's opinion that the drawing was originally titled *Anthropomorphic Tower*.

2. According to the fax cited below (note 5).

3. Ibid.

4. According to a letter of August 13, 1996, from Andrew Barlow to Adam Jolles, in curatorial files.

5. In a fax to Adam Jolles of June 20, 1995, Sharon-Michi Kusunoki of the Edward James Foundation verified that James did not purchase this drawing from Levy's 1939 exhibition. This implies that the drawing was one of the works James purchased under contract from the artist between June 1, 1937, and June 1, 1938, and that James loaned the work to Levy for his exhibition.

6. According to the fax cited above (note 5).

7. Dalí sometimes referred affectionately to Gala's Russian origins in diminutives of her name, as in this inscription.

8. The drawing was published as a self-portrait in 1963 (see Exhibitions).

DELVAUX

1. De Bock (1967, pp. 69, 289, no. 27) claimed that the painting was destroyed in London during World War II, a claim repeated with slight variations by Houbart-Wilkin (Butor, Clair, and Houbart-Wilkin 1975, p. 174, no. 83, as "destroyed") and Sojcher (1991, caption to fig. 8, as "destroyed by the artist"). These sources refer almost certainly to the large losses suffered by the London Gallery to stock that its owners, Roland Penrose and E. L. T. Mesens, housed at Taylor's Depository, Ranelagh Road, SW1. During the bombing of London in 1940, the Depository took a series of direct hits. Mesens wrote in a letter of 1944 (to P. G. and Norine Van Hecke; see *Magritte Catalogue*, vol. 2, 1993, pp. 84–85) that two or three early Magrittes and "most of all, *The rape* by Delvaux" had been lost in a fire caused by incendiary bombs. It has thus been incorrectly assumed that this painting was also destroyed. An inscription in pencil on the stretcher confirms that this painting was in the London Gallery stock; it reads *Col. Penrose*, the

Penrose crossed out and substituted with *Mesens*. Mesens's inventory of work stored at Taylor's Depository was subsequently annotated to show which works survived. *The Lamps* was among the latter (information supplied by Sarah Whitfield).

2. Gordon Onslow Ford, in a phone conversation with Adam Jolles of February 13, 1995 (see note from Adam Jolles to Margherita Andreotti of February 14, 1995, in curatorial files).

3. According to Wadsworth Atheneum records, this painting was lent to that museum in 1942, "along with over 100 other paintings from the Julien Levy Gallery, for safekeeping during World War II"; see a label on the back of the painting and a letter from Peter D. Barberie to Alison Siegler of July 19, 1994, in curatorial files.

4. See a label on the back of the painting and the records of The Minneapolis Institute of Arts. A copy of these records was kindly provided by Catherine L. Ricciardelli (letter to Alison Siegler of July 18, 1994, in curatorial files). According to Ricciardelli, the brief period of the loan suggests that the painting was at The Minneapolis Institute of Arts as a possible acquisition.

5. According to a letter cited above (note 3).

6. The exhibition catalogue does not include a list of the works shown.

7. See Julien Levy, *Memoir of an Art Gallery*, New York, 1977, p. 311. No catalogue has so far been found of this exhibition.

8. In the background, the pentimento of another mountain is just visible on the central horizon; Delvaux's overpainting deteriorated and restoration was required in 1985.

DUBUFFET

1. Neither the signature nor the inscription on the painting appear in the reproduction in Loreau's catalogue. This suggests that Loreau used one of the photographs Dubuffet was in the habit of taking very soon after completing a work and before signing it.

2. See the label on the back of the painting and the 1955 exhibition catalogue.

3. According to a letter from Lynn Sharpless of the Margo Leavin Gallery to Alison Siegler of August 5, 1994, in curatorial files.

4. According to a letter from Baudoin Lebon to Adam Jolles of January 17, 1995, in curatorial files.

5. According to the letter from Baudoin Lebon cited above (note 4).

6. According to a fax of April 26, 1995, from Jeanne Havemeyer of B. C. Holland, Inc., to Adam Jolles, in curatorial files.

7. According to a letter from Abigail Willis of the Waddington Galleries, Ltd., to Adam Jolles of January 16, 1995, in curatorial files.

8. According to a letter from Patricia H. Tompkins of the James Goodman Gallery to Adam Jolles of February 25, 1995, in curatorial files.

9. According to the records of The Minneapolis Institute of Arts, a copy of which was kindly provided by Catherine L. Ricciardelli (letter to Alison Siegler of July 18, 1994, in curatorial files); and an invoice from the James Goodman Gallery to Edwin Bergman of March 8, 1983. These records indicate that *Bird's Flight* was on loan to The Minneapolis Institute of Arts for the annual Prints and Drawings Department sale.

10. This work was dated to September 1959 when it was first exhibited in 1960 (see Exhibitions).

11. The medium of this collage was described as "agave" when the work was first exhibited in 1960 (see Exhibitions).

ERNST

1. The catalogue for the 1921 *Exposition Dada Max Ernst* at Au Sans Pareil, Paris, lists "S[imone] K[ahn]" as the owner, as does the catalogue of the 1936–37 exhibition at The Museum of Modern Art. Simone Kahn, the first wife of André Breton (they divorced in 1928), later changed her name to Simone Collinet and was the owner of the Galerie Furstenberg, Paris.

2. A similar title is given on the back of the drawing on a label from the Julien Levy Gallery, which reads: *Original Personnage by Max Ernst*.

3. The Graf Zeppelin airship was launched for transatlantic flights in 1928, and was followed by the larger Hindenburg in 1936.

FINI AND CORNELL

1. The two printed labels derive from a one-page announcement of the

Leonor Fini exhibition at the Julien Levy Gallery in 1936 (copy in the Ryerson Library, The Art Institute of Chicago).

2. This letter is in the Bergman family archives and may be translated as follows: "Dear Madam, / Yes, I gave Joseph Cornell the drawing featured in this collage (probably with the dedication). / But he's the one who made the collage. The photo of me is not by Charles Ford."

3. It is unclear whether Fini's drawing preceded or followed *The Lost Needle* painting. In a letter to Lindy and Edwin Bergman of March 10, 1979, Helen Serger (see Provenance) described the drawing as "a study for her [Fini's] painting *The Lost Needle*," but without explaining her source for this statement. Tashjian, instead, in his 1992 book on Cornell, described the drawing as "based on the painting" (p. 48), again without providing a basis for his conclusion.

GORKY

1. According to Allan Stone, in a telephone conversation with Adam Jolles of March 14, 1995.

2. According to a fax of April 26, 1995, from Jeanne Havemeyer of B. C. Holland, Inc., to Adam Jolles, see copy in curatorial files. Harold Diamond probably acquired this drawing after 1966, since it is still listed as belonging to the estate of Arshile Gorky in Levy's 1966 book (see References). According to the Bergman files, there is an unconfirmed inscription on the back that reads: *This is an original Gorky drawing – ink and crayon on wrapping paper. Agnes Gorky Phillips 2-10-75.*

3. All of the preceding items in this section refer to a show organized by The International Council of The Museum of Modern Art, New York, under the supervision of Waldo Rasmussen, Executive Director of the Museum's Department of Circulating Exhibitions. The show's many venues have been listed here in chronological rather than alphabetical order. While it appears that the 1965 Brussels exhibition did have a catalogue, we were unable to locate a copy of it by the time this book went to press.

GRAHAM

1. This inscription should be under-stood as a kind of signature rather than a title, as it clearly refers to Graham himself.
2. Although the work was owned by the Bergmans at this time, the exhibition catalogue indicates that the work was loaned by the André Emmerich Gallery, New York.

LAM

1. This study was painted on paper, as was *The Jungle*, and shipped in this form to the United States, where it was mounted on Belgian linen. Some paper was later added to unfinished areas of the composition (Bergman conservation records, February 21, 1957). In a letter to Edwin Bergman, dated April 1956, Lam described the execution as "'a la Tempra' not commercial, but a formula prepared without a varnish base 'Darmal' [probably a reference to damar, a resin-based varnish], lint [seed] oil, eggs, and water." The worn and flaked areas of paint in the center and on the sides of the picture might be a result of its having been rolled up for some time in Lam's studio, but some of the effects of dripping and streaking may be a result of a partially automatic technique.
2. The back of this work also bears a sketchy drawing related to the "ax-headed" woman on the front.
3. According to a letter of July 13, 1995, from Olive Bragazzi, director of the Pierre Matisse Foundation, to Adam Jolles, in curatorial files.
4. According to the letter cited above (note 3), this work appears in one of the installation shots of this exhibition.
5. See letter cited above (note 3). A photograph of this work from the Pierre Matisse Gallery is labeled 1947 (see photocopy in curatorial files).
6. In his "inventory sheet" for the painting, a copy of which was sent to the Bergmans when they acquired this work, Lam listed under exhibi-tions "1954 *Cahiers d'art*, Paris," and the Art Institute's 1959 exhibi-tion *The United States Collects Pan-American Art*, although no record of the painting in either exhibition has been found so far.
7. According to a letter of March 11, 1995, from the Galerie Albert Loeb to Adam Jolles, in curatorial files. Albert Loeb was the intermediary between Edwin Bergman and Lam for the purchase of this drawing, as

demonstrated by correspondence and an invoice with the gallery's letterhead in the Bergman files.

LINDNER

1. According to Allan Stone of the Allan Stone Gallery, New York, in a phone conversation with Adam Jolles of March 14, 1995.
2. According to Jeanne Havemayer of B. C. Holland, Inc., Chicago, in a fax of April 26, 1995, to Adam Jolles, in curatorial files.

MAGRITTE

1. According to photographs in the Bergman files of the original lining. The painting was relined after being damaged during the 1965–66 Magritte retrospective at The Museum of Modern Art, New York.
2. According to a letter of February 2, 1995, from Grace Hokin to Adam Jolles, in curatorial files.
3. According to Kanoi Keith of the Pace Gallery, New York, in a phone conversation of August 24, 1995, with Adam Jolles.

MASSON

1. According to a letter of June 27, 1995, from Quentin Laurens of the Galerie Louise Leiris, Paris, to Adam Jolles, in curatorial files.
2. According to a letter of September 19, 1995, from Quentin Laurens of the Galerie Louise Leiris, Paris, to Adam Jolles, in curatorial files.
3. According to a fax of July 6, 1995, from Miriam Dacosta of the Galerie Claude Bernard, Paris, to Adam Jolles, in curatorial files.

MATTA

1. According to a letter of November 22, 1961, from Robert Elkon to Edwin Bergman.
2. According to a fax of May 24, 1995, from Susan Stroman of the Sidney Janis Gallery, to Adam Jolles, in curatorial files.
3. A label on the back of the canvas from W. S. Budworth and Son, Inc., lists "Moskin" as the owner; on an adjacent label from the Sidney Janis Gallery, the name "Sidney Janis" is scratched out, and above it is inscribed the name "R. Moskin."
4. Matta's paintings of this period are often referred to as *Psychological Morphologies*, although according to Gordon Onslow Ford, Matta rarely gave titles to his paintings at this time. It was only in 1956 that Matta gave the title *Inscape* to one of his canvases from this period (Onslow

Ford in Paris, Musée national d'art moderne, *Matta*, 1985, exh. cat., p. 33 n. 2).
5. According to a letter of April 5, 1995, from Olive Bragazzi of the Pierre Matisse Foundation, New York, to Adam Jolles, in curatorial files.
6. According to Allan Frumkin in a phone conversation of January 11, 1995, with Adam Jolles.
7. According to Melyora Kramer of The Elkon Gallery, Inc., in a phone conversation of November 16, 1995, with Adam Jolles.

MIRÓ

1. According to a statement of authen-tication of February 24, 1972, by Eugene V. Thaw.
2. According to a typed label on the back of a photograph of *Viticulture* from the André Emmerich Gallery, New York.
3. Carolyn Lanchner has suggested, in her comments on this manuscript, that this work may be one of the "15 drawings" listed by Miró in a notebook dating to 1923/24 (folio 613 b, notebook F. J. M. 591–668 i 3129–3130; see Barcelona, Fundació Joan Miró, *Obra de Joan Miró: Dibuixos, pintura, escultura, ceràmica, tèxtils*, 1988, p. 87, no. 259; cited in New York 1993–94, p. 350 n. 219).
4. According to a fax of May 26, 1995, from Claudia Neugebauer of the Galerie Beyeler, Basel, to Adam Jolles, in curatorial files.
5. Ibid.; confirmed by a fax of May 18, 1995, from Susan Stroman of the Sidney Janis Gallery, New York, to Adam Jolles, in curatorial files.
6. Ibid.
7. According to the fax from the Sidney Janis Gallery cited in note 5.
8. According to a letter of April 5, 1995, from Olive Bragazzi, director of the Pierre Matisse Foundation, New York, to Adam Jolles, in curato-rial files.
9. According to Kanoi Keith of the Pace Gallery, New York, in a phone conversation of August 24, 1995, with Adam Jolles.

MIRÓ AND ARTIGAS

1. According to a letter of August 18, 1995, from Jeanne Frank to Adam Jolles, in curatorial files.
2. According to a letter of February 25, 1995, from Patricia H. Tompkins,

director of the James Goodman Gallery, Inc., New York, to Adam Jolles, in curatorial files.

PICABIA

1. When the collage was purchased by the Bergmans, it was given a new frame, loose elements were stabi-lized, and missing matches and one "eyebrow" (hair curler, consisting of leather rolled over a core of metal wire) were replaced; see Louis Pomerantz's preliminary condition report of October 19, 1959, in curatorial files. An earlier frame is visible in New York, Sidney Janis Gallery, *Ten Years of Janis*, 1958, exh. cat., n. pag., fig. 84 (installation photograph).
2. A reproduction of the Bergman work, clipped from an unidentified newspaper, is attached to the back of the picture and captioned: *A NOVEL CONCEPTION* / *Portrait of a woman by a French artist at* / *the Tri-National Exhibition at the Chenil* / *Galleries. Matches, straps and hairpins have* / *been superimposed on the canvas.* The reproduction is slightly cropped at the bottom so that neither the artist's signature nor the date can be seen.
3. An anonymous review entitled "Art Galleries Offer Rich Variety" in the *New York Times*, Jan. 31, 1926, sec. 7, p. 12, described Picabia's con-tribution to this exhibition as com-posed of "hairpins, matches, and one-franc pieces" (see Borràs 1985, p. 295 n. 5). Camfield (1979, pp. 218–19 nn. 12–13), unaware of the London clipping mentioned above (note 2), proposed *Match-Woman II* (fig. 1) as the work to be identified with *Portrait* in the New York exhibi-tion catalogue. The Bergman piece was not included in the first venue of the *Tri-National Exhibition* (Paris, Galeries Durand-Ruel, *Exposition trinationale d'oeuvres de peintres et sculpteurs français, anglais, et américains*, May 28–June 25, 1925). Picabia added the picture to the show in London as a replacement for *Straws and Toothpicks* (Borràs 1985, fig. 542), which its owner, Jacques Doucet, was unwilling to send to London and New York.
4. According to a label attached to the back of the painting.
5. The media description on p. 287 of this source is incorrect, since there

are no "buttons" in the Bergman piece. There is also no evidence that the Bergman piece was ever in the collection of Mme Pierre Roché.

PICASSO

1. According to a telephone conversation of August 24, 1995, with Kanoi Keith of the Pace Gallery, New York. The work was sold to the Bergmans under the French title *Diable*.

2. The pigment was applied very crudely to the corrugated cardboard, and some conservation has been necessary to fix fragmenting paint. It has been estimated that about half the white pigment is lost, possibly because of flexing of the cardboard support, which tends to confirm that the figure was used as a costume.

3. See, for example, Picasso's print *Faun Unveiling a Woman* of 1936 (New York 1980, p. 332, ill.).

RICHIER

1. According to a fax of April 26, 1995, from Jeanne Havemayer of B.C. Holland, Inc., Chicago, to Adam Jolles, in curatorial files.

2. In her review of the Frumkin Gallery exhibition ("Art News from Chicago," *Art News* 53 [Oct. 1954], p. 55), Marilyn Robb Trier mistakenly referred to the small version of *Man of the Night* as *Little Bat Man*. Franz Schulze, in a review of the Arts Club exhibition of 1958 ("Art News from Chicago," *Art News* 57 [Oct. 1958], p. 45), repeated this mistake, this time in reference to the large cast formerly in the collection of Joseph and Jory Shapiro, Chicago, and now in the Museum of Contemporary Art, Chicago. Trier and Schulze may have been confusing *Man of the Night* with *L'Homme chauve-souris* (*The Bat Man*), which had been included in Richier's 1957 New York exhibition at the Martha Jackson Gallery (*The Sculptures of Germaine Richier*, no. 3, ill.), a confusion that is understandable since *Man of the Night* is indeed a form of "bat-man."

SCHWITTERS

1. According to the Thompson collection sale catalogue, p. 142 (see next item of provenance).

2. According to an undated label on the back of the collage.

3. According to a fax of April 26, 1995, from Jeanne Havemeyer of B.C. Holland, Inc., Chicago, to Adam Jolles, in curatorial files.

4. Ibid.

TANGUY

1. *The Certitude of the Never Seen* has been photographed with these five objects in various arrangements. In 1994 the objects in this work were restored to their original arrangement, as shown by early photographs of the piece (figs. 2–3).

2. According to an invoice of October 10, 1958, from Richard L. Feigen and Co., Inc., Chicago, to Edwin Bergman.

3. According to a fax of April 19, 1995, from Sam Trower, of Richard L. Feigen and Co., Inc., New York, to Adam Jolles, in curatorial files.

TCHELITCHEW

1. According to a fax of April 26, 1995, from Jeanne Havemeyer of B.C. Holland, Inc., to Adam Jolles, in curatorial files.

VAIL

1. According to a letter of May 16, 1997, from Yvonne Hagen to Adam Jolles, in curatorial files. This letter mentions that this work "was called the Trumpet Bottle."

2. There may be a distant precedent for Vail's bottles in the lamps made by poet Mina Loy around 1923–24. Loy's lamps were sold at the time in a Paris shop financed by Peggy Guggenheim, who occasionally added paintings by Vail – then her husband – to the shop's merchandise (see Weld 1986, p. 72). According to Robert McAlmon, Mina Loy "procured glass globes and bottles and transferred archaic pictures and maps upon them, inserted lights within, and wished to market these as table lamps" (Robert McAlmon, *Being Geniuses Together*, London, 1938, p. 163).

This is an index of artists' names and works. Neither the Exhibitions and References sections of each catalogue entry nor the footnotes have been indexed. Numbers in bold type refer to pages with illustrations. Catalogue numbers of works in The Lindy and Edwin Bergman Collection at The Art Institute of Chicago appear in brackets. Untitled works and works sharing the same title are distinguished by either date, medium, or current location, or some combination thereof.

CREDITS

COLOPHON

The typefaces used in this edition are Scotch Roman, Geometric, Torino, and Chevalier.

Scotch Roman, the serif typeface used in this edition, is a nineteenth-century "modern" face whose rationalist geometry and delicate serifs have their roots in the industrial revolution. It was designed in 1833 by Richard Austin, and redrawn by the Monotype Corporation in 1908.

Geometric is the sans serif face used in this edition. Designed by W. A. Dwiggins in 1932 as "a Gothic of good design" for advertising, the typeface was originally called Metro. It was later recut and renamed by Bitstream.